The Art Dockuments

TO MARCY,
I FEEL HONORED THAT
A NEW FRIEND MADE
IN CHINA HAS SUPPORTED
ME ON THIS PROJECT SO
DEAR TO MY HEART!
CARL 9/28/12

Coulton M. Davy

Supporters of the Art Dockuments include the following donors to the Kickstarter campaign:

- Doug Blush & Lisa Klein
- Kevin Curran
- Niki Davis
- Sevra Davis
- Elisabeth DesMarais
- Paul De Vries
- Ron Filson
- Scott Griegor
- Steve Heiken & Emily Novick
- James Hyde
- Eddie King
- Lory D. Lanese
- Howard McAlpine
- Nicole Poliquin, M.D.
- Rebecca Russell
- Carl Walsh
- Mark Welz
- Carolee Willison

THE ART DOCKUMENTS

Tales of the Art Dock:
The Drive-by Gallery

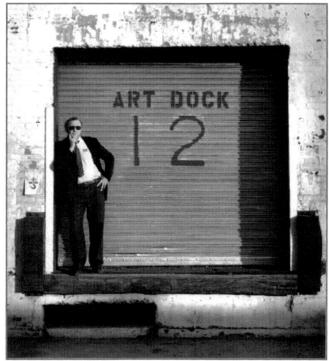

CARLTON DAVIS

First Edition

Paperback: ISBN-13: 978-14610821-0-1
LCN: 2012911532

Printed in the United States of America on acid-free paper.

Cover and book design: Patricia Bacall

ACKNOWLEDGMENTS

- Inspiration
 - Marcel Duchamp

- Art Dock Curator and Creator
 - Carlton Davis

- Assistant Curator
 - Marti Kyrk

- Art Dock Directors
 - Michael Salerno
 - Gary Lloyd
 - Karen Kristen

- Manuscript Editors
 - Linda Burnham
 - Pamela Guerrieri
 - Kayleigh Gray
 - Virginia Tanzmann

- Photographers
 - Ed Glendinning
 - Mark Tresize
 - Michael Levin

- Graphic Design
 - Patricia Bacall

- Production Art
 - Ottó Dimitrijevics

The Art Dockuments are dedicated to all the artists of downtown Los Angeles and Ellen Dorland, the artist who founded the Dorland Mountain Arts Colony, who eyed my drawings, heard my words, and saw music in them.

The Art Dockuments are my exploration of what it is to be an artist—to live the reality, the fantasy, the misery, and the joy. This story takes place in 1980s Los Angeles, but my hope is that the chronicle will touch the artist's experience of any time.

"The most interesting thing about artists is how they live."
- Marcel Duchamp

"An unDockumented life is not worth living."
- Linda Burnham

"An artist, chess player, cheese maker, breather, fenêtrier."
— Marcel Duchamp on Marcel Duchamp

THE CASE OF THE DRIVE-BY ART DOCK: OPEN AND SHUT

FOREWORD

Or should this be called "In Forward Drive" since the Art Dock kept on, whatever circumstances whirled about it, until it rolled to a full stop?

It was a heroic endeavor to present real art within an open loading dock, whenever it happened to be open. It was an offering in whatever form it took to the passing and disintegrating scene. It was part of a sensible attempt to provide studio space and living space to a community of artists. It was a continual battle of wits with the City Fathers and Real-Estate Moguls, while creating art. It was a land mine of the psyche, living in a disaster area of homeless poverty, while maintaining a limited comfort-and-sanity zone. It was a dedicated endeavor, letting the invited artist-of-the-month do what they would with no lip from the beleaguered curator. It was an event without polemic; it was what it was. I had the pleasure of marveling at all of it.

And it came, flourished, tore its hair, continued, achieved magnificence, all but failed, worried, pleased, and recognized its own end, that last in itself a rare occurrence. Its life spanned five years of intense and large-scale political and environmental change: 1981–1986. Whatever the time frame, it inevitably will shape many of our choices.

Typical record-keeping is seldom in the form of a diary telling it like it is—funny, sad, incomprehensible—complete with drawings made by the writer and photos of the artists and their art. Yet this is presented along with a review of each achieved monthly art event and an update as of 2012 on what has become of all persons named in each review.

This little neighborhood—with its backyard railroad tracks and nearby jail and road made of potholes and bumps, formerly the venue of factory workers and any kind of industrial hazard you can imagine—was home for a while to an extraordinary community of artists. And out of this dedicated group came an extraordinary reality: art that met the viewer on a level playing field, not abstracted away. And it was art.

This account of all it was and tried to be and was not is to be treasured.

▶ Carol Rubenstein, *Ithaca, NY, 18 February 2012*

CONTENTS

PREAMBLE

"The beginning is the most important part of the work."
—Plato

"I don't believe in art. I believe in artists."
—Marcel Duchamp

"Art is my life and my life is art."
—Yoko Ono

PREAMBLE

ART DOCKUMENT #1
THE COSMIC HUMEROID'S JOKE—1981

"**A**rt is my fate, don't debate," I wrote in my 1981 sketchbook. Strange fate, I thought, driving back to the illegal loft I inhabited east of Little Tokyo and west of the Los Angeles River in the Citizens Warehouse. The life I lived wasn't anything like what I imagined the LA artist's life would be. The reality of the creative life in downtown Los Angeles was more like outlaws running from the posse than beach-attired, avant-garde bohemians of Venice serving coffee to the elite who have come to see the latest creations.

My bed, a big, heavy, shield-shaped mattress and sturdy frame made of lumber, lay upside down in the back of my pickup truck. Below the wood frame, the limp, pink-striped, cotton slab sagged into the truck's bed, hiding all my clothes. The mattress edges draped over the truck's bed. This playboy relic of the 1960s resurrected from the trash (urban mining, the activity was called) had been visiting Venice while the authorities visited the lofts.

My loft. My enormous room! Gary's loft. Karen's loft, Ellen's loft. All the twenty-some artists' lofts in the old pickle factory (later furniture, book, and soy sauce warehouse) at the juncture of the river

bridge, the endless First Street, and the short Center Street. First Street stretches for miles from Mid-Wilshire, through downtown, across the Los Angeles River, and disappears finally into East LA. Center Street, extended one block, the length of the warehouse. The artists think of First and Center as ground zero—the prime spot—for the art community. That day, the Los Angeles building inspectors scheduled another raid on ground zero to catch the artists in the act of illegal living. Warehouses aren't residential buildings. Kitchens shouldn't be found. Beds are forbidden. Showers and bathtubs are suspicious. Clothes are proof of 24-hour inhabitation. Therefore, bed in truck, clothes under bed, I day-tripped to the beach to avoid the inspectors.

As I departed the ocean's edge, the late afternoon sun at my back painted the city's immense roof-top-spotted and palm-punctuated land canvas in bright hues and black shadows. In the freeway distance, LA's central city mound of towers shimmered. From the Venice beach perspective, Los Angeles was an astonishing Oz of vivid color, with infinite and amazing potential. Venice, the beach slum turned into a cultural treasure and real-estate boom by artists, was proof of the tremendous cultural energy that spread from the ocean to the mountain backdrop for the Hollywood dream, then reached to the rising towers of great capital ventures on the plain beyond. Evidence of a cultural bloom abounded. In the empty place in front of every new office building, sculptures were plopped. In the lobbies of Bunker Hill and Figueroa Street skyscrapers, art exhibitions were embedded. Colorful murals adorned the walls along Venice alleys, the freeways surrounding downtown, and the streets of East Los Angeles. Along San Vicente Boulevard, a conceptual artist had, turned the bus stop benches into art by striping them blue and white. On Sunset Boulevard even the billboards were art. Local artists believed Los Angeles was the successor to New York's position as the center of the art world.

During the mid-century, Venice was the engine

driving the cultural boom. For artists this was the ideal bohemian place to live and create the west coast art defining the new art capital. The sun, the surf, the sand—they were so California. The suntanned, nearly nude population mixing with hippies, roller-skating gangs, and the health-conscious elderly was so exuberant. The remnants of the old real-estate dream—to create a "new Venice"—were visible in the shallow canals. The colonnaded end of Windward Avenue provided a curious cultural precedence. Artists found Venice and Los Angeles bright, happy places to do their thing. The cultural elite, the rich, and the Hollywood royalty embraced them and their work. The cool light-and-space art of the West Coast found its home.

The old storefronts and the relic structures of the once great, later shabby, amusement park beside the Venice boardwalk created opportunity, and the artists moved in. Artists converted these anonymous, dead spaces into energetic, live-in studios, and nobody objected. The sunny days and cool ocean breeze made a wonderful environment, and crowds of beach visitors were an interesting diversion. The gathering community of creative people added more stimulation. Venice became a hive of avant-garde galleries, coffeehouses, and restaurants. More people were drawn to the excitement. Counterculture vendors and strolling musicians found new customers. Beach bums found a beach to sleep on and tourists to panhandle. The Venice mix of urban reality and tinseltown fantasy hinted at an authentic cultural alternative, but the artists were soon priced out.

Success brought developers and house buyers to the place once declared the slum by the sea. Rents soared. Stores changed to studios became stores again. Old structures were demolished and replaced by fancy architecture. Emerging artists and artists who weren't anointed by critical acclaim looked for a new place to go. Downtown LA became the new place.

As my pickup entered downtown, I noted how

my neighborhood bore little resemblance to Venice, except for the homeless. There were no hip coffeehouses, no garden restaurants, no wacky street vendors, and no roller-skating musicians. My destination wasn't vibrant. It had no allure of leisure or fun. Where I lived was hard and gritty. The neighborhood east of Alameda Street was mostly empty except for a few surviving businesses, the wandering bums, and the illegal artists.

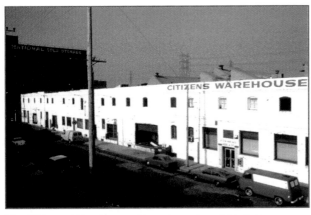

The Citizens Warehouse, Downtown Los Angeles

My artist friends called themselves artistic astronauts landed on the alien planet of downtown Los Angeles. Gary Lloyd was Captain Spacemeat after his meat sculpture, which he drew floating in outer space. Karen Kristen was Nerak, Karen spelled backwards. She was the space princess. They called me The Cosmic Humeroid, a humorous traveler from a curious asteroid; and we called Ellen Fitzpatrick, a business executive, Gunga Ma, Mother of Ganges, for her interest in Indian spirituality. We four inhabited the center section of the spaceship Citizens Warehouse moored in downtown Los Angeles. We all felt threatened by the authorities who governed this foreign industrial landscape. I wondered why I had come to this unwelcome place. To become an artist, I had given up a lot. I had more or less abandoned my career as an architect. I had separated from my wife and daughter, leaving them in San Francisco to come

and seek my fortune as part of the downtown art community. The separation was extremely painful. My wife did not want to join me in LA, our marriage had been in a difficult place for a long time, and I felt guilty leaving them to pursue my dream. I was self-centered and unmoved to resolve the difficulties in my marriage. I, a mature man, chased a dream when I should have been concerned about my wife and child. I wondered if it was worth the loss but, as imperiled as a felt, I was excited about being a part of this outlaw artistic community.

The downtown LA artists colonized a land of railroad tracks, trucks, and dumpsters. Their studios hid in two- or three-story structures dotted among the old industrial edifices beyond the new office towers and Skid Row. In buildings unrentable for commerce, artists found the cheap space no longer available in Venice. Three feet above the sidewalk on the first floor of a warehouse built before 1900, I lease a 2,000-square-foot unfinished space for very little money. I thought of my studio as more low than lofty. To build my studio dream, I contended with leaks, rats, and raids.

The first raid came last week. A building inspector arrived at an appointed hour after lunch. From our entryway stoop, Gary, Karen, and I watched him pull up in a big white car marked with the City of Los Angeles seal. He parked at the curb in front of the main entrance to the warehouse: glass doors flanked by brown pilasters and inscribed above in faded black paint "Citizens Warehouse, 1001 East First Street." The tall African-American man, wearing a white shirt with striped red tie and pressed navy blue trousers, emerged from the automobile. In his left hand, he cradled a clipboard. Joel and Marc, the artist-owner representatives, greeted him dressed in sneakers, jeans, and T-shirts. We couldn't hear the discussion, but from our prior strategy session with Marc and Joel, we knew they intended to show the inspector only a few studios. Our four in the center of the building would be one group. Joel told the inspector he could only show the studios to which he had keys.

The Art Dockuments

Keys weren't available to the door of the space on the second floor with the big hole in the roof connecting it to a newly built studio, nor to the door of "The Pit," the space on first floor with the big hole in the floor connecting it to the basement. No guardrails surrounded the hole. No handrails protected the steep stair that descended into the dark cellar. None of these alterations were done with permits or adherence to code.

Keys to the basement weren't available. The basement divided into several sections. A middle section held the remnants of the old pickle vats. North of the vats was a section with the ceiling three feet above the sidewalk and a floor three feet below the sidewalk. In this low and broad space of more than 6,000 square feet, populated by a forest of short stubby columns, lived a couple with a three-year-old child. They had no natural light or ventilation. They defined and subdivided their spaces with thin, black, plastic tarps hung from the joists of the floor above and spanning from column to column in a network of planes—a lot like a maze. They had no kitchen or bathroom. They were having fun in this radical life style, but allowing the inspectors to see it would mean instant eviction. South of the pits was a space with an airplane under construction. A twenty-foot wing lay on its edge between columns, filling the gap from floor to ceiling. Other pieces of fuselage and tail were scattered over the space. Around the pieces were many cans of paints and solvents, all flammable liquids. Should a fire inspector see this, some artists might go to jail.

The inspector's body language revealed his annoyance. Marc, shrugging his shoulders, expressed his apologies. The inspector tapped a pen against the white paper on his clipboard and glared at Joel. Joel examined the paper with a bewildered expression. I imagined that this man was not happy with his given chore of playing a game of cat and mouse with these unconventional characters who were violating page after page of the building and zoning ordinances and getting away with it. Marc invited the inspector to enter through the glass doors. We left the stoop to await the inspector's visit. Our preparations were complete.

My bed and clothes were in my truck parked a block away. The rickety stairway leading from my studio to the basement and family space was barred with wood slats nailed over the door. Ellen's mattress lay outside her locked and keyless loading-dock door, propped against the building. Karen and Gary's clothes were buried at the bottom of a pile of painting tarps. When the inspector entered with Joel and Marc, he found Gary and me playing ping-pong over a table specially built to conceal the couple's bed.

Without a word, the inspector marched past us and stopped in front of the open, empty alcove that was the studio bedroom. This space was usually enclosed by a gigantic pivoting partition. The twelve-foot by twelve-foot wall hinged to a wood column could pivot 90 degrees on casters. The partition was pivoted out for the inspection, shielding a kitchen and a hole in the studio wall that led to Karen's space. The bedroom was empty except for a television monitor positioned on milk crate. The monitor played one of Gary's performance art videotapes. The inspector stared at Gary's monologue then turned and stepped behind the pivoted partition. Joel and Marc trailed after him into the kitchen area. Between paddle-whacks of our game, I heard the inspector declare, "See what I mean?" Marc responded, "He spends a lot of time here. A kitchen is necessary." The long silence meant they had moved into Karen's studio.

The inspector wouldn't find much incriminating evidence in Karen's space. It was one large room with an entry door and three windows on the exterior wall that looked out on the railroad yard. Large layout tables filled the space. Paints, brushes, and canvas covered the tables. Along the wall beyond the entry door, a toilet sat. No walls provided privacy.

The inspector's tone became accusatory as he strode back into Gary's space. "Are you telling me people use that water closet without privacy?"

"Is there something wrong with that?" Joel asked.

"Oh, I can think of about twenty things," the inspector said exasperatedly. The three men approached the ping-pong table. Marc lit up a cigarette. Joel fiddled with a small ring of keys. The inspector folded his arms across his chest and pressed the clipboard to his body. His head raised, he scanned the open ceiling. I asked the inspector if he wanted to see Ellen's studio and my place across the hall.

"Of course," he said, eyeing me suspiciously. Putting down my paddle, I grabbed my keys off the recently refinished maple floor and led the inspector down the hallway to Ellen's door.

"Ellen's out of town," I said, inserting the key in her lock. The door swung open. I flipped the light switch and stepped aside. "This is her dance and meditation space," I added as the inspector entered the enormous room. The polished floor glistened.

"All the floors in this section of the building are maple. Aren't they beautiful?" said Marc, his cigarette dangling from his lips. Ash fell to the floor. Marc stepped on the ash and ground it into the polish. The inspector walked into the middle of the room followed by Marc and Joel. I remained by the door, leaning against a white wall. It extended more than thirty feet to meet an exterior brick wall with a gigantic metal-covered sliding door. Marc and Joel hadn't been in this space since Ellen finished her improvements.

Most of the work on Ellen Fitzpatrick's space was done by workmen because she could afford the cost and didn't have the time to do it herself. This studio was her sanctuary away from the competition and clutter in business life. Here she could do her devotions, meditate, dance, and play her sitar in a vast uncluttered space. Her dream of the creative life wasn't centered on making art

although she did paint a little. Her dream was spiritual. She sought membership in an imaginative community where she could engender the creative spirit in herself and others. We gave Ellen the name that asserted the motherly nature obscured by her workday outfits, connected her to the river in India revered as a spiritual source, and identified her with an Indian guru. The name fit her well. It captured her flowing compassion, physically manifested in her big body and her long, lush hair that flashed reds and blues among the auburn strands. Ellen was Gunga Ma.

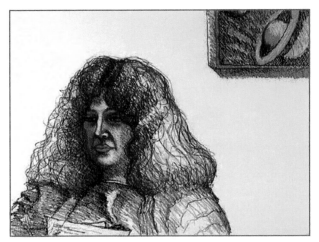

Gunga Ma drawing by Carl Davis

I could hear Gunga Ma return at night. Her high heels made a determined clack on the floor of the corridor next to my studio. One evening shortly after her return, I walked in to find her standing in the middle of her studio, still dressed for day in a fashionable outfit, high heels, a long silk scarf draped around her shoulders. She was sanding her floor. A big, circular, electric sander pulled her across the loft, making the scarf flutter like a flag. Her fabulous hair waved in the air like a huge canopy. I laughed. She couldn't hear me, nor see me as I approached her.

I touched her shoulder. She nearly lost control of the machine in surprise at my touch. I grabbed a handle to help her regain equilibrium. She turned off the machine.

The Art Dockuments

"What are you doing?" I asked with a big grin on my face. "You're not really dressed properly to operate a floor sander."

the white wall, a shower, another unenclosed toilet, and small sink cabinet with a mirror above provided for Ellen's physical needs. To the right of the entry

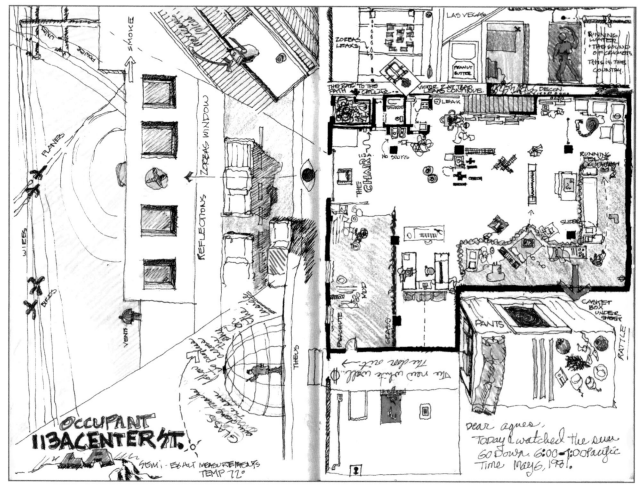

The Art Dock Loft 1981 Sketch by Carl Davis

"I saw you and Gary and the others working so hard to make your studios, I felt I had to do some of the work of making my space myself."

As I stood by the entry door, I thought about this incident while I watched the three men survey Gunga Ma's space. The huge room, with its polished maple floor and the grid of square wood columns, had only one intrusion—a long white wall separating a private space from the main volume of the loft. The rest of the space was empty, two red brick walls and two white walls edging the perimeter of the studio. Behind

door, along the white wall, a pile of pillows and a box covered with Indian silk cloth were the remnants of Ellen's bed and clothes. There was no kitchen.

Joel, Marc, and the inspector stood in the empty space beyond the wall defining Ellen's private area in the empty space. I visualized Ellen dancing around the wood columns in bare feet, wearing her colorful saris, her arms extending, bending, and waving to music from a tape deck lying on the floor.

The three men walked to the far brick wall. A shrine to the Swami Muktananda was positioned

there. On a small table flanked on either side by large vases filled with silk flowers, were two candlesticks, a bowl for incense sticks, a bunch of incense and a photo of the Swami. The bearded Indian guru was wearing an orange cap and orange shirt. His forehead was smeared with white and between his eyes was a red dot. Mutananda smiled. The three men bent down and stared at his color photograph. Joel lingered at the shrine while the inspector and Marc crossed the studio. Marc picked up a sitar propped against the white wall. The inspector shook the large lock that pinned the 15-foot-long metal door against the brick wall.

"The railroad tracks lie beyond that door," I called across the studio, while I imagined Ellen sitting in the open doorway playing her sitar and watching the trains pass under the First Street Bridge spanning the concrete ditch of the Los Angeles River.

The inspector ran his hand over the galvanized metal surface of the door and turned to walk toward me. The three men converged at the door, stepped into the corridor, and started walking away. I was left to close the studio and hustle my way ahead of the group so I could open my place.

The inspector marched in and headed for the big silvery enclosure positioned in the middle of the studio. From the ceiling hung a section of Christo's Running Fence wrapped so that it created a rectangular room. This parachute-cloth panel was so much taller than the ceiling that the cloth covered the floor inside the rectangular space like a rug. This was my bedroom, now empty of the bed. The inspector stuck his head inside the open seam. He stepped back quickly and walked across the studio into the gap between the enclosure around the elevator, and the open wall of my bathroom. At the far wall of the studio he spun around, walked several steps forward, and peered into the opening that defined a toilet and shower space.

Several steps more and he turned to his right at the edge of the next wall and stared at the mailbox emerging through a door. He tried the door handle but nothing moved. "It's not a door," I said, "It's an art piece in homage to Magritte."

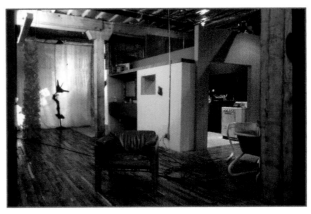

The Art Dock Loft

"A what to whom?" the inspector sneered.

"The artist is the surrealist Magritte. He did a painting with a train emerging from a door. I didn't have a train, so I used a mailbox." The inspector shook his head, and moved along my construction of separate walls that made a kitchen and bath. He stopped at the staircase beyond the walls and a metal sliding door. The door separated my studio from Rae's on the other side of a thick brick wall. The staircase went nowhere. It ended at the ceiling. Under this stair was the stair that went to the basement. He traveled no farther into my studio. Turning around shaking his head, he walked to the front wall of the studio and stared at the big metal roll-up door.

"This still work?" he asked, banging the clipboard against the metal slats.

"There is a pull chain on the right side that will raise the door," I replied from my position next to the entry door. Before I could walk to him, he stepped to the chain side of the door and yanked on the long loop, pulling the wrong direction. The chain jumped the gear above and crashed to the floor. The inspector defiantly strode out of my studio. Joel and Marc followed him hastily out my door, out the entry door, and into the street.

The Art Dockuments

I heard the angry words of the city inspector. He said this rundown firetrap should be leveled immediately for everyone's protection. He said the building should be closed down for all the infractions of code he saw. He identified the exiting violations, like the stair that went nowhere and the bathroom without a door. He was dismayed at all the ventilation violations where there were toilets. He observed that there wasn't enough lighting, like in the studio with all the pillows. The last and perhaps most dangerous condition was the lack of earthquake reinforcement, he declared. Everyone who entered this building was at serious risk.

"You are fortunate," he said to the silent Marc and Joel, "because I am not inspecting for these issues at this time. The question of occupancy has to be established first, and then the other rules will apply. The city has its procedures. You will have other visitors soon."

The next evening Marc and Joel appeared at my door. They warned of another inspection coming tomorrow. Joel and Marc were part-owners in this secret real-estate development and were our sole contact with the city authorities. Joel, in blue shorts, black tee shirt, and ragged sneakers, stood stiffly in the hallway. His hairy arms were folded across his chest, his hairy legs exposed. The unshaven face below the lush curly hair completed the casual bohemian attitude. Marc, in a red tee shirt, blue jeans, and thongs, slouched against the wall smoking a cigarette. His full mustache moved above a smirking mouth.

"Don't have a bed. Don't be around when they come. That way the inspectors can't tell and they can't ask if you live in your studio," said Joel. In a gruff serious tone, he added, "This new visit is the most serious threat yet. There are four inspectors coming tomorrow: building, plumbing, electrical, and fire."

"They have a task force after us now," Marc said sarcastically.

"You have to get rid of anything that reveals you live here. No toothbrush. No dirty dishes. Have nothing around that hints you are here 24 hours," Joel commanded.

"If the inspection does not go well, the building inspectors could lock us out of the warehouse," Marc said with a broad smile. I could see Marc was enjoying this game. He believed artists had to be outlaws—to live as they wished, to do as they liked. On other occasions, I'd heard Marc admonish artists for too-loud parties and lovers' fights that brought the police. "Outlaws avoid drawing attention" was his motto.

"We are bringing the inspectors to this section of the building first," Joel stated, backing away from my door. "Disappear."

"You must keep up the pretense, continue the illusion." Marc intoned in a somber tone, turning down the corridor and heading for Ellen's door.

I decided to take the recommended course of action and disappeared for the day, taking my bed and all my clothes with me. I went to the beach and swam nervously in the ocean, worrying I would lose all the work of dry-walling the studs, insulating the ceiling, sanding the floor, building a kitchen and bath, and painting my 2000 square feet with the curious loading dock. Many artists, forewarned, disappeared and took their beds and clothes with them. The word was out on Center Street.

Full of apprehension and recalling the words of the inspector, I turned onto narrow Center Street from my day at the beach. That's when I saw the police. Two officers astride their motorcycles blocked the road. "It's happened," I muttered, "I'm homeless."

I drove up to them. They waved me off. I halted. One officer rose off his bike and walked up to the truck window. "You can't enter here," he said.

I panicked. My worst fear has come true. We were evicted. I have nowhere to go.

"Can't I even go in and get a few belongings?"

I begged the officer. He looked at me strangely. "I used to live here," I said desperately.

"Oh, that's different," the officer said, standing up straight and beginning to smile. "They are filming here tonight, and anybody who doesn't belong here has to stay out." The cop stepped away from my truck, and waved me to pass.

The second cop signaled to me. "You can enter," the officer said, "but speak to the guy at the pay phone. He is the location manager and will direct you where to park."

"I have to put this bed away," I told him. "I have to reach my loading dock."

The officer turned to look at the back of my truck. "Are you an artist?" he asked, "I heard they live around here."

"Yes," I replied, "that's part of my art. I'm doing an installation."

The cop's face twisted into a sneer. He waved me on and I pulled onto Center Street, where people swarmed around camera dollies, and electric cords crisscrossed the street.

The 1001 East First Street sign above the entry to the warehouse was covered up. Above the two glass doors a new sign was installed. It read "Third Precinct." A squad car for the New York Police Department was parked in front. The man on the pay phone saw me, dropped the phone, and rushed to my truck. "No! No! No! What do you think you're doing?" he yelled.

"I live here, man," I replied. With a sigh, the man backed away. He yelled to the crew up the street to let me through. They moved to the sides of the street. The camera dolly was pushed off the road. I drove slowly toward my loading dock, maneuvering the pickup between sandbags, dollies, and technicians. While the movie crew watched, I turn and backed the pickup to the edge of the loading dock. Jumping from the truck, I ran to the entryway of 112 Center Street. The door was unlocked. I opened my studio door and ran to the loading dock's door pull chain and began to hoist the door.

"How long is this going to take, buddy?" I heard the location manager shouting in the street. I had to operate the chain carefully or it would jump the gear and fall on the floor, letting the door shut. The door opened slowly. "You are holding up production," the manager shouted at me as I stand above the street looking down on a crowd of Hollywood folks surrounding my truck.

"It will go a lot faster if one or two of your people help me offload the truck." They did and I rolled down the door, safe in my studio. I spent the night listening to sirens, shots, screams from the street, wondering if my studio had been condemned by the day's inspection.

Nothing happened for a week. No one wanted to discuss what happened with the building inspectors. Life returned to normal. Later, on an afternoon many days later, several other artists and I were enjoying the sun in the opening of my loading dock when an old Chevy cruised up and halted. The car, heavy and long, held five worried-looking people. They stared at us in silence.

Gary, his eyes fixed on the car, said, "I think they think they are looking at an art tableau: Residents of Alien Territory. Maybe they got lost going to Laguna Beach."

"A scene like Manet's 'Le Déjeuner sur l'herbe' with clothes on," retorted Michael, wiggling his eyebrows at the car passengers and emitting a brief aborted laugh.

"No, I think they are looking at a George Segal installation with figures more like the realistic sculptures of Duane Hanson's 'Artists in Downtown,'" said Karen, speaking with her lips immobile and her body frozen in a relaxed position in her chair.

"Illegal artists in their lair," Gary said, becoming motionless, slumped in his low lawn chair. Michael and I, sitting on the floor with our backs against the edge of the wall, our legs dangling over the lip of the loading dock, and our faces turned to the

car, became still. Jan, his back to the car, stood on the sidewalk, leaning into the loading dock with his arms extended and supported on the floor. He didn't move a muscle. The people in the car shifted their heads to get a better view of the picture. They turned to each other, speaking words we couldn't hear. We remained motionless.

The front-seat passenger turned back toward us and, after several moments of silence, spoke. "Can you tell us the way to the County Jail?"

The tableau of artists remained motionless, each person contemplating whether to answer. The visitor asked the question again. He had asked the most common question asked on Center Street by passing motorists. In this area of downtown, far from the activity of shops and theaters on Broadway, the office buildings around Bunker Hill, and the government edifices of the Civic Center, people came only if they had business in the old warehouses or factories, if they were homeless and seeking anonymity, or if they were lost. Most of the lost wandered around looking for the road that would lead them to the County Jail, a huge gray structure that lay a quarter-mile north of the Citizens Warehouse, past the chicken slaughterhouse, the oil field, the auto impound yard, and beyond the freeway. The way was not easy to find. The streets by the river reflect the railroad era when they were made; they curve into each other and often dead end. Rail tracks run down them. Big potholes reveal the city's disinterest. Only one street gets you beyond the barrier of the freeway.

Gary broke the silence. He rose slowly to his six-foot-five-inch height and moved forward to the edge of the loading dock. Raising his right arm, he kept his eyes trained on the man in the car. The two men stared at one another. Gary turned his head toward his arm and extended his index finger. He pointed north. In a loud and clear authoritative voice, he said, "Go straight ahead. Pass the cold storage warehouse. Watch out for rats. Lots of big

ones live there. Pass the slaughterhouse on your right. Watch out for fugitive chickens. Pass the walls that hide the oil wells and the towed cars. Watch out for the wild man without legs in the wheelchair. He charges from nowhere. Pass the paper box factory. Watch out for the transvestite hookers. Pass under the freeway overpass and curve around the police arsenal. Watch out for the police battering ram. Stop at the corner of Vignes Street. Turn right. You will see all the bail bondsman trailers and the jail straight ahead. Got that?"

Gary's arm slowly descended to his side. He stood erect and silent. His head rotated very slowly, and his eyes returned to stare at the man. All the artists remained motionless. The four people in the car stared at the artists. We waited. They waited. "Good luck," Karen said, her lips remaining almost motionless, her body still. The front-seat passenger, looking up the street in the direction Gary pointed, then down the street as if to see that he could retreat in that direction if needed, finally said loudly, "Thank you." He hesitated for one last look before driving off quickly, peeling rubber in the direction Gary pointed. When they were beyond the cold-storage building, we all slumped, rolled, and laughed.

"I think I should start an art gallery in this loading dock," I said. "It's perfect for Los Angeles. In the city where there are drive-ins, drive-throughs, and drive-bys of every kind—restaurants, cleaners, banks, movie theaters, even churches and shootings—there should be a drive-by art gallery. It solves the persistent parking problem. It allows the art patron to see art at the pace of automobile culture. The art lover will take two seconds of driving by with the occasional halt when something grabs the eye. This could give Los Angelenos their culture zap, quick and easy."

"Come on," Michael replied, "Street art ain't a new idea. What about all the art billboards in LA and San Francisco and outdoor murals? Gang graffiti is getting attention from curators. There are

plenty of art windows in the storefronts on Melrose and Beverly. Artists do installations in downtown all over the place. What would be new about an art gallery in a loading dock?"

"Err...it's behind rubber bumpers and a wooden rail," I said, trying to think of something more amazing.

"If you have a street gallery in this hole in the wall," Gary said, "you can't be separated from the audience by a pane of glass. Hiding behind glass—that's too cowardly."

A discussion ensued about glass as the ultimate isolator of art and the intellectual merits of a drive-by gallery. Conversation drifted to the appropriate name for a drive-by gallery. Several alternatives were proposed. Michael suggested LAAG, Los Angeles Art Gallery. Gary threw out Drive-by Gallery of Center Street. Karen proposed First and Center Drive-by Gallery.

"Nah, nah, nah," I said. "Boring!"

Nothing seemed to fit, and interest in the concept began to wane, just like the sun descending behind the façade of the warehouse across the street.

"The beach is closing," I said, rising from the corner of the loading dock and dusting myself off. Gary and Karen rose and folded up their lawn chairs. Michael jumped down to the street. Jan, who had been silent through the discussion and proposed no gallery names, spoke. "It should be called the Art Dock," he said, and walked off toward his studio at the end of the building.

We all laughed.

"That's it," I yelled to Jan's back. "That is the right name. The Art Dock it shall be."

"Yeah? How long do you think your Art Dock will last, when we could be kicked out of this building any minute now?" Michael said as he headed to his studio at the other end of the building.

"Good question, but worth testing," I replied.

Gary and Karen disappeared behind the Running Fence to go back their studios. I crossed the loading dock opening to roll down the metal door. I was very amused. All I had to do was find an artist to put his work in the Art Dock. The chain that looped over the gear at the head of the dock jumped the sprockets. The heavy metal shutter clattered swiftly down, and closed with a loud echoing kabang.

"An Art Dock," I chuckled. "That will humor the powers that be."

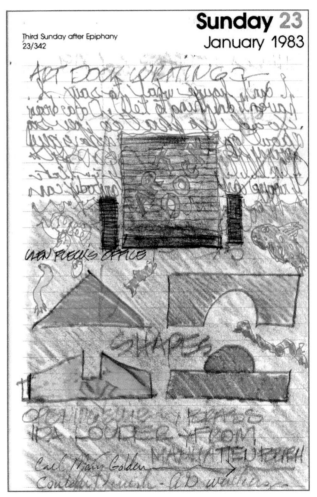

Daily Diary Page by Carl Davis

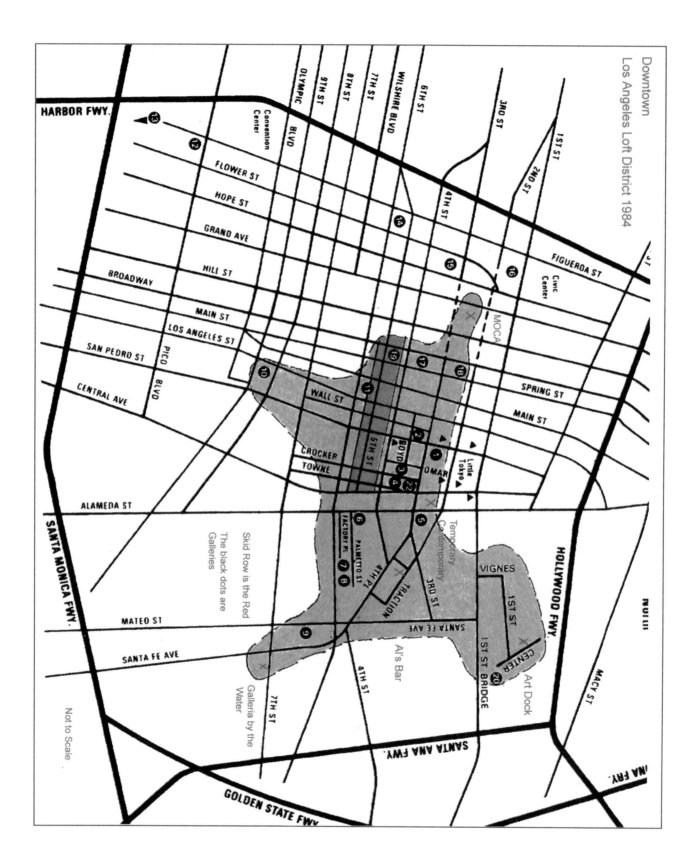

Downtown
Los Angeles Loft District 1984

ACT I
THE MANIFESTO

"*I love Los Angeles. I love Hollywood. They're beautiful.
Everybody's plastic, but I love plastic. I want to be plastic.*"
—Andy Warhol

"*The artist is seen like a producer of commodities,
like a factory that turns out refrigerators.*"
—Sol LeWitt

"*A commodity appears at first sight an extremely obvious, trivial thing.
But its analysis brings out that it is a very strange thing, abounding in metaphysical
subtleties and theological niceties.*"
—Karl Marx

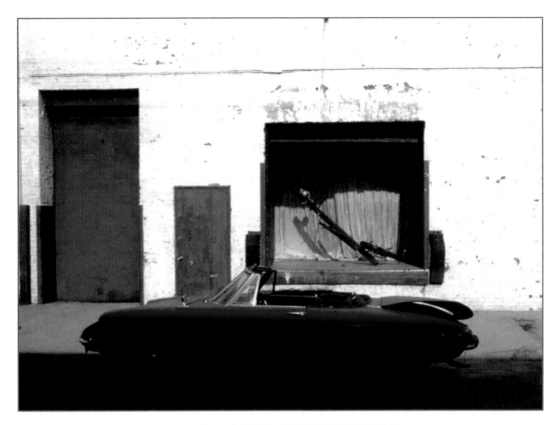

ACT I THE MANIFESTO

ART DOCKUMENT #2 "LUST FOR LIFE"
BY FRITZ HUDNUT—AUGUST TO SEPTEMBER 1981

Success! It wasn't easy, but I finally managed to convince someone to exhibit in the Art Dock, the drive-by art gallery.

The first show was a sculpture by Fritz Hudnut, an artist who lived in the Citizens Warehouse. "Lust for Life" was better described as a three-dimensional collage rather than a sculpture. The assemblage was made of metal objects, found along the railroad tracks behind the warehouse, spattered with paint, and fastened onto two long wood boards. One end of two wood pieces—4 x 4s—touched the floor. The other end of second wood piece was pinned to the other about a fifth of the way up its length. The second wood length, much longer than the first, hung from the ceiling at an oblique angle by a nylon thread. "Lust for Life" looked as if it was either rising up or falling down. The work was raw, unstable, and ephemeral. It was the first public street-side display of this artist's work.

I first came across Fritz's work along the tracks—at least, what I thought was his work. He later denied the assemblages were his. In what I called the artist's playground behind the Citizens Warehouse there were many scraps of metal and wood, which were collected and repositioned into intriguing compositions. Whoever did these was the perfect person to do the inaugural show at the Art Dock. I thought it was Fritz. He did playful, gestural, and unpolished work. It fitted the rough context of the loading dock.

The Art Dockuments

I spent a considerable amount of time trying to convince Fritz to put one of his pieces in the Art Dock. When I opened the loading dock's roll-up door to show him the space, he was very skeptical. His freckled face squeezed into a smirk, and his prominent bushy eyebrows moved up and down while he kept repeating, "You have got to be kidding."

"Well, in a way I am," I replied, "but I am very serious about my kidding."

"Where is the gallery? You open the door and all I see is your studio. That's not an art gallery."

"Hear me out," I said. "You see that big piece of parachute cloth? I use it now to create my bedroom. I could hang the cloth behind the loading-dock door and create a gallery space. It would be maybe six to eight feet deep."

Fritz continued to give me his doubtful smirk.

"You know, that piece of cloth is an art object in its own right," I said. "It's one section of Christo's 'Running Fence.' I bought it when I lived up in San Francisco. This guy had many sections he stored in an abandoned country club north of the city. He would sell you a section for about 100 bucks. I went up there. Bundles of the fence were piled all over the floor inside the building. He let me pick over the pile until I found a section that didn't have too many holes or stains. I have never known quite what to do with it, but as a backdrop for the drive-by gallery I think it's perfect."

"I'll think about it," Fritz responded. He turned and walked up the street toward his studio.

"Come on, Fritz. You'd have fun," I called after him.

He gave me the finger.

His gesture only made me more determined to convince him to show. I knew he would be perfect as my first exhibitor from the day I visited his studio and conjectured he was the creator of the assemblages I came across in my daily walks along the tracks. Imagine my surprise when he denied he made these railroad track creations. His denial did not deter me. I thought he was lying, since he consistently denied being involved with many of the lady artists in the building, when we all knew he was. Fritz was a very magnetic man, but quirky.

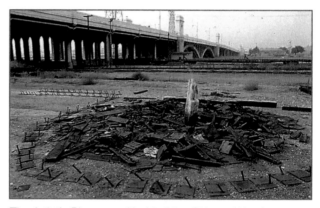

The Artist's Playground behind the Citizens Warehouse

I first struck up a conversation with Fritz one day in the street when he was returning home from a day of work in construction. Fritz worked as a framing carpenter. He was dressed in jeans, a tee shirt, and work boots. The short sleeves revealed large biceps from swinging a hammer everyday, and a taut, defined chest. I could tell Fritz was proud of his muscular physique. Fritz's manner was also very aggressive— very "in your face." Gary was talking with Fritz when I walked up. Gary introduced me. Fritz turned to Gary and asked, "Is this guy really an artist?"

Gary replied, "Why don't you ask him?"

Fritz turned to me and moved in close. Fritz is considerably shorter than I am. He rose to his tiptoes and put his face an inch from mine.

"You an artist?" he asked in a challenging tone.

Responding to his tone I stated, "Depends on who's asking. You an artist?"

His face turned crimson but remained fixed to my face. "Depends," he said. "At least I look like an artist. You look like a cop. You a cop?"

I was dressed in a jacket, dress shirt, and slacks. I smiled. He laughed, wiggled his big eyebrows up and down, and slowly descended from his tiptoes.

"See you later, Gary. Come over to my studio soon. You can even bring the cop with you." Fritz sauntered away. His tool belt with a claw hammer hung from his waist like a gun belt.

Many artists in the building thought I was an undercover agent, an FBI man trying to infiltrate the artist community seeking a drug bust. I looked too straight to them, and I was admittedly an architect, engaged in a profession which most artists view with suspicion. I spent a year fixing up my loft. I covered the interior stud demising walls with drywall and painted them white. I put foil-faced insulation in my ceiling. I sanded and polished my maple floor. I created the false door with the mailbox emerging from its center as my homage to Magritte. I connected a tongue-shaped plastic laminate table supported by a small tree trunk to the wall of the staircase that went up to the ceiling. I constructed an assemblage of multi-colored and wallpapered walls, à la Gerrit Rietveld, to create my kitchen and bathroom without doors, re-hanging my section of Christo's Running Fence behind the loading dock door to shield my space from the exterior. I even placed my bed in the open like so many artists did. Despite these renovations, I was still not considered an artist. I had little work to show other than my creation that I called my "enormous room." I thought of my enormous room—a place big enough to roller skate around and long enough to throw baseballs from the pitcher's mound to home plate—like the room which e. e. cummings wrote about in his book of the same name. I would have my aesthetic laboratory where I could redefine myself as an artist. But that hadn't happened yet. Making the drive-by gallery behind the loading dock door and in front of the Running Fence curtain would, I hoped, gain the favor and acceptance of the Citizens Warehouse artists. I desperately wanted to have that title of artist. If I could convince Fritz to show, it would be a giant step forward.

Several days later Gary came into my studio. He said he was going over to Fritz Hudnut's studio and wanted to know if I would like to come with him. "You sure he'll let the police in?" I asked.

"It's okay, you'll be accompanied by a certified artist," he replied.

We walked to the end of the building and entered on the Banning Street side of the old warehouse. Fritz's space was up on the second floor at the end of a corridor flanking an open stairway. I remember thinking here was another code violation, an unenclosed stairway in a loft building. I wondered if the fire department had seen this.

The door to his studio was open. Gary called to Fritz at the doorway. Fritz yelled, "Come on in." A wall in front of us blocked the view into his space. We stepped in and turned left. In front of us was a huge mound of junk. We turned right into a narrow convoluted path that led us into a forest of found objects suspended from the ceiling, piled into mini-hills, or stood up like primitive totems.

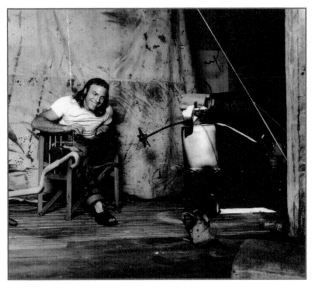

Fritz Hudnut by Ed Glendinning, Photographer

Our trail wove through a landscape of bizarre creations. Wheels, cans, pipes, screens, hunks of wood, blocks, boards, sticks, steel plates, angles, screws, bolts, spikes, nuts, and barbed wire were thrown together and spattered with red, blue, yellow, or green paint. Hidden from our view by

this prolific collection of railroad-yard debris, Fritz was talking on the phone. We picked our way toward his voice. Fritz was seated at a small table surrounded by piles of steel shapes and open cans of paint. He waved us toward him and pointed to two chairs at the table. We sat. Gary picked up a piece of steel, observing its shape, turning it over and running his hands across its surface. He tossed it back into the pile and picked up another shape. I gazed around the studio. It wasn't that large, but it was full. Aside from some walls that surrounded a bathroom and microwave on top of a scavenged countertop cabinet, the place was crammed full of junk piles and assemblages made from the junk. There was hardly a space big enough for four people to gather except around the table. I could see no bed, nor anywhere to store personal belongings or clothes.

I felt as if I were in the sacred hut of some modern primitive, surrounded by his ceremonial objects. The place was a wild fantasy populated by creations of inventive intensity. I wondered if the stories I'd heard about Fritz's attraction for all single females were true. Maybe he didn't ever sleep here, but bedded down in other studios.

Gary, bent over with his hands on his knees, had fondled four or five shapes before Fritz got off the phone.

"Finished with your surveillance, copper?" Fritz asked me, with his intense and confrontational look.

"Yes, but I was wondering. Do you have the proper permits to take all this material from the rail-road yards? You could be violating law and subject to arrest." I gave him a wry smile.

Fritz barked a laugh and offered us a beer.

I asked, "How can you make any more sculptures and fit them into your studio? Haven't you run out of room?"

"I work fast," he said. "I change and rearrange often. You shouldn't be bogged down in making art. Work or think too long and the inspiration gets lost."

"Would you be interested in exhibiting in a gallery I am starting in the loading dock of my studio?" I asked. Fritz gave me a look of disbelief.

Gary sat up and took a sip of his beer. "Carl is serious," he said.

"I'll think about it," Fritz answered. I invited him to visit my studio the next day.

He did come to look at the loading dock again. He rejected me a second time. After his rejection of my invitation, I asked Gary to talk to Fritz. "He respects you. After all, you *are* a certified artist. You have shows in real art galleries," I said, trying to keep the sarcasm in my tone to a minimum.

"Only if you can beat me at ping-pong." I had never won a game from him before, but I accepted the challenge. By some miracle, I managed to win. Gary begrudgingly said he would speak to Fritz. Fritz agreed to exhibit. I had rearranged the Running Fence to make a backdrop for the Art Dock Gallery already.

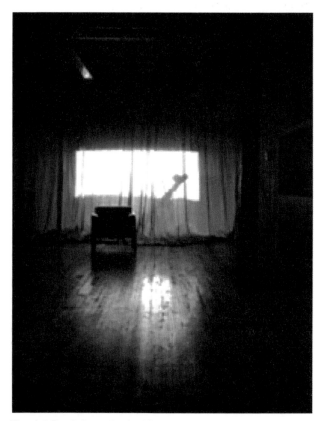

The Art Dock from the inside out

The joke was now a reality. The Art Dock opened without fanfare. No publicity announced the first exhibition. No opening party took place. Fritz installed his sculpture, and I rolled up the metal door. Gary, Karen, Ellen, Michael, Fritz, and I stood in the middle of Center Street in the early evening and observed. There was this sculpture: a curious combination of large stalks of rough wood, decorated with small metal shards, a bar, a spring and some bolts. Each metal piece was painted in a bright color. The assembly half-reclined on the floor with one wood member almost standing upright. The thin cord that suspended the sculpture from the ceiling was invisible against the silvery white fabric behind it. The sculpture looked impossibly perched, either about to fall in a comfortable pile or rise into a stable vertical. The piece was insubstantial and almost nothing. I wondered if this was art. Yet there was something here. Perhaps it was an attack on the studied composition of the historically informed art of professional sculptors. The work hardly seemed saleable or even collectible. It seemed almost a spontaneous phenomenon of nature, like a log fallen against a rock creating something curious to look at. Only the framing of the almost square opening of the loading dock isolated the thing and declared it as art. I anxiously awaited the critical dialogue I was convinced I would now hear from the assembled artists.

We stood in silence in the street for so long I started to get uncomfortable.

"It needs more light," Gary commented.

All nodded their heads in agreement and the group split up. Fritz headed toward his studio. Gary and Karen walked to the entryway to their studios. Michael strolled down the street in the other direction. I was left alone in the street to admire my accomplishment until a pizza delivery van nudged me from my spot. I moved to the vacant piece of road directly in front of the loading dock, from which I could closely observe the sculpture. My contem-plation was ended by Zorba, the artist who lived above me, returning to the warehouse in his truck. He honked at me to move so he could park in the empty place. With a sour look, I retreated.

Zorba and I were not friends. I had grown to dislike him intensely because his amateur plumbing job continually leaked into my studio. I crossed to the other side of the street and watched him pull his pickup with the high homemade shell on the back directly in front of the loading dock, effectively blocking any view of the installation. All that could be seen was a big shell inscribed with an enormous Z. Zorba leapt from the truck and disappeared into the elevator next to the loading dock without even a glance at the art in the dock. I hadn't anticipated that large vehicles would block the view. My good feeling deflated, and with a sigh I retreated into my studio. Later that evening, I stepped around the curtain and entered the Art Dock to find Zorba's truck still blocking the view. I closed the loading dock's roll-up door.

For the next four days, the loading-dock door was open from morning until late evening. Zorba's truck remained parked in front. Zorba had left town. I remained in my studio. I could not see if the exhibit got any reaction. Once I heard a voice in the street calling into the studio from the sidewalk. "Anybody in there?"

"Yes," I replied.

"Say, what are you holding that wood up with?" the voice asked.

"String," I answered.

"Oh," the voice said. I got up from my chair at the table by the kitchen and walked up to the Running Fence, hoping I might finally have the dialogue I wished. There was only silence.

I pulled the curtain aside and stepped into the Art Dock. I peered around the edge of the wall. No one was there. I was curious how anyone could have disappeared so fast.

There was only silence concerning the work. No one challenged "Lust for Life" as art. I thought

the artists would be vociferous in their opinions, but the question about how the wood got supported was the only comment I received until the owners' committee demanded to see me.

"Come out here. We have to talk to you," Joel yelled from the sidewalk outside the open dock. I rose from the lodge-hall seating in my work area at the back of the studio, crossed to the curtain, bent under the fabric, and walked to the edge of the dock. Glaring up at me was Joel, his wife Sydney, Marc, and Judd.

"What do you think you are doing?" Joel said.

"What are you talking about?"

"This art here," Joel said, waving his hand at "Lust for Life," "showing on the street."

"Ah, this," I replied, stepping to the side so I was not in the center of the loading dock. "This is the Art Dock, the world's first and only drive-by art gallery."

"You can't do this," Marc said. "You have to close it immediately."

"Why?"

"You're exposing our secret occupation of this warehouse to the city officials. They'll swoop down and throw us all out if they see this!" Marc responded, yanking a lighted cigarette from his mouth and pointing the hand holding it directly at me.

"You have got to be kidding. The city already knows we live here. The newspapers are full of stories about artists living down here," I said.

"This creates notoriety. It can only cause difficulty. Close it," Joel demanded. His face was becoming red with rage.

"But the building inspectors have already been here several times. They know we are here. What difference does it make if some art gets displayed?"

Sydney, standing behind Joel, screamed at me. "You can't have a gallery in a building like this! Don't you understand? A gallery is a commercial use and that is prohibited."

"I'm hardly commercial."

"Listen, you asshole. Close the loading dock. Close it! Close it! Close it," Marc yelled, acting like an irate building owner and flicking the cigarette toward the dock. It bounced off the wooden bumper below the floor line and fell to the ground.

"I'm not going to do it. Go to hell!" I turned my back to the group, went to the end of the curtain, threw it aside, and stomped across my studio, curses trailing behind me.

"You'll do it, you pain in the ass," Marc yelled above the others' epithets.

"Artists censuring art. That's truly amazing," I screamed back.

The next several days were tense. I waited for the worst. I imagined attacks against the art. I fanaticized about eviction by the police. I sought out confederates for my cause. To all who would hear me out, I railed against art censorship, the abridgment of my civil rights, and the sellout of the artist owners to the evils of capitalism. Fritz refused to become involved.

"I made it. My part is done. I am no longer attached to the piece," Fritz told me, as a crooked smile spread across his face. I pleaded with him to stand by me when the art police came to shut down the drive-by art gallery.

"I make art. I don't get involved in politics." His manner and tone implied that I could prove my artistic commitment if I stood up to the owners and kept the Art Dock open.

The gallery stayed open.

Postscript 2012: Fritz Hudnut gave up making art many years later and became a doctor of oriental medicine. He lives and practices in Los Angeles and has written a book about meditation.

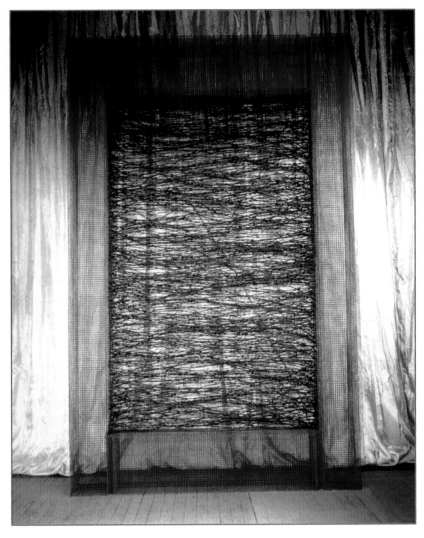

ACT I THE MANIFESTO

ART DOCKUMENT #3 SOLIDARITIES DIAPHANE
BY CARL DAVIS—NOVEMBER AND DECEMBER, 1981

No one wanted to exhibit in the Art Dock after "Lust for Life." Nor could I blame them. I was hardly ever open—working as I was every day away from my loft. When I was open, which was at night, Zorba's big truck with the Z on the side blocked any view of the loading dock. And there was the opposition of the artist owners to any overt display of art on the building. Most artists were scared away.

In late October, Fritz came to collect his piece. "What you going to do, copper?" he asked with a wicked smile on his red face. "Give up?" Fritz was challenging me again.

"I won't be bullied into submission. It's a censorship issue," I blithely announced. "There must be freedom for art. Art is my fate, don't debate."

"Blah, blah, blah. What are you going to do, show your own crap?"

"Those are fighting words from a two-bit carpenter," I replied. Fritz charged me, running right up to an inch in front of my nose. He, shaking his long hair in my face, barked a loud "Ha!" before backing off.

I turned to Giant Jane, my punk musician friend sitting at my dining table enjoying a glass of tequila and a cup of espresso. "How do I deal with this guy?" I asked.

Art Dock's Curtain was a section of Christo's Running Fence

"Show your own work, like he said," Jane replied. Fritz turned his back on us and strode out of my loft, raised the curtain of the Running Fence, and disappeared into the dock area.

"Fine, I'll show," I yelled at the disappeared Fritz. "Ha," I heard him reply again as he began dismantling his work. In minutes, he had it down and left the dock.

"What you really need is a manifesto," said Jane, between sips of tequila and espresso. "Every good movement needs a manifesto to state its position and relationship to the art world. Why don't I draft something up for you?"

I immediately agreed. "What position should we take?" I asked, thinking out loud. "We could talk about cars and art. How a drive-by gallery solves the parking problem at a cultural venue."

"Cultural venue?" Jane said. "You're missing the essential point. This is more than just a parking solution. Think big picture." I could see Jane was warming to the topic; either that or she was getting looped.

"What about the time anyone spends looking at a work of art?" I said. "I think someone once timed how long a person looks at a work of art in a museum and came up with a second and a half. Traveling by in a car gives about the same amount of time to view a work of art."

"Huh, I thought it would be longer. Maybe twenty seconds tops," said Jane. She studied her glass of tequila and her cup of coffee, and abruptly poured the tequila into the coffee. "Now that's better," she said to herself, picking up the cup to take a good-sized swallow. Jane was dressed all in black. She wore a slinky black dress, black nylons, black high heels, and long black gloves that extended up her arms almost to the elbows. We were going out that evening to a punk rock concert and Jane wanted a certain look. She had perched a black satin pillbox hat with a small net that hung just over her forehead on her long blond hair. Jane looked very 1940s, like Veronica Lake.

"Better thoughts," Jane added turning her head toward me, showing her full red lips, "but still not on the mark. The manifesto needs to address the essential situation of art and how a loading dock defines that."

"I don't get it," I said.

"We'll work on it," Jane smiled draining the last of her cup and standing up to her full height of six-foot-ten in high heels.

"God, you look fabulous," I stated.

"I always do," Jane replied. "Let's get out of here and head to Madame Wong's." I put on my leather jacket, rolled down the loading dock door, and we took off for Chinatown.

The next day, I pulled my sculpture "Solidarities Diaphane" into the loading dock. The big, red, and rusty stele didn't look bad. It filled up the opening pretty well—a frame within a frame. The luminous, silvery fabric behind the sculpture offset the open grid of the red hardware cloth surrounded by and layered with a barbed wire rectangle held within the open grid enclosure.

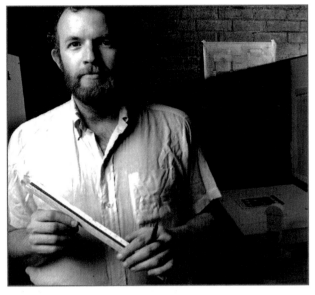
Carl Davis by Ed Glendinning 1984

barbed wire. This seemed to me an enticing new way to look at this material. Instead of creating a forbidding barrier with a few strands, I used the barbed wire to build up an almost solid, but not quite opaque surface. Barbed wire, which has so much meaning as a threatening space divider, had now become something else. The material still retained its sinister character, but the sculpture played with it in an uncommon way. When seen together as one thing, I thought this composition of light and air, hardware cloth, and barbed wire tested the limits of surface and transparency. The frame was less substantial than the field it surrounded. The barbed wire hovered like an ominous iron cloud inside a perforated volume. The look, the material and the

This idea of a diaphane—a transparent veil—that revealed and concealed was an idea I had been playing with for a long time. I started trying to make sculptures that verged on the edge of nothingness. I found that thin steel wire grid called hardware cloth could be bent and soldered into all manner of shapes and forms. The open grid of the material gave it both an insubstantial feel and a real presence. Formed into cubes, rectangles, and other shapes, the sculptures had form like David Smith's best work, but without his mass. What I found was that the shadows cast from this light material had more substantiality than the forms themselves. This led me to the idea of using the material to create semi-transparent veils. This first diaphane was a rectilinear armature, the interior of which was a field of coiled baling wire bundles. I had made a freestanding Rothko-like form, which changed in look and feel depending on the light cast on or through the sculpture. The shadow had more density than the form. I had made a light machine.

In my new studio, I eagerly constructed a new diaphane. The armature was the same as the first, but instead of baling wire, I laced the defined rectilinear space surrounded by hardware cloth with

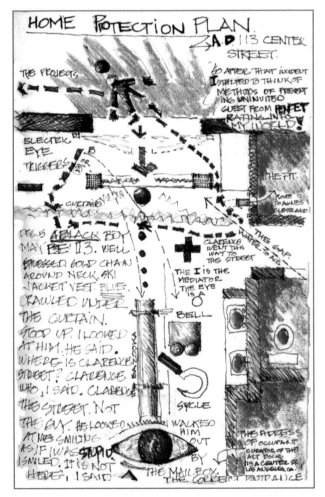
Home Protection Plan – Sketch by Carl Davis

light passing through and reflecting off it brought to my mind questions about what art is. I eagerly awaited critical response to my display on the street.

Silence followed. No one said anything to me. It was the opposition to the Art Dock itself that drove me forward. As the weather turned colder, I kept the loading dock open when I could.

Zorba's truck disappeared from in front of the loading dock. But a new problem presented itself— studio invasion. One chilly evening the dock was open. A young black man, dressed in a blue ski jacket with a gold chain around his neck, stepped around "Solidarities Diaphane" and crawled under the curtain. He was surprised to see me sitting at my dining room table. I was surprised to see him.

"Where's Clarence Street?" he asked.

"Clarence who?" I replied.

"Clarence *Street*, not a guy," he said giving a big toothy grin as if to say I was stupid.

"Not here," I said, rising from my chair and walking aggressively toward him. He backed up and started to bend down to go back under the curtain.

"Not that way," I yelled and pointed to the end of the curtain where the mailbox penetrated the phony door. He scurried in the direction I pointed and put his hand on the doorknob of the phony door.

"Not that way," I yelled again, moving closer. The young man turned, nearly stumbling over the triangular form emerging from the floor at the right end of the loading dock. He leapt off the dock and ran up the street. With his departure, I rolled down the metal door and kept the Art Dock closed as I thought about my alternatives.

Jane arrived several days after my home invasion with a draft of the Art Dock Manifesto. I told her I did not know if I was going to continue based on what had happened. She cajoled me not to give up. "The Art Dock is too good an idea," she said and asked me to read the manifesto. I did, laughed, and said we should work on it a little more. We made a final version of the Art Dock Manifesto and taped it to the wall outside the loading dock. I opened the gallery again and didn't close until I had an intermission two years later. I never again was invaded. I decided art was the best home protection plan.

Postscript 2012: Jane Gaskill left Los Angeles without a trace. Carlton Davis still makes art.

THE ART DOCK MANIFESTO

STANDARDIZATION – DISTRIBUTION – VOLUME – COST – MARKETING

In Los Angeles, the asphalt grid veined with concrete freeways, where standardized painted art work of the unabashed sort rules the mass, the real bait of social sadism is offered in Pre, Post, Final, Absolutely Final, Closeout, Sacrifice, and Are We Crazy? Expressionism of Sales, we give you an Art Dock, epitomizing the nature of contemporary art in the on-loading, off-loading, and up-loading of commodity.

In Los Angles, city of tinsel, where in exclusivity the limited-edition ranks higher than the unique and the rare, where meaning is the alluring bubble of money and the glancing light is fashionable only on the momentary cross-hatching of the digital frame, we give you an Art Dock, the Polaroid of polymorphism that can be one-offed again and again and scratched for singular value.

In Los Angeles, cauldron of continuous change, where sickened souls embrace the information age, renascent crudity, the speedy piecework dream of distribution, the deathly slyness in heterogeneous detail, and minimalist sabotage in petit point, we give you an Art Dock, an instant theatre of marketing and the cost-effect transference of one commodity to another.

The Art Dock commemorates the last refuge of industrialism, the gallery system that is the raw guts of career promotion ground to a halt in post-industrialism. It is the last refuge where art is reproduced with light, untrusting, incorruptible objectness in the free-for-view peepshow—not pay TV, not digital, not mathematical realm.

The Art Dock, drive-by viewing of a rolled–up roll-down door in the framed and bumper-lipped raised loading dock in the whitewashed Citizens Warehouse, contains daily and monthly deliverables of art, fully inventoried and tagged for Will Call. Commemorate a new economic model—view a work today. Drive-by on the endless macadam of the west. No parking allowed. No parking fee included.

Jane Gaskill and Carl Davis
1981

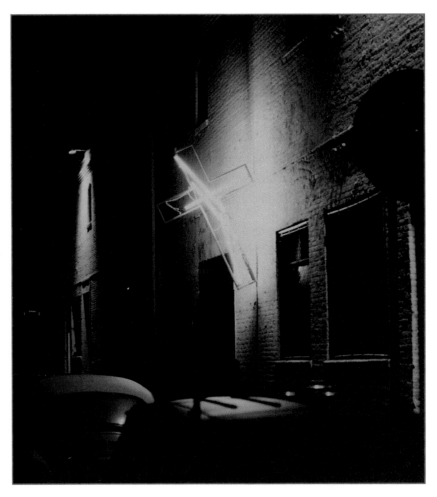

ACT I THE MANIFESTO

ART DOCKUMENT #5 CHRIST AMONG THE VAGRANTS BY JAN TAYLOR—DEC 1981 TO JAN 15, 1982

The Christmas of 1981 was a tempest in a teapot in an Art Dock. The drive-by art gallery I had begun as a whimsical joke on my front porch where I and other artists sunned ourselves in the late afternoon now had a manifesto. Art in a loading dock was a statement about commodity, the standardization of creativity, and the sale of culture. The artist who had named the Art Dock decided he would exhibit. Little did I know what he planned to do. He created even more controversy with the building's owners.

Jan Taylor lived in the first-floor studio at the corner of First and Banning Streets. Banning is an old name in Los Angeles. General Phineas Banning owned the original stagecoaches that served the city, and his stables were originally somewhere along this street, closer to Alameda. Most of the historical structures in this old part of the city, from Center Street to Alameda, had long ago vanished to be replaced by parking lots, which were vacant after dusk. I knew Jan from meeting him in the street late one evening early in my tenancy at the Citizens

The Art Dockuments

Warehouse. He had a bag of golf clubs over one shoulder, a nine iron in his left hand and a large brown paper bag in the other. He was in discussion with Gary Lloyd and Marc Kreisel near the entryway to my studio. After introductions, Jan offered me some of the shellfish he had in the bag.

purchased clandestinely from the backs of trucks that pulled up to the cold-storage warehouse well after midnight.

"Wait a minute," I said. "You were out playing urban golf?" Jan laughed and said he went out every few evenings or so to hit rocks in the rail yards or across

Studios of the Citizen Warehouse. Jan Taylor's has all the oysters in it. Sketch by Carl Davis

"Clams," I said. "Where did you get these?"

"They're not clams, they're oysters from the cold-storage warehouse at the end of the block," he replied. Jan explained that he was out playing his favorite game, urban golf, when he met up with one of the people from the warehouse. He found out they stored fresh oysters in there, along with other fish and meats, and bought some. The oysters were

the empty parking lots. He said several other artists joined him and that I should as well. He claimed it was very relaxing after a long day in the studio and good exercise too. I chuckled but declined.

Jan Taylor invited me to his studio on December 14th to see his piece before he installed the next day. Till then, Jan had been very secretive about what he intended to do as his Art Dock installation. He had

responded to all inquiries about the project with a smile, a wink, and the comment, "Oh, you'll see soon." I was very curious, since Jan was a painter. His usual work consisted of a large color field, near the edge of which was rendered, in realistic fashion, a trout. I wondered how he intended to display a painting in a space that had no wall. Did he intend to construct a wall? "No way," he said. "I am not going to help you finish your studio; building mine took long enough."

His was a very nice studio: a spacious open room with a large painting area in the middle and plenty of racks for the storage of completed canvases, a dining area with big kitchen and an enclosed bedroom at the very back. It was altogether a neat and tidy place. The bag of golf clubs rested next to the entry door.

Jan revealed nothing until I walked into his studio and saw a large frame made of metal tubing in the shape of an open cross with four fluorescent tubes crisscrossing the frame standing upright on the floor. This was his piece, a lighted sculpture called "Christ among the Vagrants." I asked him if he intended to display the work in the Art Dock as it was shown in the studio. "No," he said, "I have a different idea for it. I want to hang the sculpture on the outside of the building, next to and over the Art Dock."

Jan explained his reasoning: "The Art Dock is hardly ever open," he said, "so I decided to display outside the dock in such a way that there would be no question of the hours of exhibition. The piece will always be visible." I recall Jan looking at me with a wry smile and a twinkle in his eyes to see if I would be disturbed by his challenge.

I should have known. This was the man who invited me for midnight sessions of urban golf, where the participants would club rocks around the railroad yards to see what they could stir up, then celebrate their game with beer and oysters on lawn chairs in the dead-end street next to Jan's loft.

"Why did you make this particular piece?" I asked, interviewing Jan. "It's like a sign beckoning homeless people."

"I don't think it's about attracting anyone," Jan replied. "I'm talking about the area we live in. I did it because of all the problems we have with these studios and getting kicked out of them. I mean, on the creature comfort level, artists live at about the same level as the homeless. The average income of an artist is about $6,000 a year, or so I was told. That's poverty level. The artist and the bum are not too far apart. It wouldn't take long on the skids for an artist to end up where the vagrant is."

"But artists choose this lifestyle," I said.

"If artists fail," said Jan, "they become office workers. It's a loss of potential whether you wander around with a briefcase or with shoes that don't fit. It doesn't matter; they are both the same thing. Anyway, I think bums are happier than the artists who are office workers. The hobos in LA are the healthiest in the country. It's the climate. Bums in Boston freeze to death in winter. In LA, the agencies take care of them; send them up to Camarillo, the mental hospital, when they need it."

"Why do you think artists choose to live in the same area as bums?" I asked.

"I don't think it's a choice. I think it's a reality. It's money. If we could to live in the Hollywood Hills, we all would. Who would want to live in a building that could fall in on you at any time, or put your money into the electrical and plumbing on some place you might be in for only a couple of years?"

"Would you have conceived of your piece differently if the Art Dock were a more typical gallery?" I asked.

"Yes, it was the area where the dock is," Jan said. "I had been thinking of this piece for a long time, and I always saw it in relationship to the Art Dock. It was connected to the dock, but next to it. The dock is more a thing for small-scale sculpture or street theatre. I think you should install one of those things like at a drive-in movie where you pull up and put one of those speakers in your car. Then you would never even have to get out of your

car. I think in the next century drive-by galleries will be common. People won't have the time to go to galleries."

Making art, Jan explained, was a lot like fishing— you throw your line out and wait and see what you come up with. You just do your work and you wait to see what effect it has on you or someone else.

"I like fishing," he said. "I have no notion why I like it. It is the most frustrating thing I can think of. Fishing is an art experience. You're fishing, fishing, and nothing happens. In a lucid moment, you change lures, snap it on the reel, cast it out, and a fish bites. That's art. I have lucid moments, it all clicks, the fish bites, and I've got it. It's a feeling. It's a truth that creates a harmony through your bones, and if it happens a few times in your life, that's enough. Art is as true as you can be to yourself. There is nothing more intellectual in it than that."

I asked him if that's why he painted trout. He answered, "I don't know." He smiled craftily. "Aren't we getting off the subject?" he added. "Are you going to put up the cross or not?"

"Yes, I will," I said. "Let's go fishing."

The provocateur was out-provoked. I couldn't say no to his plan. I had already refused to cave into the landlords' demand that I cease exhibiting art in the gallery. They claimed the gallery threatened the safety of the studio building through exposure of its existence. Jan's intended action declared that the drive-by gallery was really public. He upped the ante on my conceptual idea and forced me to take seriously what I had begun in jest. I had to support his concept. I did it knowing full well that it would renew the controversy that had calmed down by very visibly displaying art in what some wished to be only a private place.

On December 15th, I returned to Center Street in the evening to a startling sight. Traveling down Santa Fe Avenue from the freeway off ramp, I saw in the distance four lines of light popping out of the darkness perpendicular to the surface of the Citizens Warehouse. "Christ among the Vagrants" was up, and it looked beautiful. You could see it for blocks from the north, where Center Street merges into Santa Fe. You could see it hovering under the First Street Bridge driving up Santa Fe from the south. The building was marked, but in a most ambiguous way. The cross looked like something akin to all the mission signs, only a few blocks away from the Midnight Mission, Union Rescue Mission, Salvation Army Mission, and Full Gospel Mission. Each of them had its own neon marker announcing to the homeless where they could find a bed, some food, and a portion of spiritual guidance. The art mission had no name, but the look was similar, a blast of shaped light in the urban darkness.

As I drew close to the warehouse, I half-expected to see a congregation of street people. Center Street was a common passageway from the missions to the hiding places under the railroad bridges, and a frequent dumpster foraging place for many of the destitute. We would often see incredibly dirty men with matted hair, filthy pants, torn shirts, and bare feet picking through the refuse bins of our building. They picked at the trash just like the artists did, trying to find some treasure to be reused. To gain access to the railroad yard where they lived in boxes under the great bridges, the down-and-out, the maimed, and crazy would walk down Center Street, stopping to peer or climb into the dumpsters.

The homeless inhabited an area of the city abandoned by others; like the artists, they felt alienated and threatened by the power structure of society. There were major differences however, that separated the groups and made us non-communicating members of the same neighborhood. The artists chose to live in this squalid section of the city. The homeless had no choice. The artists were motivated by the needs of their work. The homeless had no motivation but crude survival. "Christ among the Vagrants" spoke to this similarity and difference of the neighbors in downtown.

I threw my lot in with this group of artists by signing a lease in the Citizens Warehouse, the illegal

loft building. No one seemed interested that I had violated my architectural license by building my space without permits in the un-permitted building. Desiring to be seen as an artist, I was willing to take this chance. I had perhaps ruined my marriage, leaving my wife and child behind to pursue this dream. She was talking about divorce. I was barely clinging to a part-time job teaching at UCLA and working part-time as a counselor for unemployed architects at a staffing agency. I knew I was not long for either job. The money was not adequate to pay my bills. I was broke and had used up all my savings in constructing my loft from which I could be evicted at any moment.

The recent film "My Dinner with André" spoke eloquently to me. André Gregory and Wallace Shawn talked about theatre and life over dinner in a New York restaurant. Gregory talked about his life since he gave up a career as a theatre director and his most vivid experience working on a piece of performance art where he was briefly buried alive on a Halloween night. I felt my move away from a career as an architect was like Gregory's life, a piece of performance art. I buried myself alive in the bowels of downtown LA amidst incredible squalor. Was it just thrill seeking—an activity I was prone to?

Like Gregory, I undertook something that most people would not do. Unlike most people, he lived a dream life. Like him, I did that. I needed something more. I needed to have the freedom to pursue an artistic life. I knew I would pay a price for it, but I didn't understand how high that price would be. The dream I chased seemed more like a nightmare each passing day. The piece "Christ among the Vagrants" spoke directly to me. I crucified myself living in dirty, rat-invested, outlaw land where my fellow outlaws mistrusted me as a spy, and the down-and-out homeless congregated around my mission of the Art Dock, ready to claim me as one of their own should my financial distress continue. All these thoughts whirled in my mind as I pulled

up and parked beneath the cross. The street was empty. The homeless knew this wasn't a place of salvation for them. Only the artists thought of this as Jerusalem.

At home in the studio, there was a message on my answering machine. The landlords wanted a meeting right away. Jan and I met with them the next day. They demanded that the cross be removed immediately. First, they stated we had not asked permission. Second, we did not get a permit, and third, the cross was an insurance liability. Again I protested their desire to censor the work of their fellow artists. The debate grew quite heated; Mr. Taylor and I were described as irresponsible anarchists. I referred to the owners as capitalist pigs concerned only with investment and blind to any art other than their own. Jan remained silent. He said he would remove the piece despite my protestations.

Marc Kreisel was a bit of an anarchist himself. He was the proprietor of Al's Bar, the infamous downtown artist hangout known for its many run-ins with city authorities and neighbors over a variety of nuisances created by patrons and the goings-on at this sleazy club. Kreisel offered some hope to this lost cause. If I could get a permit, he would allow the cross to be reinstated. Neither Jan nor I thought this possible, and on the 16th of December, one day after its installation, we removed the cross. The Art Dock looked like it was a goner.

This occurrence of cowardly censorship really steamed me up. I had to counterattack. First, I put up a sign outlined in silver foil below the place of "Christ among the Vagrants" installation castigating the artist landlords for their failure of nerve and sheepish resort to bourgeois values. I saw myself as the defender of artistic freedom and a last radical in a world of careerist art professionals. This was art war, outlaws vs. bourgeoisie. Repression, no matter how mild or seemingly insignificant, does have its value. It can force one to fight and give meaning to that which once had seemed a whim. The opposition

gave life to the Art Dock and theory to its concept. I began an exploration of a way to reinstall the work.

I tried to get a permit. No one at City Hall, however, seemed to have the vaguest idea of whom I should see or under which category this object would fall. It wasn't a sign and it wasn't permanent, therefore the building department could not issue a permit for it. Calls to the fire department and the planning department proved equally unfruitful. However, it was the City Attorney's Office that suggested I call the Public Works Department, which might have a suggestion as to what I could do. An official of the department queried me about the piece and ended up by saying that it sounded like a Christmas decoration to him. He informed me I needed no permit for a seasonal decoration. I was ecstatic. "Christ among the Vagrants" could not be displayed as art, but could be displayed as Christmas ornament. I returned to Center Street with the good news.

Jan was unwilling to take the risk of reinstallation, but he said he would sell the piece to me for one dollar and I could take responsibility for reinstalling it. He said he didn't feel the piece was really his anymore. Because the artists who owned the building felt that the piece shouldn't be shown, the piece had gotten confused with politics. If he sold the piece, the people who were really the opposing parties could fight it out and he wouldn't be involved anymore. Besides, it didn't matter to him if he sold the piece for a million dollars or a dollar. Making the art was the important part. The politics of art did not interest him.

On December 23rd, the Art Dock purchased "Christ among the Vagrants" for one buck and reinstalled it on the wall of the Citizens Warehouse, where it showed for the rest of the holiday season and every year for three years thereafter.

Daily Diary Page by Carl Davis

Postscript 2012: Jan Taylor continued to live in the Citizens Warehouse for many years. His studio in the closed-up Citizens Warehouse later became the field office for the contractors building the Gold Line Transit System over the First Street Bridge. He is still making art, and is still fishing, but playing urban golf is a thing of the past.

ART DOCKUMENT #6 FIRST FUNCTIONAL PAINTING BY MARC KREISEL—WINTER 1982

"Van Gogh died in LA. He died of drugs," Marc Kreisel said in a serious tone as he leaned into the Art Dock and placed a small folded white card on the floor next to a worn pair of white leather boots. The boots had sunglasses perched on top and a hospital prescription card propped against their toes. The card read:

"In Memoriam"
Andy Wilf

We stepped back into the street to observe the installation. To the left and behind the boots, the sunglasses, and the cards was a large freestanding wall, which nearly filled the opening of the loading dock. The wall was covered in repeated black-and-white photographs of stone masonry. In the upper middle of the wall was a rectangle of lighter color made of overexposed photographs of the same stone masonry. Stapled over the photographs was a layer of thin transparent plastic partially stained with blue-grey blotches. The smaller rectangle appeared as a frame of light illuminating and penetrating the wall, revealing the insubstantiality of the surface. The blue-grey and white stains became clouds drifting across the vertical plane. The effect created a mysterious fogged partition of indeterminate depth wrapped in a shiny plastic cover like a

cheap poster. This wall was only a memory of a wall, obscured, sliced from its context, and presented as a precious object.

Outside the loading dock on the exterior of the warehouse next to a taped announcement of the show, Marc mounted a framed artwork. Covered with glass and protected inside a natural wood frame was a newspaper clipping pasted cockeyed to a brown piece of butcher paper. The cutting was scribbled over with red and blue marker, almost obliterating the dark photographic image of a rock performer. Above the scribbles were the words "First they made him a Rock Star, then they made him a God."

"I call this 'The First Functional Painting,'" Marc said.

"You're kidding," I replied. "Where are the stone masonry photographs from?"

"The Wailing Wall in Jerusalem," Marc responded.

Calling this a painting was stretching the definition, I thought, but it was consistent with Marc's views. Marc made "paintings" of crudely assembled photographs either glued or stapled to plywood sheets or shafts of wood. He painted and scribbled personal messages on these collages, most made from Polaroid pictures. The paintings were never pretty. The wall in the Art Dock was the closest thing to a beautiful aesthetic object I had ever seen him make. Art, he said, didn't have to be beautiful.

"All art has to do is have an effect," he said.

Marc could justify his work with intellectual arguments developed from his extensive reading. Duchamp, Klee, and Baldessari were his mentors. Like Duchamp's, his images existed as a critique of the established art ideas, their lack of painterliness an indication of his advancement beyond the confines of style. Like Klee, the scribbled lines created a private art language, whimsical and direct. Like Baldessari, the photographs were evidence of the photojournalistic roots in contemporary art and a connection to the commonplace images of newspapers, film, and advertising. The written statements scrawled over the images were graffiti, like the new

art star Jean-Michel Basquiat. They returned his art to the personal, where an artist who sees his life as art must position his work.

"Being is art, if lived as art," Marc often said.

Art to Marc Kreisel was not a profession but an attitude. The crudity of his images was a commentary on the slick presentation favored by the galleries where smooth technique was valued as proof of the professionalism of the artist. The art establishment valued the art object over the artist, he felt. Marc said he valued the community of artists over the art establishment. Not everyone believed him.

Many saw Kreisel as either one of those artist landlords or as the proprietor of a sleazy establishment, Al's Bar. His decision to exhibit in the drive-by gallery was looked upon with cynicism by many of the tenant artists in the Citizens Warehouse. How could he now back the gallery he had so vociferously opposed at first? I was happy to exhibit Kreisel, for it meant the opposition from the landlords was at an end. Kreisel agreed to exhibit because he finally saw how little the gallery's existence threatened the building. Being open only when I was home, the gallery was not much of an attraction. Besides, he said it would discourage others from decorating the outside of the building. Marc always knew how to play both angles in any situation. He could make points establishing himself as an artist, and at the same time blunt the threat to his real estate entrepreneur position. I didn't care. Marc's clearly uncommercial work underscored the anti-commodity Art Dock Manifesto.

His "First Functional Painting" was at once commentary and commemoration. Andy Wilf, a well-known downtown artist and one of the first to receive critical success, was Marc's friend, or so he claimed. Their friendship was strained at the end before Andy died in his sleep from a combination of drugs and alcohol. Both were part of "The Young Turks," a group of artists who had embraced downtown squalor and used it to instill harshness in their work. They

attacked LA's previous decades of soft art fixated on slick finishes and ethereal light and space.

The Young Turks were among the first artists to move into the old downtown warehouses. In these unused buildings surrounding Skid Row, amidst decay and chaos, thousands of square feet of space could be leased for pennies a square foot. The grime and depression around them became their aesthetic. Jon Peterson, the engineer-artist-real-estate-speculator, erected bum shelters as sculpture. Monique Safford, artist and feminist, contrasted photographs of downtown's desolation with lyrical descriptions of faraway places. Marc Kreisel's witty and often caustic graffiti statements surrounding layered Polaroid images were an interpretation of the terse scrawls and tags of the downtown homeless and the gangs. Andy Wilf's scary paintings of severed pigs' heads and tormented humans mirrored the psychological terror of life on Skid Row.

Expressionism, drifting west from New York, was the hot new style. The German Expressionists of the '20s and '30s were all the rage. Georg Baselitz, with his upside-down paintings, and Anselm Kiefer, with his landscapes recalling the Nazi era, were shown in Los Angeles museums. Andy Wilf's work matched their emotional intensity, and he became the first star of the Young Turks and the first of a raft of new West Coast expressionists. The Los Angeles County Museum of Art had in the previous year awarded Andy its prestigious Young Talent Award. Andy was showing at the best galleries in town. His work was selling. He was making a living as an artist, but in the process he destroyed himself.

The more famous Andy became the more inebriated he got, hopped up on cocaine, grass, asthma drugs, and alcohol. His paintings become more and more bizarre, and his work was even more in demand. In his personal life, his actions became increasingly violent. Sober, Andy was engaging and friendly. Drunk, he was alternately withdrawn

Andy Wilf painting detail

or aggressive and abusive. A remark could make him sullen or summon his rage. Although lanky, thin, and not particularly strong, he would attack people. A hard look would arise in his narrowing eyes, indicating an unrelenting fierceness that once awakened was hard to deflect. His Japanese-American wife took the brunt of his rage. Battered once too often, she left him. He took up with another woman artist whom he also was reported to be beating. Fights broke out between him and many of his friends. He threatened his landlord with an ax. Many artists avoided his company or walked away when he came around. After one violent altercation, he was permanently banned from Al's Bar. There was bad blood all around. Only the art collectors, curators, and dealers seemed to excuse his actions as the expressions of a tortured genius.

Upon Andy's death, the newspapers published articles analyzing his talent and his problems. Critics

said the artist failed in self-exorcism. In spite of his genius, or because of his genius, he was doomed. They said he had taken the last exit from a living hell. His last painting, a dark canvas slashed with bright yellow that showed the artist in shadowy profile by a table strewn with bottles of booze and drugs called "Peace through Chemistry" was reviewed as a metaphor for his destroyed talent. Andy was called the complete artist. Totally emotional, he couldn't deal with the real logic of life, not even the humdrum things like rent, let alone the line between indulgence and excess. The artist was mythologized. Los Angeles finally had produced its own Vincent Van Gogh story. His work was selling for big money.

forehead pushing his curly black hair prominently to the sides, Marc leaned against the pick-up truck parked across the street from the open loading dock and lit a cigarette.

"This ain't Hollywood, but it could be," he said, turning to look up the block, his hand twisting his mustache and his eyes twinkling, gently bemused. At the end of the street under the bridge, a video crew was setting up. A group of young women, each wearing peach-colored gang jackets inscribed in black on the back "Satin Dolls" primped each other in preparation for the shoot.

"I don't understand," I asked. "Do you mean the installation or the sexy young women?"

Mark Kreisel –Photograph by Gary Leonard

Marc and I remained in the street for a long time looking at the finished installation. With his favorite narrow-brimmed black hat pulled low on his

Marc shrugged his shoulders. "I have to maintain my sanity." The look in his eye became dreamy. We alternately looked at the art installation and the

women shaking and fluffing their hair, putting lipstick on each other, adjusting their tight spandex pants, shifting from foot to foot on their spiked heels, and zipping and unzipping their Satin Dolls jackets.

"Have you created a wailing wall for Andy Wilf, Rabbi Kreisel?" I asked. Marc stood silent for several moments staring in the direction of the young women. Then he let out a long breath from his pursed lips, an expression somewhere between a sigh and lust.

"There once was a city in the Near East," he said, "called Saffid or something like that, in which the rabbis controlled everything from business to politics. They threw the parties and held the wakes. It was a very harmonious place. I'd like to have an art community like that. There would be a place for wailing walls and dancing girls in that community." A slight smirk appeared on his face. "The emotions for both aren't that far apart."

Marc lifted himself from his slouch against the vehicle and strode away down the street, away from the young women.

I called after him, "The town was Safed and it still exists. It's one of the four holy cities of Judaism and is the center of Jewish mysticism." Mark said nothing and disappeared around the corner of the warehouse. *How typical*, I thought. *You can't get a straight answer from this guy.*

I couldn't find straight answers for myself either. I was living in a knot of confusion, like words written over one another on a single page until there is nothing legible. What was I doing in my crazy pursuit to be called an artist? I still had one foot in my profession. I taught a course at UCLA in architectural professional practice, but my heart wasn't in it. I had too many disagreements with the profession, which was smitten with the chase for celebrity, cared little for the struggles of the typical professional, and did little to assuage the problems of society. I was a poor role model and a crummy teacher. At an architectural staffing agency where I counseled out-of-work architects, the work was depressing. I saw

an alcoholic architect trying to find a job who smelled of booze as I interviewed him. How could I recommend him for a job? I saw the recent graduates of the local professional schools who had portfolios full unbuildable ideas and no conception how to put a building together. Where could I find them an entry-level job? I rushed from my jobs on the Westside of the city and escaped into a drug-crazed community of bohemian artists. I left one unsatisfactory life for another, but one I very consciously chose. The life of the artist allowed you to behave badly, and you could anesthetize with cocaine and marijuana with impunity in the art world.

I smoked a lot of dope, and it seemed to provide relief. I had lots of ideas and chased them around in my head like swirly lines lapping and overlapping one another until they too became unintelligible. Yet I remained depressed and lonely. I didn't think of my life as art as Kreisel did. Attempting to forget my mental state, I bent wire and drew furiously. I thought my work would prove to the artists I was one of them. Perhaps this and the Art Dock would make the other artists in the community accept me as one of their own. I could join as part of a second wave of Young Turks, stoned but proud.

Alone in the street, I recalled Andy Wilf, whom I had last seen less than a month ago stretched out in a coffin inside the nearby Buddhist Temple, made up to look healthy and dressed in a suit, which he never wore, with his hands folded peacefully over his chest. A priest recounted his life and compared it to the teachings of the Buddha. Two priests chanted in Japanese while a television crew scanned the audience and interviewed the mourners. Four artists dressed all in black with dark sunglasses over their eyes remained motionless behind the coffin. I remembered, as I stood over the coffin, how he looked much better than he had only several weeks before when he stretched himself out between the rubber bumpers and steel plates on the edge of the loading dock like the cadaver he now was. His hands

were folded over his chest in exactly the same way. We had assisted him and placed him there after he collapsed in the street, stupefied by drugs.

Andy was a frequent visitor to Citizens Warehouse. He was often seen wandering down Center Street, a long lean Giacometti figure with his slow lope and ever-present baseball cap pulled down over his forehead, looking for friends from whom he could cadge a drink, a toke, or a line. In the week before his death, he was in a terrible state, nearly incoherent and barely able to walk. Staggering down Center Street in his white boots, cheap blue chino pants, and checkered shirt with a California Angels cap plopped on his head, he looked like a big clumsy kid. He wandered unsteadily up to the open loading dock.

There was no art in the dock since "Christ among the Vagrants" had just come down, and we were waiting to see what Marc Kreisel would do. Gary was seated in a chair on the sidewalk bending pennies for his latest series of sculptures. Michael, Lenny, Rae, and I were seated on the edge of the open loading door enjoying the sun and talking. Andy joined the group, leaning against the building for support, and stuttered his dilemma. He had no car because of his drunk driving, so he had no means to get his prescription drugs. He asked for alcohol. No one offered him any. He showed us his pills from pockets jammed with plastic vials issued by several different hospitals.

"I go to three or four hospitals and get the same prescription filled," Andy boasted proudly, standing up straight, losing his balance, stumbling forward, and falling to his knees in the street. We helped him up and sat him down on the edge of the dock. He rolled backwards and stretched himself out in the opening. He lay there still and silent for a long time, his left foot upward and his right foot drooped to the side, with the white boot curled up on its end just like the boot displayed in the dock. Andy looked like a medieval funerary sculpture lying in the niche of a wall. There lay Andy Wilf, the first downtown artist to be rewarded recognition, playing dead. This was a premonition of things to come.

Lying semi-conscious in the loading dock, Andy was ignored by the artists.

"This is too sad," Michael Salerno remarked. "The guy has real talent."

The others looked off into space. Andy stirred into feeble consciousness. He rolled to the side, positioned his head on an elbow-supported arm, and said, "Escape is on my mind. It is in everything I do."

He began to ramble on about all the horrible things in life, his remorse for the bad things he had done, and the defeats in his career.

"What defeats in your career?" an incredulous Lenny asked. Andy did not respond but continued his litany of failure.

"I have a weakness for drugs," he mumbled, "but I'm clever too. I defied all the rules of the rotten society in which we live. The cops are crap and so are the courts."

Everyone pretended not to listen to him. They quietly watched Gary intently bending his coins between two pliers. Gradually growing aware that no one was paying him any attention, Wilf abruptly stopped his complaining and remarked, "I'm going to paint one of those big stretched out nudes, like Monet and those other French painters, an obalique."

"You mean an odalisque," Gary replied. "Edouard Manet painted one, and Ingres quite a few."

"Didn't Picasso and Leger paint some too? Fat-armed, lounging ladies and tubular females?" added Salerno.

"No, those were obese-ques," chortled Lenny.

Andy's lip curled in disgust. He wobbled widely as he sat up. His legs dangled over the edge of the loading dock.

"Shit, you know too much," he said. The silence continued, so Andy changed the subject. "You sure you have nothing to drink or smoke?" he asked.

Andy slipped off the edge of the dock, and gingerly gathering his balance, he wandered away

without a word. Under the First Street Bridge, he stumbled. Gary rose from his chair and started in his direction when Andy rose and waved to us. That was the last we ever saw of Andy Wilf. He never painted his odalisque. He was dead a week later from a brain hemorrhage.

The man was a talented painter yet a tortured soul. Anyone who confronted one of his paintings couldn't fail to see that. I first came across his work when invited to a loft party in the artist's building on Broadway. Up on the fifth floor of the old commercial building, I wandered into his studio full of people drinking and snorting cocaine while surrounded by the most startling images. A large canvas of butchered sheep heads, rendered in rich reds, yellows, and bilious browns reminiscent of Rembrandt's flayed ox, loomed over the partying people, some of whom, transfixed by the work, stood gawking at the image. The eyes of the slaughtered sheep, full of fear and death stared back. The painting was called "Scared Stiff."

On another wall were self-portraits of the artist, his mouth widening in each successive painting into a greater scream. Over a crowded couch, where a group of young men and women dressed in punk attire of lace, leather, and chains calmly cut lines of white powder, hung a painting of sheeted figures standing over a tied and tormented man rendered in somber grays, blues, and blacks. The hoods of the persecutors blared in ghostly white. There could be no gaiety in this atmosphere. Everyone was intently consuming as much drugs and alcohol as possible as if to deaden awareness of the ghoulish surroundings. I was introduced to the artist, who was a surprisingly mild man, almost childlike. He smiled a sad smile as if claiming innocence for the celebrity bestowed upon him. He said he hoped I would enjoy the party, but seemed aware that this was impossible. He offered me drugs and alcohol before being called away by his art dealer to speak with an important collector who had just arrived. The increasingly drunk and stoned crowd grew more hostile. A scuffle broke out in the kitchen between two women. Andy, attempting to be the peacemaking host, became embroiled in the dispute. Too drugged to offer soothing words, his tone shifted from mild to malicious. One woman's boyfriend threatened Andy, and the rising sounds of yelling and the crash of some tossed object quieted the party. Andy's dealer rushed in to rescue him. I turned away from the paintings and the party to gaze out the windows of the loft toward the east and the Citizens Warehouse. Marc Kreisel ambled up beside me.

"They're killing him," he said.

"Who?" I replied.

"The dealers, the collectors, the media, and the art groupies who are making him a celebrity," he said. "The weirder, the more psychotic he acts, the more famous they make him. It has nothing to do with art; it's marketing. The art community is helpless to save him."

Marc left the party, and I went with him.

My reminiscences in the street were abruptly halted. A large studio van turned the corner and drove up next to me. The driver leaned on his horn. The Satin Dolls looked in my direction. I stepped back out of the road across the street from the art gallery and the truck maneuvered into the open parking place in front of the Art Dock. The big box behind the cab completely obscured the open loading dock. The driver climbed out of the cab and looked suspiciously at me.

"You crazy?" he said. "Stop standing in the road. I got work to do."

I gave him a demented, clownlike grin. He walked off toward the Satin Dolls yelling, "Phil, Phil, I got the equipment; let's roll." I thought, *This is Hollywood, real-life Hollywood.*

Soon after mid-February, the stories of Wilf had disappeared from the news, but in the Art Dock the memorial continued. Several artists were deeply offended by the exhibit. Kreisel and I were subjected

The Art Dockuments

to a torrent of verbal abuse. They said the installation was tasteless and self-serving. Kreisel, they said, was promoting himself at the expense of their dead comrade. The installation was threatened. One artist proposed guerilla action against the exhibit. He said he was going to come down one day and throw the piece in the street and stomp all over it. After that, he said, he was going to go find Marc and stomp all over him. The artist was on the verge of assigning responsibility to me, but I contended I was neutral. With some trepidation, I pleaded for artistic freedom. I stated the rules (unwritten of course) of the Art Dock enumerated and established the right of the artists to do as they saw fit without interference from the curator, as long as the work did not prevent quiet inhabitance of the studio behind the dock. This instant oration on artistic license preserved the work. Artists will usually defer to a call for creative freedom. Marc was delighted by the controversy. He said the controversy proved the work to be art, since it had a strong effect. I heard later that Marc paid a small price for his freedom when the offended artist punched him in the face. Marc denied the allegation, but there was a period before the show ended where I thought I noticed some discoloration around Marc's left eye.

Marc was a controversial person. He was someone about whom opinions were strong; someone who relished the reactions his views generated.

"My life is art. I make art running Al's Bar, when I make real-estate deals, when I make love, and when I make paintings with photographs. Not everyone sees it that way, but I do. My art exists in that nebulous place between definitions," he said.

Marc saw the artist as someone outside the boundaries of ordinary society, someone who tests the limits of behavior. He believed artists are the last free people, who do what their desires tell them to do. In communist Poland, he recounted, "artist" was the only job description that did not require employment. In discussing the Citizens Warehouse, one of his artist community real-estate deals for which the city demanded compliance with its codes, he stated, "The artist can only listen to a building inspector so long before he says, 'Fuck it, I'm going to do what I want.'"

As the proprietor of Al's Bar, Marc was in numerous difficulties with the law. They fined him and threatened to close the doors for fire-code infractions, for too much noise, for too many people, or improper this and that, yet he continued relishing in the freedom and bad-boy notoriety. The attitude was infuriating and incredibly self-centered, but it was always provocative and stimulating.

"My art," Marc stated, "comes first from my feelings, second from the reaction of my friends, third from my community, fourth from my heritage, and last from my reaction to history."

His art was a stance and a response to the conditions of his life. Marc sought to define art as something outside the object. The objects he created were only the documentation of that search. His credo was: "The undocumented life is not worth living."

"Andy Wilf blew it," Marc stated while we were busy nailing Andy's boots to the floor of the Art Dock after a homeless man had stolen the sunglasses and tried on the boots, only to discard them in the street when they proved to be too small. "He let others define him as an artist; he became a commodity."

I felt the sadness and anger in his voice, and I felt sadness and anger myself as we struggled to hammer nails through the soles of the boots down through their shafts. The boots were soft and creased. They felt like they had been pulled on and off a thousand times, that they were a favorite possession. I imagined some people, Jews perhaps, in a cemetery somewhere in Europe, replacing the photographs and the personal objects of a departed relative scattered by hateful strangers. "First Functional Painting" did not seem to be an art exhibit in the ordinary sense of the

word, but rather an experience, something akin to Marc's idea of art in life.

The effect of the exhibit wasn't aesthetic, but emotional and intellectual. The wall, whose physicality was contradicted by the changing coloration and the layered photographs, elicited feelings of loss and thoughts about the impermanence of things. This wall was at once a wailing wall and a denial of it. The framed image attached to the building's outside wall was an art commodity and slightly comic. The content was serious, and the placement humorous. One aspect commented on the other.

The nailed-down boots engendered a sense of rage and helplessness, as if we were trying to hold onto that which was gone. The exhibit was made up of transitory things, totems, representations, and relics. Our stuff outlives our lives, but it too is not immortal. The boots might be worth something, but only if they could fit on another's feet. The prescription card was worthless. It was just a piece of plastic. The wall was merely artifice. The framed art was installed in the wrong place. The open loading dock had no protection. It was just a space with no real definition. Yet something of Andy Wilf remained within the memorial, the angst of unrealized dreams. There was something of Marc Kreisel there too. He laughed at the same time he cried. Their lives, all lives, in messy unresolved reality, were celebrated.

Several days before the exhibit ended, a note written on a scrap of white-lined paper was tucked under the shoes. It read: "But what was Andy Wilf really like? *LA Times* didn't explain. Mythological apparition to us who never met him, but heard a lot."

Daily Diary Page by Carl Davis

Postscript 2012: Andy Wilf's fame largely disappeared, but as part of the Pacific Standard Time show at MOCA entitled "Under the Black Sun: California Art 1974—1981," Andy Wilf's large canvas of slaughtered animal heads called "Dead Ends of 1980" was exhibited. Marc Kreisel closed Al's Bar in 2001. He still has a studio in downtown Los Angeles, is involved with artist loft real estate deals, and continues to make art. He still maintains that his life is art.

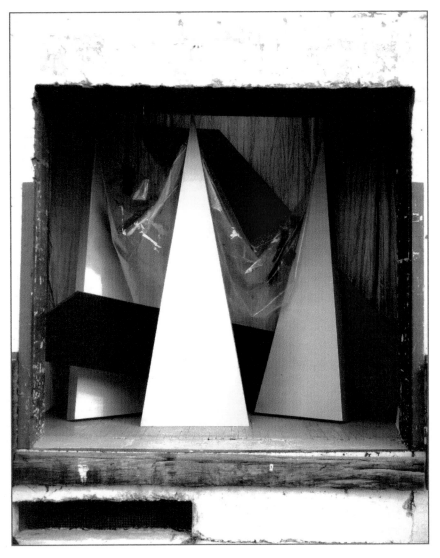

ART DOCKUMENT #7 HOMAGE TO THE STUDIO BY EVE MONTANA—WINTER 1982

Marcel Duchamp once said, 'The most interesting thing about artists is how they live,'" I said to Michael Salerno as he and I stood in front of the loading dock looking at Eve Montana's tableau.

"How so?" he responded.

"Look at this piece," I replied. "It has to be about all the materials and things artists accumulate, store, and do in their studios."

Situated in the Art Dock was an array of five colored canvas wedges. Three of the shaped stretchers were tall white triangles. Two were long rectilinear shapes with angled ends. One was dark green; the other, dark red. The red shape was the

The Art Dockuments

farthest back in the opening and stood against the curtain at an angle. The green shape was positioned between two of the white triangles, almost reclining on the floor. A tall white triangle—its form recalling a dunce's cap—stood in front of everything positioned upright on its short side. Over the peak of the triangle was a clear plastic sheet that draped down and ended over the tops of the two other white triangles. The objects were casually displayed like forms left over or forms not yet ready to be finalized.

"It's the kind of like the stuff scattered around the edges of the studio waiting to be used or rejected," I said. The plastic drape was the dust cover over these forms-in-waiting. Every working studio has this kind of spontaneous display. Eve was merely remarking on them and seeing them as art too.

I wondered about Eve's studio—a studio I had only visited once very briefly and could hardly remember. It was a huge studio—2,000 square feet or more—on the floor above and near mine. French windows looked out at the downtown skyline, the only windows like that in the building. Areas were partitioned off with drywall between the structural wood posts. Eve had a large gallery space, a work area, a sleeping space, and a huge kitchen and bath.

Eve would not allow me to visit while she was making her piece. It was her private place, she said. I vaguely remembered a place piled high with stretcher bars. Each back corner of the work area was marked by groups of projects. Stretcher bars of various shapes and sizes without canvas were placed in one corner and work-in-progress in the other. Canvases of finished work were stacked in between with the stretcher frames facing out. The paints, brushes, and cans were placed on tables in the middle of the area. An old couch dribbled with paint faced a work wall. A couple more chairs were scattered about the room. It was not the most interesting studio in the building. Clean and well-organized, it lacked the wildly profuse clutter that

marked Fritz's studio, or the barren but colorful emptiness of Ellen Fitzpatrick's place.

"The studio is like a brain," I said to Michael Salerno. "Most are messy storehouses of ideas, possibilities, and experiences."

"Maybe like *your* brain," Michael responded, "not like mine."

Michael's studio was different from most in the warehouse. He was operating an art gallery—like me, illegally—but on a much larger scale. His place consisted of two rooms and a hallway. The hallway led into a large dog-leg-shaped room, behind which was a smaller room that functioned as the bedroom. The big room had a kitchenette along the shorter inside portion of the dogleg. This was the area everyone gathered around the punch bowl at openings of AAA Art gallery. The rest of the studio was where art was displayed. I could never tell where Michael made his black ink patterns on paper.

"Your studio is like an empty receptacle, waiting to be filled," I said.

"Is that a criticism?" Michael said archly.

"Oh no, it's an observation about the different aesthetics of the studio. Yours is minimal and static. Mine, for example, is crowded with stuff and constantly altering."

"Static?" Michael protested.

"Static is not what I mean—in the sense that it has no life. Rather, in your place, the process of working is never revealed. You show the finished object when you have a show or present one of your finished drawings, but the actual making is unseen. In mine, the making is displayed everywhere," I responded.

My studio was a continual work in progress. I was always arranging and rearranging the space. When I first set up the space, after drywalling, insulating the ceiling, building my kitchen/bathroom enclosure, and making the false door for 13A Center Street, which had the mailbox labeled "Occupant" projecting out of it, I slept behind the piece of the

Running Fence along the south wall of the studio. Everything that I wanted clean or was personal I tucked behind the curtain, which extended along the east wall and hid the place where I hung my clothes on a rolling rack.

face it in toward the studio when the loading door was closed and face it out to watch the sun go down when the loading door was rolled up. In the middle of the space, I had a work area to build my wire forms and display the finished sculptures.

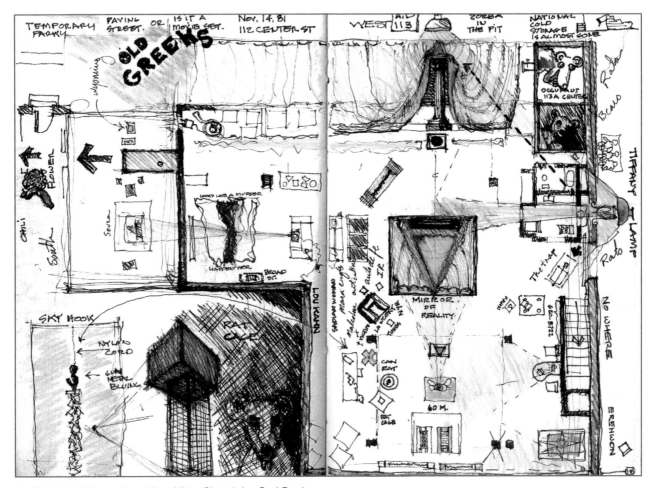

Art Dock Loft November 18, 1981 - Sketch by Carl Davis

In the northeast corner, I piled my supplies and housed my big shop vacuum. The north wall of the studio had a stair that went nowhere, my four-chair square butcher-block table, my kitchen-bathroom construction, and finally the door that went nowhere with the tiny babies in a sardine can inside the projecting mailbox. The west wall of the studio consisted of an area, covered with Astro-turf, that I used as an office and the loading dock. Behind the loading dock, I positioned my favorite—and only—leather chair. I would

By November of 1981 when the Art Dock project had started, I had completely rearranged the space. The Running Fence curtain was now behind the loading dock. By the time of Eve Montana's show, I had removed a meditation space from the middle of the studio and pushed it off into the southeast corner of the studio. I had draped an old, enormous 46-star flag near my bed to shield it from view. The middle of the studio was a sculpture garden of my finished wirework. The east wall was taken up by

the process of building a large sculpture I called "The Ironic Column."

"You just can't make up your mind on what you want to do, or where you want to do it," Michael said.

"I have many different interests. I need spaces for each of my projects' sculpting, drawing, writing, and architecture," I said to Michael. "My space reflects that and is adaptable to the size and scale of my needs."

"Your space is a mess," replied Michael. "There's no order."

"I don't want order," I said, "And besides, the most interesting studios are those with profusion and infinite possibility. Mine has infinite possibility. So does yours, in a primal way, like an empty cave. I don't like the studios divided up into little spaces, each with its own definition. I like universal space— space where the occupant is free to do anything he or she likes. That's not to say I like space without definition. The character of the space provides contrast and possibility to its openness."

"It's all impermanent," chortled Michael. "How very Zen of you."

"Yes, it is," I replied. "I think the best of these spaces, perhaps all artist spaces, are impermanent."

"I'm hoping my space lasts for a while," Michael declared.

Everything was impermanent to me. I was constantly rearranging my studio, searching perhaps for the perfect configuration. Working on my wire pieces in one area one week then moving the work to another spot the next. The location where I slept kept moving around the perimeter of the space, until I finally settled on a far back corner near the hidden stairway that went into the vast space in the basement that was rented by the plastic-penguin-making husband, French wife, and young son. They used my space as an easy way out of their huge 4,000 square foot space. I did board up the access way, making it difficult for the French woman's lover to slip down into the dark cave.

The use of my studio as an entrance and exit was more than inconvenient. It was illegal. At first I supported this pathway as one more statement of my rebellion against the norms of American society and declaration of my bohemian status. Yet as the writer from the gas station continued to use my shower and then descend to his secret romance with this exotic woman, my irritation became extreme. Nailing up the door was revenge. I used the truth that rats got into my studio from this stairway as my excuse. To mention the code violation would be unwelcome in the art community, where violations were the norm.

Daily Diary Page by Carl Davis

Around this time, the impermanence of my situation began to affect me very negatively. The real

constant in this flux was the Art Dock, an idea I could wrap my mind around and anchor an otherwise tumultuous existence. I threatened to quit my job as an employment counselor, and two days later I asked to be fired and was. One less anchor held my lifeboat in the stormy seas of my outlaw existence. I was having days of extreme depression and felt like I was at war with myself. The contradiction of my life as an outlaw artist and a professional architect was too much to bear. For four days, I got more and more distressed and negative. Black Saturday came on February 27th. I closed up my world, including the Art Dock, and crawled into my back corner bed in a darkened studio and disappeared for a day. On Monday I was renewed and ready to resume my life. I played ping pong with Gary Lloyd for control of all in the world that remained after tomorrow. I won.

"How long do you think most of these artist buildings are going to last?" I asked. I thought about the Bird House, where several painters had taken up residence in an old, partly boarded-up, late-19th-century multistory building, and the old concrete multistory shoe factory on Third Street with its impossibly winding staircase, where Peter Taylor, a sculptor, Peter Ivers, an actor and song-writer, and a bunch of other artists were holed up. In the Bird House, the artists had excavated studio space in the upper floors where birds had nested and defecated. The spaces were made up of old office areas and could be turned into living and working areas without much change to the layout of the floors. A hotplate and refrigerator would turn a space into a kitchen, and the bathroom would be the old toilet down the hall. Renewal or demolition would be the ultimate fate of this structure.

The shoe factory was a marvelous old concrete monolith bifurcated by a wide passageway, a creaky elevator, and a narrow, winding staircase that rose up the four stories like a flight of steps in a medieval church. The first floor of the building housed wholesale shoe salesrooms, probably all cheap Asian knock-offs. The artists occupied the upper floors. The back of the building was all loading docks and parking area. The building took up most of the block along Third and San Pedro Streets. To enter the artist part of the building, you drove behind the building, parked, and made your way to the passageway and the elevator. Much of the time this elevator did not work or was stuck on one of the upper floors. This meant climbing the stairs.

Once you were on the fourth floor, the elevator and the stair landed you in the studios. A corridor led past two spaces on either side that had doors. These were smaller studios and bedroom areas. One room was Peter Ivers'. The other was Leslie McDonald's, sculptor and film art director. The corridor continued into a big space where Peter Taylor slept behind a cloth partition on one side; a living/kitchen area occupied the other. Beyond this space, a doorway led into an enormous room where Taylor worked and collected all manner of machine parts and aviation metals. These materials were piled in large bins, which once must have been used to store shoe parts. This was a magical place where an inquisitive and acquisitive person could find strange metal shapes, which Peter used in his sculptures or gave away to those who asked if they could have this elbow joint or that small curved plate from an old aircraft wing.

The strangest places had become studios for creative people. In an old gas station on Santa Fe Avenue, one block away from Center Street, a writer had taken up residence. He lived there without a shower and became friendly with the artists in the Citizens Warehouse where he could often be seen with a bath towel over his shoulder on his way to or from a studio where he would clean up. Michael Blake was working on a novel about a soldier who danced with wolves on the plains in the 19th Century. His writing room was the old office of the station and he slept in the single service bay.

"What we have here is a display window," said

The Art Dockuments

Michael Salerno, pulling me back from my reverie. He was referring to Eve's tableau in the Art Dock. "The work has become a set like storefront windows. Dali did one. His was an arrangement for Bergdorf-Goodman's New York store in the late 1940s. It was Surrealism in the service of lingerie."

Michael Salerno with drawing by Carl Davis 1982

Michael went on to relay his suspicion that many of the store windows on Melrose Avenue and Santa Monica Boulevard were artists' creations. "I suspect," he said, "that many artists have found a way fit their art into the jobs they have to do in order to survive. They have become window decorators."

"Is that a criticism of this piece?" I asked.

"However you want to take it," replied Michael with a shrug.

"The storefront window is an excellent public art space. As a matter of fact, one of the large department stores downtown has an art window where local artists can display their work," I responded.

"The Art Dock isn't like a storefront," chuckled Michael. "We don't have a barrier separating art from the world. No glass." Michael rapped on the plane of air where our glass wasn't.

"Don't you realize what Eve has done here?" I said to Michael. "She has come up with the first installation that is specifically meant for the space of the Art Dock. Everybody else has installed a work that could go anywhere. This piece was assembled for where it is."

"Oh, good. Can we go and get a drink now?" said Michael. "I've had enough discussion for one afternoon. Talking about art gets boring after a while. The looking is what matters. Do you think this is good work?"

"Hmm. Good question. Let's discuss that over a drink," I said. I headed inside and rolled down the door on "Homage to the Studio."

Postscript 2012: Eve Montana worked in Citizens Warehouse for several years. She moved to the west side of LA with Fritz Hudnut. Eve became an interior decorator and is now a fiction writer. Michael Salerno closed AAA Art/Michael Salerno years later and moved to a new studio. Michael's art has been included in 250 exhibitions. His latest show was an 18-year survey, 1992-2010, at the Downtown Center in Pomona California. The shoe factory was demolished and replaced by low-income housing. Michael Blake's novel *Dances with Wolves* was published in 1988 and became a hit movie in 1990 staring Kevin Costner. Michael received an Oscar for it. He continues his novel writing.

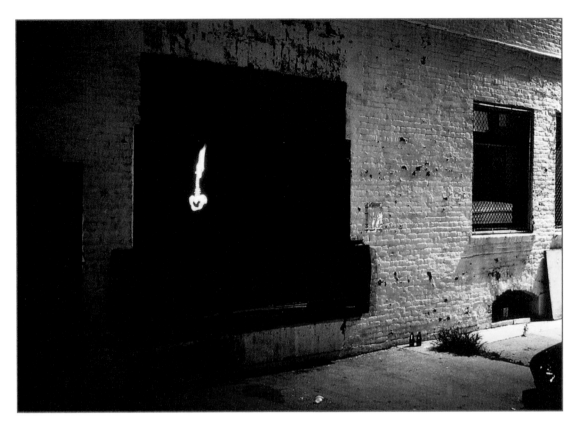

ART DOCKUMENT #8 VIVID
BY SCOTT GRIEGER—EARLY SPRING 1982

Scott arrived at the studio with a roll of wide, black, photographic backdrop paper. He rolled up the loading dock door and proceeded to tape the photographic paper into the opening. I protested. How was I to close the loading door if the paper was in front of the door? "You close the door with the paper in front," Scott replied. When Scott finished taping the paper in position, the opening of the loading dock was completely covered. He reached into his pocket and pulled out a mat knife. In one quick move, he cut an enormous trapezoidal shape into the paper. I was amazed. There was no careful planning or calculation, Scott just cut with confidence. "I have made this shape a thousand times before," he said

when he saw the surprise on my face. "I don't need to think about it."

Scott, a tall man with curly black hair, large eyes and a bemused expression that never disappeared, shook out a large plastic sheet from the center of the roll of black paper. He duct-taped the plastic sheet over the opening cut in the black paper. We positioned two flood lamps on behind the plastic sheet and turned them on. We went out into the street.

In the darkness of a Friday night, the opening of the Art Dock showed a flaming human spine. Scott gave me his instructions. The piece was to be on view for only three weekends on Friday, Saturday, and Sunday nights, starting with this Friday night. He handed me a flyer he had made for the installa-

tion, told me he would be back on Saturday night for our opening party, and departed.

Michael Salerno and I—Michael had invited Scott to show in the Art Dock—then proceeded to spend several hours taping out the light flares that leaked from the edges of the trapezoid, until only the flaming spine could be observed. "I can't believe how casual Scott was installing this piece. There was no planning, just whap bam, and it was done," I said to Michael.

"That's Scott for you," replied Michael. "He's not into finished products. He likes his art to have rough edges."

"Rough edges is one thing, not giving a damn is quite another," I responded, thinking that Mr. Grieger had not given me his best effort. I was wrong, as I determined after an hour or so of staring at the image of the flaming spinal cord blazing forth from the shadows of Center Street. "Vivid" was truly vivid.

Scott returned Saturday night for our small opening. About ten people stood in the middle of Center Street looking at the piece and drinking wine from Dixie Cups served from a gallon box. Sitting next to the wine box in the loading dock, I got to talk to Scott about the piece and his art. I had several questions for him.

"I liked that whole premise of drive-by," Scott said. "The Art Dock fits with my sensibilities as a valley teen who put 500,000 miles on a car driving up and down Van Nuys Boulevard, searching for something happening, when there was none. I drove up and down Mulholland Drive looking for crashes." Scott and I, along with the small crowd, looked down the street where two large trucks sped and shifted gears noisily along Santa Fe Avenue to the freeway underpass.

"'Vivid' is so vivid, it could cause a car crash if you stared at it," I replied.

"You don't have to stare at it. Just have a quick take. I think most people's take on art is real quick here on the West Coast," Scott said. "I always

wondered why in a museum the walls didn't move and *you* stood still. Take the Norton Simon Museum, for example, which looks like a bus depot with a lot of alcoves. You go into it and walk around without stopping. Pretty soon you're out the door. Drive-by art was something I have thought of before, but had never put into practice. Those sorts of media things like billboards are appropriate to Los Angeles, or like one of those big light-up signs on Hollywood Boulevard."

"Some people say a person looks at each individual piece of art for 1.3 seconds," I said.

"Well I don't know about that, but there is not a great deal of time spent on art in LA compared to the media and other things. Culture is in spite of the environment. You have to make a real effort to go out and find culture here, whereas in New York, going to a gallery is light entertainment," Scott said, sipping on his Dixie cup and turning to refill it from the wine box set on the Art Dock ledge.

"Why did you do a flaming spinal cord?" I asked, looking up at the spectral image with flames emerging from the top end.

"I see a lot of artists doing light-up pieces with light boxes. I wanted to use that technique. The reason I did it this way was that it was a means to an end. I had this image in my mind and this was easiest way to do it," Scott stated, lifting his Dixie cup in salutation to Gary.

"What does that image mean for you? Is it the rising Kundalini?"

"I've always been involved in Eastern stuff since I was raised in the Orient, so that stuff came naturally to me. The image came to me organically. I'm not a follower of anything. It's a personal image that comes from experience and intuition. If it happens to connect with Kundalini and maybe sexual imagery, that's OK, but it came from a personal intuition of extreme emotional pain. The image comes from the spiritual crossroads I'm at. I'm trying to depict for myself the feelings I have under extreme physical

and psychic distress. Literally, there are times when I feel like that."

"You don't seem to think art is about producing things." Four people approached the dock to refill their Dixie cups.

"Since I was about thirteen, I thought art was about free thinking. I don't think I'll ever compromise the idea of free thought. There's enough in our society that's a challenge to free thought. When working in the studio, the goal is to end up with something more than an economic package. I like the rough edges of art. I wonder about art as manufacturing. I see artists work on something until it's perfect, and then produce four or five of them. That's economics driving the art world, not art driving the art world. That's not so interesting to me."

"What do you think the role of the artist is? I know an artist who sees art as a way of working on himself. Objects are a byproduct of his work. How do you see the artist and his products? Are they inseparable?"

"I can make one piece and be satisfied with it. The idea of self-evolvement and those ideas of learning to love, to care, and to have empathy are very central to me. The product part is interesting to me, but not as interesting as having a fruitful life. Artists like Duchamp studied art so deeply that they didn't do art anymore, even though Duchamp did things on his own which nobody knew about. I believe, like Matisse, that making art is an old person's activity. I wonder why I do it. I think about why I don't just give this up. Then the need comes back, and I do it again. I start making art again."

"I think for all of us the need is outside of the market system. If you take the attitude that art is a way of personal expression, it's very hard to give up that activity," I said, reflecting on my own reasons.

I couldn't get that desire out of my system, and architecture did not fulfill that need. After my bout with black depression, the snakes of unrest were back in the basement of my mind where they belonged. I raced from place to place and project to project. I intensely concentrated on my construction of a welded wire column made of fabricated pluses and minuses. I fell off the ladder, hitting my head, but I was all right, although momentarily stunned. I stayed up most of the nights for the better part of a week working on it, some drawings, and my performance piece script called the "Grand Egress" with Giant Jane, only breaking away to teach a few hours at UCLA, to visit the office of Councilman Joel Wachs about the artists' living situation in downtown, and to attend my weekly group therapy session with Dr. Ed Wortz in Pasadena. Dr. Wortz expressed concern about my highly energized state. I replied that this was the artist's life I fervently desired. The creative spark set off an explosion in my mind and gave my body the energy to keep on beyond any need for rest. "I prefer not," I repeated to myself and anyone who would listen, meaning I wouldn't want to live any other way.

My wife and daughter came from San Francisco to see my new loft and experience first-hand how happy I was in my new creative life. My wife refused to stay with me and retreated to a downtown hotel. I took her to meet with my psychologist. She told him her side of the problem in our marriage. I hoped he and I could convince her to join me and forgive the errors of the past. But she would have nothing to do with it and demanded that we divorce. As the rain poured down, she departed Los Angeles International Airport without another word. I knew my marriage was over. We would divorce, and the pain of losing her and my daughter was intense. Still I held out hope we could reconcile. Only slightly did my enthusiasm diminish. I returned more determined than ever to build my wire sculptures, to prove to all my credentials as an artist, and perhaps to win my wife back.

"Art just happens to be a passion; it galvanizes my life," said Scott interrupting my momentary silence.

The Art Dockuments

"Art to you is more than a craft?" I quickly asked and slid over to fill my Dixie Cup from the wine box between us.

"Once craft can reach invisibility you're there. Take Leonardo, for example. Do you really look at one of his painting and say that's a finely crafted painting? It goes far beyond that. I think that's about fifth down the list. There was some real belief going on there. The belief in art makes for the transcendental experience. If you communicate that to a few other people, it's enough."

The small group of people at the opening was caught up in Scott's words, and a silence came over the group as they listened to the interview.

Vermeer— "The Milk Maid"

"Your Art Dock piece, which is not a traditional piece of art, has a lot of impact," I said. "It had me staring at it for a long time last night."

"That is because it has to do with basic things. Basic things communicate to people. It's like the painting by Vermeer of the woman pouring milk out of a jug. It's as potent today as it ever was because it's something everybody can connect with. This is the genius of Andy Warhol. You know the painting before you see the painting. In that second-and-a-half, it clicks with you. There's something in the nervous system. I think that great art is about something extremely common. Great novels are that way too."

"There's a look to that activity that leaps out, like the Vermeer milk pitcher. There were a lot of people who were painting similar pictures then but they didn't have what Vermeer had," I said.

"Yeah, what's interesting about it all is that our economic structure is so screwed up today. When you look at it, how many great things did Man Ray do? A few. Yet he was on a romantic search for those great things. How many great things did Brancusi really do?" The small crowd in the street murmured in agreement.

"Maybe three," Gary said. He stepped forward and lifted his glass of wine.

"Or Giacometti?" asked Scott lifting his glass to Gary. "Those skinny figures, that's where he made an aesthetic leap into great art. It was a personal leap. You can't expect that many in your lifetime. Nobody is that good. Again our corporate structure commodifies that in some way. I suppose the popes wanted commodities too, and so did the dukes and princes. So I think personal aesthetic leaps happen infrequently for any artist."

"Have you changed since you did the switch plates with the skulls where the plugs should be inserted?"

"I am no longer fascinated with death. I am fascinated with life. It is much more subtle and difficult to do something beautiful. The flaming spine is beautiful and transitional. There was a period of my life when I had to go as far down toward death as I could and then come back up. It was an extreme experience that I think I had to do."

"How did you convert that into art?" I asked, pointing toward the flaming spine. A vehicle drove

by the Art Dock momentarily making the ten people in the street move aside to let it pass.

"How can you have empathy if you haven't experienced something yourself?" Scott replied. Some people don't allow themselves a great range of experience. There is a certain safety in that. To communicate something you have to experience it. It's like gratuitous abstraction. You look at a Pollock and you look at someone who has reproduced one. There's something missing. It's because of the gratuitous gesture."

"The dribbles could have the same color, but they don't have the same feel," I responded.

"Hear! Hear!" A British accent echoed from behind Gary and Karen. Everyone turned to look at the person who took a sip of his drink and walked away.

"That point of view about the authenticity of gesture has been discredited to some extent. It's all artifice, they say. It's all just paint on canvas. I really don't believe this because I have seen art that doesn't do that, and I know it is extraordinarily hard, and there are very few practitioners who get there. Some of those objects are extraordinary."

"Is that what's going on with artists who appropriate images?"

"I think they claim there's no such thing as authenticity. It's a closed-ended argument. Again it comes from the expectation you have of a picture. If it's an extraordinary picture, that's what it is. But it can be extraordinary from many different perspectives. It can be historical, ahistorical, or different technique. There are individuals who can communicate. It's like musicians. There are ones who just saw on the violin, and then there are those whose playing is inspiring. They interpret. Somehow, in their fingers, they have a little bit more."

"Is there something in art that goes beyond its history?" I asked. "Is there something outside the evolution from Cubism to this- or that -ism? Is there an original voice that comes out?

"That's like Pablo Casals playing Bach. What's the difference between someone playing a piece and reaching you, and someone just playing a nice rendition? That's what's so subtle. Why is it someone like Matisse can do cutouts in paper at the end of his life, which are just paper cutouts, and they are some of the most extraordinary things that he did? The form issues are not very interesting to me. You test the edges of your envelope. The word is fine art, it's not just art."

"I'm a little confused here. Is there a difference between originality and authenticity? Can you somehow be original in the unoriginal?" I asked.

It's authenticity, the gee-whiz factor. I think about what Einstein talked about. It is not so much that you discover anything new, but you look at things in a different way, from a new perspective.

"Do you mean to create the gee-whiz factor in your own piece?" Gary and Karen indicated with hand signals that they were going back to their studio and several others slipped away.

"No, the gee-whiz factor is in there, but to expect it to become a NASA-like breakthrough, changing consciousness, is unfair," Scott said, rolling his hands indicating we should move this interview toward conclusion.

"Is that what is the difference between what's at the Louvre and what you see at an art expo?"

"Maybe. I'm not sure. It's hard to draw the line."

"So you think that great art is that basic connection that rings true?" I asked.

"Great art can be almost anything," Scott replied. "Surrealist objects are that way because they go into the psychology of the viewer. Why is it that the human figure always rolls back into the fray every once in a while? I think because it's authentic and basic."

"How does this relate to the critical community?"

"I think there's something interesting in the expectation of the critical community in Los Angeles. Why are these people so deeply disappointed in art? They have a false expectation about art. A picture

is just a picture. Damnit, it ought to be a really good picture, but it's just a picture. There are poignant images that are basic to our repertoire of thoughts. Jung talked about this. I wonder if it's all that complicated. Pictures are just pictures. The genius of artists is that they know how to create hot images that communicate with people."

"Do you think art is philosophy, like Arthur Danto says?"

"I think that's too intelligent an analysis. Art at its best is empathy. The connection comes not when you do it and not when you have the transcendental experience, but when you connect with another somebody. That is interesting, whether or not it sells is another issue." I could see Scott growing impatient with the interview as he moved his body side to side.

"Did you go to that show in the LA Convention Center where there was a lot of art that 'connected' to people?"

"Yes I did. I had a friend who had a piece in that show."

"That show had a lot of empathy for certain folks," I stated.

"Clowns, motherhood, John Lennon retreads, Western art, Impressionism of all kinds were there in abundance," Scott said, puckering his lips and relaxing into a whimsical smile.

"Do you believe that stuff is art?"

"Yes I do. I believe what Joseph Beuys used to say: The more people that are involved in art, the better, because all social forms or ideologies are dead forms. The only revolution really left to humankind is aesthetic. How in these circumstances in the modern world can we live a sensitive and aesthetic life? Interesting idea. I have my personal dislikes, but I haven't ever bemoaned the huge number of people becoming involved in the arts because I see people who have contact with the arts as bettered. I don't expect spectacular results from the arts generally. What it does is sensitize and create empathy, which

there is damn little of in capitalism lately. So I let people go for the clowns, horses, and Western art."

"Duchamp said the artist's role is to make each man an artist."

"I don't know that quote. What I think is that art is a revolutionary activity. It may be the only unmanaged part of our society." Two people from our crowd wandered away down the street. Only Scott and I were left in conversation.

"It sounds to me that you think making art for the gallery is only part of art's function."

"Making art for the gallery is part of it, but it's a small part. I wonder about our corporate world. It is extremely successful. It seems that being given infinite choice means there is less choice. Knowing how we live, we function, what we might say is more interesting than art in the gallery."

"Is there somewhere you draw a line on what's art and what's not?" I asked.

"I don't think I draw the line. Why is it there are a lot of artists who teach art in prisons? We are allowed to do art as children, then somehow it becomes gauche and it gets trained out of us. I think there is a political movement connected to art. I think it is a bastion of sensitivity," stated Scott.

"That's a Beuys idea."

"I think it's a Southern California version of his ideas. In his heyday in Dusseldorf, Beuys had thousands of students in his class. He accepted anybody into his class as an artist. Are you almost finished with this interview? I am getting cold and almost everyone has left."

"A couple more questions. Wasn't it John Adams who said, 'I am a warrior, so my son could be a farmer, so his son could be a poet?'" Scott rolled his eyes.

"Bohemia is alive and well, despite what the critics say. They just don't know about it. They never did. Bohemia moves around. My friend Dave has the freeway overpass view of art history. He says all these artists are on the road going different direc-

tions on different roads. The art historian comes along in a helicopter and takes a picture from above. All these artists are in a little nugget on the overpass. They come back in three years and it's all different. They then declare it's all fallen apart. It's a kind of frozen view of the art world, but really this artist has gone this way and another that way and they were never going in the same direction anyway. It's cultures in collision."

"What do you think about what's going on in downtown right now?"

"There are a lot of interesting people in downtown, but it's sort of a-professional. There's a need for these things to happen, and so they happen. Success will spoil it. I think that's our dilemma as late-capitalist citizens. We professionalize things immediately because the nature of art is to become commodity. The question is how do we stop doing that? I haven't got an answer to that." He shrugged.

"Can you explain to me what you mean by the a-professional stance of downtown? Is it an inversion of the whole professional stance? Does it relate to an explosion of some kind of energy out into the world that art is famous for, like the beatnik generation, Dada, or Surrealism?"

"It's a very volatile time down here. It's like the Oklahoma territory land rush. Real estate is booming. Buildings are being bought up and spaces developed. Everybody is stomping around in cowboy boots, smelling of drywall. It's Tin Pan Alley. It's pioneer time. It's like what you would see in Dodge City during the land rush or the gold rush. The Art Dock is like one of those houseware businesses that went up in a tent and will be gone once the gold is tapped out of the mine."

"I hope that's not true."

"I've said enough," replied Scott, slipping off the dock, tossing his crumpled Dixie cup into the street, and heading towards Gary and Karen's loft.

On the following Saturday I was standing in the middle of Center Street photographing "Vivid" in the

Art Dock. A black man came up to me and asked me what I was doing so late in the night. "Photographing art," I said.

"Art, huh," he replied, looking at the flaming spine illuminated on the warehouse, both of us standing silently for a minute. "Goddamn right it is!" he said before wandering off down the street.

Daily Diary Page by Carl Davis

Postscript 2012: "Vivid" went on to be displayed at the American Hotel and at four other places. It was outdoors at Otis Parsons Art School where Scott Grieger taught. It also showed at an event called "Designer as Diner" in Venice. Scott Grieger continues to make art. He teaches at Otis (now Otis College of Art and Design), where he is a full-time professor. Councilman Joel Wachs left Los Angeles to head the Andy Warhol Foundation.

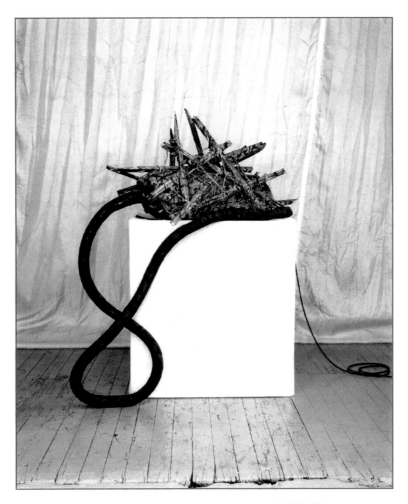

ART DOCKUMENT #9 VACUUM LOVE
BY KIM JONES—EARLY SPRING 1982

Michael Salerno placed the cardboard box in the middle of the Art Dock and wrapped it with a white sheet. He went back to his studio, leaving me contemplating an empty white plinth. Salerno reappeared later carrying an odd-looking object—a small fuselage covered with camouflage-painted sticks. Draped over his arm, he had an old black hose. Michael hopped up into the dock and placed the object on the plinth. He uncoiled an electric cord from the object and disappeared into my studio to attach it to an outlet. He reappeared and inserted the hose into the opposite end of the object and carefully laid it out on the pedestal.

"Voilà," said Michael, leaning over the object and switching on the mechanism. The thing made a loud whooshing sound and a long pronounced groan as it started up. "There you have it, 'Vacuum Love.' It sucks up love and blows it out its rear end."

Michael Salerno had selected this work by Kim Jones to be displayed in the Art Dock. Kim was never seen. He had gone to New York to seek his

fortune, leaving a large part of his sculptures and drawings in the care of Salerno for display and sale. From this stock of objects, "Vacuum Love" was chosen. The sculpture was a old working vacuum cleaner altered by the addition of wooden sticks and slats roped and glued over the surface then painted in a camouflage pattern of blues, blacks, and grays. This new skin for the mechanical object converted it into an alien apparatus. It was an object almost animal-like, a primitive otherworldly porcupine or perhaps a robot for the post-nuclear future. When running, the thing made a loud sucking sound, an unending moan like a wounded beast thrashing in the dirt. As Salerno delighted in telling all who looked at this artistic instrument, its long hose coiled beside the prickly body. "This beast is a love sucker. It's a very sexual object."

Polaroid found in Alley and Exhibited
by Michael Salerno in Exile's Sex Show 1982

"Vacuum Love" was to be the Art Dock's exhibit on the big day of the LACE studio tours. The artists in downtown were finally exposing themselves and the LACE (Los Angeles Contemporary Exhibitions) studio tours were to be the unveiling. Everyone in Citizens Warehouse was excited. Westside Los Angeles would finally become aware of the dynamic and large community of artists that was spread out over downtown Los Angeles from the commercial buildings along Broadway to the east around Skid Row and beyond. First and Center Streets, where Citizens Warehouse was located, represented the far eastern end of the colonization. Saturday and Sunday of the tours would change the whole perception of the community. It was a big deal.

Not that the total community of LA was unaware of the artists and their alternative galleries, but its image was unfashionable. This was the time for sex in downtown—sleazy sex and sex on Skid Row. Exile, an alternative gallery at the corner of Winston Street and an alley famous for its lowlife denizens, had a sex show that got a review in the *LA Times*. The piece that made the biggest splash was Michael Salerno's. Michael exhibited a series of Polaroid photos he had found in the alley next to the gallery. These Polaroids were of Skid Row women, passed out, exposing their bloated and discolored bodies with vaginas oozing sperm. The women were purported to be Native American and ended up in the alley because of the Native American welfare office next door. The Polaroids were raw and unbeautiful. Meant to be pornographic, the photos were perverse but not in an attractive way. They were an inversion of pornography. Rather they were a total turn-off for sex, yet the photos touched something visceral. They showed the reality that even on Skid Row lust was working. Like these disturbing pictures, the image for the denizens of the downtown art community was dark. Downtown artists were the tortured antidote to the sunny, abstract, and cool art of Westside LA. The image of light and space was the image of Los Angeles to the larger art world. Downtown art was the antithesis of that, epitomized by Andy Wilf and the Exile sex show.

"Is this a companion piece to your photographs in Exile gallery?" I asked Michael.

"What, you don't think my found objects were art?" he said, a devilish twinkle in his eyes.

"I, for one, found them difficult to consider art," I responded. "I find this piece more acceptable, but isn't it really just one of the artifacts left over from a Kim Jones performance?"

"No, this is the real thing."

"Do you really think anyone would buy this as a sculpture?" I asked.

"Vacuum Love" served as a mechanical clone for the artist. Kim Jones was well-known in Los Angeles as a performance artist. In his persona as "Mudman," he would appear nearly nude, his body colored in white and brown, carrying on his back an assemblage of sticks and rope. Kim would parade on public streets in the image of a wild and primitive man amidst the suit-and-tie set. He would engage in savage behavior, like building fires and killing rodents.

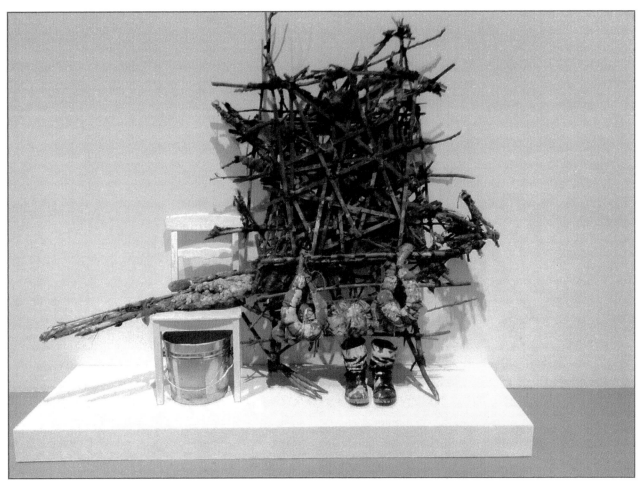

Mudman Structure by Kim Jones 1974 at MOCA 2012

"Wait a minute. You're the one who wrote a manifesto about art as commodity. This is a deliverable just like any other deliverable on a loading dock," answered Michael. "It's an icon for the artist, a way of holding something true to his art. It's like Joseph Beuys' felt."

One performance at California State University led to a court case and the gallery director's dismissal. Kim Jones, painted as the aborigine with his long wild hair standing in all directions, built a fire with sticks and chips, burned a dead rat, and pretended to eat it. At Exile, Kim Jones, the aborigine, and artist Gary

The Art Dockuments

Worrell squatted around a small fire and burned themselves alternately with cigars. The display was repulsive, yet visually engaging and very sexual. I felt barbarian urges welling up. I could remember playing as a child where I assumed the role of the "Indian" and ran semi-naked in only a breech-cloth. My body marked with streaks of charcoal, I pretended to live in the forest stalking animals for food, wary and ready to kill enemies. Some connection to the primordial is reached with this behavior, an underlying nature below the veneer of civilization.

That sense is related to the skin. Normal clothes mask the skin. Clothes indicate the culture and the sex without exposing the feeling. Women's attire is often designed to stimulate animal urges, but men's hardly ever. Only in the assumption of primitive attire or near nudity do men reveal an attitude of animal freedom. This hidden sensuality and the reasons for its control in modern society were the issues that Kim Jones explored in his art. His appearances as Mudman were startling, sometimes disgusting, as in the Exile performance. Sometimes his performances were funny: a strange white aborigine scaling a telephone pole in the midst of the well-dressed. There was humor in the juxtaposition, and embarrassed laughter at the recognition of our closeness to the primitive state. Lose our clothes and any of us is savage. It is the second skin of clothes that proclaims us civilized.

The altered vacuum cleaner was an extension of these ideas. Any ordinary vacuum cleaner has an anthropomorphic quality. The upright cleaner has always seemed to look like a robot to me. "Vacuum love" was a funny and vaguely erotic sculpture. Kim put a new skin on a familiar object, making it primitive and calling up its animal aspects. The altered object became sexual and indicative of the sensual in all things. A modern machine converted in this manner became a comment on a society that had removed itself so far from the natural state that its machines have become sensual objects.

The comment was humorous. A vacuum is not a malevolent device. It is an object of convenience and a marvel of human invention but one capable of stimulating many metaphors. To see it as some primitive artifact sucking up love was a gentle poke at human foible and a celebration of imagination. It's this imagination that is unleashed when the human strips off his ordinary veneer, assumes the primitive, and plays like a child. Man can become the art, the art becomes the play.

I was still attempting to strip off my ordinary veneer (teacher, architect, husband, father) to become an artist. I was living a dual life. Weekdays I taught one class at UCLA, my last remaining hold on the academic life, traveled to Orange County to sell advertising in a design magazine, or traveled to Vernon, the industrial town south of downtown LA, to work as a draftsman at the Golden Oak Furniture Company. Golden Oak makes knock-offs of better quality desks. My descent from a professional career was precipitous.

On weekends and nights, peeled from my civilized clothes, I strolled naked in my loft like a barbarian living in a primitive cave. Once, outside on the street, there were gunshots. I went to my steel wire covered window to see a body lying on the pavement with blood oozing from it while bums and artists assembled like sentinels until the police arrived. The police chased the gathering crowd away then threw a white sheet over the body. One artist yelled to a window above me, "He got shot in the head."

I watched a performance in the street where an artist dumped a ton of bricks on a mocked up living room near the gas station where crack and heroin could be bought, and watched the homeless lined up their tents down a rutted crumbling alley. I went to an opening of graffiti art, which were ugly abstract swirls of spray can lines and alphabets over a dark background. I measured the upper floors of the Bird House building where Exile Gallery was located and

the artists lived in spaces amidst the pigeon drop-pings. Expressing my free sexuality, I prowled along corridors of a bathhouse, where near naked men wandered the semi-darkness seeking anonymous sex. I missed my daughter's fourth birthday when I was furiously working on my sculptural column of pluses and minuses. I was truly a resident of a curious hell, dank and miserable, but free of all convention. I found the anti-nirvana.

These were sensual times in downtown LA. "Vacuum Love" was part of a whole nexus of sites, sounds, and events that began in the late '70s, and extended well into 1983 when the atmosphere in the art community gradually changed from wild revolt to dogged survival. Is sensual the right word? That word implies pleasure, which does not particu-larly suit that time. Perhaps the word raw describes the situation better. Rawness includes a sensual element but indicates an unbridled horror, the grim reality that went with life in downtown. Kim Jones performing in Exile on Winston Street mirrored real-istically the alley fires, the feces, the loss of civility, and the violence that the down-and-out perpe-trated on one another on Skid Row, just outside the door. There were homeless people who engaged in sex in broad daylight on the concrete pavement of downtown side streets. Exile staged the sex show just before "Vacuum Love" was on display at the Art Dock. This was an event of raw sensuality like none other, before or after. Michael's photographs became a hallmark of the downtown attitude, char-acterized by a raw emotion and the embrace of the uncivilized. Downtown art was radical in its denial of the beautiful. The aesthetic was coarse and critical of the pretty, the collectable, and the marketable represented by the Westside galleries and the public museums.

The Art Dock was a milder but sympathetic element of this principle. A loading dock is a coarse place. There is no provision for aesthetic charm in the design of this utilitarian site—just a hole in a wall commodious enough to pass goods through and high enough to be level with the bed of a truck. The wall of the building surrounding a dock is protected with bumpers, the opening with a steel door. Nothing is for beauty; all is for function. A loading dock is merely real, perhaps even raw, and they are everywhere all over the industrial landscape of Los Angeles. Loading docks are the gaping maws of the city where products and produce are spat into the marketplace.

Daily Diary Page by Carl Davis

It wasn't the excess of art that kept the art patrons away, but the idea of downtown itself. To suburban Los Angeles, downtown was an awful place, to be avoided unless absolutely necessary. A trip to City Hall was one of the few valid reasons to visit the

The Art Dockuments

area. So far art hadn't had enough appeal to draw people in large numbers to this den of iniquity.

I thought the LACE studio tour would be the big day when the Art Dock really went public. So far, about the only people who knew about the dock were the inhabitants of Citizens Warehouse, a few other artists, and their friends. The fears that the Art Dock would publicize the building had been unfounded, but the busloads of eager art patrons swarming on Center Street following the LACE Tour would end all that.

But the crowds never came. Maybe ten people showed up. Most could never find the street. Some got lost in the attempt, and, as we were later to hear, they crossed over the First Street Bridge, landed in the housing projects, became frightened, and sped back to the safety of the white side of town.

Postscript 2012: Kim Jones lives in New York and continues to make art and perform. His work was on display in the Pacific Standard Time exhibitions. In Under the Black Sun: California Art 1974–1981 at MOCA his Mudman Structure 1974 and two drawings were exhibited. In LA RAW abject expressionism in Los Angeles 1945–1980 at PMCA (Pasadena Museum of California Art) Kim Jones was represented in two photographs of his Mudman performances and two ink-on-paper drawings. Gary Worrell is now an Exhibit Technician/Museum Preparator at the Turtle Bay Exploration Park and lives in Redding, California.

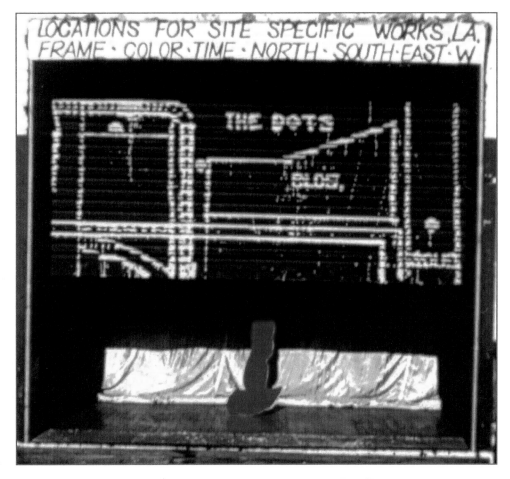

ACT I THE MANIFESTO

ART DOCKUMENT #10 LOCATIONS FOR WORK BY GARY LLOYD—EARLY SUMMER—JULY 1982

On a hot, lazy, late Sunday afternoon, the Art Dock door was half-open. White dots and a map were affixed to the door's freshly painted, green metal ribs. Taped above the door was a paper banner that read "Locations for Site Specific Works, LA. Frame—Color—Time—North—South—East—West." Behind and below the vertically opening, heavy steel door, "Defense Spending" stood upright. The sculpture was in the shape of a fire-ax rendered to look like it was made out of meat, but its surface was not flesh—it was American pennies. The ax edge was

fabricated from dimes. The sunlight shimmered off the surface and reflected off the back wall's silvery curtain. The street was quiet, the city hushed. The sun beat down on the hoods of cars lining the block-long curbs.

The short length of curb in front of the loading door was open—the only open space along the street—and for once the art was easy to see. Nothing was moving. The homeless weren't wandering, as they usually did, from trash bin to trash bin searching for stuff. Center Street was a favorite location for scavenging and Sunday was an

active day. By the weekend, the warehouse's two trash bins were always full of strange and wonderful things discarded and collected and discarded again by the artists who, like the homeless, shared a fascination with the bin's treasures. But the day was too hot for scavenging. Most artists were inside their studios in the shade. In Gary Lloyd's cavernous studio across the hall from the Art Dock, a group of artists were gathered around his kitchen table. Gary offered iced tea to his guests.

Lenny asked, "Wasn't that ax just in your show at the Kantor Gallery?"

"Yes," Gary responded. "It was the piece featured on the poster."

Salerno piped in. "What's it got to do with the dots?"

Gary eased his long frame into a chair and took a big sip of tea. Everyone knew Gary was about to begin a long and convoluted explanation. We all shifted in our chairs, the wooden legs scraping loudly on the maple floor.

One artist, Jan, stood up, gulped down his tea in one swallow, and said he had to get back to his work. We nodded and watched as he disappeared out the studio door.

"I want to use the Art Dock as a sign," Gary began in all seriousness, riveting his dark eyes on the artist who had asked the question. "The dots indicate the locations of a series of works existing in the landscape all around the warehouse. The dots are a visual language." Gary inhaled, flaring his nostrils, and leaned forward as if to burn his words into the listener. He continued calmly and deliberately.

"I see the Art Dock as a mouth. It looks like a mouth." Leaning even closer to Salerno, Gary spoke very slowly to emphasize the significance of each word, "Like. The. Big. Orifice. On. The. Front. Of. Your. Face."

Salerno sighed and laughed. Gary leaned back grinning, satisfied that the full meanings of his words were conveyed. He continued mildly. "The Art Dock is, of course, just one big hole in the wall of the warehouse, but it is the hole in the soul of this art community."

Several of us chuckled.

Gary smiled and proceeded with his argument. "It is conceptually an oracle, the Delphi of Downtown. From here the artists speak their ideas—or display their ineptitude. They broadcast from this loading dock, experimenting with their art and declaring their points of view. In that sense it is like a sign. It signifies our presence and our dispositions. I am signifying the signifier."

"Is that Beuys or bullshit?" Marc asked, delivering a dig at Lloyd's favorite artist.

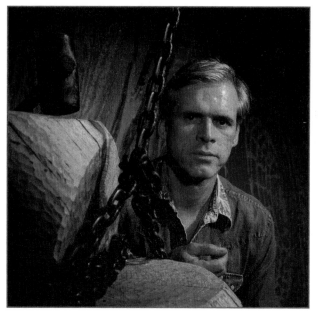

Gary Lloyd by Ed Glendinning

"Barthes, bonehead," Gary quickly retorted.

There was a general shifting of chairs, and another artist declared she needed to go do her laundry and departed.

Gary was just getting started. "The dock is a transmitter, like a radio or a TV station. Stay tuned for the latest program. Images at six, follow-up at eleven. You know the whole communications thing."

Indeed we did, since Gary Lloyd was well known in the art circles as "The FAX Sculptor." His piece at

LACE (Los Angeles Contemporary Exhibitions) had caused both snickering and intellectual debate when, in a two-way communication over a facsimile transmission device, Gary connected real-time events in New York City and Los Angeles. Artists in each city sent drawings to one another while discussing the meaning of art over the telephone. The wonderful new invention, the FAX machine, was mounted to the wall on a little shelf next to some paintings. A crowd of costumed artists gathered around to watch the chalky paper dribble onto the floor. A rumor was circulating that the Internal Revenue Service had taken a dim view of Gary's claim that his telephone time was sculptural material.

Another artist departed. The group had dwindled to five: Gary, Lenny, Salerno, Marc, and me. We sat in one ring around a kitchen table placed in the far end of the big open room. Gary's studio had been combined with Karen's studio through a wide passage cut into the wall between them. It made an oblong space stretching through the building from outside wall to outside wall. The studio was cavernous and cool. It was the largest studio in the building. One big room was for Karen, one big room for Gary. A little kitchen and bathroom without doors was on Gary's side of the wall. On Karen's side, a toilet stood six feet from the entry door just off the wall. A curtain hung around it. Between the two studios there was a large wall that could pivot on a caster and swing out into Gary's studio to make a projection screen or a display surface. When the wall was spun closed, it screened an alcove where Gary's bed and closet were. The wall was closed today, and the bedroom had moved into Karen's studio.

On the walls around the kitchen table were watercolors of axes in space disasters. On rolling tables in the middle of the studio were more watercolors of axes in progress, as well as jars of tinted water, masking tape, mucilage, paints, and brushes positioned for use. In the shadow deep inside this artist's cave, I could discern the glow of a serpentine line gouged into the shiny hardwood floor by an old forklift truck and filled in by Lloyd in green fluorescent plastic. Gary's discourses could be as convoluted as this line, and as strange and fascinating in their tone as the line's eerie glow. Gary's observations would usually relate the history of art to the history of technology. For example, he enjoyed comparing the achievements of Picasso and the Cubists, who according to Gary had scrambled visual communications and created a new language, to the principles of Nikola Tesla, who, the artist often recounted, was able to transmit electricity through the ground without the aid of wires and was thus able to communicate without form. The Cubists, Lloyd postulated, had misunderstood technology and created a new formalism, while the scientists had not foreseen the art in their discoveries. But Tesla, Gary surmised, was probably an artist.

Gary Lloyd's Studio in the Citizens Warehouse

Always the gracious host, Gary refilled the iced tea glasses of those remaining, and offered us foods from his refrigerator, while expanding his explanation to include Einstein, Beuys, Foucault, Ruscha, and a host of other theorists, writers, and artists, each offhandedly referenced in a fast moving synopsis of art history, technological progress, and statistical evidence—culminating in his latest piece "Locations for Work," which was merely a test for a more ambitious and significant work to be undertaken later.

"The dot screen of the best Japanese television has 6,000 dots per inch of line—600 lines per screen. The best American TV has fewer dots and only 385 lines. We are losing the information contest," Gary stated authoritatively. We had no way of knowing if what he said was true, but it was never good to quote Gary's facts to someone who might have knowledge. The ideas were always interesting, but the statistics often garbled. Everyone smiled. With this artist, bizarre statistics always preluded a conceptual proposal.

"The dots are the message," Gary said, returning to the installation in the loading dock. "The Art Dock is the medium, the mouthpiece of the building, speaking art out into the street. The communication is, however, local, reaching the artists who inhabit this area, the artists who come to visit, and the occasional lost soul. I want to communicate with that audience."

"The homeless and the criminal have always shown a big interest in the dock. It's their landmark on the way to the trash bins, the river bank, and the jail," I said sarcastically.

"'Locations for Work' will change that," Gary responded semi-seriously. "This exhibit communicates my ideas about the commodity of art and art in the context of the community," he continued. "First, treating the dock as a billboard emphasizes the idea of it being a communication device. I made it a map—another communication device. The dots on the map relate to dots around the neighborhood that identify and frame places that are worthy to be called art because they are dotted. I have made an inversion of Duchamp's readymade. The dots represent the 'already in place.' The dot, as you are no doubt aware, is the device every gallery uses to indicate a sale. A dot next to a work legitimizes the art because it was sold. The dot in nature is un-saleable, but nonetheless it can be interpreted as a marker of what can be considered art in nature. The irony is that a dot in nature turns that nature into an object."

"Nature?" I asked.

Gary turned a squinted gaze my way. "The outdoors. The environment. Whatever is not classified as art," he said, exhaling the "ar" out as a long sound ending in an abrupt "t."

Gary turned away from me and reverted to a mild professional manner. "The dot is two-way. The dot alone is nothing. Next to a picture, it speaks. The dot in nature needs the nature to have meaning. The dot gives the environment it calls out a new meaning. The dot is punctuation."

The dot under the First Street Bridge

As we were to discover in the coming days, there were many dots. Two were easy to find. Under the First Street Bridge, so often the residence of the homeless and a location for Hollywood filming, a dot positioned on a column marked a view through a series of soot-streaked concrete arches to a solid wall across Santa Fe Avenue on which was inscribed in red the word "Solidarnosc" in the script that made this word famous. The view was sad and forlorn but familiar, like some famous photographer's image of a depressed city. A dot was placed below the words "Young Turks" recently painted on the red brick wall at the end of the warehouse and used as a backdrop in an artist's film. The Young Turks were that group of artists who came first to downtown and promoted themselves very effectively as brash bohemians through exhibits, events, and films. They were also

sarcastically referred to by the jealous as cheap self-promoters. The dot marked their mark and called out the long vista of the railroad yards flanked by the big wall of the artist-occupied warehouse.

Finding some of the dots required searching the neighborhood. A dot appeared on the wall of the channelized river. A dot appeared on the ruins of the cold-storage warehouse next to the Citizens Warehouse, and on the bridge piling behind the warehouse. This dot, low on the bridge's massive concrete supports, punctuated a view through a series of arched colonnades dividing the railroad tracks and supporting the bridge. This image was stark and powerful.

I was never sure I had seen all the dots, nor could I be sure other dots weren't being added to their number. There seemed to be more appearing every week. Gary said he had finished, and whatever happened was just reaction and participation. "The artists are talking back to my transmission," he said. "The radio is working." Around the dots other writings appeared. At the end of "Solidarnosc" someone added the word "Wilson," an enigma no one understood. The "Young Turks" graffiti was altered to read "Young Jerks" and everyone was silently amused. On the pilings of the bridge next to the dot someone wrote, "It all has meaning, nothing is without purpose." Then, as if this philosophical musing were not enough, someone else drew a naval battle scene of opposing black fighting ships floating over the concrete surfaces above the sentence. Each destroyer was rendered with shells spouting from its long guns. Above the dot was inscribed, "Bleed White." The artists went out to look. One pronounced it a satisfying work; another said it was probably the work of a movie company decorating a realistic set.

Back at the discussion, the gathering of artists pondered Gary's lengthy explanation silently for several minutes. They asked for refills of their iced tea, and wondered if it was still too hot to contem-

plate returning to their own studios and their own artistic endeavors. Lenny, who had asked before about the sculpture, asked again, "How does the coin-covered sculpture fit in with the dots?"

Gary looked startled and hurt as if the questioner had found a hole in his argument. He was about to respond, leaning forward as he liked to do, and locking his eyes onto the questioning artist, when Fritz ran into the studio.

"The ax has been stolen!" he yelled, and everyone ran into the street.

The street was empty, and so was the Art Dock. The banner and the map were still visible, but the sculpture, "Defense Spending," was gone. The artists stood in front of the open dock looking in all directions for signs of movement. To the north, the street was clear all the way up to the curve bending under the freeway next to the huge gasoline tanks. To the south, the dark underside of the bridge revealed only the vague hint of a white spot. To the west, the wall of the small one-story warehouse and the line of parked cars could have concealed a thief. Gary strode across the street, stepped between two bumpers, and dropped to the ground.

"No one's under the cars," Gary yelled, standing up.

"Looks like your work has found a new location," Salerno remarked.

Gary strode back across the street and stared Salerno in the face. "Very funny, asshole," he growled.

"Wait a minute," Fritz said, "don't get excited. It won't do any good. Let me tell you what happened." We gathered around the empty loading dock and Fritz, with elaborate gestures, recounted the theft.

"I had my windows open to get any kind of breeze," he said, pointing to his windows on the second floor at the far north end of the building. "I walked over to the window on the corner, which has a high view down along the street. I had just sat down on the sill, when an old bronze Buick with a peeling vinyl top turned onto Center Street by the bridge and started slowly up the block. I thought

they were casing the cars so I decided to watch them closely, pulling myself back into the shade to be more difficult to see. They cruised up to the Art Dock and stopped. Two guys got out of the Buick and walked over to the loading dock. I could see a woman was the driver. They hopped into the dock and disappeared. I could hear one of them yell, 'Shit, that's hot!' I leaned out the window and started screaming, 'Stop, thief, stop! Stop!'" Fritz yelled this at top of his lungs, wildly swinging his arms.

"The two guys," he continued, "were now on the edge of the dock, the hot ax gingerly held in their arms. I could just barely see their heads. They were startled by my yells, and dropped the ax over the dock onto the pavement. They jumped out of the dock and started to run toward the car."

"The woman yelled at them," Fritz said, "'Get that thing, you fools!' The guys stopped and turned around, retreating back toward the abandoned sculpture. They grabbed it again and raced for the car, tossing it into the back seat. One man jumped into the front seat, the other into the back. The doors slammed as the driver peeled away." Fritz pointed toward the north. "They are long gone now. That lady was moving."

Gary stood silently for a moment, glowering at Fritz, then at me. "This is a big problem, Mr. Gallery Director," he said, scowling at me with an accusatory glare. "I think you should call the police."

The police were a long time in arriving. The crowd, which grew for a while when word of the theft spread through the building, dwindled to just a few waiting patiently and silently. On the edge of the dock sat Salerno and I. Gary and Karen brought deck chairs from their studios and sat in the empty gallery. Fritz paced the street, disappearing and reappearing every fifteen minutes.

I thought it was much like the day a year ago when the Art Dock's board of directors convened and the idea of the drive-by gallery was conceived: a group of artists sitting in the loading dock creating

a tableau. *This*, I thought, *is probably the last tableau*. Now no one would risk showing in the Art Dock. This location for work was kaput. I thought about the question never answered: "How does the ax relate to the dots?" Few knew that it didn't. The sculpture exhibit was added to the show after I exerted considerable pressure on the artist to do something more.

Defense Spending with Dish by Gary Lloyd 1980

The addition of "Defense Spending" was the result of a complex negotiation. Gary's exhibit had evolved considerably from the first ideas. Upon conception, the site-specific works were going to be all over downtown. There were going to be real events in real locations. There was to be a video screening, a slide projection, street theater, and performance pieces. The Art Dock's opening would be filled with letters mounted on a metal screen, with the lighted space of the gallery and its curtain as backdrop. The concept was too ambitious. It kept changing to accommodate the artist's evolving ideas and his limited time. Gary wanted the piece to work even if the gallery was closed. Perhaps this was in response to what had happened with his recent show at the Ulrike Kantor Gallery, when the artist got into a dispute with the gallery owner about the placement of his work and she rejected it. In response, Gary headed out in the middle of the night and painted a meat ax on the gallery's

front door, which enraged the gallery owner but endeared Gary to the local community of artists.

At the Art Dock a map painted on the closed door replaced the idea for the screen mounted with letters. The site-specific works kept moving closer to the building and simplified from events to marks. I protested to Gary that the map on the door presupposed a closed Art Dock. He unkindly remarked that the Art Dock was generally closed. I retorted that the critique had already been made by Jan Taylor, but at least his installation, "Christ among the Vagrants," did not preclude the roll-up door from being open. I complained that his installation required that the gallery always be closed, and he was guaranteeing an end to the Art Dock due to its complete non-existence. I said there were plenty of times on evenings and weekends when the gallery could be open, and I begged him to use its space. We reached a compromise: the Art Dock door would be half-open when the director was in. The map would be placed on the lower half of the door so when the door was half-lifted, the map was still visible. Gary would display a sculpture of some sort inside. He chose the work "Defense Spending," recently displayed at a La Cienega gallery.

"'Defense Spending' is an ax-shaped sculpture about three feet long, modeled as if it were made of organic material, and covered in shiny copper pennies and dimes," he told me. It would be interesting to explain this art to the police.

We'd all been waiting on the Art Dock for a while when the black-and-white cruiser turned slowly onto Center Street from First and rolled to a stop in front of the loading door—just like the thieves. Two patrolmen stepped out, adjusting their batons in their heavily laden belts. They stared at the group in the loading dock. One cop asked, "Who called about the theft?"

Before I could answer, Gary rose and stepped forward, his tall lean body in the raised dock towering over the police officers. The cops stepped back, their hands shifting toward the butts of their batons.

"My art has been stolen! From right here! I want it back!" Gary stated emphatically. He jumped down from the dock and strode toward the officers. They were looking very worried and stepped several paces back. Gary's hand flashed forward, and then slowed as he realized he was making the police very nervous.

"This is it," he said, reverting to a soft tone and waving in his hand some flyers from the La Cienega gallery show. He drew close to the officers, pointing to the image on the flyer. "'Defense Spending,' it's called. It is a sculpture."

The officers looked carefully at the color photograph of the sculpture lying on a paint-spackled background resembling outer space. Gary handed each officer several flyers. They looked bewildered.

"You gotta be kidding," said one.

"No. I'm not," said Gary, stiffening at the remark. "This is great art." One officer placed the flyers in the patrol car, pulled out his report pad, and began to take notes, a slight smile spreading over his serious face. Fritz related his story again, embellishing his role as witness with recreations of his "Stop, thief" yells and the thieves' movements. I described the drive-by gallery. Gary gave the officers a full dissertation on the significance of the work and his installation in the Art Dock. The officer put his pad away.

"If I were you," the officer said, "I'd give up on it. The likelihood of getting your sculpture back is minimal."

The police officers asked us about the building and we said it was full of artist studios. We didn't live here, we offered. They said they would submit a report, and we could call the department later to find out if anything had happened. They finished by lecturing us on the lack of safety in the gallery, the open door on the building, and the general unsavory character of the neighborhood.

"There are a lot of vagrants around here. Protect your cars," the cops declared as they pulled away.

"This won't do," said Gary. "We have to contact the TV stations."

The Art Dockuments

We called, but most stations said politely that someone would phone us back if they were interested. ABC News seemed charmed by the "stolen art" angle. They said they would see what they could do. Gary decided that we had to push their interest. We would go to their studios and speak to them directly. Gary and I climbed into Gary's old red-finned Cadillac and raced off to the ABC offices near Silverlake. I suggested a short cut, which seemed reasonable on the map, and got us lost. Gary was very agitated and driving wildly, so determined was he to get his story aired. He berated my skills as a navigator and a curator.

As we cruised lost near the Silverlake reservoir, I thought that Gary might be right. I wasn't much of a navigator. In navigating my own life, I had run aground on the sandbar of my career and shoals of my marriage. My situation seemed hopeless. I was as lost in my life as I was lost on this lush bird-of-paradise- and palm-festooned Silverlake hill. My teaching assignment at UCLA was over. I quit my drafting job in the Golden Oak furniture factory saying it was employment only a stupid idiot could endure. Now I had no income other than the little I could get measuring up the various artist loft buildings. I finished constructing my "Ironic Column," made of hardware cloth pluses and minuses, and I had run out of ideas for new sculptures.

I had returned from San Francisco several days ago in a last ditch effort to save my marriage, where I spent a week trying to make amends by fixing up an old house my wife purchased. I ripped out old flooring, a back room, demolished part of the exterior wall to the backyard, and cleared out the brush. I installed new plumbing fixtures, framed up and drywalled a new storage area, installed new flooring, and replaced the back exterior windows. I was doing this, and I hated carpentry. I had enough of it building my loft. My wife and I argued over every little thing. There was no opportunity anymore for me to return to San Francisco, resurrect my relationship, and restart my architectural career. I was stuck on the path I began to think I unwisely had chosen.

Nor was I much of a curator. I had no further offers to exhibit in the Art Dock, other than Karen Kristen, the next exhibitor. How could've I enticed anyone to exhibit in such a locale, where on the evening of my return to LA, I found a madman sniffing glue under the bridge at the end of the street shouting obscenities? I thought that maybe I should just close up this crazy experiment and drive off to a far away place to salve my wounded soul.

At the top of a hill near the lake, we found ourselves on Tesla Avenue, which seemed to be an omen and calmed us down. I found Tesla on the map and from there a route to the studio. At the station, the security guard wouldn't let us in. From a pay phone outside the gates, Gary told his tale to a sequence of news directors. The last agreed that the stolen art seemed to be an interesting story. They would call us back. We raced back to the warehouse to wait. The night passed with no call.

On Monday morning, Gary rushed into my studio saying ABC News had telephoned. He said that they would be coming at midday to get a report, and we had to get ready. Gary disappeared back into his studio and reappeared an hour later with a cutout of the sculpture fashioned from cardboard and painted red. He carefully positioned it in the loading dock where the real sculpture had been, with its shaft vertical and the ax head on the floor. He opened the Art Dock door to its full height because this displayed the model best. He straightened the curtain, folding all the excess length under to make a clean line along the floor. We stood in the street to scrutinize the new display. We discussed the composition and the color, deciding the cutout needed more rendering. Gary removed the ax cutout and repainted it before finally positioning it again. I typed a small sign to be placed on the wall next to the Art Dock: TEMPORARILY REMOVED.

The reporter, a woman named Joanne Ishimine, arrived around noon with her cameraman. They scouted the street and the loading dock to determine the best angle for the shoot, deciding that Joanne and Gary should sit on the edge of the dock with the red cutout in the background while Gary recounted the story. I was left out of the picture. There was a long period of preparation. Joanne had to do her makeup and hair; Gary had to make sure he looked appropriately like an artist, in paint-splattered blue jeans, white t-shirt, sunglasses, and his favorite brimmed tweed cap. The filming was short. The reporter, standing alone in front of the loading dock holding her microphone, zipped through the story. There was no mention of the Art Dock by name. No description of the gallery on the street or the fact that there was no security. The art had simply been stolen from a downtown gallery in broad daylight. Joanne moved in and sat next to the artist on the lip of the loading dock. Gary, looking extremely serious, appealed for the return of his work, which he described as pivotal in his money series. He pointed to where the sculpture had been and was now replaced by the red cutout. He showed the real work as it appeared in the photo on the flyer. The reporter leaned over to scrutinize it, and the cameraman pulled in for a tight shot. The money meat ax was recorded, and the shoot was over. The reporter and the cameraman quickly disappeared, and we waited for the 5 o'clock news.

The story aired. It was brief. A commentator preceded the report, saying, "Now we have an unusual story about stolen art." The reporter appeared, stating she was in downtown Los Angeles in the area where artists have their lofts and where artist Gary Lloyd had his sculpture stolen from a gallery. She sat down next to Gary and he appealed for the return of his work. On screen appeared "Defense Spending," floating in the infinity of outer space. The screen cut back to the anchorman, who said to his co-anchor, "Well that is

an unusual sight. I guess you can call anything art today." The co-anchor, smiling, her hair perfectly arranged, said, "I'm surprised anyone would steal it." The anchorman, tapping his bundle of paper authoritatively on his desk, rejoined, "There's no accounting for taste. Now how about the weather?"

Mantra Jappa by Gary Lloyd 1981

I thought about how, for many years, Gary Lloyd had evolved his idea about art as a special communication linked to but not locked inside the artifact. The ax was primarily a metaphor connecting concepts of art as both an object and art as anti-object. Through various permutations, he explored the ax idea, which culminated in "Defense Spending." He made axes of strange materials: forks, dentures, mirrors, wire, and twigs, each having a relationship to the utilitarian purposes of the ax and the symbolism of these uses. The object could symbolize violence, like the fireman's ax, a distinctive long-handled tool with a head that turns into a pick at one end, the shape of "Defense Spending." It could symbolize power and authority, like the Roman ax, a bundle of sticks indicating the many parts of the Roman Empire, unified by the iron cleaver of the state. Gary made Roman axes from twig bundles holding jagged mirror fragments or from forks and dentures cast into the ax heads, which implied new meanings and uses. These axes were meant to raise questions about art's utility and

art as a commodity, in a way parallel to the work of the German artist Joseph Beuys, to whom Lloyd always attributed an influence.

The ax idea led to a work called "Mantra Jappa," in which Gary fashioned an ax from raw beef, then irradiated and stored it in an underground chamber where the meat would remain unspoiled, but inaccessible for hundreds of years. Ironically, the object couldn't be possessed, only contemplated in a photograph. The photograph became the art commodity. This demonstrated a distinct layering of ideas. The art object was made of the ultimate life-sustaining commodity, food. Food cannot be permanently possessed. It can only be consumed. This art food became permanent through radiation, but would become death to possess. The deadly art object was permanently stored in its own controlled museum, but we couldn't look at it. We could understand and possess this object only through the intermediary of the photograph. The photographic image was a thing itself but, in this case, only had value because it represented something else.

The ABC News report never appeared again. It was bumped from the six o'clock news and didn't show up at ten. The "contemporary art stolen" story had its airing. Gary took some satisfaction from the thought that, through this brief TV story, more people had become aware of his work than in all his numerous gallery shows. Gary always aspired to a broad communication for his work. There could be no denying that the ax and the Art Dock had reached out into greater Los Angeles. "Defense Spending" was gone, but the art idea was broadcast. The TV report, however, was not the end.

Several days later, two detectives arrived and had us recount the story. They took notes diligently and accepted another batch of flyers with the image. They informed us that they had information from a Mr. Vasquez in East Los Angeles, who saw the TV report and called the police, informing them that he had seen the ax. It had been offered to him in the street. Wrapped in a towel like hot jewelry, the sculpture was quickly flashed before his eyes with the question, "Do you want to buy it?" Mr. Vasquez did not buy the thing, but he was struck by the curiosity of the object. Was he looking at a metallic liver? Squad cars cruising the East Los Angeles neighborhood were given the flyer with the picture of the sculpture.

Weeks passed, the show closed, and the gallery seemed to be limping toward conclusion, with only one more show scheduled. There was no raft of artists anxious to exhibit in the drive-by gallery. Many weeks later the police, checking out a routine report, spotted the ax mounted on wall of a living room above a fireplace. They did not raid the residence immediately, but staked it out, suspicious of additional criminal activities. The ax thieves were later caught unloading a pile of loot into this house from another, bigger burglary. The police discovered the house to be full of stolen appliances, TVs, VCRs, and stereo equipment. The purloined ax had led to the exposure of a major ring of house burglars. The ax remained in the custody of the police and was used as evidence at the trial and conviction of this gang.

"Solidarnosc" passed away. It was painted over many times by different groups: artists doing guerilla murals, Hollywood filmmakers, or city maintenance workers trying to clean up the visual clutter. The white dots remained for a long time. The artist Michael Hughes made a photograph from his studio of the bridge and the trains, placing a white dot in the center. Hughes remarked that Susan Sontag would probably approve. The punctum in his picture of urban realism was focused right on the dot. The white dot with the naval battle scene and statement, "Bleed White," became a favorite homeless encampment. I made a large drawing of the dot and a homeless man. This dot and all the other dots gradually passed away.

The Art Dock did not pass away. Word of the recovery of "Defense Spending" spread through the

neighborhood. The Art Dock acquired a reputation. Artists from other buildings in downtown made a point to cruise by the loading dock to see if it was open and what was exhibited. Artists started calling to get shows. I said I could not guarantee the safety of their work. It didn't bother them. Exhibitions were lined up for several years into the future. The drive-by gallery was recharged with energy. The Art Dock had survived its manifesto and had became a community gallery.

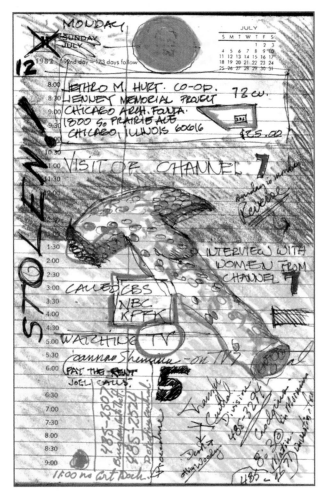

Daily Diary Page by Carl Davis

"I told you I would change the awareness of the Art Dock," Gary said. "And there are at least three thieves who will have plenty of time to ponder the meaning of art."

All the events seemed so perfectly harmonious. They were logical extensions of one another. The ax sculpture became more than an afterthought. It was an integral part of the show "Locations for Work." "Defense Spending" added a whole layer of meaning to the dots, while it traveled the city from living room to courtroom dispensing its implications. The dots ceremonially marked places the ax could have been in its passage through the city. They asked questions about the ax's existence, and the fate of all things real.

The dots seemed to say that art sits out there somewhere. What art is and where art is depends on your point of view. All you have to do is look with open eyes. The possibilities for art had definitely expanded. What an appropriate outcome for the FAX sculptor.

Postscript 2012: "Defense Spending" was eventually returned to Gary Lloyd years later. He still has the piece. "Mantra Jappa," the sculpture of irradiated meat, housed in a radiation storage facility at UCLA was destroyed in the 1990s when the storage facility was relocated. Gary's work was exhibited in a show at MOCA in 2010 of Los Angeles artists involved with formulating the museum. Lloyd continues to make art, but he also has had a long career as a sky painter with the next Art Dock exhibitor, Karen Kristin. These two artists painted the skies on the atrium ceilings of Las Vegas casinos, such as Caesar's Palace and the Venetian, and on the ceilings of shopping centers and casinos worldwide.

ACT II
THE COMMUNITY GALLERY

"The community stagnates without the impulse of the individual. The impulse dies away without the sympathy of the community."
—William James

"Great things are done by a series of small things brought together."
—Vincent Van Gogh

"The artist's world is limitless. It can be found anywhere, far from where he lives or a few feet away. It is always on his doorstep."
—Paul Strand

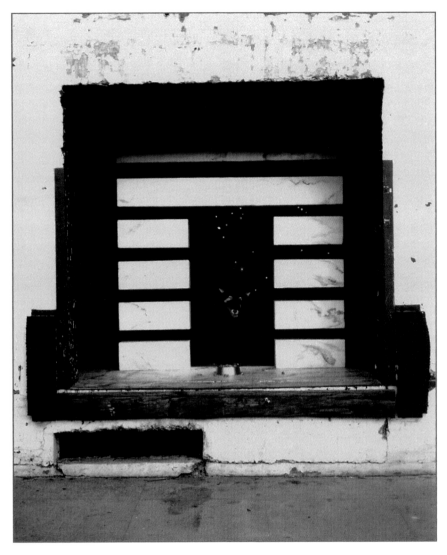

ART DOCKUMENT #11 "WOLF AT THE DOOR"
BY KAREN KRISTIN—MID SUMMER TO EARLY FALL 1982

The wolf was at the door of the Citizens Warehouse, and "Wolf at the Door" was in the drive-by gallery. A year of relative quiet had passed since the City of Los Angeles, in 1981, legalized living in the old warehouses of downtown, but now the city was geared up for inspection of the old illegal lofts. A task force would inspect for violations of the building, fire, electrical, and plumbing codes. The jig was up. We no longer had to hide the fact that we lived in the building, but now enforcement would come for all the code issues we avoided during the illegal occupation. The lack of earthquake reinforcement in the building would become obvious. The fire-code issues of unrated corridors, unenclosed stairways, lack of fire extinguishers, and no two-ways out of the studios would

be exposed. The electrical problems—insufficient service, exposed wiring, and lack of code-required outlets—could be seen. The self-installed plumbing without adequate piping, and improper and exposed toilets would not amuse the inspectors.

Everyone in the building was concerned, but it was summer in Los Angeles, and the artists and I, except for the landlords, were happy. I went to the beach, rolled in the surf, and walked the Venice Boardwalk with a beautiful woman. I was really excited because I was going away. For six weeks I would depart the problems of the Citizens Warehouse to go to the Dorland Mountain Arts Colony, where I could immerse myself in making art and writing. I could go in spite of my current dire economic situation because my father had lent me a thousand dollars. Why worry about what I could do nothing about? Then reality caught up with me.

The artist owners of the warehouse called a meeting and said our situation was dire. Once again, we were threatened with eviction if our circumstances were fully revealed. The tactic was to stall. The artists were to delay access as long as possible, and prevent access to those studios deemed too unsafe to be revealed. The studio with the pit (the hole cut in the first floor to the basement that had no rail around the opening) was at the top of the list for places in the building the inspectors should be denied access to. The four studios at 112 Center Street were at the top of the list for studios that the inspectors could see. This included the studio with the Art Dock. The inspectors were coming next week for their first visit. The owners demanded that the loading door be closed and the drive-by gallery not be revealed.

The inspectors caught me red-handed with the loading door open when they made a surprise visit two days prior to the scheduled visit. A car pulled up outside my office area between the open Art Dock and the doorway to 112 Center Street. I was packing

to leave town. Karen intended to keep the Art Dock open when the inspectors weren't around, but now we were busted. I could hear four car doors open and slam shut. In a few moments, above the sound of the radio news, I heard the murmur of voices in front of and below "Wolf at the Door." One voice declared, "What the hell is that?"

"Art!" I replied in a loud voice from behind the curtain inside the studio. I stood up from my desk and stepped around the curtain. Four inspectors in open-collar shirts with clipboards stood in the street looking up at me. They did not look friendly. I was smiling.

"This is 'Wolf at the Door,'" I continued, "an installation by the artist Karen Kristin." The inspectors' faces showed bewilderment, so I began an explanation, talking loudly to be heard above the radio.

"This portal within a portal is a richly layered tableau." Their perplexed expressions continued. "Tableau is another word for story," I said quickly. "There are six elements to this miniature narrative… ah, story. There is the portal …ah, gateway." I pointed to the white marble colored blocks suspended with no visible means of support. "The wolf mask, the black plane…ah, the wall behind with the small lights indicating the world's biggest cities—the major art markets in America: Los Angeles, and New York— are identified with red bulbs, the bowl of nuggets in front of the portal, an I-Ching that is integral to the portal, and a hidden radio that plays the news of the world. Note first the simulated marble gate. Each column has four blocks, which mysteriously float in space. Spanning between the blocks are two lintels, also floating in space. The gate is dreamlike, real yet unreal. It is an impossible apparition. This portal creates an I-Ching hexagram no. 20."

"What's an I-Ching?" one of the white inspectors asked. Of the four inspectors, one was black; two were white, and one Asian.

Before I could respond, the Asian inspector spoke up. "Fred, the I-Ching is an old Chinese method of reading the future."

I knew I had their attention then, so I continued my explanation. "The interpretation of this ancient hexagram relates to the question of the contemplator and the contemplated. In the I-Ching, the object of contemplation is blocked from access by difficulty. The wolf's head, straddling the I-Ching doorway, symbolizes the difficulty, but also presents opportunities for growth and increased awareness. Are you aware of the Janus head?" I asked the inspectors. They shook their heads no in unison.

"In ancient Roman mythology, the Janus head, a double-sided face, was placed in doorways. One face faced outward, the other faced inward. It symbolized the transition from one place to another, one universe to another, one state of mind to another, or from the past to the future. Here we have in the doorway only one, that of the wolf. The wolf looks out at us to the future. The wolf for Karen Kristin is a persistent theme developed in other paintings and assemblages. Being an animal of cunning and intelligence analogous in many ways to man, the wolf is also one whom man fears and has made the archetypal outlaw. The wolf in this piece has a double function, at once referring to the forces outside oneself that threaten well-being—thus the outward face—and at the same time referring to oneself and the limitations we self-impose. The wolf stands between the past and the future. The past is portrayed…ah, displayed by the map and the radio broadcast of the news. News reports are always stories that take place in the past. The bowl of golden nuggets in front of the portal indicates the future. The bowl is full to overflowing and some nuggets are scattered about the floor. The nuggets are the reward for overcoming the difficulty inherent… ah, represented through the I-Ching hexagram, if the wolf has the ability to move beyond the protection of the portal and the nest of the past."

I turned from the installation and met the gaze of the inspectors.

"You can see from my description that the piece develops upon the ideas of threat and opportunity. The world news constantly reminds us of the dangers in everyday life. The map locates us in the world. The I-Ching reminds us of the opportunities for good or bad inherent in all difficulties. The wolf reminds us of our enemies and ourselves; the golden nuggets, the aspirations of us all."

"I like it," said one of the white inspectors, and all the inspectors nodded their heads in agreement.

I didn't tell the inspectors that the analogy could be taken further. The wolf also represented the artist community, the outlaws in downtown LA. The artist community was threatened by success, and by the public officials who claimed to desire preservation of the community. Nor did I mention that the golden nuggets were a direct copy from an LA politician's comment that the artists were the "golden nuggets who would lead people back to downtown." The building inspectors were our difficulty. Could we as a community overcome our past and take the golden nuggets of legalization, or was the wolf literally at our door in the form of the A.I.R. (artist in residence) task force? Did these inspectors threaten the end of the artist community?

A few moments of silence passed while the inspectors contemplated "Wolf at the Door."

The black inspector spoke up, clearly the leader of the group. "Can we come inside the building, please?"

"Of course," I said. "Give me a minute to open the front door." I stepped behind the curtain, ran across my studio, and raced down the corridor to Ellen's studio. I knew Ellen was home, so I knocked on the door and she answered.

"The building inspectors are here," I said. "I will stall them in my studio for a while to give you a chance to get ready." I ambled down the hall and opened the door to 112 Center Street. "Welcome to the Citizens Warehouse," I said and stepped out of the way to let the inspectors in.

"I'm sorry," I said. "The two artists who live across the hall from me aren't in today and I don't have a key. But you're invited to see my studio and the studio of the woman who lives down the hall." I pointed to the open door of my studio and waved the inspectors in.

The inspectors wandered in and glanced around without comment. The Asian inspector poked his nose in front of the curtain separating the loading dock from the studio. The two white inspectors went to my kitchen/bathroom construction. They scribbled some notes on their clipboards. The black inspector stood in the middle of the room surveying the whole area. "How many square feet is this space?" he asked.

"Twenty-two hundred," I replied.

"Do you have a fire extinguisher?" he asked.

"No," I replied.

"You should get one, and mount it on one of these columns."

"I will do that, sir," I responded.

"Where does that stairway go?" he asked.

"It goes nowhere," I said. "The stair runs up to the ceiling and is blocked off."

The inspector nodded, and all the inspectors gathered together and walked out of my studio.

"Can I answer any other questions?" I asked.

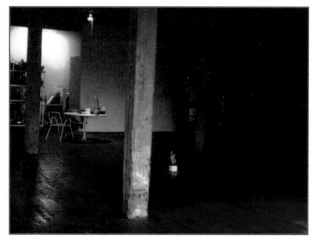

Ellen Fitzpatrick's (Gunga Ma) Studio

"Not at this time," the black inspector replied. "Point us to the other studio." I led the inspectors down the long, bent corridor to Ellen's studio. Ellen was at her open doorway.

"Welcome, gentlemen" she said, dressed in a flowing purple blouse, uneven-hemmed black skirt and high-heel shoes. With her long hair brushed and shining, she beckoned the inspectors to enter. "Can I offer you some milk and cookies?" she asked.

"Thank you very much, that sounds great," the black inspector responded in a charming voice.

I departed as the inspectors made their way to a table in the center of the studio where Ellen had laid out the offering.

Later in my studio, I heard Ellen laughing with the inspectors as they walked up the corridor. "And you're welcome any time," Ellen said as she guided the inspectors out of the building.

Two days later I left for the Dorland Mountain Arts Colony. The inspectors never returned in the six weeks I was gone. Karen kept the Art Dock open all week for all that time. This was the best time I had in several years. I frequently walked on foggy mornings and on bright hot August afternoons through an oak grove I entitled "the cathedral of light," through an earth arch on the trail, to a far spring in the midst of the chaparral. I sat on a hillside and watched red and yellow sunsets fade to pink and lavender over the dark hills around Temecula. I swam in a pond full of frogs and lily pads. I visited with the ninety-five-year-old Mrs. Dorland, formerly a concert pianist, who had met Picasso, Braque, Kandinsky, Klee, Kirchner, Nolde, and Max Beckman. She knew Wallace Stegner, Ansel Adams, Arnold Schoenberg, and Einstein. She listened to my written words and kept time to their beat. "Have you read *Angle of Repose*?" she asked.

"No, I have not," I replied.

"You should," she suggested, "The music in Stegner's words will inspire the music in your own."

Most of all I wrote, drew, played the piano—I didn't know how to play a piano—and bent wire in a one

room cottage looking up through a big picture window at the Lupine Canyon splashed with flowers which rose rapidly up to the rocky top of Dorland Mountain. I had a lot of time to think about the Art Dock.

"Wolf at the Door" was the first stage set in the drive-by gallery. Karen Kristin is an artist whose background was in set design for the film industry. She used her set design skills to great advantage in this installation. "Wolf at the Door" was the most sophisticated art idea created to date for the space. Previous installations were either objects installed in the Art Dock from the general body of the artist's work, such as Kim Jones' "Vacuum Love," or works adapted for the location, such as Marc Kreisel's memorial. Works developed exclusively for the Art Dock had tended to expand the idea of the drive-by gallery, such as Gary Lloyd's "Locations for Work" or Jan Taylor's "Christ among the Vagrants." Only Eve Montana's "Homage to the Studio" dealt with the space and concept of the actual Art Dock opening.

"Wolf at the Door," exclusively designed for the loading dock, was an evolution of the installation idea, following on the ideas initiated by Eve Montana. "Wolf at the Door" clearly viewed the Art Dock as a stage. The installation was also very specifically scaled to the opening. The simulated marble blocks were positioned and sized to complement the size of the loading-dock opening. Each element of the display was thoughtfully placed for visibility and impact from the center of the road. The piece was also conceived in relation to the idea that the loading dock was a portal. The marble block I-Ching gateway represented a portal within a portal. The viewer looking through another opening is confronted with a philosophical, or in Karen's words, a psychological opening. Karen gave the gallery added energy, building on the notoriety established by Gary Lloyd's show. Karen Kristin went on to exhibit at the Santa Monica Art Gallery as one of five emerging artists.

The artist Karen Kristin

Karen saw herself as an illustrator. Most of her works prior to this installation were commercial endeavors. The majority of that work was done in connection with the construction and painting of movie backdrops. The Art Dock piece was one of a fewer number of efforts at fine art. Karen had painted canvases with some success at commercial galleries, but the Art Dock installation was her first attempt to use the skills of set-making as an artistic medium. Karen was absolutely convinced the Art Dock installation could be called the highest fine art. She pointed out that the stage-set idea has precedent in the work of such luminaries of the art world as Marcel Duchamp, who designed a room at the Philadelphia Museum, and Ed Kienholz, whose piece "Backseat Dodge" is an altered and enhanced car body.

The interest created by "Wolf at the Door" established Karen's reputation as an artist with other artists in the Citizens Warehouse. Artists in the little community no longer dismissed her as "that set decorator." I, a trained architect, found there remained many artists in the Citizens Warehouse who refused to look upon me as an artist. I was "that architect" who pretended he was an artist. Jud Fine and Joel Bass, two of the artist owners of the building, dismissed me. They went to Gary Lloyd, the artist tenant everyone felt was a leading artist, and asked how could he support me when I was a fraud. He refused to answer. To them the Art Dock added to their disregard of me. It made me "that annoying gallery director." Artists are quick to declare, based on the work or the method of making a living, that this or that person is not an artist. It would take more work in the studio and more exhibitions of my work for me to win the recognition of my peers as an artist.

Karen said that the Art Dock and her piece allowed her to formulate ideas about herself as an artist that were unconnected to the concept of commercial success. The "Wolf at the Door" instal-lation wasn't created with any desire for sale or media publicity. It was her attempt to use her skills to examine certain ideas and to elicit certain emotions. Karen said that she was very proud of the favorable response the piece drew from the community, but she most relished the effect the work had on an indigent passerby. Once while she was sitting at the show, a man ambled past and gasped at the wolf in the portal. He stumbled and, shielding his eyes, rushed away with a look of terror. Karen's work had had a demonstrable effect, something most artists I've met fervently desire.

The great strength of this installation was its universality. Anyone, artist or not, could find an interpretation to his or her liking. However, the piece struck many of us as an encapsulation of the feelings of impending disaster rampant in the artist community. The law had declared that artists could occupy these warehouses if they met the earthquake and building codes. In particular, the sections of the code regarding housing were to be enforced. The artists were also required to register with the City Clerk as an artist, taking out a business license declaring their status as a small-business person. These requirements created a nightmare of compliance and constant harassment by the building inspectors. Everyone foresaw the community being destroyed, a prophecy that would come true but not on the timetable or in the form fantasized. That story functions as a subplot to the Art Dock that will be unfolded in the tale of future exhibitions as they relate to this sad dissolution, the death of the community.

The story so eloquently testified to by the "Wolf at the Door" installation really began with the slow development of an artist community downtown, starting back in the early 1970s. Indeed, the first live-in loft downtown probably dates from the 1940s, when an art photographer built a Parisian garret above his commercial business. The Young Turks were the first defined group of artists to take up residence in the decaying downtown buildings. Leases

were incredibly cheap. Huge spaces and even whole buildings could be rented for something around eight cents a square foot. These were buildings no longer considered useful, in many cases because the structures were unreinforced masonry. The city considered these buildings dangerous and liable to collapse in an earthquake, so they targeted many of them for demolition under strict new safety ordinances. Into these abandoned and under-utilized buildings, moved the artists—the illegal inhabitants of unsafe structures. Landlords turned their heads, happy to rent their white elephants to people who could not complain. Some artists managed to get master leases and ownership of the worthless structures. They very happily rented to their peers, providing themselves with incomes through the time-honored exploitation of others. This situation was not without risk, but no one was particularly upset with the circumstances. Artists got lofts of great size for very little money. They could build what they wanted without reference to code. All anyone had to do was prevent knowledge of his or her presence.

The situation remained unpublicized for some years until the police and fire department discovered the illegal community in the ordinary practice of their duties. The police arrested several female artists, thinking they were prostitutes because of where they were walking. The fire department discovered people living in more gracious circumstances than the indigent people one could expect to find camped out in the abandoned buildings where the firemen practiced their hook-and-ladder skills. The Citizens Warehouse was one of those surprising discoveries. The newspapers began their exposés and the forces of repression and tolerance began their discussions. Finally, in the fall of 1981, the city legalized artists' residences in buildings not zoned for use.

By the spring and summer of 1982, the A.I.R. task force was starting to investigate each artist building and beginning the process of enforcement of the city's building regulations. The Citizens

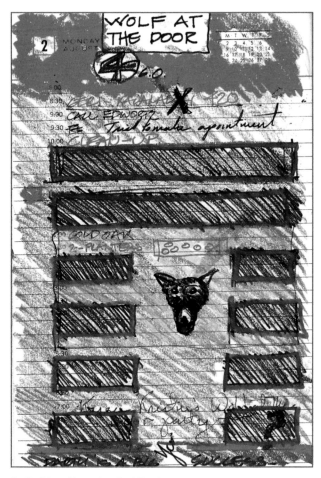

Daily Diary Page by Carl Davis

Warehouse was visited many times. In addition to an absence of earthquake reinforcement and inadequate plumbing, electricity, and fire protection, none of the extensive construction in the building had been undertaken with any building permits. There were new hallways throughout the building, some fancy remodeling, even structures built on the roof, and there was the Art Dock. The owners and the building officials levied threats of imminent closure of the building. Everyone was to take a low profile. The Art Dock was to disappear. It didn't. The Art Dock stayed open. It became the symbol of a community resolved to stay. The "Wolf at the Door" declared that position.

The threat was real, but it was also the harbinger of opportunity for the growth of the artist community and

a reasonable response to the needs of the law. The outlaw community could no longer just stand in opposition. It had to find a way to coexist with the bureaucratic society and its representatives. The future would be a rocky one. The wolf at the door came disguised—not as inspectors, but as developers.

Postscript 2012: Karen Kristin went on to form Skyart, a company that paints enormous skyscapes on casino and shopping mall ceilings. She continues to paint landscapes of the American West. She lives in Cortez, Colorado.

ACT II THE COMMUNITY GALLERY

ART DOCKUMENT #12 "MARGARITAVILLE, A SUCCOH" BY MILES FORST—FALL 1982

Under the white dot on the arches below the First Street Bridge, a naked, bearded black man crawled up from his own swill and started to walk down Center Street toward the Art Dock. His black hairy chest matted with dirt, he strode past me in the doorway to the lofts without a look. His smell was atrocious. He stopped momentarily in front of the open loading dock, glanced in where Miles was organizing his bamboo branches,

and shuffled on toward the end of the building where he turned and headed for the railroad tracks. I walked up to the loading dock.

"What was that?" Miles asked.

"More of the beautiful people of downtown," I replied, looking to the right edge of the loading dock and noticing a piece of paper. "What's that?" I asked.

"That is my label for Margaritaville and an invitation to use it," responded Miles. I went over and read

it. "Margaritaville, a harvest succoh. Please feel free to lie in the hammock and enjoy the fall weather."

"Jesus! What are you doing, Miles?" I demanded. "What if somebody like the man who just walked past here gets into my dock?"

"Hold on, Carl, wait until I'm finished. You'll like it," Miles assured me.

"Shit," I said, mumbling under my breath, "goddamn artists," and walked away into my loft. I was in no mood to think kind thoughts about the Art Dock, downtown LA, obdurate artists, or any human beings, for I was in a difficult place, unemployed and nearly broke.

Seven days back from Dorland and five days since registering for unemployment, I was fast losing the joy from my residence at the magical place. The snakes of disquiet were filling my brain again. The big red rattler I confronted on one of my last walks to the far spring sprang to mind. The coiled, large-headed snake, a dusty red color, rattles vibrating, blocked my path back to the safety of my cabin. My mind blanked. All I could think of was singing to it as I stood there, five feet from the reptile. I sang out and the rattler stopped rattling. Gingerly, I made my way around the snake by going off the trail into the Manzanita-covered, steep edge above, singing and hoping the whole time that I didn't misstep and fall into the snake's coil.

And what did I sing? I sang, "Froggie went a-courting and he did ride, uh-huh" running all the way back to the shadows in my oak grove and my cabin on the edge of the Lupine Canyon stream. The snake was an omen of the difficulties I faced back in LA. Confronted with these difficulties, consumed by the actions of the new art dock artist, all I could think to do was sing, "Froggie went a-courting and he did ride, uh-huh, uh-huh, uh-huh," as I left the artist and disappeared into my studio. The tune refreshed my memory of the peace and beauty at Dorland Mountain. Perhaps I could keep that recollection with me, calming me as I faced the challenges of my return.

The wolf was still at my door. Aside from Miles in my loading dock, building his harvest hut, brick testers were in my loft drilling to test the building's structural strength. This two-man crew was the first wave of workmen that would come to reinforce the Citizens Warehouse against earthquakes. They left piles of brick fragments and dust all around my kitchen and bathroom. The workmen and registering for unemployment combined into a horrible experience.

I went to the state unemployment office on the south edge of downtown Los Angeles, where I stood in a very long line before one of the service windows. I was the only white person there, in a room overflowing with African and Mexican Americans. When I finally reached the window, I told them I had just lost my job teaching at UCLA in the School of Architecture. The woman behind the plate-glass window did not believe me. How could someone from the UCLA faculty be on an unemployment line? I must mean LAUSD (Los Angeles Unified School District). "No," I said, "UCLA." She asked me for an employment number. I said I had none. She told me I had to get out of line and get that number. I protested. Did I have to start in the line all over again? Yes, she replied. The line behind me was twenty to thirty people long.

"So where do I get this number?" I asked.

"Call your employer," she replied in a surly tone, "The phones are right over there." She pointed to a bank of phones at the very end of the lines of unemployed.

I went there and stood in the line for a phone. Only two worked. The third phone, its cord dangling toward the floor, was broken. Fuming at the disgrace of my situation, I stood angrily in line for thirty minutes. Finally, I was first for the next phone. Two women occupied the phones for a long time. I swayed back and forth with impatience. One woman hung up, and I raced to the phone. I dialed the operator. I deposited my two dimes and asked the operator for the number to UCLA's School of

Architecture. Memorizing the number, I hung up. Immediately, I realized I had made a mistake. I should have asked the operator to dial the number because I had no other dimes, and the operator did not return my change.

I banged the receiver against phone box. I stood in front of the phone breathing deeply, nostrils flaring, until the next person in line demanded I move away. I threw my hands up in the air, cursed, turned from the phone, and marched up to the double street doors. I raised both palms and struck the doors with all the force in my arms. The glass in the doors blew out, shattering on the ground in front of the building. I kept walking. I thought I would be detained. I didn't look back. A security guard ran up to me. "Are you hurt?" he asked. I said no. "Those doors are supposed to be break-proof," he said. I said nothing, just glowered down the road. "Give me your name and address," he asked. Begrudgingly I did, sure that this incident would lead to more trouble for me.

I went home thinking evil thoughts about my entire life and living in downtown Los Angeles. What had I done to myself coming to live with the artists? This illegal art community stretched from the Nickel—5th Street Skid Row—around and to the east of Little Tokyo, through the old warehouses to the railroad tracks and the concrete ditch of the LA River. The hottest art show in downtown was called Mit Fahrt. Exile gallery was showing the work of mental patients from the Norwalk Hospital. The whole environment was sick, shabby, barren, and filled with homeless people. I was now broke and in danger of losing my loft, not to the law, but to the landlords. They would evict me for non-payment of rent. I decided to go for a walk to examine my alternatives.

I walked along the railroad tracks in what I previously thought was the artist's playground. All I could see was garbage. I lived in an environment of excrement. Piles of human and dog feces lay along the railroad tracks and in the bushes. In the open rail-

cars, bums had crapped and left their waste flagged with newspaper. Dog carcasses littered the landscape here and there where the animals had been unlucky in chasing rumbling rail cars. Bum shelters made of cardboard boxes populated the ground beneath the bridges. The once-green Los Angles River had flowed beside vineyards where trains now traveled and old brick warehouses stood. Nearby, the river's broad concrete ditch created for flood control trickled in a narrow slot. Its embankments were plastered with graffiti of Greg, Chuma, Cholo, Chico, Rama, Rico, Al, Luis, and the East LA 13. Its bed littered with garbage. I wanted to puke. I couldn't come up with a good alternative to my situation.

The following day, I had the brick crew in my loft and a strange artist, a man with a beatnik reputation—an artist who said his loft in New York was the scene of a party in Jack Kerouac's *Dharma Bums*—was in my loft assembling giant stalks of bamboo into a Succoh, a traditional Jewish structure for the celebrating the festival of Sukkot. The Succoh, or Sukkah, I learned, from looking it up in an encyclopedia, is a symbolic shelter "commemorating the time God provided for the Israelites in the wilderness they inhabited after they were freed from slavery in Egypt." It is common for Jews to eat, sleep, and otherwise spend time in the Succoh. In Judaism, Sukkot is considered a joyous occasion. I was not feeling joyous at the prospect of anything.

The telephone rang. I answered in a surly tone. Someone asked for Carlton Davis. I said I was he. The unknown female voice identified itself as a representative of NBC News.

"What do you want?" I asked defensively. NBC News had heard of my experience the day before yesterday at the unemployment office. "How did you hear that?" I queried. The representative didn't know that all she had been asked to do was contact me, and see if I was willing to be interviewed for a series they were doing on the new poverty in LA. I hesitated. I wasn't really poor; my circumstances

were sure to be temporary. Besides, artists were always struggling for money. The woman persisted, and I finally agreed to NBC's proposal. A TV crew would come to see me the day after tomorrow.

Miles finished constructing his Succoh the next day. He invited me out into the street to see the finished product. In the loading dock, three flimsy walls of bamboo stalks surrounded the open loading door. More branches with leaves still attached created a roof over the three walls. Large leafy fronds hung down into the opening. In the middle, slung across the aperture, was a hammock. Miles climbed up into the dock and stretched out in the hammock. He informed me that the three sides with the open front was the traditional form for a Succoh. It was also traditional that a Succoh be made of temporary materials. The hammock was an addition and symbolized the carefree joyousness of his creation, which Miles called "Margaritaville." Miles intended to spend a lot of time in his Succoh enjoying the western sun, drinking a few Margaritas, and reading.

Miles Forst and Monique Safford

I was not amused. "How do I keep bums out of the hammock?"

Miles shrugged and smiled. "That's your problem, Mr. Curator," Miles replied and departed.

Disgusted, I immediately went inside my loft and rolled down the slatted door of the loading dock, which I had newly painted after the closing of Karen Kristin's show. I thought I might not open the loading door again and just let the Art Dock fade into oblivion.

Miles arrived the following afternoon and opened the loading door. I was silent and anxious, anticipating the arrival of the TV crew in several hours. They arrived on schedule and I could hear one of the members ask Miles, who was reading in the hammock, where they could find Mr. Davis. He directed them to the doorway and I opened up. A three-man crew entered, led by the reporter Furnell Chapman.

Furnell surveyed my loft and decided to interview me at my dining-room table. We sat down and I reiterated my view that I was not the new poverty, just an artist who, like so many of his compatriots, never was rich but always managed to survive. Furnell was uninterested in my views. He wanted to know what my education was, and what I did before I was laid off. He wanted to know why I blew out the doors at the unemployment office. I couldn't answer that question. He asked me what I was going to do for money in the next week. I didn't know, but there was a possibility I could paint a friend's kitchen for a couple hundred bucks. He asked me to call him before I did the job. He wanted to shoot it. He asked me if we could go outside and if I would walk along the railroad tracks because he needed some atmospheric pictures. The railroad tracks made a good background: desolation.

I was instructed to walk along the railroad tracks kicking a few cans and rocks. This is when I realized I had gotten a new job for the day. I was an actor in their recession story.

I began to laugh. Furnell told me to act serious. I said I would. I asked him if they paid. Furnell told me they didn't pay for news stories. I introduced the TV crew to Miles, still lying in the hammock in the Art Dock. I tried to tell them about the drive-by gallery,

but they weren't interested. They had a deadline to meet and only one story to tell. They drove off, and I turned to Miles and said, "Maybe your Succoh is a joyous symbol."

Miles responded, "The succoh symbolizes the frailty and transient nature of life. Enjoy it while you can." He leaned over, picked up a Margarita, and sipped with a big grin on his long, craggy face. "The salt and lime make it perfect. Here's looking at you, kid."

LA Times Advertisement for "Striking it…Poor"

My story aired that evening. The reporter was in the foreground talking about the down-and-out population of Los Angeles, whose dire circumstances were illustrated by the image of a well-educated professional who was barely surviving and could be seen in background walking along the railroad tracks in gritty downtown Los Angeles like a modern-day hobo. I kicked a can vigorously, sending up a cloud of dust. A close-up followed of me explaining how I could not find a job. After it appeared, I was inundated with phone calls. Everyone loved the track sequence. Denise called and offered me the job to paint her kitchen. I accepted. The following morning I called NBC News and told them I took the assignment to paint my friend's kitchen. They said they would come and record my work. I opened the Art Dock, and spent the better part of the day lazing in the hammock.

I thought my troubles were ending, but late in the afternoon Marc and Joel, the artist-owner representatives, strode up to the open loading door. They informed me that the fire department had seen the installation and deemed it a fire hazard. I would either have to remove the Succoh or fireproof it.

I called Miles to tell him the situation. He said don't worry about it, and arrived the next day with a canister of California Official Flameproofing—Number 55 Interior. He provided the fire-suppression material but no way to apply it. I groaned. When I told him the tube was useless and only for inside use, he shrugged, looking severely disappointed. I would take over the issue, I said. I called the Fire Department Prevention Bureau for information. Fireman Perez directed me to the conservation bureau. Mr. Takafuji didn't know how to flameproof bamboo. He directed me to the Fire Department, where I talked with Fireman Jones. He didn't know of material for flameproofing bamboo, but said it would probably be expensive. Jones suggested I call somebody in the yellow pages that did flameproofing. I could find no one. I called Jones back. After a long explanation of what the Succoh was, and that it was a work of art, Fireman Jones said that there was a loophole in the law. If the Succoh was only a display it had to be fireproofed, but if it was for sale, it didn't.

The Art Dockuments

I was delighted, but presented with another conundrum. If I put a price tag on the Succoh, the Art Dock became a commercial gallery. I was not allowed under the zoning code to have a commercial gallery in a building like the Citizens Warehouse. After thinking about this situation for not very long, I decided to go for it. I walked outside the building and printed at the bottom of Miles' invitation to use his harvest hut, "Price $25,000." I was laughing. The drive-by gallery had undergone a new permutation. It was now a commercial gallery, sort of.

In the last week of the Succoh temporary installation, I had the loading door open while I was inside drawing up the plans for 1001 East First Street. I heard a rustling in the Art Dock and went outside to find a strange man lying in the hammock, wearing a blue brimmed hat like a ship captain's. His fading yellow hair bunched over his ears below the cap. He was wearing thick blue-rimmed glasses and reading the newspaper. His face was blotched with bright pink. His shopping cart, overflowing with personal possessions, was positioned on sidewalk

Succoh and Art Dock Sketch by Carl Davis

Over the next weeks the Succoh was open and had a number of occupants—artists and their friends—aside from Miles and me. I painted my friend's apartment and NBC News reported my work. I was offered many jobs as a consequence of my appearance. Most were for telephone sales. None were appropriate to my skills, but still I was encouraged. The owners of the building hired me to measure up and prepare drawings for conversion of the warehouse into an A.I.R. (Artist-in-Residence) building. They wanted me to go slow on the work, so I did, which left a lot of time to enjoy the beautiful fall weather lying in the Succoh. The more time I spent in the Succoh, the better I felt.

in front of the dock. I had my first homeless occupant of the Succoh.

"Who are you?" I asked.

"Alvin Marshall," he said. "I was just passing through and read the sign."

"Are you enjoying yourself, Alvin?"

"Indeed I am," Alvin stated, rolling toward me in the hammock. I explained to the man how a Succoh was a ceremonial hut for eating, resting, and reflection, and that this Succoh was a work of art. Alvin told me his life story. He lost his wife at Pearl Harbor, began to drink, and ended up homeless. He was an artist also and, through the help of a minister at the mission, he got sober enough to paint in relief

a view of Jerusalem in the mission chapel. Then he relapsed, and now he wheels his shopping cart around looking for cans to collect. Alvin asked me if I could give him a drink.

"I don't have any alcohol," I lied. "But let me get you something else." I went into my studio poured a glass of iced tea and grabbed a banana. I was glad I could share the joys of the harvest hut with another human being.

Postscript 2012: The artist Miles Forst, former teacher at the Otis Art Institute, died April 5, 2006, in Manhattan following a brief illness. His *N.Y. Times* obituary says, "His unrivaled zest for French and Chinese cuisine, world literature, especially James Joyce, art in its countless forms, and jazz, will continue to enliven his nieces, nephews, students, and friends." Several months after the Succoh exhibition, Miles burned up all his old paintings at a performance in Exile gallery.

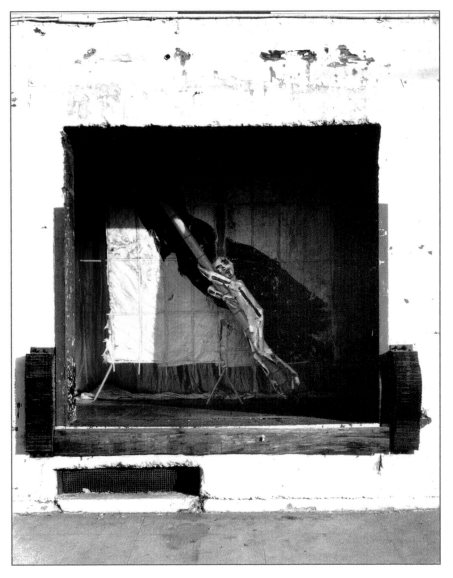

ACT II THE COMMUNITY GALLERY

ART DOCKUMENT #13 "THE SHADOW OF A MAN"
BY RAE BURKLAND—LATE FALL 1982

"Is it public or private?" the critic asked me in the middle of Center Street, examining the open dock and Rae Burkland's installation "Shadow of a Man."

"What kind of question is that?" I said.

"Answer my question. Is it public or private?" the redheaded critic asked again, her eyebrows raised.

"Public," I replied angrily.

"Really," she said, "and why do you say that?

"It's on the street, open to public view. The Art Dock is a gallery of public art."

"Really, are you so naïve as to think just because I see this art on a public street that it is part of the street culture? I could see this piece in a living room or installed in an office."

"Ok! Call it semi-public. It takes me so long to get you to leave your mailbox-sized studio, and this is the reaction I get? Who cares if the art is public, semi-public, or private? Do you like it? What is your reaction?"

"Oh, calm down, Carl. I'm just trying to establish a context," the critic replied, looking over her glasses as if I were a backward student. "I think you were right on track when you said 'Shadow of a Man' is semi-public. Doesn't your little community of artists in the Citizens Warehouse feel in jeopardy? And isn't Rae Burkland one of that community?"

"Yes," I replied. "The whole community of artists in downtown feels in jeopardy. It's what artists talk about when they get together. It's what you hear in Al's Bar. Either they are worried about losing their studios or what didn't happen on the LAVA tour."

I thought of Rae, just days after her piece was installed in Art Dock, sitting on the front steps talking with Karen, Gary, Marc, and Joel Bass about her worries that her studio was in peril. A diminutive and rail-thin artist with close-cropped hair, she fiddled with her fingers as if she were knitting some invisible garment as she spoke rapidly in a high voice about how all her money was invested in the loft. What would she do if evicted? Marc and Joel, managers of the building, were reassuring. The inspectors weren't scheduled to come again until next month, so everything was cool for now. Gary, returning to his loft with his dogs, stood with two long timbers in his arms. He reassured her that nothing was going to happen. We would be safe if we played our cards right. Karen, sitting on the steps above Rae, wasn't so sure.

"They could evict us at any time," she added.

Joel, dressed in shorts and a t-shirt, was casually leaning against a car in front of the doorway. "They won't get us if we're careful," he said. Looking at me, he added, "That is, if you keep that loading dock closed when we ask you." I shrugged. Marc took a deep drag on his cigarette, turned to Rae, and offered to help her any way he could.

Rae smiled. "Yeah, I know how you would like to help me."

I remembered the words "I hear the ruin of all time, the shattering glass, the toppling masonry" that repeated through my mind when Rae and the other artists were sitting on the front steps into 112 Center Street. They were my mantra, but I couldn't remember where I had heard them. Was it from Shelley's poem "Ozymandias?" No, it wasn't. Were they my own words, an omen of an earthquake, or Yeats', or Eliot's words? I couldn't figure it out. They summed up my mental situation. I was alternately deeply depressed and excitably determined. I was smoking too much marijuana, which negatively affected my mood. I felt guilty about my impending divorce and the end of everyday contact with my daughter. I was still far from being accepted as an artist, but I was hopeful. The directors of Exile Gallery were going to give me a show along with the artist Pamela Burgess. Maybe after this exhibition my critics would be silenced. I invited the respected artist Constance Mallinson to come visit me. She said my work had two directions, and I needed to choose one. My portrait drawings represented one direction and my wire constructions represented another. I didn't want to give up either interest. Puzzled by her statement, I floundered and did little except worry. And I was broke.

Unemployment insurance remained unattained. I went to the Hollywood unemployment office thinking I could more easily register there, but the lines were even longer than in downtown. After waiting four hours without significant progress toward a registration window, I gave up. The man in line next to me said the place was full of out-of-work actors, and I needed patience. I had no patience. Denise Domergue, an art restorer, paid me two hundred and fifty dollars to paint her kitchen walls and floor, but it wasn't enough to keep me going for long. She wasn't happy with my work, and I was not happy doing it. Here I was, a well-educated Ivy League

graduate, painting a room for minimal money. My friends castigated me for my self-pity. Artists did crummy jobs all the time to stay alive, they said.

NBC news came and filmed me painting her kitchen. When the piece finally aired, I was inundated with strange offers. Most were telemarketing jobs I had no desire to do. I turned them down. One voice on the phone said, "You're still not hungry enough." I replied, "Fuck you!" and went to lie down and play dead. I played dead a lot. Lying in the dark on the floor of my studio, I pretended to be totally inert, a corpse free of all my problems. Often I fell through psychic space to a place of utter tranquility where I could see a ball of white light. Nirvana had come to my hell on earth. After achieving that state of mind, I could arise and continue with my absurd existence.

My situation started to improve, but it was a return to architecture. The owners of the Citizens Warehouse hired me to measure up the building. Against my judgment and need, they wanted me to go slow so they could stall on compliance with the new Artist-in-Residence Ordinance. Not much income was coming to me. I had to dust off my resume and start a job search. The only good thing I seemed to have going for me was the Art Dock.

Coughing, the critic interrupted my private thought then took one step toward the open loading dock, stopped, and perched a cigarette between her lips. I lit it for her. Inhaling and exhaling in silence, she studied the work.

"It's all about context," she said.

"You're not talking about the Art Dock itself, are you?" I said.

"Now you're getting it. Most of the best public art speaks to its context. By context I don't just mean the location of the work. I mean its context in time,

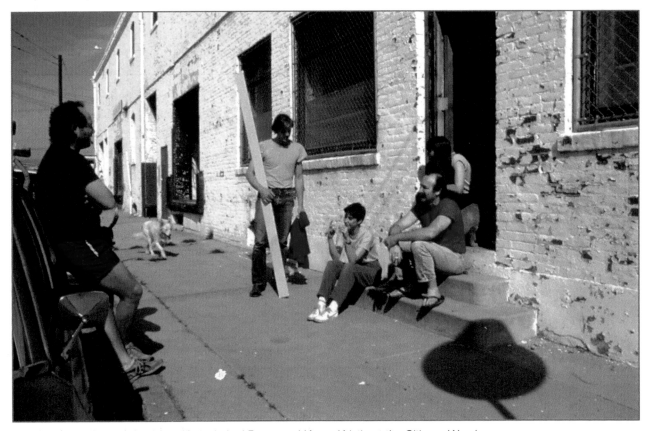

Rae Burkland, Gary Lloyd, Marc Kreisel, Joel Bass, and Karen Kristin at the Citizens Warehouse

attitude, and observation. Here the loading dock contributes to the work, but as I see it. The dock is like a picture frame around the work that focuses one's attention on work alone. The context here is more the situation confronting the artists than the reality of the loading dock itself. Rae made this piece for the Art Dock, did she not?"

"I'm pretty sure she did," I answered. I pictured Rae who, immediately after Miles raked his bamboo fronds into the street and piled them in the dustbin for salvage by artist and homeless, jumped into the open loading dock, paint can ready, and painted a long black wedge on the floor. The next day she had her work installed. Invited by Gary Lloyd to participate, she was enthusiastic about installing a piece. When I stated that the gallery wasn't very visible, she said she didn't mind.

"I'm trying out something new," she said. "I'm interested in the reaction of my fellow inhabitants of the Citizens Warehouse."

"Bride and Groom" by Kent Twitchell 1973–1976

Rae lived in the studio next to mine to the north. She had a long narrow studio with a loading dock in front. Her loading door was never open and merely functioned as a wood segment of the west wall of her studio. She didn't need a big aperture for unloading sculpture or other work. Rae designed little things like alphabets and printed them on handmade paper. What she did in the dock was a

departure for her into large-scale work. I explained to the critic how this work was different from Rae's other work. The introduction of the figure was new. Size and support of the paper-covered grid was not something I had seen from Rae before. The big black slash of paint was unlike her delicate script on small paper.

"This is an extension of her other work," the critic replied, stomping on the cigarette butt with the toe of her high heel. "I don't see it as a radical departure in technique. 'Shadow of a Man' is still delicate and ephemeral. The man is made of paper. The pole he is attached to is a stalk of bamboo, which at a smaller scale would be a brush for writing script. The background is a large sheet of paper with a smear of black, like the painting of script in Japanese or Chinese calligraphy. The black shadow on the paper grid mimics the shape of the man. You see the head revealed near the upper left-hand corner of work, and the stroke widens down to the right. The bamboo pole tilts to the left as if it could fall. The papier-mâché man, with black stripes over his eyes, arms, and torso, clings to a big bamboo as if he were hugging the pole for dear life. The markings remind me of Indian warpaint. His legs are pressed against the pole. His head is cocked to the viewer's side to emphasize the peril. It's all very emotive. I think this is a statement about the artist's situation in downtown. The wild Indians are under attack."

"You get all that from this installation?"

"I'm very literal. This is part of the art that lies east of Broadway in Los Angeles."

"What? What do you mean?" I asked.

"It just came to my mind. I was thinking of public art in Los Angeles," she said. "To the east is the temporal, emotional, and fascinating art. Broadway is the dividing line. There is Kent Twitchell's 'Bride and Groom,' his gigantic painting on the outside of Victor Clothing. Its scale, content, and location give it power."

"What about artists in downtown who make public art?"

"Woods Davy is the only artist who crosses the line. He lives in the community but manufactures plop art for the other side."

Woods Davy Sculpture 1986

"You're so cruel," I said, turning to the critic, who had a bemused smirk on her face. Plop art was the disparaging remark often made about all the sculpture that was plopped in front of office buildings. This art had little meaning to the workers in the buildings whose plazas it decorated, and little meaning to anyone but the artist. The artist Richard Serra had tested the definitions and limits of plop art when he erected his "Tilted Arc," a curving rusted steel arc almost eleven and a half feet high, in the Federal Plaza in New York City, which impeded the flow of traffic in and out of the surrounding office buildings. This was art people had to deal with and it was art they hated. "Tilted Arc" was ultimately removed from building's plaza.

"I stand by my comment," she stated imperiously. "The viewpoint is sharp because the situation is so cut and dried. On this side of Broadway, the situation is different, the art has context, evocative power, and is generally temporal. Who knows whether the 'Bride and Groom' will last? Murals are painted over all the time. On the other side it is art, economics, and permanence, as usual."

"What about Little Tokyo? It's east of Broadway."

"It's an outpost of the mainstream that shows some promise. Noguchi's 'To the Issei' has some merit. I understand the artist worked with the community to define a public space.

But Woods Davy's 'Dover' at Little Tokyo Towers is a prime example of irrelevant art, a concoction of log sections and steel supports that stands in the landscape pretending to be part of it."

"What've you got against Woods Davy?" I asked.

"Nothing, it's just that his art is everywhere at the moment, and it's such easy art. The steps of

"Triforium," Downtown LA 1975

The Art Dockuments

City Hall are covered with his creations. He's moved from supporting log lengths on his steel supports to placing stones on the ends of columns and beams. They look precarious, but aren't. They're supposed to be contemplative, like Zen gardens elevated into sculpture, but they're not arresting. They're common and belong to the third tier of art."

"Your condemnation is severe and probably too narrow," I replied. "Didn't Joan Hugo describe his work as elegant and say that he renders space and volume with precision?

"Ah, yes. She said he 'expresses attitudes about psychological relationships, creating metaphors of perception at all levels.' Gobbledygook, if you ask me. It's just rocks on steel with the look of art," the critic stated devilishly, blowing her red hair out of her eyes with a huff and a nod.

"What about other works in downtown?" I asked.

"Do you seriously want to discuss that piece in front of Manulife Plaza on Figueroa, the 'Salmon Run' by Christopher Keane? That piece of bronze fluff was just installed.

It's like some tourist statue picked up in the northwest that's best displayed on a CEO's desk."

"No, but what about Herbert Bayer's 'Double Ascension' of 1973, in front of the towers on Flower?"

"The best that corporate art has to offer," the critic explained. "But still it's bloodless, a mere pretty assemblage of spiraled red lengths. The context of the black corporate towers gives it some power. An ice-cold, black box offset by bright red geometry, but it's the fountain below the sculpture that animates the plaza."

"What about the 'Triforium' built in 1975?" I felt sure that the critic would have something devastating to say about that artistic abomination on the mall near City Hall.

"It's too easy to attack. Did you know the three bony supports of the glass bulb strings are meant to represent the three branches of government? I visited it recently late one evening. The mall was empty except for several shopping-cart pushers. I stood under the artwork, which is by Joseph Young, and listened to selections from Michael Jackson's 'Thriller' while the lights played over the vertical strings of multicolored balls. Post-apocalyptic desolation was the mood. The piece was supposed to have more to it, but cost overruns squelched the laser beams that were to shoot out into the sky from the piece. The work is a real testament to 1970s hubris, but the context of the deserted mall makes it seem like some alien toy dropped onto a culture-less city."

Dustin Schuler's "Pinned Butterfly" on the American Hotel LA

"What about Dustin Shuler's pinned airplane on the American Hotel?" I probed.

"Talk about context, there we have context—

physical, psychological, and emotional," she said, her eyes brightening at the mention of the gaily painted Cessna shell attached to the old hotel with a gigantic nail. "And it's well east of Broadway and evidence of my supposition. Wasn't it installed for the recent LAVA tour?"

"Yes," I said, recalling the fall weekend recently, when busloads of art lovers descended on the down-town art community, sponsored by a group called LAVA (Los Angeles Visual Arts). LAVA was reported to be an amalgam of downtown art galleries, the more aboveground ones. Prominently featured in the *LA Times* story of the event was Dustin Shuler's "Pinned Butterfly," which appeared to be nailed to the fourth floor of the unreinforced brick wall of the old railroad-era hotel. The American Hotel amounted to the spiritual center of the community; it was next-door to Al's Bar and housed artists new to the community searching for loft space.

"That event was a big bust for me," I continued. "Did you know hardly any art lovers made it over here to Center Street and the Art Dock? We're too far away from most of the galleries: Ovsey, Oranges and Sardines, Stella Polaris, Double Rocking G, Exile, the Japanese-American community, and the American Gallery. I had a report from friends in the building that the people they personally invited got lost. Some people went over the First Street Bridge into East LA and the housing projects, became frightened, and returned to the safety of the West-side. The few who were intrepid enough to find our little street seemed more interested in the courage or foolhardiness of the artists to live in such surround-ings. They were either envious or shocked."

"What did these people have to say for them-selves? Where they aware of the perilous situation of the artists?" asked the critic.

"Not at all. I recall two people who visited my loft. One matron, clutching her yellow LAVA map close to her breast, said, 'I've always wanted to have a big place like this to live and paint in.' Another, a

military-looking man, asked me how I could live in a place swarming with homeless. Where did I buy groceries? How did I protect my car? My answers only brought more questions. When I would try to get them to look at my art and the Art Dock, they were anxious to get out the door and move on. None of them wanted to lie in the Succoh."

"I'm sorry for you," said the critic with mock sympathy. "Did you recover?"

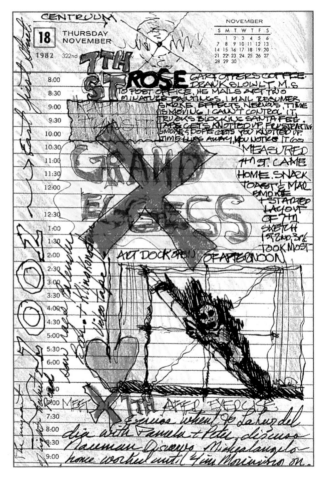

Daily Diary Page by Carl Davis

"I recovered," I said with an edge to my voice. "But I wasn't alone in my disappointment. Artists all over downtown were similarly disillusioned. A lot of them wondered if they would still be here in 1983 for another LAVA tour. The art lookie-loos came and went but didn't buy art. That was the common complaint. The

inspector came and went and tagged the buildings. In any case, 'Pinned Butterfly' was a big hit."

In a serious voice, the critic said, "That's because it was such a jarring statement. Think of it. If the plane had been installed on a high-rise it would hardly be noticed, but placed on the old four-story hotel, it dominates the façade. It was almost close enough to touch. Its bright colors and gaudy paint job contrasted marvelously with the semi-wrecked appearance of the hotel. It was as if a big beautiful butterfly had landed on the side of a sad old building. It seemed to say that even in this shabby neighborhood, beauty still abounds. The context made the piece. The piece was also emotive. We can laugh at the absurdity of a plane nailed to a building. Lastly, the work is only temporary. It is temporary, isn't it?"

"I think it is," I replied. "But it's still there now."

"Not for long. Nothing lasts a long time in LA, and especially in this neighborhood. It's prime renewal territory." The critic started to walk away down Center Street.

"Wait a minute," I called after her. "You never said what you thought of 'Shadow of a Man.'"

The critic stopped and turned toward me. "It's all context, darling. The shadow of the man is the shadow that follows you around."

"Great, what's that supposed to mean? Will you write something?"

"Another day perhaps, when the shadows aren't so long." She tossed the words over her shoulder as she gingerly avoided the dog poop deposited in the middle of the sidewalk.

Postscript 2012: Rae Burkland moved from the building and went on to work as a model maker and visual-effects artist in Hollywood. Dustin Shuler's "Pinned Butterfly" was finally removed from the American Hotel years later. At the time of his death in 2010, Shuler was working with the *Inglewood (California) Arts Council* to create the *"Inglewood Butterfly,"* a reincarnation of "Pinned Butterfly." Kent Twitchell's "Bride and Groom" still exists, which is a miracle considering the loss of Twitchell's Ed Ruscha and Gary Lloyd murals that were painted over. Woods Davy still makes sculpture from boulders. In 2010, he had a one-man show in Paris. He lives in Venice, California. The "Triforium" still stands in mall of the Los Angeles Civic Center 37 years after its installation.

ART DOCKUMENT #14 "IN THE NAME OF GOD" BY DENNIS GODDARD—DECEMBER 1982

"Where are the ox and the ass?" I asked Dennis Goddard lightheartedly as he busily arranged the pieces of his installation in the Art Dock.

"Don't be a wise ass," Dennis growled, removing the brush from between his teeth. Dennis, bent over in the loading dock, intently brushed white paint on a bubblehead of the Baby Jesus.

"You're creating a nativity scene, aren't you?" I said. "It's traditional to have an ox and an ass as part of the show. And where is Mary... or Joseph?"

"I'm making a nativity scene for our time," Dennis responded. "No need for Mary or Joseph. They got killed in the first bombing raid. The ox and the ass ran off when the booming started. My nativity scene will be the bloody birth for a Cold War turned hot."

The Cold War could have gone hot at any time in 1982. Global anxiety was high. The Soviets waged war in Afghanistan. The Americans deployed

The Art Dockuments

Pershing II and cruise missiles around the world. The Soviet Union pointed their SS-20s at Western Europe. The Reagan Doctrine of global opposition to the Russians was in full force, challenging Soviet influence in Africa, in South America, and at the edge of the Iron Curtain. Anti-nuclear-war protests broke out. In June, a half a million people marched in New York against the nuclear arms race. In the fall, 20,000 women encircled Greenham Common Air Base challenging the deployment of cruise missiles in England. Then, in November, Leonid Brezhnev, General Secretary of the Communist Party of the Soviet Union since 1964, died. Yuri Andropov, veteran leader of the KBG, the force behind the smashup of the Hungarian Revolution, and a hard-liner committed to Communist expansion, replaced him. Ronald Reagan, at the height of his presidential power, confronted him. These two cold warriors dueled through the arms buildup. War could've broken out at any time. No one in the downtown Los Angeles art community seemed to care—we were too weary—except for Dennis Goddard.

I'm not sure I cared. Maybe it would've been best if an atomic bomb were dropped on downtown LA and life in this absurd city was started anew. Metropolitan LA was a city center of stark and often unreal contrasts. The homeless swarmed the streets of downtown, and the poor surrounded the core, while the rich worked in the towers above them and made their homes in splendid mansions far away. I walked one day by the Union Rescue mission on my way back from City Hall, where I had examined the municipal code, an exercise in mind-numbing futility not unlike the experience that Kafka describes in the Castle. A bearded man with a heavy accent accosted me as I passed the mission. He yelled that the police in LA were worse than the cops in Russia. I silently stepped away thinking he was probably right. When I reached the Citizens Warehouse, thugs were beating a man in the street with a length of lumber. Startled by the violence, I quickly changed my

assessment when I saw the camera. Hollywood was on Center Street again. You never could be sure what you saw in this neighborhood was reality or acting. Living here approached insanity. This surreal environment fueled the negativity I fell into easily, given my impoverished circumstances. At my worst moments I thought of my predicament as banishment from grace to a dismal underworld.

Nuclear cloud over Hiroshima, Japan 1945

Perhaps the atomic bomb had gone off in my mind. A newspaper vending machine refused to return my last coins to me one day. I attacked the machine, punching the glass then lifting it up while shaking it violently. When that did not work, I dropped the machine on its side and started to kick it angrily, cursing loudly. A manager from the nearby restaurant came out, righted the machine, and told me to calm down. He put coins in the slot, and the machine worked. I got the paper with the employment ads. I said, "I hate machines. They instigate paranoia. Big Brother makes them not work when you need them." He laughed.

Excitement took over my life. Otis Parsons gave me a job teaching a drawing course. The artist Pamela Burgess and I were planning a show at Exile Gallery. I was making art furiously, staying up very late at night to paint my metal screens, make watercolor pieces, and draw. A poster with my "Ironic Column" and the work of eight other downtown artists was created by Salerno. The magazine *U-Turn* would soon be issued with several articles I wrote about artist housing and the Art Dock. Woodbury University offered me a job to teach design. I had another assignment to draw up the American Hotel and Al's bar. I raced from LA to San Francisco, San Francisco to LA, art show to art show, and job to job. In December, I wrote about the Art Dock for *U-Turn*, met Margurite Hossler at Woodbury to discuss my course, worked at Exile Gallery testing the ceiling for hanging my Ironic Column, measured the American Hotel, where artists new to the neighborhood established their first residence, stretched watercolor paper for a City Hall image, went to dinner with Pamela to discuss our coming show, and painted the Dorland oak grove on a metal screen positioned within an iron frame made from an old bed mattress. I was alight. I finally felt I had become a member of the downtown art community, which included Dennis Goddard.

Dennis Goddard was the director of Exile Gallery and a gypsy artist who moved from illegal building to illegal building in search of an affordable studio space. He moved his studio into the street and the loading dock. He saw himself as the outlaw. The sentimentality of ordinary society represented the conformity that the artist must struggle against. Living downtown was a statement of independence. From this vantage point of freedom amidst poverty, the artist was loose to attack the inconsistencies of society. Dennis' work was rough-edged and full of raw emotion influenced by daily contact with the down-and-out inhabitants of Skid Row. Dennis worked in the open dock for seven days. The rough

forms of the figures—formed paper bodies and balloon heads covered with plaster—were made in his studio on Winston Street, next to one of the worst alleys of Skid Row. The figures and the backdrop were painted in the Art Dock. The painting and arranging process of his tableau being done on site became part of the work. The artist exposed his process of painting to public view.

Dennis stood in the middle of the road to observe the effect of his painting and positioning of the figures. Other artists would wander by and stop to comment on the progress of the work. Dennis seemed to relish this dialogue, even as it slowed the completion of the piece. I saw Dennis leaning against a car one afternoon, his brushes clasped in his hand, looking hard at the partly painted tableau in the loading dock.

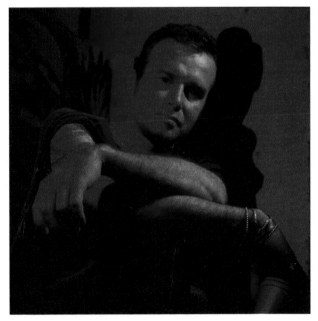

Dennis Goddard by Ed Glendinning

"What's happening?" I asked him. I had just returned from a meeting in City Hall with the deputy of Councilman Joel Wachs, who had referred to the artists in downtown as the "voluntary poor." I was depressed.

"I'm questioning the color of the three wise men's uniforms," he said. "Maybe they should all be green

to contrast with the white and black paint on the background." One of the three figures in the nativity was painted black and the other two were still white. The background was roughed in black and red paint. Written in red on the background was the statement "in the name of GOD." Baby Jesus was white and the missile hanging from the ceiling was white.

We both stood there leaning against a vehicle in silence. I was happy to be thinking about art rather than brooding over the fact that I was a member of the "voluntary poor."

"I don't know, I like the black on the one figure you have painted so far," I said. Dennis gave a quick grunt.

"It needs something more…something to make it jump, maybe some skulls…more blood." Dennis stepped away from me, jumped into the dock, and began brushing paint on the second figure. He stopped and looked thoughtfully at me.

"Blood, that's it," he said, and reached for the can of red paint and a clean brush behind the wall next to the loading dock. He walked over to the manger on the opposite side of the opening and began to splash red paint all over the outstretched arms and fingers of the Baby Jesus. The paint splashed onto Dennis' white long-sleeved T-shirt. He paid no mind, humming as he busily threw paint on the figure and it dribbled like flowing blood down the hands and arms.

After many days of tweaking and adjusting his installation, to the amusement of passers-by, he declared the work finished—a nuclear nativity he called "In the Name of God." "Christ among the Vagrants" was reinstalled above and next to Dennis' installation, and the Art Dock was ready for its second Christmas. Dennis Goddard, one of the most controversial artists of downtown, created on the Art Dock stage a crèche for the holiday season. This nativity was not one of hope and joy, but one of duplicity and death. Christ was shown in the manger, sitting up with his hands stretched out in supplication, the hands covered with blood.

Three wise men dressed in military uniforms knelt before the child, each offering a missile or a gun. Above the figures, a missile angled downward in descent toward the manger. At the foot of the manger, instead of incense and myrrh, a pile of missiles was stacked. The backdrop to the scene was a canvas painted with skulls, black outlined figures, city buildings, and the words "in the name of GOD" blocked out in large bold letters. The mood was not peace and love, but anarchy and fear. Christmas 1982 in the downtown art community made me cringe.

"In the Name of God" was consistent with Dennis Goddard's themes, but carried out differently. Dennis painted. He was not known for sculpture or installations. Once again, an artist used the Art Dock to experiment with new forms. The paintings he displayed in other galleries were figurative, but represented strong and violent feelings. Skulls, tortured and agonized people, and strong gestural slashes of color were common elements of his work. In one memorable painting entitled "Palestinian," a larger than life-size head stared frontally out of the canvas, the face crossed with a big red X over the nose and below the eyes. The painting was crude but very skillfully handled, the form developed out slashes of paint in jarring and contrasting colors.

Dennis's paintings, like Andy Wilf's, were disturbing. They confronted the viewer with strong emotions and harsh realities. They were manifestations of a passion reminiscent of the great works of Spanish painting. The work of Zurbaran and Goya came to mind, where the skill in painting was combined with images of spiritual exaltation or horror to create visions so engaging that one marveled. I gaped at Dennis' paintings and his Art Dock installation. "In the Name of God" was a scene from a horror comic suddenly become three-dimensional. In his paintings he captured a destructive and self-destructive world that was the dark side of mankind—and of Los Angeles.

A grim reality, local but not global, was easy to see and feel in downtown LA in 1982.

Unemployment, crime, homelessness, vacant office space, and government threat loomed on the streets of the central city. "Good times will come" was the official pronouncement, but the reality was a climate of silent gloom. A disconnect between what was promised and what was real was evident to anyone willing to see beyond the political rhetoric. All artists who lived downtown at the end of 1982 were aware of inconsistencies of the city's views toward them. The artists were seen alternatively as the golden nuggets leading the middle class back into downtown or an illegal group of ruffians flouting city law. An economic study done and published in 1982 referred to the artists as a buffer for downtown commercial interests against the ugliness of Skid Row. A law was passed in 1982 that was supposed to help artists legalize their tenancy, but its effect was to harass and threaten their studios. The city that ostensibly wished to help them was destroying them. The "voluntary poor" was a group that had abandoned the comforts of normal society to pursue their own idea of personal freedom and therefore were responsible for their fate. The posse was about to catch the outlaws, and they weren't offering amnesty.

The inspections of the Citizens Warehouse continued in December. In a building meeting the owners informed the artist tenants that on December 22 the A.I.R. task force would return. The cross was to be removed and the Art Dock closed for the day. All evidence of the illegal gallery was to be hidden. I obeyed the demands and removed the cross again, since neither the owners nor I wished to argue the point that the work, which was wired in a very crude fashion, was only a Christmas decoration. The lights of "Christ among the Vagrants" were precariously held by clips that had to be bent decidedly inward to hold the fluorescent tubes. Each light was wired with twisted lines held together with wire nuts. On

the exterior, the nativity scene was hidden behind the closed Art Dock metal door. I removed all the extension cords for the evening lighting so there would be nothing suspicious lying around for the inspectors to comment on. The lights that lit "In the Name of God" were wired with ordinary extension cords, pieced together to reach the loading dock from far inside the studio. If the inspectors looked behind the curtain, I was going to say this was a piece in progress and protected by the curtain until it could be worked upon again. None of this fabrication or installation met code requirements. Therefore retreat was a better solution than confrontation.

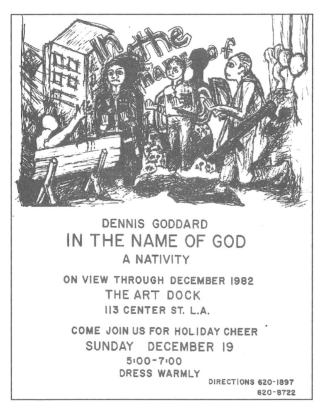

DENNIS GODDARD
IN THE NAME OF GOD
A NATIVITY

ON VIEW THROUGH DECEMBER 1982
THE ART DOCK
113 CENTER ST. L.A.

COME JOIN US FOR HOLIDAY CHEER
SUNDAY DECEMBER 19
5:00-7:00
DRESS WARMLY
DIRECTIONS 620-1897
620-8722

Art Dock flyer for Dennis Goddard's installation

The inspectors arrived as declared on the 22nd. They arrived at 11:30, stayed for one hour without ever visiting the studios in the center of the building, then left for lunch. They never returned that day. Later we were informed they would come back in

The Art Dockuments

January. The Art Dock was safe again for several weeks. The cross went back up and the installation reopened the following day. December passed peacefully without further problem or comment. "In the Name of God" aroused no emotion in the art community. There was silence on the silent night.

On December 31st in the late afternoon, the Art Dock had a party. As a distinction from ordinary art galleries, which celebrate their latest show with an opening party, the Art Dock had a closing party. A long bench was set up in the parking space in front of the loading dock for visitors to sit and contemplate the installation. Beer and wine were served. The crowd was small.

The winter day was bright and crisp and the edges of all surfaces sharply distinct. The sun, dropping lower in the west, cast a strong beam of light into the lower left corner of the dock where the Christ in the manager was positioned. The four edges of the loading dock opening were clearly defined, prominently framing the nativity scene. Most of the installation was in deep shadow, the colors muted, and the figures of the military wise men only discernible in detail upon close inspection. In contrast, the image of the bloody Christ was blasted by a bright square of light. The figure of Christ popped out of the tableau in stark white and the bloody red. The tip of the missile was caught in this bright light beam. The crèche came down to a study in light between Christ screaming and the menacing missile about to batter the baby. A living tableau, lit like a Rembrandt or a Georges de La Tour, appeared before us, powerful in its simplicity and meaningful in its iconography. We all watched in silence while the square of light slowly diminished into a point and disappeared.

"I think the Art Dock is a light machine," I said to Dennis. "Did you know this would happen?

Dennis smiled knowingly and said, "We made it through 1982 in one piece, didn't we?"

"Yes, we did," I responded. "If only we'll be so lucky in 1983. Maybe the voluntary poor will strike it rich."

Dennis replied with a twinkle-eyed grin, "Christ will come again before that happens."

"Yeah, and if he comes, there's a missile marked for him."

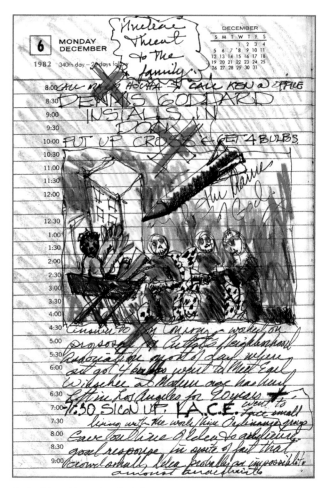

Daily Diary Page by Carl Davis

Postscript 2012: Dennis Goddard left the downtown art community and moved to Vacaville, California. He continued to paint—not like the tortured work in LA, but personal more lyrical abstractions—and began a nursery specializing in sculpting Bonsai trees. The nursery gradually became his main concern in life. He married and lived in the suburbs. He became a meditator and yogi. In 2007, he died of pneumonia. The Cold War ended in 1991.

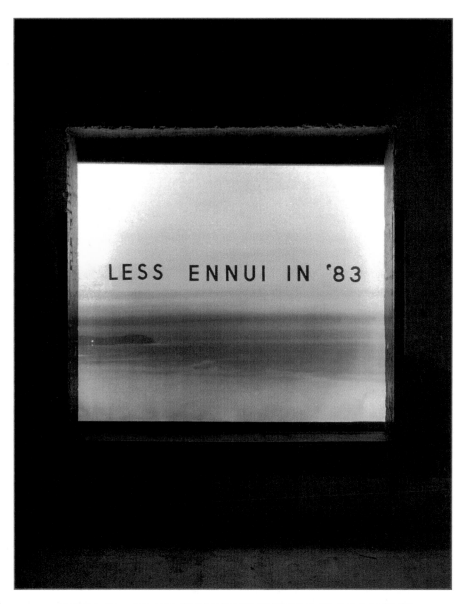

LESS ENNUI IN '83

ART DOCKUMENT #15 "LESS ENNUI IN '83" BY MONIQUE SAFFORD—WINTER 1983

"Cities, like dreams, are made of desires and fears even if the thread of their discourse is secret, their rules absurd, their perspectives deceitful, and everything conceals something else," said the critic.

We were on the roof of the old shoe factory at Third and San Pedro Streets well after midnight on New Year's, 1983. Her face and red hair were obscured in shadow as we teetered at the parapet. She was high and so was I from the alcohol and cocaine flowing freely at the party in the loft of the two Peters below us. Peter Ivers and Peter Taylor

The Art Dockuments

had put on a big bash overflowing with artists, musicians, and Hollywood types. Loud music pumped out into the city even at 2 a.m. We looked out over Los Angeles to the east and south.

"Say that again," I said.

The critic repeated her words and told me they were lines from Italo Calvino's book *Invisible Cities*.

Los Angeles River

"Everything I see below us conceals something else," I responded. "In every way this city is a lie." I looked over to the low glow of street lamps emanating from San Pedro Street and from between the gray blocks along The Nickel—Fifth Street. The pops of firecrackers—or were they gunshots—and the wail of sirens could be heard in the darkness.

"Oh, don't be a spoilsport. That's just fatigue

speaking," said the critic. "Someday the whole inner city inside the four freeways will be different. Skid Row will be wiped out. The Los Angeles River will become the Seine."

The critic pointed to the east where the gray landscape was even darker and the inner-city hamlet of Little Tokyo loomed with its couple of towers and bright illumination along First Street. The old industrial buildings between Little Tokyo and the river lay in almost total darkness. The Citizens Warehouse was in shadow.

"There," she added, "is the prime land. It's the cheapest land in the city. Pedestrians and housing will crowd into the zone. Cafés will come. Trees will come. Nothing remains the same in Los Angeles for long. The frontier is over. The outlaws will leave town and the money-wolves in sheep's clothing are ready to pounce."

We stood there nursing our tequilas, looking at the desolate darkness that shrouded the land east of Alameda. After a few minutes of silence I said, "This reminds me of my next exhibitor in the Art Dock. Monique Safford, one of the Young Turks, is going to install a piece."

"How does she relate?" said the critic without turning her gaze from the east.

"Her sense of absurdity, the secret life, and the concealment of something else. She is a conceptual artist and calls herself 'A Post Demateral Romantic Literalist.'"

"What does that mean?" asked the critic.

"I'm not sure, but it sounds good and she's written a manifesto about it. She takes photographs and applies text over them. It's like the work of Jenny Holzer and that group of artists, but it's different. For instance, I saw several of her works that were photographs of the downtown Los Angeles urbanscape—pictures of parking lots and old commercial buildings like the ones artists have taken over for studios—that she's added text to. The text is about being in some romantic place, someplace far away. The state-

ment and the image resonate with irony and a feeling of weariness."

Diaphane," "The Ironic Column," and several other new pieces. I piled up Miles Forst's adobes, leftovers

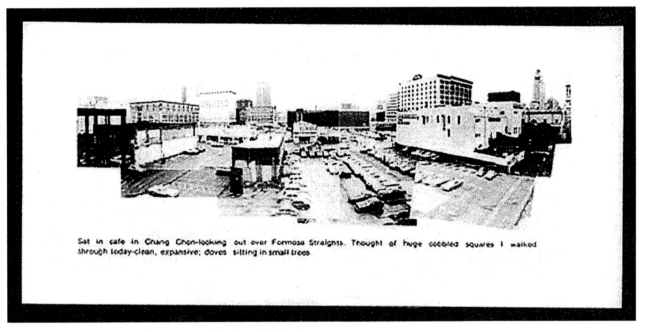

Sat in cafe in Chang Chen-looking out over Formosa Straights. Thought of huge cobbled squares I walked through today-clean, expansive; doves sitting in small trees.

"Sat in the Café in Chang Chong..." by Monique Safford

"Is that so?" replied the critic.

"Yeah," I said. "Her works bring us into collision with the reality of daily life and the frustration of our desires. It's a confrontation that enriches our awareness and heightens our understanding of the contradictions in contemporary existence."

"You've had too much to drink. You sound like an art magazine."

"I'm very enthusiastic about her work."

"I'll be on the lookout for her piece. Is it installed yet?"

"Not yet, but in a few days, Monique tells me."

Jim Tucker came up behind us. "There you are," he said grabbing the critic by the arm. "You have to come now. The Angry Samoans are going to play."

Not until January 12th did Monique install her piece. In the meantime, I was busy. I had my show at Exile gallery with Pamela Burgess. Pamela and I spent the first week of January painting and sweeping out the shit—it was true shit—from Exile's gallery. I installed my show, including "Solidarities

from his show, into a solid column to contrast with my lightweight "Ironic Column." Pamela installed her big black sculptures. The show opened on January 9th with no acclaim or publicity. We split our time gallery-sitting the show, since Exile had no staff. The artists were in charge of keeping the gallery open.I was offered two jobs: one teaching at Woodbury University and the other designing an exhibit on economics (how ironic, I thought) for the California Museum of Science and Industry. My employer was to be Glen Fleck, protégé of Charles Eames, and the exhibit was to be ready for the 1984 Olympics in Los Angeles. Between covering my show at Exile and running from one job to the other, I no longer had a lot of time to devote to the Art Dock project. I gave the keys to my loft to Monique for her to install her piece, telling her the gallery would now only be open at night and on weekends. Monique said that was fine with her.

I came home after dark to discover the Art Dock

opening transformed into an enormous fifty-six-square-foot image. Even from a distance I knew something special had happened. Driving along Santa Fe Avenue toward the Citizens Warehouse I could see a bright yellow glow on the lower floor. Driving by the loading dock, I saw a yellow-reddish picture of a sunset on the ocean with a dark landmass on the left side where one small bright white light stood out. Above the sea and in the luminescence of the sky were written the words "Less Ennui in '83." I laughed, pulled over, and parked. I stood in awe in front of this illuminated image surrounded by the dark mass of the warehouse.

Exile gallery 1983

"This is great," I called through the image into the loft.

Monique answered, "You like it, huh?"

"I do, it's so…appropriate."

Monique continued talking. The translucent image came from the trash bin at a photographic shop where she frequently found interesting treasures. The gigantic transparency was suspended from the ceiling and held down with weights. The words were stick-on letters. It was backlit with two rows of fluorescent fixtures. The words, she thought, were evocative. They reminded me of the critic's quote from Italo Calvino's *Invisible Cities*. "Less Ennui in '83" seemed to speak to the dream of existence in downtown LA, to the fears and desires of the artist community.

This was art. The commonplace transformed by the manipulation of a twentieth-century craft—the luminous billboard. Monique had changed the big signage of a backlighted billboard into a modestly jarring statement. It refocused the message of the typical illuminated sign—Coors—the real lite, Marlboro—the real thing—to something less tangible but more thoughtful. It reminded me of my favorite of those big images, the ones in Grand Central Station, New York City, where there were luminous billboards that showed a happy family on vacation or a gorgeous sunset after a beautiful day at some cape, island, or peninsula, with the brand name Kodak slashed across a diagonal corner of the image. We expect sunsets, deodorants, personal desires, and films to go together since we are confronted with them every day in magazines, on television, and on the roadside. To see that imagery played with, its form used to express ideas other than consumerism, was unexpected. To see it in a loading dock on a deserted street in a desolate urban manufacturing zone, a desert island so to speak, was startling.

"Less Ennui in '83" was only open at night. In the evening, driving down Center Street past the shuttered docks, closed doors, and blinded windows of the paint-peeling brick warehouse, you would come upon this image. The stark and barren industrial landscape would give way to a momentary flash of the sentimental. You were confronted with a vision of escape that so many artists desired after the travails of downtown living. The image was unsettling and the words provocative. You were at once pulled away from the present and pushed back into it, as Monique played with expectations in this piece of deceptively beautiful conceptual art.

The time of its installation passed more or less peacefully. Downtown LA began to appear more frequently in the media. *U-Turn* magazine came out with articles by me about artist housing and the trouble brewing because of legalization. Karen Kristin's "Wolf at the Door" was on the cover. Models for *Ebony* and *Vogue Magazine* were seen on Center Street. Hollywood came again, usually at night. *Hill Street Blues* filmed an episode. Chicago police cars filled the street. The Citizens Warehouse was converted into a precinct station and in the street they filmed a car chase and a gun battle. Days later the street converted into New York. New York cop cars were all around and parked in front of the Art Dock. The building became the hangout of drug dealers. Mike Hammer fought it out with the bad guys under garish yellow lamps. Then the street became Seattle and the area under the bridge an encampment of homeless souls plagued by a mad killer. An artist could step into the street on any given day to find himself surrounded by New York, Seattle, Chicago, or New Orleans police cars. You would have to guess whether this or that bum was real or merely an actor. You would have to guess if the graffiti was real or the markings of a Hollywood set decorator. A gang rushing down the street was probably the cast of a rock video—or was it?

One evening when the Art Dock was open, I knew I was living an absurd dream. There was a rapping on the exterior door to 112 Center Street. I was seated at my desk near the door to my studio and the exterior door. The rapping kept repeating until I rose reluctantly to respond. Dressed in a red bathrobe tied with a blue polka dot tie, the wide end of the tie dangling below my waist, untied work boots, and a Los Angeles Dodgers ball cap, I stumbled to the door, calling out, "Who is it?"

A voice replied, "Jerry Brown."

I replied, "And I'm the king of England."

The voice responded, "I am Jerry Brown, former governor of California."

Incredulous, I opened the door, which was elevated above the sidewalk by three steps, and immediately stepped back. On seeing me, he instinctively stepped back showing surprise at my unusual appearance. It was the Jerry Brown I knew from TV reports, called Governor Moonbeam, and he was looking for Karen Kristin. I let them in, and Jerry and his Zen advisor stepped up into the corridor and rapped on Karen's door, opposite mine. Karen appeared. Jerry and his companion, his Zen advisor, Jacques Barzaghi, entered. As he passed by me, Jacques said, "You do remind me of the king of England." I laughed. Life in the Citizens Warehouse was truly bizarre.

I hadn't been laughing much. I was more and more depressed each passing day of the New Year. Busy but not happy, everywhere I looked life was foul. It shouldn't have been this way. I should've had less ennui, despair, and hatred in my life. I had started three new jobs and had an opening at a gallery. I had no money, but the fact that I would soon seemed to make no difference to my mood.

My economics exhibition design job began with laying out a history of the American economy wall; an economy in which I imagined the rich win and the poor always lose. All I could focus on was the poverty in my own life, which I was sure would never end. The exhibit at Exile Gallery came and went in a flash as a bad dream that resonated with me, like burning trash bins and drunken Indians pissing or passed out in the alley behind the gallery. Hardly anyone came. Those who did were stragglers looking for an open bar. My art career was going nowhere; I wanted to go to that nowhere, the place the Native-Americans went to forget contemporary America.

Everything I did was difficult. I went to the Learning Development Center, continuing my efforts of overcome my dyslexia. On one test, I looked through a prism at a red circle with a white line across it. The disk kept disappearing, and then reappearing. The instructor told me, "You have to work three times as

hard as other people to process information. This causes a lot of stress." I was amazed but further depressed about my prospects of ever finding the right path for my life. I went home and played dead in the dark.

I was beginning to see a pattern of highs and lows. My periods of high energy and excitement were followed by weeks of despair and self-loathing. In these low moods, I was particularly susceptible to upset and anger. Monique Safford and I got into a big argument over paying for pictures of her piece. I was furious and said things I shouldn't have, and then had to apologize to the artist for my bad behavior. Being an artist in downtown LA was my personal nightmare, only mitigated by my interest in the Art Dock. But what was I going to do about my mental situation?

To be there, to live there, was to pass through ordinary reality into a no-man's land where nothing was sure, even the likelihood that you would be living there tomorrow. Each time I approached the street I wondered if the place would be Los Angeles, Chicago, or New York. Would the police force me away for interfering with a movie shoot? Would the real Citizens Warehouse be boarded up and tagged as uninhabitable for violation of the city codes? At least it was never boring. If anything, I began to wish for something quieter. I wanted to step through Monique's luminous slide and escape from the curious but stressful realities of downtown to a peaceful seaside and watch the sunset, but that wasn't to happen. What I was confronted with was the demand that I close my loading dock so the image of "Less Ennui in '83" would not conflict with filming.

The critic—we called her Carlotta P because she kept her last name secret—came by one evening. The Art Dock was open. She called to me through the loading dock.

"I like the piece," she said. I came out of the studio and joined her in the street. "I think the location of the loading dock is an essential part of the installation. Context is everything. The romantic sunset image gets its contradiction from the juxtaposition of the surrounding real landscape." The critic waved her arm over her head to the north and south. "The seedy warehouse, the empty street dead-ending in the heavy gray bridge, the oil tank, railroad tracks, and power lines provide the nowhere-but-everywhere backdrop of the urban industrial underbelly of every American city. But unlike a billboard, which is separated from the surrounding landscape by its frame and position, the Art Dock image becomes part of the environment. The environment surrounds the image, and becomes the context for the message."

"It's kind of surreal isn't it?" I replied. "The psychic context is subverted. The picture of sea and sunset could be taken as the real in what is the stage set of its surroundings. The metal door opens and we pass through a wonderland of waste into the paradise beyond."

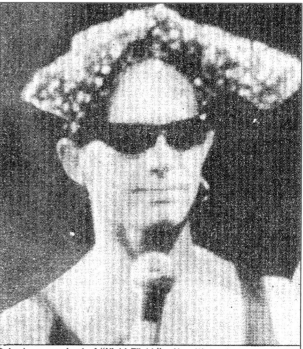

Peter Ivers was host of "Night Flight," a New Wave show on cable TV

Peter Ivers Photo in the LA Herald Examiner

"Well, don't get too carried away. Next you will be giving me some hokum about romantic negativism and positivism," said the critic.

"Those words are right out of Monique's manifesto," I replied.

"Let's stick to the, ha ha… surrealism before us," chuckled the critic. "This piece is like an advertisement. The manipulation of imagination and desire is a powerful presence in modern consumer society. Maybe it's more powerful than art, which is often incomprehensible to the average person. These advertising mechanisms are familiar to us all through the sheer enormity of their presence around us in our daily lives. It's fertile ground for artists to examine the structure and create new and critical meanings through use of its forms."

"I follow, but where are you going with this critique?" I asked.

"Be patient, all will be revealed," the critic stated. "The words 'Less Ennui in '83' conflict with the sunset sea scene. Ennui is an exhausted boredom, to which Center Street and the Art Dock are the antidote. To ask for less ennui in the New Year against this sentimental scene is to call into question our desire for a wistful respite from the trials of life. The statement slams us back into the present. It calls to us, in ever so gentle a fashion, to reinvestigate our grounding in the here and now. It asks us to take an active role in the present and not seek escape into the romantic and nostalgic."

"That's heavy," I said.

"I see 'Less Ennui in '83 as a warning about the future delivered in a visually delightful manner. She has converted the loading dock into a visual oracle," said the critic.

"Wow," I exclaimed. "The Art Dock as oracle." Once again, an artist had stretched the possibilities of an Art Dock to communicate in a new and unusual way. Monique made it the mouthpiece of the Citizens Warehouse and the downtown art community. The Art Dock speaks art to all who care to drive by.

"That'll be twenty bucks," said the critic, smiling wickedly.

Life continued in the warehouse district. The structural building inspectors scrutinized the warehouse, and nothing horrible resulted from their visit. Gary Lloyd and I ran down a purse-snatcher who had ripped a handbag away from an elderly Japanese woman walking down the sidewalk with her husband. Her screams brought us outside and we chased the perpetrator to the end of the street and up the stairs to the bridge, where we caught him and held him down until the police came. In my day job,

Daily Diary Page by Carl Davis

The Art Dockuments

I designed the history wall of the American economy. The Exile show ended in the beginning of February without any unusual occurrences. Everyone seemed too busy with his or her life to suffer from ennui. In late February, Monique took down her show.

On March 4, days after Monique Safford removed her piece from the Art Dock, Peter Ivers, host of the "New Wave Theater" segment on USA Cable Network's *Night Flight* program and infamous for dressing like a bag lady on the show, was bludgeoned to death in his loft on 3rd Street. His battered body was found in bed by his loft mates, Jim Tucker and Peter Taylor. Rumors flew that he was murdered either by a Skid Row robber, one of the various weirdoes who appeared on his TV show, or a downtown artist. The death displaced ennui with flight and fear in the downtown art community.

Postscript 2012: The old shoe factory at 321 East Third Street was demolished. A large housing project was erected on the site. Jim Tucker and Peter Taylor moved away and were never heard from again. Monique Safford moved to New York City in 1985. She is employed by the New School as a Visual Resource Curator. She is still an artist and has a studio in Long Island City.

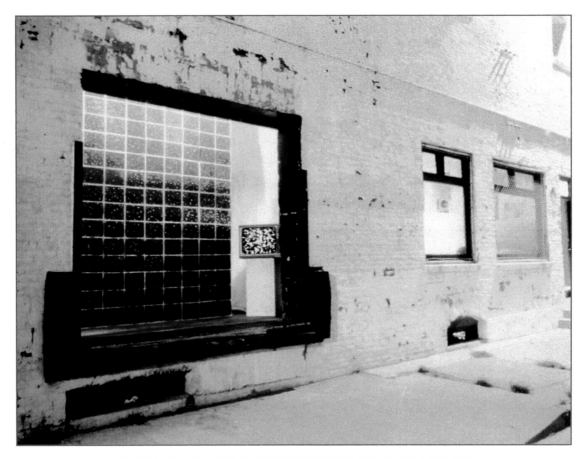

ACT II THE COMMUNITY GALLERY

ART DOCKUMENT #16 "MEMORIAL TO BONNIE CALVERT" BY JEFF KAISERSHOT—LATE WINTER 1983

In 1983, the ennui in the downtown art community was replaced with death and fear. The artist community was stirred up like a giant beehive that the city had kicked with its Artist-In-Residence Ordinance. The art community and all of Los Angeles were swarming over the killing of Peter Ivers. Many theories were proposed about his murder. A burglar did it, or an artist, or someone from one of the bands he had on his cable TV program. The most paranoid theory was that real estate investors had him murdered to make the artist's life unattractive so speculators could move in and purchase the depressed properties.

The Citizens Warehouse was also buzzing about the death of Bonnie Calvert. Bonnie shared a studio with Jeff Kaisershot until she left in November 1982 to go to Italy. In February 1983, she was killed there in a theater fire. Right-wing extremists threw an incendiary device into the theater, which was showing left-leaning art films. The theater's seats caught fire, giving off a toxic smoke. The exits to the theater were blocked either by the extremists or careless theater management. Many people lost their lives, including Bonnie Calvert. Jeff Kaisershot said Bonnie had predicted this fatal incident in a dream where there was fire and people yelling in a

language she did not understand. Her premonition came true.

Jeff kept safe the project Bonnie had been working on prior to her departure for Europe. He asked if he could display this work in the Art Dock, and I readily agreed. The second winter exhibition in 1983 was a memorial to a dead artist, just like Marc Kreisel's commemoration of Andy Wilf.

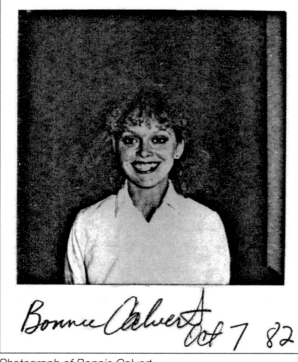

Photograph of Bonnie Calvert

Jeff built a wall to display Bonnie's work. The piece he installed was a big field of small, black rectangular sheets, each marked with dots of white luminescent paint and separated from each other by a white border. To the right of the wall he installed a television set. The screen was painted over with black paint except for small holes through which portions of the televised images could be seen. The work was to be seen at night when the controlled light within the Art Dock made the dots of luminescent paint on the black paper twinkle like gigantic galaxies and light shimmered through the black-

ened television screen. This was good for me, since I was away in the daytime hours trying to survive.

Survival had me running all over Los Angeles. In the mornings, I taught either at Otis or at Woodbury near downtown but on the other side of the 101 Freeway, a short ride across the central city. On one ride there, heavy rain and high winds engulfed me. From Woodbury's window onto Wilshire, I watched the wind tear the panels off the façade of the Convention Center in the near distance. The Southern California mistral, the cold north wind that drives men mad, swept out of the San Gabriel Mountains and roared across the city below.

At noon every day, I sped seven miles north to Glendale to continue my retraining for dyslexia at the Learning Development Center, which I found revelatory and stressful at the same time. The exercises were harder each visit. Say left, then right; raise your arm; walk the beam; and watch the swinging ball. Bounce on the trampoline to the beat of the metronome and say the same, then do the opposite; point to the left at the seal, say right; point to the right at the bear, say left. I got confused. Left became right; seal became bear. I yelled and pulled at my hair. Then there was the string test. A length of string held at your nose was pinned to the wall four feet away. Using both eyes, I should see two lines converge into one at the pin. I could not. The two lines crossed one another creating an X in front so my eyes. I tried to move the lines together. The line from my right eye kept going low, and never would focus together with my left eye. The instructor said my left eye read in front of my right eye. That was why meaning was often unclear for me and created stress. I cried in frustration.

After the hour of tests and exercises, I zoomed, often in tears, down the 5 freeway, across the 101, to the 10 freeway for the twenty mile journey west to Santa Monica and my job designing the economics exhibit for Glen Fleck, a filmmaker out of Charles and Ray Eames' office, and a devil I said I would never work for again. He was abusive to his

employees, but his project was so interesting and the wages would solve my financial crisis, so I decided to take the Faustian deal. Late in the evenings, I returned east to downtown LA exhausted. I had little time to worry about nor the concentration and energy to give to being an artist.

I could find no one to rage against. I returned to my loft, rolled up the coiling door of the Art Dock, turned on the display lights, plugged in the TV, and went and sat at my dining table to brood and sulk.

Through the opening I heard a voice.

"What's this?" said the voice.

Art Dock Loft with Bonnie Calvert Memorial installation—Sketch by Carl Davis

I arrived home one evening to find pinned to my door a letter threatening me with eviction if I did not pay my rent immediately. Shaking with tension and consumed with rage, I buried a fire ax into one of wooden columns of my loft, then scrambled off to find an owner I could yell at. I swore the owners were out to get me because of my activities in rallying artists in opposition to the A.I.R. Ordinance.

"Go away and leave me alone," I replied.

"No, what is this? I see the painted TV set. It's very humorous. But what is the big black field of rectangles with the dots on them?"

"Leave me alone. It's art, that's all."

"Art? What kind of art?

"Conceptual art. Now go away."

"What conceptual art?"

"The kind of art person like you doesn't understand."

"Now listen, buddy, you don't have to get mean about it. I'm just asking a question."

I stood up from my table and walked to the back of the wall. I was not going to appear in the Art Dock opening.

"What does it look like to you?" I asked.

"It kind of looks like the sky."

"There you go. You are looking through one window into another window to the vastness of space. The small paper blocks give you a view into infinity where the individual disappears. Our lives and our cares are swallowed up in the great beyond. We are confronted with the eternal, where we can realize our small place within the depths of outer space. It's mysterious, tragic, and a little bit sad. How does that sound?"

"Too heavy for me, man. I'll check you out later."

The next day my car was gone. I found out it was towed away in the middle of the night, repossessed by the bank. All I could think of was violence.

Artist Equity put on an event in the afternoon to discuss the A.I.R Ordinance. Dan Cytron read the ordinance while I thought evil thoughts. Emily Hicks blew bubbles at the presenters and spoke with passion about the plight of the artist. Joe Fay stood up and said, "I moved from Venice because of the speculators, but the same thing is happening in downtown. Artists get fucked. They should give out Vaseline with the ordinance to make it go in easier." I smiled for the first time that day and then presented the Art Dock. In the evening I went to see *Gandhi*, the movie, to immerse myself in nonviolence.

The Community Redevelopment Agency (CRA) proposed a study of the artist neighborhood. The First Street East Study would look at conditions in the area and recommend that it become a redevelopment area, if the community agreed.

An Ad Hoc Advisory Committee was formed. I became a member of it along with some other artists, including Gary Lloyd, Peter Zecher, and Dan Cytron. Building owners were appointed, including property owners from Little Tokyo, manufacturers and artist owners including Marc Kreisel, a co-owner of Citizens Warehouse, and George Rollins, who owned the artist building across the street from Al's Bar on Traction Ave. There were even several developers on the committee.

Opinions in the artist community were divided. Some artists saw the CRA as the precursors to developers. The CRA, they believed, would hasten the end of the art community through imposition of guidelines that artists couldn't meet and only major investors could. Others argued that the CRA was the only hope in mitigating the imposition of the building codes. Manufacturers, other building owners, and artist owners were vehement in their opposition to the study. They saw this as the opportunity for the city to confiscate their property for other interests. The developers were for the study, seeing it as way to further their interests, which they couched in terms of needed civic improvements. The Little Tokyo interests were for the study. Little Tokyo was a very successful redevelopment area. I was on the fence, seeing at once the opportunity for help with the building department and the promise of help posed by behind-the-scenes developers.

Each weekly meeting of the committee usually ended in a shouting match. Peter Zecher brought one meeting to silence when he asked, after a question about the meaning of redevelopment, "What's the meaning of meaning?" Deep sighs and a call to adjourn followed.

On Easter evening, Marc Kreisel and George Rollins appeared outside the open loading dock. They demanded to see me. I came out from behind Jeff Kaisershot's wall and joined them on the edge of the dock.

"Do you support the CRA's proposed study or not?" George Rollins asked forcefully.

"I haven't made up my mind," I replied. The wind was picking up.

"We need you not to support it," demanded Marc Kreisel. "We should have laissez-faire. The CRA won't help; they'll just tangle us up in bureaucracy." He puffed on a cigarette and blew the smoke out of the side of his mouth.

Daily Diary Page by Carl Davis

"I don't know, maybe they can protect us from characters like you who want to evict their troublesome tenants."

"Let's not get into that," said Kreisel. "You paid your rent and everything's ok." The wind was growing stronger, and so was my temper.

"So we're just supposed to let the rich get richer and the poor poorer. You make me want to puke."

"You're an asshole," George Rollins replied. Just then a big gust of wind blew across the Art Dock. Five of the black rectangles flew off the wall and into the street. The paper kept rolling down the street. All three of us ran after the loose artwork. We corralled them and brought them back. I re-pinned the art to the black grid.

"Thanks for your help," I said.

"I guess the only thing we are going to agree about is art," said George Rollins.

"I think that's right," I said. George and Marc walked away.

Postscript 2012: The murder of Peter Ivers was never solved. Joe Fay is still an artist, now living in Montana. Dan Cytron remains a California artist. Dr. Emily Hicks moved to San Diego, where she is a professor of Chicana/o Studies, English, and Comparative Literature at San Diego State University. She still does performance art. Glen Fleck died after a brief illness. Learning Development Centers can be found around the world dealing with dyslexia and other learning disabilities. In early 2012, the state voted to disband Community Redevelopment agencies. Los Angeles' CRA, after a run of over 30 years, closed. The First Street East Study never happened and no significant projects in the downtown arts community were ever completed. I voted against the First Street East Study and got my car back.

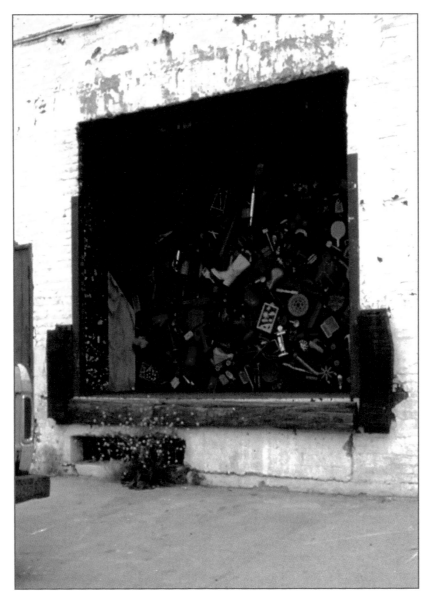

ACT II THE COMMUNITY GALLERY

ART DOCKUMENT #17 "WALL OF OBJECTS"
BY JEFF KAISERSHOT—SPRING 1983

The wall was covered with objects: a bicycle seat, a boot, a roller skate, a hammer, a spatula, a meat grinder, a microscope, a bat, a glove, a bowling pin, a water bottle, a plastic duck, a big F, scissors, cups, shoe horns, chains, crow bars, toys, pliers, spirals, hinges, combs, brushes, a toilet seat, and much, much more. The Art Dock had become a field of things. All the ordinary stuff that populates our lives, fills the shelves of department stores and specialty shops, is stuffed into drawers, piled in attics, and becomes the treasures of a thousand

The Art Dockuments

garage sales was mounted on the big gray wall, covering it from top to bottom. Each item was altered in color. Each item was painted in a bold red, green, pink, or yellow. The wall was an assemblage of shapes—an enormous collage where nothing overlapped. From across the street the wall looked like an abstract painting, from which a big yellow boot stood out.

"But what got you to using the objects themselves?"

"I wanted to get back to basics. I wanted to take the artist out of the work, so I began collecting cast-offs from our consumer society. I liked these forms we mass-produce. Working with them was playful. Other artists like Tony Craig put bits and pieces of things on the wall in their art."

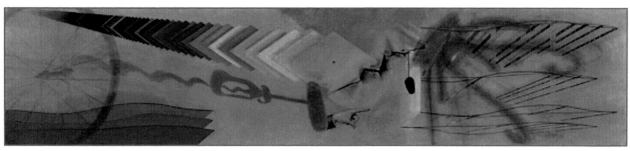

"Tu'm" by Marcel Duchamp—Yale University Art Gallery 1918

Jeff reported that while he composed "Wall of Objects," pedestrians would stop and ask him what he was making. "Art," he would reply.

The onlookers would be silent. They would identify an object and say, "I used to have one of those" or "Isn't that a Dice and Slice?" or "Does that microscope still work?" Jeff would be patient with all the questions, and try to answer them truthfully. "Yes," he said. "I got that telephone from the trash" or "I bought that meat grinder at a Goodwill store for ten cents." The people would drift away without engaging in a dialog about the art. I decided I would provide that dialog. I interviewed Jeff.

"What got you started with these spray-painted objects?" I asked.

"What attracted me to these objects was their relationship to objects in Hiroshima when we dropped the bomb. Objects' shapes were flashed onto a wall as if by some enormous light source. The images were blasted into the concrete. Human shadows were created around the dead. I made prints and photographs of these aura-like deposits. The prints remind me of Man Ray," Jeff said.

"Rauschenberg, with his goat and rubber tire, and Duchamp, with the brush projecting from his painting, did a similar thing," I replied. "What's new with your 'Wall of Objects'?"

"It's all very visual. I like all of the objects together. There's a thing in our society about who has the most stuff wins. It's rampant consumerism. I loved shopping for these things. They were great deals. They were out of style, but for me it was the aesthetic look of each object. There's beauty in every object. I could play I was wealthy in some way. I could put my own value on them, like the homeless guy who collects stuff in the street or a stamp collector," he said.

"I knew this guy, William Buller, who collected lamp parts. His house was full of piles of lampshades, lamp stems, and bases. They covered every surface and filled up the free space. There were trails through the piles to his bedroom, kitchen, and living room," I said.

"Humans are like pack rats," said Jeff. "We're industrious. We like to enhance the life of objects."

"There's something in this about artists and the way they live their lives. It's an inversion of the way most people live their lives," I said.

"I like the idea of artist as collector. One object doesn't have any more importance than another. I make no differentiation between one object and another. I collect everything, any cast-off object. I do it because of the way I am, and it seems like a good path for me to follow."

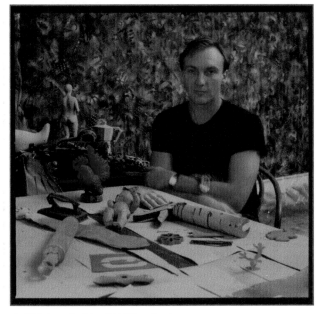

Jeff Kaisershot by Ed Glendinning

"Is that why you're an artist?"

"I'm not always clear why I'm an artist. I kind of like that. I like spending my life doing what I like to do. I like pondering. I enjoy the search."

"For art?"

"Yeah, I like going to the studio not knowing what's going to happen. I like the idea of an artist as a worker going into the studio every day and investigating something. I hope I'm extending the meaning of what art is."

"Is art your career?" I asked.

"I'm struggling with why we're here. It's not just a career. Life is tough. Everyone must pay the bills. Artists are always struggling to get time to do their work. I struggle all the time. I spend more time on art than sleeping and more time on my art than anything else. I get very little financial reward out of the work."

I, on the other hand, seemed to spend less time on my art than anything else, and got no financial reward at all. The teaching, the work on the economics exhibit, the retraining for dyslexia at the Learning Development Center, the artist housing projects, and two new involvements had taken me away from art. I became engaged in forming a tenants organization of the renters in the Citizens Warehouse, and I got a dog from the pound to keep me company, since I was lonely. As if my life weren't complicated enough, I added more complications. I needed the excitement, but also needed some focus. I was here and there but really nowhere.

I dabbled at my art. Occasionally in my free time, when I wasn't on the phone discussing the issues of artists in downtown, I did large drawings of confused men and contorted forms. Some were self-portraits composed of squiggly lines or compositions of elements stacked up on a railroad rail, coiled up like a snake, and topped by a bizarre brain head. Snakes of negativity were always in my mind, and real snakes seemed to find me.

Weekends and evenings I would escape the loft to walk my dog along the railroad tracks or up in Elysian Park. Walking on Memorial Day with my friend, Leroy, the baker and writer I had met at Dorland—he was criticizing me for being down on myself—when MOCA, my new dog, which I named after the museum and its mocha coloring, came across a boa constrictor lying in the path. The dog ran away in fright, and I had to go retrieve her from the chaparral. Two weeks previously, I was at a house in the desert north of Los Angeles, sitting around a coffee table with a glass top inside which were several rattlesnakes. What was it with snakes and me? I kept confronting them. Where they omens? Were they meant to snake me out of my confusion and awaken me to the light I should be following?

Light, which I maintained was my artistic interest, was diffuse and vague around me. Only the snakes

were vivid. I taught about light and I admired light as a medium and an expression. At Otis, I taught students to observe light and how it fell in spaces and on objects. Teaching a drawing class in the Elks Building next to Otis, I instructed a student, Becky, to see light and how it fell on the walls. I told Alisa to look at the shadows that had no edge. I went to see James Turrell's "Ganz Field" at Flow Ace Gallery where, in an unlighted room, a rectilinear hole was cut in a wall and an a beautiful even field of light filled the void. The art dock I thought of as a metaphorical light machine. But I wasn't living in clear, focused light. I wondered if the fog around me would ever lift.

The Art Dock
Lawn is
1/2" wide

Sketch by Carl Davis

The critic came by the Art Dock one weekend. She called to me inside my studio and asked me to come out and tell her about the piece, which I did, adding that Jeff did not try in any way to create a composition. He dispersed the items over the wall at random covering the surface to the maximum density while maintaining the individuality of each object.

"What do you think of it?" I asked.

The critic shifted her weight from one foot to the other swaying slightly back and forth, and then pulled on a strand of her red hair. "Did you see the James Turrell show at Flow Ace?" she asked.

"Yes, I did," I said. "I loved the empty room with the rectangle cut into the far wall, where the plane of space hovered in the background, lit by invisible lamps."

"There you had a nothing that was something. Here we have something that is nothing. Both are art," the critic said.

"I don't get what you mean," I said.

"I think it's an inverse of the readymade. It's the *already isn't* made into art. The artist has altered these common objects very simply by spray-painting them, and then he disperses the items on a wall with no attempt at aesthetics. Unlike James Turrell, whose work is all about aesthetics without displaying the artist's hand, Jeff Kaisershot has taken the hand of the artist—he spray-painted and placed the objects on the wall—and tried to make non-aesthetics. Yet he fails because it's still art. The art resides in the ambivalence of negation where the artist does not create the anti-art object, but the anti-art composition. Using these ordinary objects, commodities, things, he created another commodity—art—which isn't a commodity. There is no singularity to the piece—though it is made of things."

"Well, that was heavy."

"There's no painting here, no sculpture, no real assemblage. It's just a collection of things, none of which is an art object but which, when collected together, make an art statement. The statement,

while it pretends to be non-aesthetic, is aesthetic and philosophical. It's aesthetic in that the wall of objects is quite beautiful. It's philosophical in that there's really nothing here that qualifies as an art object. I once saw a van in Oklahoma that was covered with little metal trinkets. The layering was so dense that only the shape of the vehicle could be observed—its boxy form, the front and side window, and the wheels. The van, I thought, was art."

"But do you like the piece?"

The critic was silent and scuffed her shoe against the pavement. "I've said enough," she answered.

"Do you like the Art Dock's lawn?" I asked, pointing down to the half-inch gap between the lip of the loading dock and the bumper in front. A little seam of grass had grown in the gap.

The critic laughed. "I do."

Postscript 2012: Jeff Kaisershot continues his life as an artist. His work has gone through several permutations. He began making huge wood-burnings using the sun and a magnifying glass as the means to burn a black line. He works with his wife Pamela Goldblum doing joint paintings and installations. He and Pamela exhibited in a new drive-by gallery at the Distillery on the west side of Los Angeles. He teaches digital media at Otis Art School in west LA.

Daily Diary Page by Carl Davis

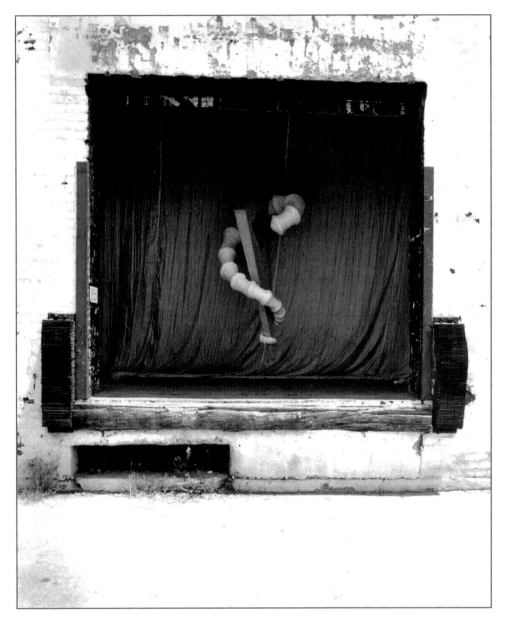

ART DOCKUMENT #18 "SEARCHING"
BY PAMELA BURGESS—LATE SPRING TO SUMMER 1983

"Searching" hung in the open Art Dock on the last day of July, the last day of the installation. Pamela was on her way to remove the piece. I propped myself in the open loading dock against the wall and read the latest issue of the *LA Reader*. The cover page of the *Reader* blared: "The Loft Scene is Dead." Steve Erickson had written an extensive article, in which he quoted me, telling the story of the downtown art community and its threatened demise. The story began with a long statement:

The Art Dockuments

"It's conceivable such a demise might still be thwarted. In a way it's conceivable people might suddenly one day cease desiring to make money, cease desiring to accumulate property...cease exercising the uncanny facility for sacrificing larger concerns for smaller ones, communal fulfillment for individual aspirations...In which case, the down-town loft scene may continue in the midst of an altogether more heavenly world."

the Citizens Warehouse on Center Street, built in the 1880s as a pickle factory, then became a furniture warehouse, and then a soy-sauce repository before its was emptied and finally homesteaded by artists.

This land had once been vineyards beside the ever-changing course of the Los Angeles River. Then the railroad came and everything changed. The vineyards became warehouses and industrial buildings to feed the growing monster. The Los

Carl Davis's *Art Dock*

THE LOFT SCENE IS DEAD

LA Reader, July 29, 1983

I thought about the hellish world I inhabited north and east of Skid Row centered on Traction Avenue in the old industrial heart of the city—a hollowed-out zone amidst the bustle and commerce of the great electric fungus of LA. This was an area of aban-doned buildings like the huge LA Soap Company complex on Banning Street, empty two-story rail-road siding structures, worn-out tin shacks on Rose Street, discarded fire stations, 1920s concrete structures, and unreinforced masonry buildings like

Angeles River became a concrete ditch. All this was happily prosperous until the Great Depression, and the area started to become dingy. World War II gave it new life, but then came the freeways, and rail transportation began to decline. The old buildings were designed for railroad sidings. They did not fit big trucks, except for a few who hung on. The bums began to inhabit the shadows as the industries moved out. Into this cavity of declining real-estate value, the artists moved. They had found nirvana—

huge studios at a cheap price. Eight cents a square foot could give you a space of 2,000 square feet for $160 per month. Mine was so big I could roller skate in my loft or pitch baseballs at the loading-dock door from sixty feet away. I loved the bang of the ball as it crashed into the steel barrier.

had stopped to think, I surely would have realized that the neighborhood I had invested in—with my toil building my studio—was prime land. This was the cheapest land in LA, and it lay in the very heart of the city. It was the underdeveloped left ventricle lying next to the redeveloping right ventricle of the

The New York loft of Enrique Castro-Cid

But I doubted my decision to move here. I was thinking about how great the life of an artist was— free to do whatever I wanted. I was thinking of those great lofts in New York City like the one of the Chilean artist Enrique Castro-Cid, whose big space had a bed in the middle of it and, many yards away, his wall for work, his stacks of unfinished stretchers, and his display of finished works. His tables were filled with brushes and cans, his chairs and couch splattered in paint. I wasn't thinking about real estate and development, although I had an architectural interest in the idea of artists' housing. If I

critical muscle, and surrounded by the major veins that were the freeways: I-5, I-10, and I-110.

The illegal artists had homesteaded on gold, and the city let them get away with it for a time. From 1976 when the Young Turks had found the mine until 1983 when the A.I.R. Ordinance passed, downtown LA, from Broadway east to the river, was the wild west, or, perhaps more appropriately, the wild east. Artists came in droves. Like in Citizens Warehouse, artists master-leased and bought buildings and leased out the unfinished space to other artists. The owners built the corridors with drywall on one

side only. The artists put up the drywall on the other side and built anything their hearts desired. The good times couldn't last.

The city passed the Artist-In-Residence Ordinance allowing occupation of the buildings, but at the same time required, as they should, that the buildings meet code. Reports were circulating from studio to studio building of incidents where artists were being forced out of their lofts. Everyone seemed to know some people whose landlords evicted them because they didn't want to undertake the hassle of complying with the new A.I.R. law. One artist reported being locked out of her studio upon returning after a week away. Meeting code was no easy matter. Building inspectors entered all the buildings they had avoided before the ordinance and cited the owners for violations of code. I was quoted in Erickson's article as saying:

"To my mind, making it legal probably killed the community—the gentle hand of government, coming down and sanctifying it, makes it impossible to do it."

It was impossible to comply without major investments. Much of the construction done by artists was not to code, and it would be costly to fix. Artists were cited for illegal sun decks, bad plumbing, substandard electrical wiring, and lack of earthquake compliance. Earthquake-reinforcement of the Citizens Warehouse was estimated to cost $470,000. *U-Turn* magazine, for which I was a guest editor, documented all the commotion. Artists were meeting; a teach-in took place at LACE (Los Angeles Contemporary Exhibitions), one of the prime alternative galleries, to discuss the new A.I.R. Ordinance. The meeting at LACE descended into name-calling and accusations that some artists were secretly developers or in cahoots with the developer, Norm Solomon, who attended the meeting. LACE, after this meeting, was cited by the fire department because the number of people at the meeting exceeded the allowable occupant

use of fifty persons. Artists were organizing. Doug Ward, Andi Alameda, and others started the DOA (Downtown Organization of Artists). The title of the organization, DOA, was a premonition of what could happen: Dead on Arrival. Doug Ward was quoted in the *Reader* article saying:

"If worse comes to worst, we're talking about chaining the doors of the building shut and going up on the roof with megaphones and just camping out there. We've got a building that looks like a fortress and probably is a pretty good place to hold a last stand…being veterans of Kent State and the '60s. We feel maybe that certain kinds of civil disobedience would at least put in people's minds what is happening to the artists' community down here, if indeed we are going to be kicked out."

The reality was, as Jon Peterson was quoted as saying, "Those people trying to stop what is happening now are pissing in the wind."

Gary Lloyd Mural by Kent Twitchell 1982–1983

As I read this article and the doom it foreshadowed, I could not help but feel that there was never a more creative time for downtown artists. Exile was gone, but galleries were popping up all over the neighborhood: Cam and Wally's Galleria by the Water on 7th Place, the American Gallery on Hewitt by Traction Street, AAA Art Gallery on Center Street, LA Artcore on Mateo, Oranges and Sardines on East Third Street, Ovsey Gallery, Double Rocking G,

and Kirk DeGooyer Gallery. Downtown artists were showing across the city: Gary Lloyd at the Loyola Law School, Karen Kristin at Santa Monica College, and Fritz Hudnut at the Security Pacific Bank. Performance art was taking place everywhere: the Boyd Street Theater, the Wallenboyd Theatre, LAICA (Los Angeles Institute of Contemporary Art), and the Woman's Building on North Spring Street. John Sturgeon and Aysha Quinn, who were staying in my loft, performed at the Los Angeles County Museum of Art (LACMA). Kent Twitchell painted an image of Gary Lloyd on the side of a fish company's building off Alameda Street. At the LACMA Young Talent Awards, a whole room was given over to the work of Andy Wilf. The new MOCA was soon to have temporary quarters—the Temporary Contemporary—off First Street, no more than four blocks from the Citizens Warehouse, and Pamela Burgess was showing in the Art Dock.

Say the same, do the opposite they commanded me at the Learning Development Center. I jumped up and down on the trampoline turning left then right and saying bear when I saw the seal picture, seal when I saw the bear picture. I compared the confusion I experienced and my inability to do the exercise correctly to my life and the life of the downtown art community. Everything was exciting and creative, but contradictory. Andy Wilf was extolled, but dead. The art galleries of downtown were under pressure to conform to the building codes, and many wondered if they could go on exhibiting. Pamela Burgess destroyed the new wall Jeff Kaisershot created for the Art Dock without telling me. Asha Quinn and John Sturgeon were hanging upside down in my studio as a way to relax. They convinced me to hang upside down. The blood rushed to my head, and all I felt was disoriented. I was still rushing all over town and wondering if it was worth the effort.

I was engaged in interesting projects from the design of the economics exhibit, the presentation in New York of a possible second exhibit project on

business to the National Junior Chamber of Commerce, artist housing concepts, and workshops on the issue of artist housing at LACE. Yet all of them felt tenuous and unreal. My life was disoriented.

Pamela Burgess by Ed Glendinning

The client for the economics exhibit was not paying Glen Fleck. While I worked long hours on designing the future exhibits, Glen was threatening to close down the project. If he did this, I would be left in grave financial condition. Glen sent me to New York to present our ideas of a business exhibit for the National Junior Chamber of Commerce because he was angry at the client and refused to go. I went, exhausted after being up for three nights in a row working on the project fueled by speed, and made a terrible presentation because of my lack of sleep. The artist housing projects could not be realized without significant capital, which neither I nor my artist friends had. The workshops about the artist community housing issues divided the artists. No consensus could be reached. One camp rejected city help and considered those who wanted help to be sellouts to the establishment. The other camp thought city help was the only way

to save the community, and thought the opposing camp was all greedy developers. I was stuck on the fence, wishing I never got involved in the controversy, but could see no way out.

My daughter came to visit with me. We went to Disneyland on July 4th. I bought her a big wide brimmed pink hat with a hot pink silk band and a silk flower. While we sat on the curb of Main Street—she in her new hat—and waited for the parade, she asked me, "Will you die before I do?"

"Yes," I replied. Tears came to her eyes.

"Then I'll be all alone with nobody," she said.

"You'll never be alone," I said and choked up, feeling burdened by the choice I had made to stay in LA and pursue this indefinite and diminishing goal to be an artist.

I stood up, taking my camera with me, jumped into the street, and leaned against my vehicle to view Pamela's piece for the last time. The sculpture commanded the center of the Art Dock stage. A suspended triangle with a square hole in its upper portion had a bony coil wrapped tight around its skinny end. The coil enlarged and moved away from the geometrical form as it swept around and ended not quite penetrating the triangle's hole. Pamela told me the name of the piece was "Study for Embrace." She later changed the name to "Searching." I saw the relevance of both names as I contemplated the sculpture. Its two pieces seemed to be in the process of embracing. They were caught in the moment before the embrace would be completed with the insertion of the coil through the triangle. I could also see the idea of searching as the bony coil wrapped around the triangle, looking for a place to end. It all seemed very sexual to me.

Pamela explained her thinking to me when she

John Sturgeon's and Aysha Quinn's performance at LACMA 1983

installed the piece. She didn't emphasize the sexual nature of the sculpture, but she alluded to it. The piece was conceptual, she said. The suspension of the piece was a metaphor for suspension in the mind. Its unfinished materials placed the sculpture as part of a series of works-in-progress. The sculpture was an idea the artist was developing, and the Art Dock was her laboratory. Pamela said she designed this work specifically for the loading dock. She calculated the scale and considered the materials best suited to work with the character of the opening. The piece had to be large enough to have presence and activate the negative space around the sculpture. At seven feet tall, the sculpture hovered about a foot above the floor and hung about a foot below the loading dock opening. Its width divided the Art Dock space into three approximately equal parts. The location of the drive-by gallery—in a loading dock surrounded by bumpers, metal guards, and backed by a curtain—allowed her to imagine it as a large model for a subsequent finished work for another location, fabricated in more traditional materials. The unfinished look of the plaster and wood installation sited within a rough location doubly reinforced the concept that the Art Dock presentation was an idea rather than a finished product. I liked that the Art Dock was a place artists felt free to work out ideas.

The two titles of the piece implied a figurative content, Pamela said. The forms were symbolic. The shape of the coiled form suggested bone growing organically, from small at the base to large at the top. The geometric wedge, although abstract, retained a sense of the human. The pointed lower end suggested a foot and the larger upper end implied a head. It was at once an icon and a statement, referencing the work back to the forms of the Constructivists and other early moderns, where the human body was made into a machine. I thought of Malevich's geometric theater costumes and Duchamp's great painting of the nude descending the staircase, in which the female body was shown as a congregation of overlapping oblique triangles simulating movement. Pamela's combination of the two forms created a symbiotic relationship between geometric and organic. The machine and the animal were intertwined in a symbolic union, establishing new possibilities for future harmony. The union was suggested, rather than established, because the coitus hadn't happened.

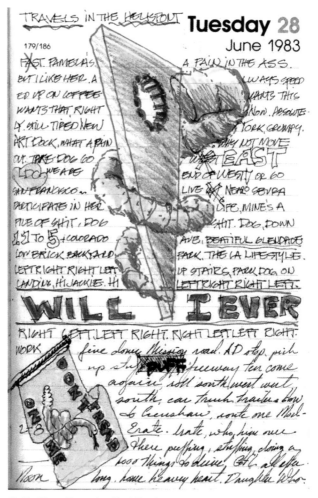

Daily Diary Page by Carl Davis

The hole in the wedge hinted at a female sexual connotation, Pamela said, while the bone-like coil was phallic. The coil twisted around the wedge, embracing it and searching for entry. Pamela said she purposely kept the coil from penetrating the wedge.

The Art Dockuments

In earlier drawings, she studied the relationship of the bone coil to this wedge and determined that the greatest amount of visual tension was created by the position of the elements apart from one another. The position of the bone coil about to penetrate the wedge established a dynamic in time. Were the coil to be positioned through the wedge, there would've been an impression of completeness. The visual story would be finished. But keeping the coil away from the hole in the wedge implied a possible future penetration. "Time becomes a major aspect of the sculpture," Pamela explained.

The inertness of the physical form was infused with a dynamic tension and the sculpture came to life in contradiction to its static reality, she said. This contradiction was underscored further by the incompleteness of the sexual union, as if the harmony implied by the embrace of the two forms might, in truth, be impossible. Machine and animal, mechanic and organic could be eternally opposite and irreconcilable, or, carrying the analogy further, male and female could never be resolved into one essence.

An interrelation was set up between the frame of the opening and space behind it. Pamela declared she wished to alter the space of the Art Dock without changing anything. The intent was at once sculptural and theatrical, arising from the uniqueness of the gallery. The viewer was presented with a frozen play in the proscenium of the loading dock. The symbolic characters acted out a movement of embrace as a study in time and space, leaving in their wake a residue of expectation. A public showing was made of a private rite in a mysterious art altar. As I stood looking at her installation, Pamela drove up, got out of her truck, and walked toward me with her tool chest, ready to take down her installation.

"I've just been reading about you," I said.

"Where?" asked Pamela.

"In the *LA Reader*, in the article on how the loft scene is dead."

"Read it to me," she said.

"It's about your loft. Quote: 'When I rented this place,' says sculptor Pamela Burgess of her loft, 'I figured that anything I got out of it after five years was gravy.' The writer says as commentary that's about the only perspective that makes a lot of sense."

"I never went for this political stuff. The work is the only thing that matters to me. I can do that anywhere."

Pamela hopped up into the Art Dock and hugged her sculpture. I took a photograph.

Postscript 2012: Pamela Burgess continues to be an artist. She lives in Atwater Village in Los Angeles and makes nature-based art. In 2010, she had a show at the Rancho Santa Ana Botanic Gardens called "Radiant Light: Shadow Sculpture of California Native Plants."

Enrique Castro-Cid moved from New York to Miami. He died in 1992 of a heart attack. John Sturgeon continues performing and teaches cinematic arts at the University of Maryland, Baltimore County. Aysha Quinn lives in New York City. Kent Twitchell continues to be one of America's most important muralists. His most recent show in 2009 at Look Gallery explored his lost works. Most of the downtown galleries mentioned have closed, but new ones have sprung up in Chinatown and LA's historic core around Broadway and Hill Streets. The Temporary Contemporary still exists. It is now called the Geffen Contemporary. The theater spaces and the performance art venues mostly disappeared by 2010. Gary Lloyd's image on the fish company building was painted over.

ART DOCKUMENT #19 "FOR MARILYN MONROE" BY PETER ZECHER—SUMMER TO EARLY FALL 1983

'm an engineer," said Peter Zecher, a wry smile curling up on his thin stubby-bearded face.

"No, you're not," said Phyllis Green, the sculptor, giving him a disapproving look.

"No, you're an artist. I'm an engineer...an artist engineer," replied Peter.

"You're kinda like Calder then," I stated cautiously because, in any conversation with Peter, you had to be on your toes to catch the queer relationships, the odd insertion of words, and the verbal bridges from one idea to another.

"I have this knowledge. If you have two tripods, a right-handed tripod and a left-handed tripod, you have a cube. I came upon this information when I was working with cardboard. My first cube stack was in 1981. I was awarded a grant as the number

one contemporary artist of the year in San Francisco. I think it's wonderful to get recognition for your art. People need confirmation."

"Is your work is based on secret mathematics?" I asked.

"It's not tangible. One of my inventions is a previously uncommon way of making a cube. It'll become common knowledge now. Who knows anything? This is my way of knowing. I have studied it many different ways."

Peter Zecher by Ed Glendinning

"I'm inspired by the materials I use, so is Peter. I never make the same thing twice," said Phyllis. "Peter does."

"It's two opposing figures, a common currency of the figurative," added Peter. "'Marilyn' is steel, wood, and reflective black tile."

"You're work isn't figurative," argued Phyllis.

"My work is very sensual," replied Peter.

"A Persian cat is sensual," countered Phyllis.

"Your work is columnar," I said. "And the idea behind the column is the human body."

"To say a column is figurative isn't very specific. There are many things that are black and long," Phyllis poked.

"There's the glass box skyscraper," said Peter. "What's good enough for Mies van der Rohe is good enough for me. Mies invented the invented the glass box on a Monday morning. Well, maybe it wasn't a Monday morning. The architect who invented the Blue Whale invented it in half an hour."

"What's that got to do with anything?" asked Phyllis.

"If you can humanize geometry, I have."

"Geometry is a function of the human brain. Flowers are not geometry."

"The Golden Mean is geometry," I replied.

"You guys are fighting over something you don't need to," said Peter. "I have a good aptitude for geometry. I don't care about learning about the world through books. I like to mess around with materials. It's hard to read and walk. I have a hard time sitting in one place, being sedentary. My hands want to be active. I end up playing with myself." Peter laughed.

Phyllis laughed. "I rarely do anything larger than my human scale," she said.

"I'd like to do public sculpture. Most of it's a mistake—a turkey—but public officials think they're doing something nice. A couple of Mark di Suveros—Claus makes Claus—and Miro is nice. Some guys build rooms and store art in them. America is a land of paradox. I'm a sculptor. I make objects," said Peter. "We understand the world in terms of objects. I like to make beautiful objects. I work on wind resistance, stability, and finish. It can't all be theory, and that's it."

"You have used your work as a kind of currency, haven't you?" I said, thinking about my current occupation as a designer on the economics exhibit for the 1984 Olympics in LA. I was designing an exhibit called "Creating Money," in which a little treasure chest opened and the loot flowed out into a little bank.

"My work is somewhere between real estate and currency," declared Peter. "God created the earth. Man created art. Art behaves like real estate."

"You're not creating real estate. You're making art," Phyllis scoffed. "Now if you were making your art to sell, you'd be an aggressive marketer. You're on the opposite end of the spectrum."

"My work appeals to people. I've traded work with a doctor and to a barber for a haircut."

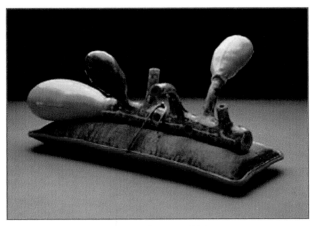
"Reptila Musica" by Phyllis Green 1996

"What do you think about art dealers?" I asked.

"Oh, they say, 'You've made another one of those things!'" Peter rolled his eyes. "They want bronze. Copping to the bronze myth is just bullshit. Bronze is too limited in the forms it can be. Bronze is limited in the structure it can be. It's just poured in a hole. Jackson Pollock never cast bronze. It's not about the enamel paint. Art is about energy. You're manifesting energy. I have materials do what they can do. Dealers get that bronze in their brains."

"Dealers want to suck your blood," Phyllis mocked before standing and leaving our conversation.

"Talk to me about 'Marilyn,'" I requested. "Cube Stack IV for Marilyn Monroe" was the sculpture he placed in the Art Dock.

"Mirrors are about tears," said Peter. "Marilyn Monroe is dead and was very beautiful, and the cube stack was very beautiful, so I named Cube Stack #4 after her."

Peter had just finished the work, and the Art Dock was its inaugural exhibition.

"Places to show are very limited. There are only a small number of galleries, each showing maybe a dozen artists. That isn't very many people. It's tragic. Marilyn was tragic. Mirrors reflect back to us that which has already passed. They show us our tears, our tears in downtown," concluded Peter, ending our conversation in his loft.

"Mirrors are about tears," I said to myself, standing in front of the Art Dock on the first evening of the "Marilyn" exhibition. The sculpture was black and gleaming. The luster of its tile surface reflected two stacks of bright white cubes on the curtain behind. I thought about Peter Zecher, his art, and the artists in downtown. Peter Zecher had dedicated his art and his life to developing a special knowledge about the cube. His dedication to developing this knowledge was unswerving in spite of the derision of others, who would often refer to his art sarcastically. Each work was similar to the next—except maybe in finish and material; the whole oeuvre was a study of small differences.

The mirrors reflected my tears, my frustration, and my desire to escape the conundrum in which I found myself. My tears were real. My marriage was over. My wife and I filed for divorce. My dog was dead. MOCA was run over on Santa Fe Avenue when I left her in the care of Michael Salerno while I went to work in Santa Monica. Salerno let her out. She ran into the street and was hit by a truck. Salerno directed me to her body in a plastic bag at the bottom of the stairs up to the First Street Bridge. Her death was payback for my not taking good care of her. I was mean when she shit in my loft. I threw her outside and threw a stick at her. She cowered. I felt cruel.

I took her carcass to the vet. It was the only place I could think of to take her. I wasn't going to put her body in the dumpster. She was already starting to rot and bloat. The vet's assistant made me help him remove the dog from the bag to lift it into the freezer. Her bloody tongue hung out. Her long legs were scarred. I sobbed. Something I truly loved was

taken from me. I wanted to talk to someone, but there wasn't anyone. No one who loved me and no one I loved. My empty life was even emptier.

out of downtown to Santa Monica summed it up. It said, "If you think the system is working, speak with someone who doesn't."

The Art Dock Loft with Peter Zecher in Art Dock—Sketch by Carl Davis

I turned 39 years old in August, and I was frustrated. I spent a lot of time reflecting on my life. I was unhappy and unsatisfied. Clarity eluded me. There seemed no place to turn to resolve my difficulties. The economics exhibit design project took up most of my time, but I was doing the work solely for money to survive. Ironically, "Creating Money" was the exhibit I was working upon. I was creating money for myself, yet my attitude was dark. A bumper sticker I saw on one of my daily journeys

I thought the system wasn't working for me. I had a job but was unappreciative. My art career was foundering. I had little time to devote to it. The downtown artists were at each other's throats. I could find no stable ground on which to pin my hopes for survival of the community or my own loft investment. Sick of the aggravation from inspectors, and the acrimony within the artist community, the time had come to abandon the effort to live in downtown. Victor Henderson, a member of the LA Art Squad, and

well-known muralist, lived at the beach in Venice. He and I agreed to swap lofts for three months. I would move into his place, which was closer to my work. He would take over my loft to paint a large mural he could not do in his small Venice beach studio. This could be the end of the Art Dock.

Peter's view of his work was rooted in the concept of art as something developed out of the process of making. The artwork included not only the finished product but the mental and physical labor that was applied to fabricating the object. Peter saw himself as analytical. He was a scientist of his form, unlocking the secrets of geometry and the aesthetic of that geometry translated into real material. The process was hermetic—magical and alchemical. It was an inward analysis concerned with its own priorities. The system was self-referential. It developed its own cosmology. Therein lay its greatest strength, its greatest weakness, and the greatest obstacle to interpretation, leading the unsophisticated to deride the formal similarities.

This explains why Peter 's work isn't commercial. In the world of art commodity, where the establishment of a look was all-important to the marketing, it appeared strange that an artist whose work has such consistency would not sell easily. The situation underscores the contradiction of a market that on one hand values alikeness at all costs, but seeks newness and originality within each similar object. The variations of Peter's intense investigations were too limited for a thrill-hungry market. The subtleties of his analysis were lost in the insatiable demand for originality. In Peter's work one has to look for microcosms of beauty—the relationship of cube to cube at their junctions and the sense of scale as cube piles on cube where the shapes elongate and compress, depending on one's distance from the object. These small differences build up into an ordered universe distinct to each piece.

With "Marilyn" a dimension of reflection was added. The mirrored cubes reflected back on one another, revealing depths of form descending into infinity. The effect was sensuous and physical, but at the same time it deconstructed the form and floated it in an infinite space. The effect was different at different times of day. The hard, black, reflective cubes in daylight hours would alternately harden into a dense dark surface or would be shattered by bursts of brightness. When the sun moved across the sky and struck the cubes in late afternoon, the stack glowed and glistened, turning into a column of white or dematerializing into lines of clear light. At night the cube stack, under artificial light, threw two columns of reflection onto the backdrop curtain and hovered over its base as if unsupported. "Marilyn" strutted her stuff on the Art Dock stage. It would be sad to see her go.

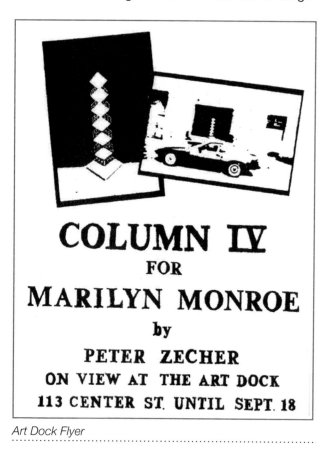

COLUMN IV
FOR
MARILYN MONROE
by
PETER ZECHER
ON VIEW AT THE ART DOCK
113 CENTER ST. UNTIL SEPT. 18

Art Dock Flyer

Mirrors are about tears, Peter said. I sort of understood the analogy, and the funny and insightful way he had summed up the situation in which the artists in

downtown found themselves bound. It was beautiful yet tragic. The tears were beautiful, for they encapsulated a meaning that was inescapable. The art of downtown was an expression of that contradiction between the aesthetic and the commodity, between the soul of a community and the real estate on which it stood. A developer said to me, "The artists are transitional in downtown." The creative community would pass, to be replaced by the currency of real estate. All the artists could do was enjoy the slide and shed beautiful tears over the frustration that their tenure would end. The Art Dock was a vehicle for this celebration. Glorious it was too, when this phase of the Art Dock history ended with a television report.

NBC News came to my loft, interviewed me, interviewed Gary Lloyd in his loft, and interviewed Peter Zecher in front of the Art Dock. Their story was about the end of the artist community. I played my part well, as did Peter and Gary. In late August, the TV report aired. It was brief. I was already established in Vic's studio, and happy to be there. I could swim every day in the ocean and bicycle to work. Victor Henderson kept the Art Dock open with Peter Zecher's show until late September. However, this was not to be the last Art Dock action. I had arranged with Ulysses Jenkins, a video artist, to do a performance outside the Art Dock on a raised concrete platform belonging to the chicken slaughterhouse to the immediate north of the Citizens Warehouse.

Postscript 2012: "Cube Stack Column IV for Marilyn Monroe" was subsequently shown at the Cotton Exchange Show in 1984 and then sold to a collector. The collector ended up with financial difficulties and gave "Marilyn" to her dry cleaner in lieu of a cash payment. Marilyn was on view in the dry-cleaning establishment's window for many months and was reportedly sold to a customer for $100. Phyllis Green is still an artist. Her animation works and sculpture are exhibited nationally and internationally. She lives in Santa Monica, was a member of the Santa Monica Arts Commission, teaches at USC, and had a 25-year retrospective of her work that opened in January 2011. Victor Henderson remains a mural artist in Los Angeles. Two drawings of his were shown in the Under The Black Sun California Art 1974-1981 exhibition at MOCA in 2011-2012. Peter Zecher died suddenly of a heart attack in 1996. One of Peter's stacks was up for sale in an art auction at Bonhams and Butterfields, Los Angeles, in 2009. Price undisclosed.

Daily Diary Page by Carl Davis

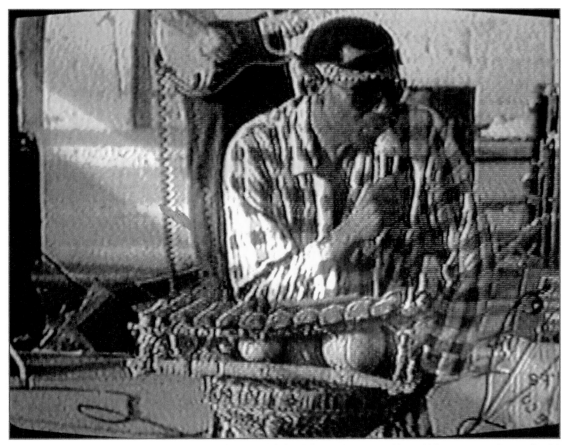

Ulysses Jenkins with "Life in the Park with Debris," Michael Delgado, guitar; Harold Hunter, saxophone; David Strother, electric violin; Larry Tuttle, Chapman stick Bass; Jack Nathan, drums; & Vinzula Kara, synthesizer

ART DOCKUMENT #20 "WITHOUT YOUR INTERPRETATION" BY ULYSSES JENKINS—SEPTEMBER 18, 1983

"Let's blow it up," sang Ulysses Jenkins as the police car rolled up to the loading platform of the chicken slaughterhouse next to the Citizens Warehouse. *Oh, God, we're in trouble now*, I thought. Officers Bashara and Torres stepped out of the patrol vehicle, hands to the guns on their hips, and demanded that the rehearsal end. Ulysses started to oblige the officers by putting down his microphone and climbing down from the three-foot-high triangular platform.

"What's up?" Ulysses asked as several of us gathered around.

The patrol officers explained that there was a noise complaint from someone in a neighboring building. Ulysses would have to stop his rehearsal and cancel his Art Dock performance scheduled for the evening. Ulysses was in disbelief. He had carefully arranged for permission to put on his performance piece with Poppy Foods who owned the platform.

"Who would possibly complain?" he asked.

The officers didn't know, but the complaint was enough for them to demand cessation of the offending activities. We determined that the complaint must have come from someone in the Citizens Warehouse, the only place inhabited on a Sunday afternoon in the otherwise empty area. As Ulysses fervently defended his right to make art and not be censured, I ran off to find Joel Bass, an artist and the manager of the Citizens Warehouse. Joel followed me back to the area at the far north end of the warehouse. I wasn't sure if Joel would support our request to continue the rehearsal and allow the performance. Joel had opposed my Art Dock in the past. I was hoping he wouldn't oppose this event. Joel surprised me and gave his assent to the activities. The police officers, satisfied that someone with authority had given permission, backed off, departing speedily down Santa Fe Avenue.

Ulysses finished his rehearsal and we sat down on the edge of the loading platform for my customary interview.

"Tell me about this piece," I requested.

"This'll be my first time using music. The stuff with the band and the dance movement by Rudy Perez with May Sun performing are all new. We did a workshop one night and now we're putting it into a larger context. You know, transposing it into presentable form. I had to do the negotiations with the chicken place. I had to go in where they have all those dead chickens.

"You mean the slaughterhouse north of the Citizens Warehouse?"

"Oh yeah. They owned the platform on which I wanted to do the performance. And now I almost get stopped by the police. Why can't I just have fun?"

"Has it become difficult to do your work?"

"Yeah, there aren't many spaces that can give you everything, but all I need is a place that can give me electricity. Outdoors, all I need is one plug, and we have that in the Citizens Warehouse. With this plug I can provide for the band, the microphone, the monitor, and the video. This is frontier time. I'm taking a risk. This is a dream. I have the ability to create a dream in a place that isn't set up for presentations. It's an old loading platform of a chicken slaughterhouse just north of Citizens Warehouse with railroad cars going by. We have no lights, so we're making it a drive-in theater. You'll drive your car, park, and see a performance. By turning on your headlights, you become part of the performance."

Mandinka Griot from Gambia

I liked the concept. Different, that's for sure. "How do you approach your work? I mean what is the impetus behind your work?"

"You define a society by the technology and tools it uses. My video and performance work together to create a kind of a ritual myth. I'm a technological 'griot,' an African storyteller. Griots make their living doing this. This is the ritual of East Africa. We have these rituals in America. We call it the Superbowl. Let me tell you a story. A guy went down to New Guinea carrying a book. They thought he was worthless because he didn't have memory. He couldn't hunt for himself. If you took away our tools we'd be like the New Guinea natives, but we'd

be helpless, unable to hunt. I am the griot of the 20th century hunt. I do this by not limiting my art, but by being open to improvisation. The performance you'll see is centered on the griot, but recorded with modern technology."

"Tell me more about myth and modern technology."

"In the performance, you'll see a couple sitting at a table watching TV, participating in the American myth. While they are watching, the TV is watching them. Thus TV can take you to the next level. Society is becoming more controlled, but you can break out of it. Controlling your own technology is one way. Videotape is a recall device. Videotape is a griot. There's a mythology to it all. I work with multilevel interpretation."

"You said 'Without Your Interpretation' is the name of the piece."

"It's a political statement. There's an absurdity to it. It comes out of my reading of Artaud and the Theatre of the Absurd. Everyone will interpret it their own way."

"You're such an involved person," I said, meaning it.

"Let me put it to you this way, I always get a reaction when I walk down the street. Being a black male, I've had to deal with issues all my life. When I was a kid and moved to the Westside of LA, I had a white friend in grammar school. His mother had me wait in the alley before I could come into their house. Society doesn't give us the time to study who someone really is. The way we approach living together is broken. You'll see in the performance when the ancestors—the performers—ask the two people at the table to dance that the woman is drinking from a broken glass. In these circumstances of a broken society, people get psychotic. That's why I sing 'Let's blow it up.'"

"Most of the art you see today is politically neutral, but you take stands," I remarked.

"Most art today is based on the market. Performance art is different. Performance art is a rejection of the market. It redefines the Western sense of how art is recognized and formed. How could anybody outdo Yves Klein anyway? Let's take all the money and throw it in the river. Klein threw the money for his work in the Seine. Let the profiteers own the river, if they want."

"How do you see yourself as an artist outside the commodity world?"

"First of all, since I've started making music, I have a whole new relationship to art. It made me realize that it's not about my persona. I have this griot concept. I'm an African-American storyteller. I use videotapes to tell my stories. I already know nobody buys videotapes. My own thing with doing art has been an odyssey for exploration of my creative potential. I use video as a tool of personal expression. There's this biblical story that really gets to me. The Hebrews were out in the desert worshiping the golden calf. Well, the 20th century golden calf is the monitor. With video, I get to be on the golden monitor. I explore the socio-political realities of the medium. How many artists will still be painting at the end of the 21st century? The Renaissance artists expressed themselves in many ways. I'm one of those artists, exploring a different way."

"You started out as a muralist, didn't you?"

"Yeah, doing murals on Venice Beach. Moving from murals to video was an easy transition. It's all mass media."

"How do you find venues for your work?" I asked.

"They hardly exist. There are Western concepts, and there are other concepts. There is art integrated into life rather than separated. Arabs don't want our shit. They reject Western materialism. You see what I'm saying?"

"Not really. How do you account for all the golden palaces of Saudis?"

"They are corrupt. I am talking about the spiritual Arabs. They reject the frame of the capitalist market."

"Can your work exist outside the frame?"

The Art Dockuments

"You transcend your obstacles. I'm making it as an artist in America on my own terms. You have to step away and look at the whole thing. I want people to look at my work without the interpretation of their cultural bias."

"But can you travel with memory without a technical manual? You know, like the manual that comes to tell you how to operate your video camera and golden monitor."

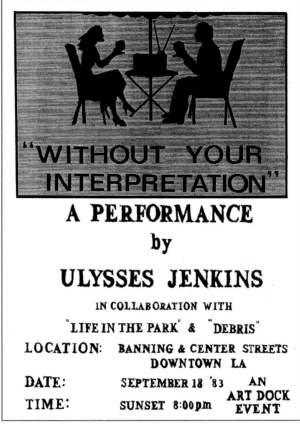

Art Dock Flyer

"I need my camera and my monitor. Even the natives have them now, but you can get rid of your suitcase full of other Western junk and travel amongst the natives naked," said Ulysses. We ended our interview when he hopped up on the platform and began working on the final set up for the evening performance.

I called to him, "Can I take a book?"

Ulysses laughed. "Better take a video camera, then you can film the natives' hunt," he replied. I laughed. Maybe I just didn't understand the African-American griot way of thinking.

Twenty cars pulled up around the blade-shaped platform and kept their headlights on. The drivers stood outside their vehicles and waited for the performance to begin. After some technical delays, it began at 9:30 pm. Ulysses was up on the platform with his band "Life in the Park with Debris." On the platform tip was an African-American couple sitting at a table under an umbrella with a TV monitor behind them. They were drinking from broken glasses. At the back of the platform, three performers, including the artist May Sun, faced the wall of the chicken slaughterhouse with their arms extended out from their sides. Ulysses began to sing an interpretation of "Drifting," a Jimi Hendrix song. The band began a jazz improvisation.

While he was singing, the performers against the wall turned around and moved back and forth across the wall in a slow rhythmic fashion. These performers represented the ancestors. Ulysses sang about freedom and justice, and the performers moved away from the wall, walking forward like apes with their arms hanging down from their bent bodies. As the performers moved out onto the platform and around the band, their movements became robotic. They approached the couple sitting at the table. Ulysses sang his chorus of "Let's blow it up." The performers asked the couple to dance, but they paid no attention. They were busy watching the TV. The performers danced, and then slowly moved back toward their position against the wall walking in the apelike fashion. A freight train rolled past the loading dock. Ulysses sang, "Don't let them push the button—for the ancestors' sake."

The performance lasted a little more than an hour. I got into my truck, backed away from the platform, and headed toward Venice. That evening began my three-month sabbatical at the beach. As

I drove down the freeway I noticed a large billboard advertising a brand of cigarettes. It said, "U.S. Government Report—Carlton is lowest."

I laughed but was sad at the same time. I, Carlton, was lowest. I was the "voluntary poor," steeped in debt and broke, but I was free. Free in my life and free from the Art Dock. Was the Art Dock finished even though I had more artists lined up to show? I could close up, go away forever, and leave behind the troublesome life of downtown LA. What would I do with the rest of my life? The doldrums of September had arrived, and I felt depressed and split. Half of me said fuck the world. Life was not worth living. Everything was shit. Everywhere I looked I saw garbage. I was garbage. The other half of me said there might be hope. The truth of nature was beautiful, and people—even I—were capable of decency. In my Venice studio I ruminated, and the ocean cooled my overheated psyche.

It was intermission time. Time to recharge my psychic batteries and reconsider my options. Did I start too late to be an artist? "No," I said. "I'm an artist, but I haven't found my way. Should I paint, draw, sculpt, or write?" In the Venice studio I started to handwrite journals. It felt really good. It was what I wanted to do when I was really young, but I couldn't type. My dyslexia prevented me. I recalled my fit of rage in my freshman year of college when typing the word THE, always resulted in HTE. I threw the typewriter out the fourth story window. It crashed into the lawn. Remorseful, I went to retrieve the machine. It still worked, but the W wouldn't strike. From then on, I handwrote my college papers and got lower grades because they weren't typed. I gave up the idea of being a writer. Perhaps a computer would change my fate. I heard you could make corrections on them easily, and I was around IBM personal computers every day at the economics exhibition design project. Maybe I could get one.

I recalled Pascal's quote, "It is not necessary to hope in order to undertake, nor to succeed in order to persevere." Persevering without hope became my mantra. I had three months to ponder my future. I enjoyed them thoroughly. My mood lifted then sank then lifted again. My doctor said I was bipolar, and gave me anti-depressant medication. The medication made me feel strange, distant, and unbalanced. I stopped taking the drug. It was one year since I had put my hand through the window at the unemployment office, became the new poverty, and descended into hopelessness. I survived. Now I had a full time job. I bicycled to work, swam in the ocean, walked the Venice Boardwalk, and ate healthy. Designing the economics exhibit started to be fun. I designed exhibits called "Monetary Policy," "Fiscal Policy," "the Economic Hotline," "the Money Machine," and "Reflections on Productivity."

Daily Diary Page by Carl Davis

My plan was to make art an hour a day to keep insanity away. It worked. I drew big drawings, worked on my wire sculpture, and wrote in my journals. My daughter visited me, and we went to the Kienholz art show at LA Louver. She stood on his piece. We visited Terry O'Shea's studio and marveled at his fluorescent wands. Vic Henderson had a show at Urike Cantor's Gallery that I attended. I saw work by Ives Klein and Louise Nevelson at the museum. I was happy. I didn't want to return to downtown, but Vic wanted his studio back. On my last day I walked the Venice Boardwalk. I saw through my illusion to the gritty reality of the homeless sleeping on the beach and the filthy young man who walked a stretch of the boardwalk back and forth, never looking, never responding to the faces of the suntanned, shorted, and sunglassed scrunched up in revulsion as they flowed by on skates. This apparition of the failure in pursuit of the good life readied me for the return to the desolation of downtown. I left Venice feeling forever the exile. The Art Dock remained an unfinished endeavor. In moment of exuberance, I promised Bob Gibson a show. The theater of life in art would continue.

Postscript 2012: "Without Your Interpretation" was performed later at the Lhasa Club in Los Angeles then made into a videotape with the inclusion of additional images collected from the mass media. Performers Chrono and Frank Parker died. Ulysses Jenkins still makes art. His work as a performance and video artist has been shown nationally and internationally. He was and still is the director of African-American Studies and the professor of video art production and performance at the University of California at Irvine. His video "Without Your Interpretation" was shown at the Hammer Museum in "Now Dig This! Art & Black Los Angeles 1960-1980" as part of a "Pacific Standard Time" exhibition of 2011-2012. Joel Bass moved to New York and then Long Island, where he is a successful building contractor. He's thinking of painting again. May Sun is still an artist. Her work as a sculptor and multimedia artist has also been shown nationally and internationally. She has made public art for the Metropolitan Transit Authority in Los Angeles and the transit agency in New York. Terry O'Shea died prematurely from cancer brought on by the resins he used to make his work. Carlton Cigarettes are still available. A carton of Carlton 100s costs $65.99.

ACT III
THE ART OLYMPICS

"The purpose of art is washing the dust of daily life off our souls."
—Pablo Picasso

*"If we are to change our world view, images have to change.
The artist now has a very important job to do. He's not a little peripheral figure
entertaining rich people, he's really needed."*
—Vaclav Havel

*"The fishermen know that the sea is dangerous and the storm terrible, but they have
never found these dangers sufficient reason for remaining ashore. "*
—Vincent Van Gogh

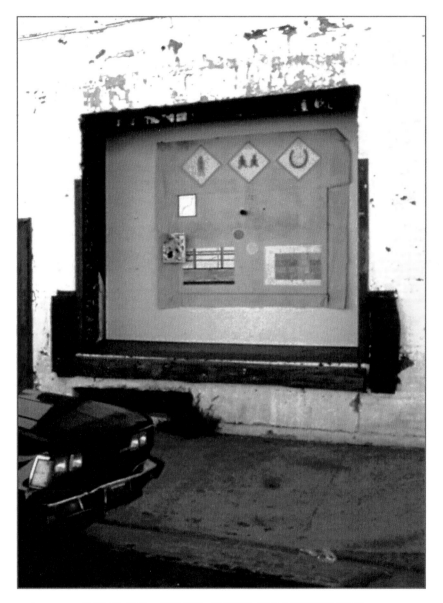

ART DOCKUMENT #21 "BETWEEN THE HEARTBEATS" BY BOB GIBSON—WINTER 1984

Nineteen eighty-four, the year we were waiting for, was here. "Between the Heartbeats" was in the Art Dock. Los Angeles was artthinkful. Development was good-thinkwise. Homelessness was ungood. We were speaking Newspeak. If Big Brother lived in town, he wanted more big buildings, hated the homeless, and loved the artists. He would've loved the Art Dock's new reincarnation.

A building boom was going on in downtown LA, pushed forward by the city's Community Redevelopment Agency. On Bunker Hill, soon to be home of

The Art Dockuments

MOCA (Museum of Contemporary Art), 54-story office towers of the California Plaza project at 4th and Grand rose next to the museum site. This was the third largest development project in the world. The new Sheraton Grand Hotel opened. The twin towers of Figueroa Plaza would soon begin construction. Citicorp built a 42-story building with a three-level retail mall at 7th and Figueroa. Across the freeway on the west side of downtown, building continued on the Beaudry Center to which the Pacific Stock Exchange relocated from its old building, a Spring Street landmark since 1929. This provided more vacant space for the homeless, who were everywhere.

Biltmore Hotel across the street. The underclass of drunks slept it off on the lawns around City Hall. The crazed babbled their incoherent sounds along the freeways where artists painted murals in preparation for the upcoming Olympics. The homeless wandered down past the vacant offices of the once-thriving business district along Spring Street. They loitered along the Nickel (5th street) in Skid Row, east of Los Angeles Street. They camped on the sidewalks of the industrial area from San Pedro Street to the river. They lived in villages under the Macy Street Bridge right next to the police arsenal. All around the Citizens Warehouse and the Art Dock

Kent Twitchell's "7th Street Altarpiece" mural of Lita Albuquerque on the Harbor Freeway (101) 1983–1984

Bums crowded Pershing Square, downtown's focal point. The indigent sprawled on the grass under the watchful eye of affluent travelers in the

many homeless were evident. They lived and dined in the community trash bins. You had to look first before tossing your trash or you might bash a bum.

They were observed under the First Street Bridge dropping their pants to defecate freely. The artists remarked that there seemed to be more homeless than usual, and went back to their private concerns unaffected…but not the media.

The newspapers were screaming. Something must be done about this unsightly mess. After all, the world would be in Los Angeles in July for the XXIII Olympiad, and we couldn't expose the homeless capital of America. The city had a new issue, and concerns about the artists faded. The heat was off. The building inspectors changed their attitudes about the illegal lofts and faded away. With the world watching, it would be bad public relations for the city to squash a cultural treasure while it was unable to rid the streets of unpleasant, foul-smelling, impoverished humans. The city concentrated on eliminating the destitute from the more photogenic locations. They pushed them out of developing downtown toward the river and the district where the artists lived.

In spite of more prevalent unwashed wandering their streets, the downtown artists were thankful that peace had returned to the loft district. 1984 was looking like a good year to be an artist in LA. The city wished to demonstrate its cultural sophistication. Cultural events were planned all over the city, and downtown was very much the focus. Alonzo Davis, Kent Twitchell, and Terry Schoonhoven painted large lavish murals along the Harbor Freeway next to the developing west edge of downtown. Davis's "Eye on LA" mural consisted of three tapestry-like panels with symbols: a heart, lips, an eye, the Olympic rings, a pyramid, and musical instruments. Kent Twitchell's mural, called "7th Street Altarpiece," celebrated the artists Lita Albuquerque and Jim Morphesis. The two artists looked at each other across the freeway. On the Hollywood Freeway, on the north edge of downtown, Frank Romero, John Wehrle, and Glenna Boltuch Avila crafted bold images. Avila, assisted by John Valadez, Margaret Garcia, Eloy Torrez, and others, painted a

large work called "LA Freeway Kids." Frank Romero's painting "Going to the Olympics" was a raucous riot of color and cars, which he painted with a broom. John Wehrle's "Galileo, Jupiter, Apollo" mural was a space landscape of floating classical elements and spacecraft hovering around a giant orange Jupiter in a background of dark blue. These artists created the largest drive-by public art installation in the world. They dwarfed my little drive-by gallery, but gave me and the Art Dock new energy.

Sketch of Art Dock portal by Carl Davis

"I'm a pimple on the ass of time," I laughed, but carried my negativity with me back to my loft after the three wonderful months at the beach. Determined to fight off my demons and prepare for Bob

The Art Dockuments

Gibson's show, I cleaned out my studio and rear-ranged the space once again. My old crap went to the back wall: the broken bike, the big lights, the 2 x 4s, the coiled wire, the tools, and the wire sculptures. A huge load of garbage (old tires, wire scraps, papers, found objects, broken lamps, drywall pieces, and old clothes) was swept into the trash. It was a new year, a new life, and a new Art Dock.

Leroy had me hike with him to Dante's View in Griffith Park. I was winded, sweating, and my hands swelled. This was because of the poison in my body, Leroy declared. I joined a gym and began to swim. I ate brown rice and apples for breakfast and made bean soup for lunch and dinners. I ate a lot of bean soup. I lost weight, and I felt good when I returned to the Citizens Warehouse.

Frank Romero mural "Going to the Olympics" on the Hollywood Freeway 1984

My writer friend Leroy helped me on a program to lose weight, eat healthier, and purge my body of the poisons I had, according to him, inhaled and ingested. No more bacon, eggs, butter, hamburgers, tacos, burritos, doughnuts, hash browns, or French fries. They were all loaded with fat and cooked in aluminum; it was a devilish conspiracy to destroy human health. He demanded I give up pot, and I tried with varying levels of success depending on my mood fluctuations.

Christmas 1983 came, I put up "Christ among the Vagrants," and Bob Gibson began to build a wall for the Art Dock and his piece. I returned to the Learning Development Center to practice my exercise of doing the same and saying the opposite. Several new challenges were given to me. Standing on a balance beam, I circled my arms clockwise, then counter-clockwise. It was hard to do, but I did all these exercises without going into a rage as I had in the past. I commuted to Santa Monica

through the hated traffic with equilibrium to continue my design work on the Economics exhibit, now on "Coconut Island," a computer game about inflation, and the "Robot Arm," which picked up ping pong balls and dropped them through a lattice work that sounded like a xylophone song and which taught productivity. I began work on another IBM sponsored project called the "Computer Garden," which was to demonstrate all the benefits of personal computers. There were talking trees, a logic fountain, and many games that could be played showing different aspects of computer use. I hardly had time for making art even though I was scheduled to have a one-person show later in the year at Michael Salerno's AAA Art gallery.

The crash came in late January. I was up one day and descended into a negative hell the next. I got into heated discussions with my employer. He remained calm and I blew my cool. I was tired from working long hours six days a week. He said we should be enjoying what we do. I yelled about how I gave up another morning for this crazy push. I had art to do! Racing out of the office, I went to eat a Hoagie and French fries even though it didn't satisfy. I bought doughnuts and milk. Then my tooth exploded. I lay in bed miserable. I smoked some pot, and it made me forget the pain. I could hear the voice of Leroy saying it was a boil; the evil chemicals were coming out through my weakest point, my mouth.

My doctor gave me drugs that ended the infection, and I rose and crawled back to work. The art life was eluding me even though it was burgeoning in downtown.

Everywhere you looked there was art. Public sculptures appeared all over downtown. There were many galleries in downtown then, including Kirk DeGooyer, Ovsey, Double Rocking G, the Galleria by the Water, Simard, Oranges and Sardines, and AAA Art among many others. A real commercial gallery scene had emerged. The Community Redevelopment Agency became one of the biggest patrons of downtown artists, buying large numbers of works for its office collection. The critical stance of the downtown artists gave way to cooperation and legitimacy. Even guerilla art was tolerated and critically acclaimed. Art Attack, a secret group (or a solitary artist), started to place "art statements" all over downtown in unauthorized locations. The new Museum of Contemporary Art opened temporarily in the Temporary Contemporary at 1st and Central, not far from the Art Dock. The museum provided support to the drive-by gallery in an interesting way. It provided the materials to build a wall.

Bob Gibson, the new Art Dock artist, worked for the Temporary Contemporary as an installer along with many other downtown artists, including Jeff Kaisershot. Gibson decided the Art Dock needed a more permanent wall. He volunteered to build it and elicited the help of Pamela Burgess, whom I helped coerce since she had destroyed my first flimsy wall. I had one requirement. The wall had to be moveable. Bob attacked the small project with vigor, using drywall and studs donated by MOCA. It took two weeks to build. I was away most of this time, working on designing the Economics Exhibit for the California Museum of Science and Industry. I would come home to the loft to find a huge scaffolding of studs rising from construction debris all over the area around the loading dock. Looking at this mess, I regretted my return from the beach to reopen the Art Dock. My regret did not last long, as I too was swept up in the cultural excitement of the coming Olympics.

When finished, the wall was an impressive two feet deep by ten feet high and ten feet wide, with drywall on both sides, and slide casters underneath. Unfortunately, the wall was so heavy four people couldn't move it. I complained. Bob reluctantly removed the drywall from the inside surface. The wall could then be pushed forward and back, but was very unstable and top heavy. Struggling with the wall, which wanted to pitch forward and crash on the floor, four of us were able to stabilize it

for Bob's installation. Or was it a painting? His work was hard to qualify.

Bob Gibson's work was little seen publicly. His studio over on 3rd and San Pedro was visited by few. Outside his door were displayed several small works. They were drawings that seemed to express deeply personal sentiments rendered in a very childlike style. A self-portrait positioned near the door marked the entry and identified the mysterious person who resided beyond. I was allowed to enter once. It was both a horror and a delight. The studio was small and cluttered, less than 600 square feet; an area piled so high with odd materials that one could only move about on defined trails. Stacked fragments of glass, old periodicals, and scraps of paper and wood lined the passageways. The glass shards were textured, jagged, and multicolored. They twinkled like diamond mounds. I was inside Bob's treasure chest.

Bob's early work was mainly stained glass, and he still used the material in most of his current works. Works in progress were everywhere, on tables, on the floor, on the walls, and in the windows. They lay in odd juxtaposition to other things. A canvas covered partly with a stained-glass scene of people in a hospital ward was propped up on a bookstand filled to the max with old magazines like Life and National Geographic. On a table, a collection of cactuses surrounded another work much more abstract but still employing glued-on glass. In the one large window of studio, a stained-glass portrait, looking almost pre-Raphaelite, reclined against the window glazing. Laundry draped over another piece. Many canvases, largely unprimed, with significant blank areas, covered most of the walls. The canvases had multicolored stained glass stuck on them, and a whole array of post-it notes spotted their surfaces. Each yellow tag had a written message or a small drawing. The place was incredibly messy and crowded. The bed, its covers bunched up, squeezed into a small space by the window. The sink was piled high with dishes. Clothes and magazines were strewn all over. Garbage bags were heaped by the door. Broken glass littered the floor and every raised surface. I walked watchfully, but the glass still crunched beneath my feet.

I felt I had stepped into a very private and isolated world, where pieces of litter and junk had been placed significantly. Each item was where it was supposed to be. There was no room here for any other being but Bob and his dog, a mutt who shared this lair with him. The work I seemed entirely personal. The reason for the glass, used like tile on each canvas, was understandable only to Bob. He would give me no explanation.

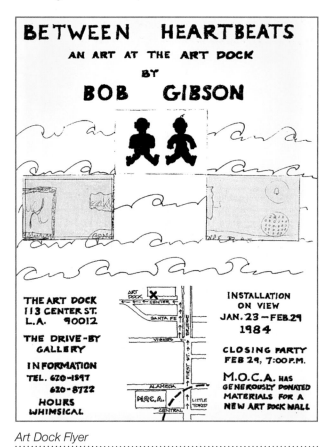

Art Dock Flyer

"Why are the canvases so naked and marked so sparingly with the glass and a minimum of paint?" I asked. Bob shrugged and said nothing.

His work was like a desert where one found

special small features here and there. His markings with yellow tags were abstruse. Glass formed an incomplete picture, sometimes realistic, sometimes abstract. The work was baffling, strange, and secretive. It made me think of Duchamp. This style was the reason I invited him to exhibit in the Art Dock, the first exhibit after a three-month hiatus.

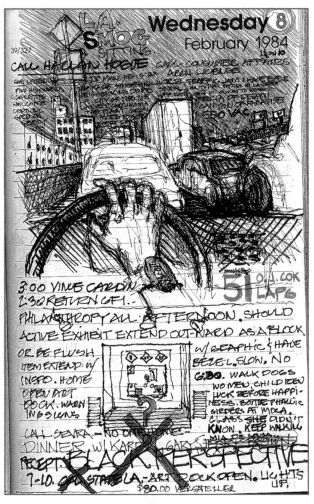

Dairy Page by Carl Davis

"Between the Heartbeats" was mysterious. Neither painting nor sculpture, it seemed like a diagram, not altogether unlike Duchamp's "The Large Glass," where the significance could only be decoded in notes provided in a green box. Bob Gibson provided no notes. A large unprimed canvas was pulled over a frame, but not pinned

behind it. The loose edges of the canvas spread out around the frame on the new Art Dock wall. Was this negation of the frame? It seemed like a needlework sampler, sewn by many Americans, the remains of fabric outside the hoop an uncut piece beyond the circle of stitching. Upon the framed canvas were mounted three yellow squares of the same character as traffic signs. Except these signs were marked with unusual images. The first was a woman symbol, the second, two babies, and the third, a horseshoe positioned upside down to look like a smile. Were these warning signs or statements of aspiration? The signs had an uneasy familiarity like the highway signs showing leaping deer in a yellow rectangle. This sign always made me hope to see a deer. Was I being warned of a woman, some babies, or a horse? Was the artist calling for a wife, children, and happiness? Bob wouldn't interpret.

On the canvas below the signs were positioned other small images. The first, in the upper left corner to the left and below the woman symbol, was a framed drawing of a red wiggly line. Moving to the right and on the centerline of the canvas below the baby sign was a rectangular piece of glass with a rod projecting from its center. A weight hung from the rod. Near the rod, a beer bottle was attached to the canvas. The bottle had been cut off and the neck of the bottle inserted into the bottom, the bottom glued onto the canvas. These two objects appeared sexual, the male rod and the female bottle. A white rod lifted a small canvas from the surface of the main canvas's lower left edge. This canvas was painted in a childlike fashion with the image of a clown. Was this a reference to the artist and his activities? In the center of the unprimed surface were some small discs. Below the discs on the bottom were two painted rectangles; one to the right, the other to the left. The left rectangle appeared to be a rendering of a grid. The right rectangle, which was the same size as the left rectangle, was painted white. Fragments of multicolored glass were glued over the white rec--

tangle, forming a second smaller rectangle. On top of this raised surface a network of wooden strips were attached. An artist who happened to walk by remarked to me that these two images looked like scaffolding in front of the Temporary Contemporary, where Bob worked. I began thinking that "Between the Heartbeats" was a very personal statement of Bob's emotions and desires. I wondered if he decided to use the Art Dock to send a love letter to some unknown member of the art community. Getting other comments on the installation was impossible; no one would talk, and Bob interpreted nothing. I made sketches of the piece in an attempt to understand.

The critic walked past the open Art Dock on her way to AAA Art to see the Kim Jones show. I was outside contemplating "Between the Heartbeats" and thinking, for no apparent reason, of its relationship to what I was doing as an exhibit designer working on a computer garden. The critic stopped and stood silently looking at the installation.

"Reminds me of Duchamp," she said.

"Really? I was thinking the same thing," I replied.

"Do you know Duchamp's 'Network of Stoppages'?"

"Isn't that at the Museum of Modern Art in New York?"

Marcel Duchamp "Network of Stoppages" 1914

"Yes. There's something in this curious piece that makes me recall that work. It's oil and pencil on canvas. Almost his last painting, 'Network of Stoppages' was derived from his 'Three Standard Stoppages,' where he dropped a meter-long string from one meter high three times, and then made shapes of the curves the string fell into. This was Duchamp's attempt to preserve forms through chance. Using those shapes he composed 'Network of Stoppages.' Duchamp imposed three layers on his painting, which remind me of the different layers in 'Between the Heartbeats.' The network was painted over an old canvas, like the clown pulled out from the grid. Duchamp painted the black areas over the old canvas to give it the right proportion. Gibson's stained-glass rectangle was glued over the white rectangle. Duchamp then drew in his network of stoppages using the three standard stoppages as a template six times. The framed squiggle recalls a stoppage to me."

"But what about the other stuff on the canvas: the beer bottle, the disk, the rods, and the signs?" I asked.

"They evoke Duchamp too. Think of his ready-mades, like 'In Advance of Broken Arm'—the shovel, the beer bottle. Or 'Tu m,' in which he has a bottlebrush sticking out of the surface, like the rod. I believe, following Duchamp's 'Museum in a Box,' that Gibson has given us his museum on a canvas."

I pondered the critic's statement, trying to make sense of what I was seeing in front of me, but I found it hard to accept.

"The work seems so personal to me. How can it have any greater meaning?" I asked.

"What? You don't know your Duchamp then. His work was highly personal, humorous, secretive, and enigmatic. Didn't he put his face on a wanted poster? Didn't he make puns? Doesn't the horseshoe upside down make you want to smile, or the babies as a warning sign make you go on guard? Duchamp worked in secret for many years on his 'Door of the

Given' and provided no explanations for his travail. Duchamp changes life into art and art into life."

The critic gave me a big smile and turned to walk away.

lation while working at MOCA, he fell to the ground. Bob was installing banners in front of the museum when the 30-foot-high scaffolding supporting him collapsed and hurled him onto the pavement below.

"Going to the Olympics" covered with graffiti 2010

I called after her. "Wait, I forgot your name."

"Oh, you, call me Rrose Sélavy," she said rolling the "r." "Don't forget your homophone. *Elle a chaud au cul.*" I knew that wasn't her name. She was making a joke. Rrose Sélavy was a name Marcel Duchamp assumed for himself.

Yeah, whose *L.H.O.O.Q.* is Bob Gibson after, I goodthink. The critic disappeared into the doorway down the street at 1001 East First Street. Just beyond, a homeless person appeared and dived into a dumpster. How ungoodful.

Postscript 2012: Bob Gibson didn't have luck in love or anything else. Several months after his instal-

Bob miraculously survived, but spent most of 1984 in a full body cast to heal his shattered body. I collected an artifact from him during that time, a 22-inch-long stick made of tongue depressors taped together and drawn upon, which he used to scratch his body under the cast. After his recovery, Bob limped and limped away from downtown, never to be heard from again. Rumor has it that he lives in Highland Park. Alonzo Davis, Kent Twitchell, Lita Albuquerque, and John Wehrle continue their careers as artists. Glenna Boltuch Avila became the director of the LA Citywide Mural Project and headed the city-owned Los Angeles Photography

Center. She became director of the Community Arts Partnership Program at the California Institute of the Arts. The LA Freeway Murals degraded. Some were lost; the others were marred by graffiti. A restoration project that hoped to refurbish the murals never happened. Caltrans (the California State Department of Transportation) eventually painted over the murals. Newspeak never caught on, but resonances of it are heard in "realquick" and "awesomeful."

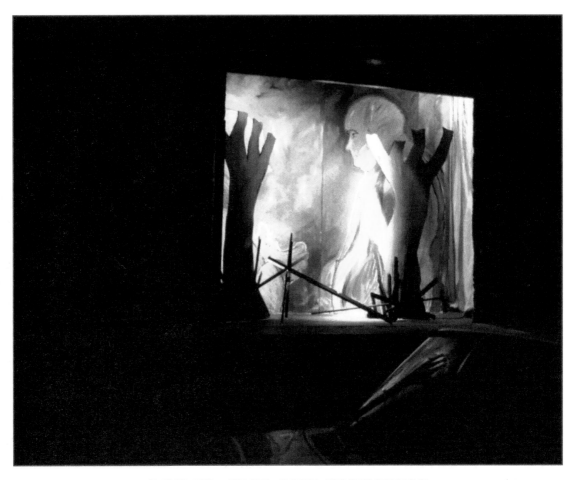

ART DOCKUMENT #22 "WATCHING LISTENING" BY SUSAN JORDAN—WINTER TO SPRING 1984

We sat in her car and watched and listened to her installation in the Art Dock. Everything was silent, except for the squeaky wheels of a shopping cart slowly moving along the sidewalk. The homeless became more aggressive in 1984 since the city pushed them east of downtown with horse patrols. Now we had more vehicle break-ins, vandalism, and dumpster-diving on the street in front of the Citizens Warehouse. The Art Dock was safe. The homeless left it alone, but Susan Jordan was more comfortable sitting in her car to discuss her installation.

Two giant men were portrayed in the Art Dock, each standing behind a tree. The trees stood in a network of sticks. The two trees, which were trunks with the limbs cut off, gestured toward each other, creating a basket of space. The tree on the left bent forward. The huge man behind it was obscured except for his eyeglasses, nose, mouth, and chin. His two hands were cupped in front of his face and touched as if holding some delicate object or making a point. The arc of the tree and the position of the hands depicted this man as the deliverer of a statement. The dismembered tree on the right bent back

in response. The taller man was mostly obscured behind the trunk except for a head and a hand that rested against his large stomach. This man stooped slightly forward as if intent on listening yet exerting the power of his bigger presence. A silent one-act play had run its course in the Art Dock. Susan and I sat in her car and talked on the night of the final showing. Her show passed so quickly I hardly got to know "Watching Listening."

"Out of my hands! Existence is fluff; there's nothing to be done," I wrote in my daily diary. My fate went with the wind. My mind rebelled against the thought, but I would drift until I crashed upon the rocks, was saved, or was drowned. I felt I mattered little. My inner mental tape was obsessively negative. Survival consumed me. At one point, I had eighty bucks left in my checking account and 600 dollars in bills. The exhibit I was designing was ironically called "Risk/Profit." In my life, I seemed to be taking a lot of risks, but realizing very little profit. My employer, Glen Fleck, and his backer, IBM, had a big showdown with the California Museum of Science and Industry that determined if they were going to pay or if we were going to quit designing. The museum paid up. I could proceed with work with even greater demands on my time.

I was so busy that I didn't give Susan Jordan's piece much thought. The assistant curator Marti Kyrk, my partner in the architecture firm he and I founded, who came daily to work in the loft, kept the Art Dock open during the days while I was in Santa Monica designing the economics exhibit. When I was back downtown, I was preoccupied with dyslexia retraining and preparing, then hanging, my own art show, a one-man exhibition of my drawings and sculptures at AAA Art.

At the Learning Development Center, they had new challenges for me. The trainer placed a series of four shapes on a brown flannel field. She then covered them up and turned to me and told me the repeat the pattern on another flannel field. I thought

that would be easy. I'm a visual person. I could remember the shapes' placement. I failed repeatedly and got increasingly frustrated. I slammed my hands on the test table and walked out. I despaired of ever overcoming my dyslexia.

Diary Page by Carl Davis

In my free time in the studio I drew huge drawings. They were fun and allowed me little time to worry about my dismal financial circumstances. I drew my daughter dancing in the Art Dock larger than life in tangle of lines that simulated movement. I tried drawing a drummer from the Venice Boardwalk striking his drum and shaking in a new style that tried to capture multiple images. I set up my latest

wire sculpture called "Sebastian," after St. Sebastian who was pierced with arrows. The wire column was pierced with wooden stakes and capped with a red plaster cube from which a plumbob hung down into the interior space of the column. I felt like a real artist. If only I could find more time to explore these ideas, I could get somewhere in my quest for a career as an artist. My show opened on March 25th and remained open past the end of "Watching Listening" in the Art Dock. The last evening of the Art Dock show would be the only chance when I could talk with Susan Jordan about this work and her life as an artist.

I was so busy during this time that I hadn't given Susan Jordan's piece much thought. Daily I was in Santa Monica designing the Economics Exhibit for the California Museum of Science and Industry. Back downtown, I preoccupied myself with my own art show, a one-man exhibition of my drawings and sculptures at AAA Art. But I wanted to take time to talk to Susan.

"Tell me about 'Watching Listening,'" I asked.

"First of all, what intrigues me about the Art Dock is that it's a proscenium stage," she said. "I have always loved theater and desired to get involved. The piece was a visual play. I was thinking of narrative, but I wasn't telling a whole story. It's a picture you could make a lot of stories from. The two figures involved are politicians. One is American; the other Soviet. They're very serious. I wanted the piece to be about dialogue. It's about the forest through the trees. The men are just one element of the piece. The props in front of them, the lifeless dead trunks, and the latticework fences are important."

"What I really like are the trees," I said. "I think of Goya's 'Disasters of War,' where the tree stumps provide the visual drama for the hanged men."

"In 'Watching Listening' the trees gesture to one another and carry on a dialogue," Susan responded. "The piece is very circular. The trees create a warped circle behind which the two heads surround a central

place of dialogue. The piece for me is the wait to see what happens. The person who drives by is part of the art. When someone drives by I want them to say, 'What was that?' I want them to slow down and look, even if it's a momentary glance. I want the same kind of response as when you flip the page of a book, where sometimes an image stays with you in spite of its quick appearance and disappearance."

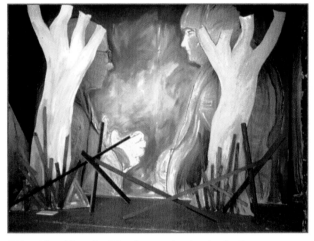

"Watching Listening" by Susan Jordan in daytime

"I get it," I said. "It's like the distant conversation of two individuals seen across a populated room. I can see the way they stand, move their heads, and hold their hands. I stop to watch and listen, but the scene is too far away to hear. I believe if I try hard enough I will decipher something of great importance, but I never can. The scene is pregnant with meaning, but calm in my mind. I have to make up my own story. I create my own narrative. You've constructed a play."

"Yes," Susan replied. "It's a play triply removed from the reality of the street. The first abstraction is the proscenium of the loading-dock portal. The second abstraction is the chopped tree trunks, and the third is the larger-than-life human forms. The driver passes by and sees a silent motionless narrative through these veils."

"Do you consider yourself a narrative painter?" I asked.

"No, I'm not. I'm definitely a sculptor; I don't know anything about paint." Susan responded. "This is a pivotal piece for me because it brought up issues of space. I think it'll be the last time I do anything in a painterly narrative. I only work with objects that are painted."

Dan Flavin's "Monument" for V. Tatlin 1964

"Do you want people to respond in an emotional or intellectual way to your work?" I asked.

"I want them to respond on a gut level."

"Most artists want that kind of response," I stated.

Susan sat up in the car seat and stared intently at me. "I think your first response to art is emotional. If you like it then you go beyond. I'm interested in your senses. I'm not interested in art as a home improvement project. Have you seen what's showing over at MOCA?"

"Dan Flavin is showing his 'Monuments' for Vladimir Tatlin and Michael Heizer has built in his 'Geometric Extraction,'" I replied.

"And what do you think of them?" Susan asked.

"I love the humor and clarity of Flavin's 'Monuments.' It's so un-monumental in that they're simple fluorescent tubes that can be turned off and on and will burn out after a couple thousand hours. This is humorous. It's monumental in that he took a common light source, changed its functional use from illumination into art, isolated it to concentrate on its light quality, and made us aware of its form and content. This is clarity at an actual and an intellectual level. Associating the work with the great Russian constructivist Vladimir Tatlin is a nice touch. It helps reinforce the idea of new technological forms and the implicit content that goes with technology."

"And what about Michael Heizer, the great earth artist?"

"His cardboard mountains at MOCA didn't blow me away. I thought the poster was better. '45 degrees, 90 degrees, 180 degrees-Geometric Abstraction' it's called. The damn thing is huge. I know Heizer likes to make art that's so big that it's not possible to take in the piece at a glance. All I know is that I felt like I was at sea surrounded by zebra icebergs. I like the idea of his earthworks better, although I've never seen one, just a pricey photograph."

"Heizer's images are about the content of form," Susan replied. "Mine are about the anthropomorphic form. It relates to humans and living things."

"What do you think about the artists in New York City, like Schnabel and Basquiat?" I asked.

"I'd rather not comment. What do you think?"

I smiled. "You opened that up for me. I just read in the *New York Review of Books* a piece by Junius Secundus—I don't know who that really is—called 'The Sohoiad or The Masque of Art.' It was quite marvelous. I even memorized a few couplets. Would you like to hear?"

"I doubt I could stop you," Susan demurred.

I quoted with much gusto:

And now the hybrid child of Hubris comes-
Julian Snorkel, with his ten fat thumbs!
Ad Nauseam, he babbles, honks, and prates
Of Death and Life, Careers, and Broken Plates
And as his victims doze, he rants again
Poor SoHo's cynosure, the dealers dream
Much wind, slight talent, and vast self-esteem.

A car drove slowly down Center Street. It paused in front of the Art Dock and moved on.

"No. I'm not a performance artist. It's not enchanting to me."

"Too bad," I answered. "Performance art is a lot of fun. I recently participated in the Five Minute Performance Olympics over at the Orwell Memorial project at one of the studios in the LACE building. Linda Burnham, Steven Durland, Paul and Karen McCarthy, and Lin Osterhage put on this event. The performances were judged by a barking dog—the more barks, the higher your score. I performed with

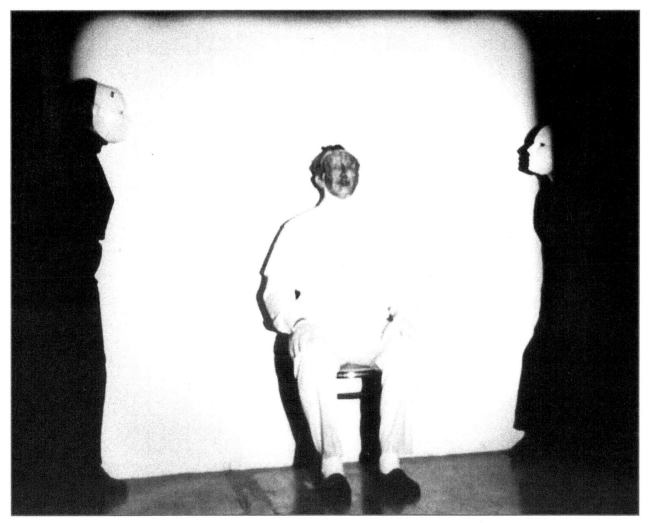

Carl Davis performance at the Performance Olympics with Lena Rivkin and Pamela Burgess- photo by Paul McCarthy

"I see your Art Dock play is working," I said. "Do you do performance art? That seems like a logical extension."

Pamela Burgess and Lena Rivkin. We dressed in white sheets and sat in three chairs in a row. I was in the middle. I blathered on, wearing an Iroquois wire

mask, about Indian ghosts and the drunken Indians next to Exile gallery. Pamela and Lena made weird sounds. The whole thing was terrible but a great experience. I don't think the dog barked once. Sally Roberts won our preliminary round. Michael Peppe was the ultimate winner."

"I think I missed that," Susan said.

"How did you get involved in the set idea?" I asked.

"When I lived in Minneapolis I had a nice studio with four working corners. In one year I made ten different vignettes. I would build these pieces and live with them for four months, photograph them, and tear them down for something else. I would rotate them around the studio to these different areas. Some of them were like beach scenes with benches and towers. They were like large-scale models. In Minneapolis we had a long hibernating time when I did my work. When I came to LA, everything seemed like a stage set."

"You can't walk around in LA without walking into a real stage set. Sometimes I walk down the street and I'm not sure whether this is real or not," I replied.

"When you live here," Susan responded, "you see how things are done in film work, and you see how futile it is to replicate something from life, something that someone else can do so well. That pushed me away from the stage set to something more abstract. I started to work in a theatrical way. I made a piece called 'East Meets West' with two people bowing. I come from Connecticut where all the people are white. When I came here I had a studio in Little Tokyo where there were Japanese and Chinese. I had never seen people bowing before. My work is very evolutionary. There's a beginning, middle, and end. I could never farm out my work to someone else like Koons does. The important aspect of my work is what it's made of, how it's made, and when it's made. I think the current trend in the art world is that this attitude is not important."

"You are talking about creating a body of work that develops over time and reaches mastery later," I commented. "It's a view that's tied to the work itself and not a trend in the art market."

"If you look at Louise Nevelson, she hit her stride at eighty, very late in life. Her work developed outside of a movement. The same is true of David Smith and Mark di Suvero. Di Suvero plays with I-beams. He's a tinkerer. It's all about that tinkering for me, which brings me back to the studio. I have to have a space to be able to tinker and the time to do it. I can't work a few hours here and there. I need time for ideas to germinate."

"Do you get to work on your art every day?"

"No, I do other things here and there to get by. What becomes odd is when I find myself doing other things to survive, like painting houses. It's strange when I can't get into the studio for three weeks because I'm doing survival things. I think I would be better off if I had a full-time job, but I've managed to get by for years in LA living this way."

"How do you define yourself as an artist?"

"I'm an object-maker in three dimensions. The issue of the stock market doesn't interest me. I'm stuck somewhere between the caveman and the Wild West."

Apparently money and the preoccupation with the monetary worth of her work wasn't a concern to her. Like the cavemen of Lascaux, she was interested in communicating with others. But like the Wild West, the communication came from the barrel of a gun.

"That's a curious analogy. Being an artist doesn't mean wearing a cloak or putting on a profession?"

Susan responded, "I am an artist; that's how I function in the world. I approach the world in a funny fashion. I tend to experience things head-on. I'm not like a lawyer who is totally rational. They see something hot and don't touch it. I would touch it."

Postscript 2012: Susan Jordan Yoshimine moved to Santa Barbara to teach at Santa Barbara

City College. She later moved back to Connecticut. Louise Nevelson died in 1988. Dan Flavin died in 1996. Mark di Suvero lives in New York City and has studios on Long Island, New York, Petaluma, California, and Chalon-sur-Saone, France. Michael Heizer continues work on his "City" in the Nevada desert, possibly the largest piece of contemporary art ever made. "City" evolved out of his geometric abstraction piece show at MOCA in 1984. Completion of "City" was intended by 2010, but now in 2012 it remains unfinished and is threatened by the federal government's Yucca Mountain nuclear waste disposal site. In June 2012 Heizer installed his 340 ton rock above a pedestrian underpass at the Los Angeles County Museum of Art (LACMA). Julian Schnabel is more famous than ever. He has become an acclaimed filmmaker, whose work *The Diving Bell and the Butterfly* (2007) was nominated for an Academy Award for Best Director.

Michael Heizer's City in the Nevada desert 2010

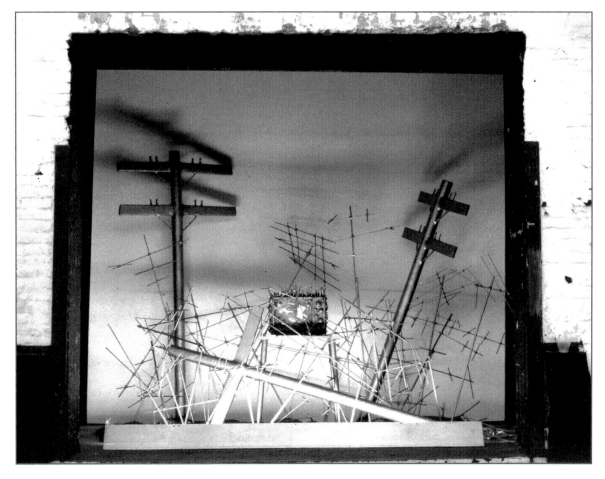

ART DOCKUMENT #23 "MEDUSA"
BY ANDI ALAMEDA—SPRING 1984

"The Art Dock is like a TV," stated Andi. "So it seemed appropriate to place a TV into the Art Dock. 'Medusa' is a commentary on the effect television has on every male I have ever known who, once they sit down in front of the TV turn instantly to stone."

I listened to Andi's words, recalling her sly smile, and laughed as she spoke. I lay in the Art Dock on a lazy Sunday afternoon in May with the sunlight beaming in, making the gold-lacquered installation shimmer. I had my earphones on, listening to my tape of the conversation between Andi and me.

When I turned off the tape, I pondered all the media attention that was coming to downtown but not to the Art Dock. There was the story in the *LA Times* in April about the pioneer settlers of the newly named Loft District. The artists of the Citizens Warehouse were not mentioned. There was LACE's open studio tour, which didn't include the Art Dock, and LACE's Cotton Exchange Show. I thought about real estate, art, and my work on the economics exhibit for the Olympics. I was designing the Reward Show enclosure, a postmodern composition of rectangles, columns, capitals, and

simplified pediments. The Reward Show was an IBM game that, once completed, would spit out a certificate verifying that the visitor has completed a quickie education in economics. I wondered if my education in art and artist housing was coming to an end. I imagined MOCA, the Art Dock dog several months deceased, lying on the sidewalk in front of the loading dock. I gave the dog my opinions on all these events, but she never talked back. Good dog.

I turned on the tape again. My conversation with Andi took place at Vickman's Restaurant and Bakery, a local artist hangout in the Produce District. Vickman's was one of the sponsors of LACE's Cotton Exchange Show, along with the Community Redevelopment Agency (CRA), the California Institute of the Arts, Roark—the local art store, Linda Burnham and Steve Durland of High Performance/Astro Artz, among many others. On the tape, Andi and I discussed her piece over coffee and a Danish. I asked Andi about the theory of the Art Dock as a metaphor for the commoditization of art and the significance of Los Angeles urbanism.

"What theory?" Andi asked. "The idea is to kick back, have fun, and have an opening." I pointed out to Andi that the Art Dock didn't have openings, it had closings.

"No matter," Andi responded. "I like to think of the Art Dock as positive generator of ideas. It's serious and fun at the same time."

"It does have a humorous quality," I said. "And so does 'Medusa.'"

"Medusa" was a small television covered with a fleshy and flashy gold substance, from which small pointed spikes and breasts projected. "Medusa" was positioned on a table in a network of gold-lacquered telephone poles and antennae. The television screen was almost entirely covered in gold, allowing only small areas of image to be seen. Static played on the TV.

"What were the telephone poles and antennae supposed to be?" I asked.

"The telephone poles represent technology, language, and dialogue. The antennae are a way of transmitting data. It's a whole piece about information," Andi replied.

"That's heavy," I said.

"Other artists and critics have said that my work uses a low vehicle for a high purpose. I use elements of the science fiction thriller and the horror movie for generating an alternative meaning. Bad taste is employed, but mitigated and inverted by a sense of humor, which can turn pessimism into optimism."

"'Medusa' is optimistic?" I asked.

"It's optimistic in that it is funny. 'Medusa' recognizes that TV is the foster mother of my generation. It's our babysitter, companion, and teacher. We are its children. TV is the thing through which we stare off into space. It's our God."

The tape was silent for a few moments. I remembered Andi's wistful look, like she was staring off into space.

"Don't turn into stone on me now, Andi," I joked. "Tell me again what you liked most about the Art Dock."

Andi looked up and responded slowly. "In the Art Dock I was free to do whatever I wanted. The audience was only your peers."

"Well, we have the homeless audience and some people who came for the open tours got to see it when they got lost in the back streets or saw the flyer," I stated. "But that was in the daytime. Didn't you want your piece to be displayed mainly at night?" I asked.

"I think my pieces in general function best in dramatic lighting. They do function in regular light, but I have a hard time figuring out how to light them, so I use corny theatrical lighting, like you would see in a horror show at an amusement park. Dramatic lighting is not very fashionable in the art world. 'Medusa' has its surrealist shadows like the movie 'The Cabinet of Dr. Caligari.' I think 'Medusa' at night mimics the surreal quality of life in downtown."

"Is this the side show as art?" I asked. "The bearded lady, the elephant man, and the coochie-coochie girls come to Center Street?"

"Could be," Andi replied. "But we are the side show in more ways than one."

"That's true, the open studio tours and the Cotton Exchange Show were the main events," I said.

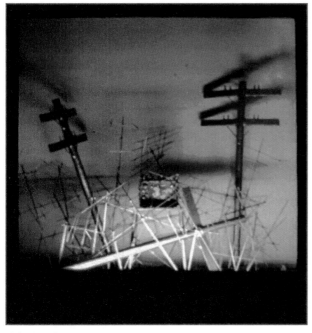

"Medusa" at night

At this point I switched off the tape, and lay in the loading dock thinking about my life for the past several months, the open studio tours, the Cotton Exchange Show, and the relationship between art and real estate.

Art dock was the sideshow to my complicated and unhappy life. I wrote in my daily diary, "I give up. I owe the government $3000 in taxes. Why continue to live? I'm just slipping backwards into the hell of poverty... I thought about when in college they called me "los," short for Carlos, but to me it was "los," short for loser. I'm lost before I began. All the way down to childhood. Who? The government! They'll take what they want according to their law. I'll never understand it. Explain it to me again. I can't

live with my mother or father, but must live in this hell until some future time."

The thoughts were jumbled and half-layered over one another. I revisited all the places of my distress: my childhood trauma, my everyday work on the economics exhibit, my desperate financial situation, my closing art show, and my training at the Learning Development Center. I thought of killing myself. In a moment of monumental sadness and anger, I tried to strangle myself. It's impossible to do. I sat at my kitchen table looking at a long knife I inherited from my grandmother, part of a set of kitchen knives I was sent when she died. I thought about ramming the knife in my chest. Instead, I waited for the mood of suicide to pass, and called my psychologist Dr. Wortz to set up a time to come and see him.

He put me back in the group therapy session, and elicited a promise from me that I would not commit suicide until October. He asked me what was holding me back in my life. I did not know. Was it the name I would not say, the truth I would not admit? Was I homosexual or traumatized by child-hood abuse? Was I afraid of love and women? I couldn't verbalize any of these answers. None of them seemed like the truth. Was I just mentally ill? I could only respond to the irony being almost desti-tute while designing an exhibit explaining economics to people. I could speak only of my fear and desire to be called an artist. I could remark only on the frustration I felt trying to learn left from right.

In my economics exhibit, the little city of post-modern forms, I was designing three shows: "Selling Umbrellas," which spoke to making profit from need; "Prosperity Station," which described how prosperity is achieved in a capitalist system; and the "Reward Show," which tested a people's knowledge and gave them a certificate if they understood what they had seen. I was blocked in the design. No ideas were coming to me. I thought it was because of my own negative attitude toward market capitalism. Yet a week later I completed the

design at break-neck speed. There were only a few months left before this exhibition was to be installed during the 1984 Olympic Games in a new building adjacent to the LA Coliseum, the main stadium of the games.

My art exhibition ended on April 21. I wrote in my daily diary, "My show is over. No sales? Maybe one. No reviews. Passed with barely a ripple. Where's the fame? Where's the GLORYYYYYYYY...Right left, nothing happened, left right. No Sales, right left, reverse. I had a show, left right. I'm an artist, right left. See the good, left right!" Could I see the good in anything?

The Learning Development Center impinged on everything in my life. They had a new exercise for me called the beanbag toss. I called it "flying beanbags on the path to perception." The instructor held a plate in her hands about four feet from me while I held a plate full of bean bags which I would toss into my instructor's plate. I tossed a bag with my left hand. It landed on the plate. "Step back, right arm forward, toss," she said. I missed.

"Shit," I exclaimed.

"Just relax," she said. "Now step back, left arm forward, toss." I tossed and missed again. "Step back, right arm forward, toss," she said. I tossed and missed again. "Step back, left arm forward, toss," she said. I missed again. Step back toss, step back toss, alternating arms, we did this eight times. Only twice did I hit the plate.

"Is there a reward for this?" I asked. "Do I get a certificate of good completion of the bean toss?"

"No," she replied. "But you will profit from it."

Did I believe there was life beyond OPROFIT? I scrunched this idea as the mantra of left right left right played in my head while I lay in the dock musing about the LACE studio tours. The LACE open studio tours took place over the weekend of April 28 and 29. The studios open were generally clustered east of LACE's exhibition space on Broadway in a small area surrounded by Main, 2nd, Central, and 6th.

Another small group of studios were bunched around San Pedro and 8th. I knew few of the sixty artists in this show except for Kim Abeles, Sheila Elias, and Marguerite Elliott, who was scheduled to show in the Art Dock in the fall. The tour was a big success. Many people came. Many of the artists who weren't included in the show tried to steer visitors toward their studio buildings on the perimeter of this central area. Artists were starved for attention, and would do almost anything to get it. Artists on Molino Street, around the American Hotel on Traction Avenue, and in the Citizens Warehouse on Center Street put up signs proclaiming their existence and availability for viewing. I spent Saturday papering the tour zone with the Art Dock flyer while others kept the loading dock open. A few intrepid souls found their way to Center Street, the Citizens Warehouse, and the Art Dock.

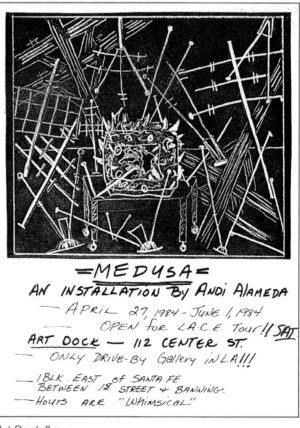

Art Dock flyer

I remarked to my missing dog that my advertising effort was generally an exercise in futility, but fun. I imagined the dog looking at me, giving a brief bark. I took that to mean the dog agreed with me.

I thought about the quote I read in the *LA Times* on April 15th in which the head of the Getty Museum, Harold Williams, stated:

downtown would ever hear that voice from the low-powered transmitter of the loading dock. What was seen was all the commotion about the new settlers of downtown—architects and young professionals mainly—and LACE's Cotton Exchange Show. The spotlight on the new settlers was in contradiction to idea that the loft scene was dead and the Cotton

The Cotton Exchange Building at 3rd and Main Street

The history of art is really the visual and tangible history of civilization. It's the only record that gives us their version of how past societies saw themselves and the world. Art can provide an understanding of the values and forces that shaped other societies and act as a guide for us.

How would the art of downtown be viewed in the future? What kind of guide was the Art Dock? Was it a truly a commentary on the commoditizing of art as recorded in the Art Dock Manifesto? Were the artists who show in it of any great import? Did the drive-by gallery really matter? I didn't have answers to all these questions, but I did know that it spoke—perhaps quietly—about the history of civilization in late 20th century America in a funny way. It was yet to be seen whether a larger audience than the peers of artists in

Exchange Show was razzle-dazzle, covering the true facts of redevelopment in downtown.

In April, the *Los Angeles Times* carried a story about Eve Steele, an architect, who was renovating the Old Challenge Dairy Building, Michael Tolleson, an architectural and furniture designer, and Jan Rowton, a fashion designer, who lived in the renovated Canadian Consulate Building on 432 South Main Street. This building housed Exile gallery, and many artists, before it was renovated. Eve Steele was quoted as saying:

"New York does have a level of sophistication we don't have here, but Los Angeles has a raw kind of creativity and real textural quality. In the past couple of years, it is the young urban professionals who are moving here, not only because of the relatively

competitive prices but because of the possibility of having a great personal freedom in choice of their environment."

of historic interest. Demolishing the building was the first step in cleaning up the area called the Historic Core, currently overrun by the homeless who slept

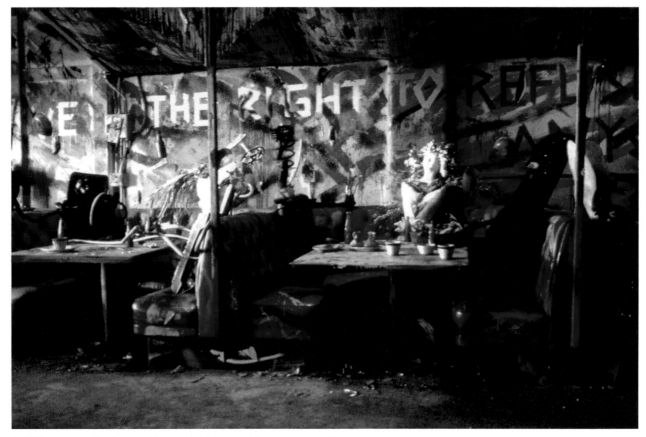

LACE's Cotton Exchange Show exhibit in an old restaurant 1975

Eve Steele estimated that there were 2,000 people residing in the area inside the four freeways. This was the beginning of gentrification. The developers were coming. Those who could renovate and pay 75 cents to a dollar per square foot were replacing the artists who rented for fewer than 20 cents per square foot. I asked MOCA if she thought we were goners. The dog was silent. I guessed the jury was still out.

LACE's Cotton Exchange Show, which started April 17th and extended through June, was an amazing event for what it was and what it implied. The Cotton Exchange Building was soon to be demolished, a sad fate for a concrete-reinforced building

and caroused in a small park on 3rd Street across from the building. The Community Redevelopment Agency (CRA) planned to replace this building with a state office building. Prior to its demolition, the CRA, with LACE and other sponsors, allowed artists to display their work in the doomed building. More than 200 artists responded to this free opportunity to display their work and transform the building's interior. Tom Heller described the situation in his article "Rattling and Rough Cut…," which appeared in the mini newspaper that was distributed for the show.

"Artists are taking the representation of art into their own hands. A whole new generation is becoming increasingly aware of the social aspects

of art. ...Projects...have been approaching art as a radical communications medium rather than as a self-referential signifier of art historical trends."

He added,

"Today's younger generation of artists is compelled to put their art back into the world from which it took its inspiration...The feeling is evident whenever you walk into an artist's studio, see graffiti in the street, or when you think of Robert Smithson's "Spiral Jetty" in Utah's Great Salt Lake."

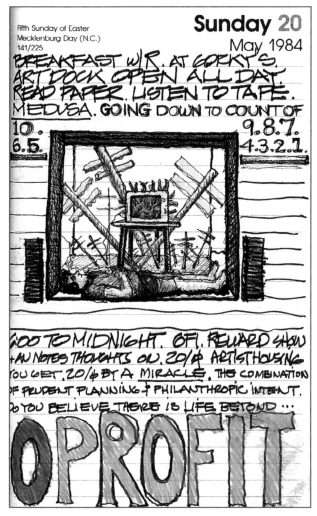

Daily Diary Page by Carl Davis

I looked at the situation differently. I saw a building stuffed with art of all kinds, most of it bad but some of it quite interesting. The exhibition wasn't for me about art as a radical communications medium, a self-referential signifier of art trends—although there was plenty in the show that mimicked this stance—or the compelling need to put art back into the world from which it gained inspiration. It was about the fanatical desire of artists to find any venue for their work. There were too many artists and too few places to show. The artists might have said they were making radical communication, but in reality they were being used by other powers for their own ends.

In spite of my assessment, I had to say the Cotton Exchange Show was marvelous fun. The whole of this six-story building was given over to artists. The artists swept over the building claiming the rooms, the staircases, the hallways, the bathrooms, and the retail shops for their work. Many did installations— some very political—others displayed their paintings and sculptures. Peter Zecher displayed "Marilyn" again in a storefront window. Pamela Burgess placed a gigantic aluminum foil snake in a niche next to the fire-sprinkler riser. Bob Gibson hung one of his works in the entry hall next to the main stairway. Jeff Kaisershot made a spray-painted wall of silhouettes from the same kind of small objects he exhibited in the Art Dock. Artists whose names I did not know painted whole rooms in their styles. Every inch of the building was covered or altered by works of art.

Brett Goldstone, an artist who would soon exhibit in the Art Dock, made what I think was the ultimate statement of this art event. In a room on the ground floor, way in the back of the cavernous office building, he placed a mechanical monster that gorged on cans. The figure was made of open welded wire fabric, the inside of which was stuffed with garbage. The head was an enormous open mouth. One arm moved, descending from mouth to side in a slow, jerky, robotic fashion. The arm grasped a crushed can, simulating the monster stuffing itself with goods. Again and again the arm moved from side to mouth and back. Amidst all the

clamor of competing art, the monster of the midway with its insatiable appetite was the most entertaining. At the opening, attended by thousands of people swarming all over the building, Bret's monster collected the biggest crowds. The Cotton Exchange show was a carnival of art. I couldn't help but think that somewhere in this I was being conned by the old shell game in which the bean was never found beneath the shell you chose. I asked my dog if this was true. I heard the dog give me two quick barks. I knew I was onto something.

Artists were being used—albeit willingly—in a political game, which diffused the focus from the destruction of a perfectly good building, a building that, had the sentiment been there, would have made excellent artist housing. As I lay in the sun I pondered about how if you want to destroy a structure, give it over to the artists first. I thought of Andi's idea—that we live in Oz. I would like to think of myself as a wizard, but I knew that the real wizards lay in City Hall and in the high-rises blooming on Bunker Hill. I was just a lizard of Oz, lying on my dock in the sun, consulting with this imaginary dog, my wizard.

Postscript 2012: Andi Alameda became an art gallery curator. Today she is an Exhibition Project Manager and Traveling Exhibit Coordinator of the Autry National Center, a museum in Los Angeles named after Gene Autry. Her art today is jewelry making. Andi says her life is art. Kim Abeles remains a well-known Los Angeles artist. Sheila Elias moved to Miami, Florida, where she pursues her art career. Eve Steele, industrial designer, and real-estate developer, is the founding chair of LAXART and a board member of REDCAT, UCLA Live and Creative Capital, an organization that provides integrated financial and advisory support to artists. Michael Tolleson, architect, now pursues his career in Emeryville in Northern California. Jan Rowton owns a fashion shop in Malibu, California. Tom Heller is a film producer who, with co-producer Oprah Winfrey, produced the movie "Precious." The Cotton Exchange building was demolished and replaced by the Ronald Reagan State Office Building. The Reagan building houses several works of art, including a mural by Elsa Flores and Carlos Almaraz called "California Dreamscape," a grizzly sculpture by Mary Chomenko, and a wall piece by Billy Al Bengston. When Eve Steele estimated there were 2,000 people living in downtown in 1984, it was just the beginning of Downtown settlement. In 2012 there are over 50,000 people in the central city. The homeless still hang out in the park at 3rd and Main Streets behind the Ronald Regan State Office Building. Men still turn to stone in front of the television.

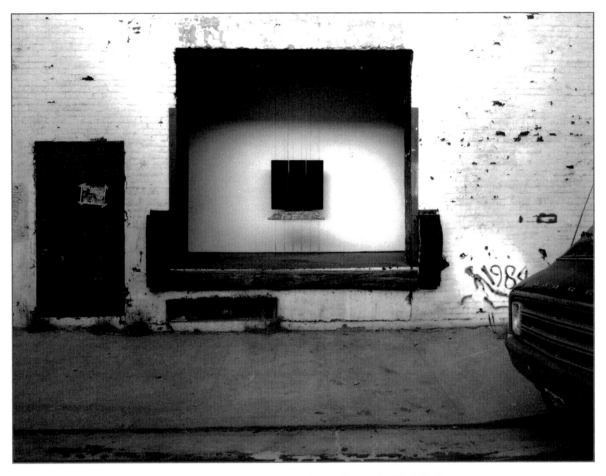

ACT III THE ART OLYMPICS

ART DOCKUMENT #24 "COMEDIA DEL ARTE"
BY LEONARD SEAGAL—SUMMER 1984

The Art Olympiad was in full swing, and the Olympics would open on July 28. I was driving back to downtown with my imaginary dog, MOCA, riding shotgun. I was chewing over what was going on in my life and in the city. It was Sunday, June 10th, and I had spent the day in Santa Monica working on the final parts of the economics exhibit scheduled to open with the Olympics. Would "Marx and Smith" be finished, or the money cases have the entire world's currencies in it? Would the reward show spitting out diplomas work? Would I have all the

targets designed for the "Water Machine Game," which shot a stream of water at increasingly farther-away targets? The "Water Machine Game" demonstrated how money was spent, from housing and food, to the arts and culture. The arts and culture targets were the farthest away in the little house that held the game and were the hardest to hit. Was labor cheese and profit air, as I jokingly remarked to one of my co-designers? I sketched two exhibits with these titles on a daily diary for March 22nd as a statement of the overall absurdity of my economic life.

The Art Dockuments

"Life in the land of dog shit," I wrote in big letters at the top of my daily diary for June 10ᵗʰ. I continued to suffer from periodic depression, and each negative event in my life drove me down. The Unemployment Commission had me on perjury of my weekly statement from when I first started working on the economics exhibit. I had only worked a few hours. I had made an error in the weekly statement. I was called to appear before an administrative judge, who disallowed all my statements. It didn't matter that I was struggling to survive. It only mattered that I signed the form, which said I didn't work when I did work. I wanted to get up and slug the bureaucrat, who sat behind the big desk with her microphone and tape recorder, but I didn't. I was powerless, branded a cheat, and slipped away angered and depressed.

The job that I was accused of not reporting, the project of the economics exhibit, was going to end soon, and I would be unemployed again. Only this time I would be disqualified for benefits because of one weekly report. There was only one month left to finish before the Olympics opened, and then I would be out the door. I started to sink into depression and suicidal thoughts, but there wasn't time to indulge those thoughts for long. The project consumed me. "Prosperity Station," "Water Machine," "Productivity," and the "Reward Show" had to be finished. I had to focus, and I did.

I focused on my design work, my retraining for dyslexia, and my health. I threw myself into the design work, laboring long hours. At the Learning Development Center, I found certain tasks I could do well. I was good at shapes and color, and could make copies after seeing the original patterns displayed for only a moment. I walked the Loman Rail and bounced on the trampoline saying left and right with fewer errors. The instructor said I was getting better. I swam. I ate brown rice.

Doctor Wortz recommended I stop smoking dope and start to meditate. I did stop smoking weed with moderate success, only falling from

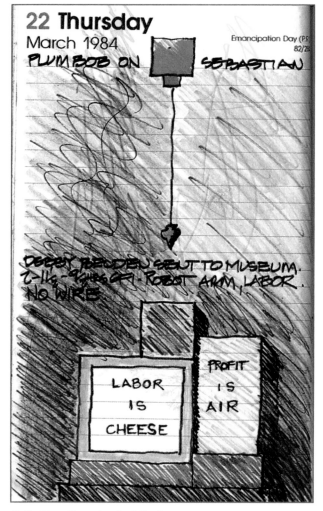

Daily Diary Page by Carl Davis

sobriety a couple to times when the stress and tension became overwhelming. Meditating calmed my fevered brain, and I vowed to do it every day, which I didn't, but I did enough that the snakes of negativity did not arise. There wasn't time for art. There wasn't time to think about it, make it, or go see it except for brief visits to four shows in a city blossoming with art exhibits. The Art Dock took at backseat to all my other concerns.

The economics exhibit was behind, and the boss told me we were running out of money. He might stop the work. Nevertheless, we had to press on. It was the Olympics, and the world would be looking at LA. I wondered if the California Museum

of Science and Industry (CMSI), which sits right next to the Olympic Stadium in Exposition Park, would be ashamed that its big exhibit on economics failed to open. Our team was working very long hours to get the exhibit done. The extreme push was beginning, and when it was done we would all be unemployed. But that was of small consequence; the project came first.

Cover of LACE's Samizdat Exhibition announcement 1984

The demand on my time was so great that I missed many of the events of the Olympic Arts Festival. The LAVA (Los Angeles Visual Arts) tour took place one weekend in Venice, and then came the next weekend to downtown LA. I was unable to go, but I imagined the crowds. Cars would jam the streets looking for the few parking places in the loft district. Busloads of people would swarm over the twenty galleries shown on a map printed in the *LA Weekly*. There were galleries I'd never visited: Gallery 318, the Eighth Street Gallery, Daniel Gouro Associates, Interpol Gallery, and the Thinking Eye Gallery. Many of the galleries were showing artists I'd never heard of: Factory Place Gallery with two Wisconsin artists, Ron Bitticks and Jill Sebastian; Double Rocking "G" with Dennis Curtis; and LA Art Core with Julie Belnick and Harold Nathan. On the Saturday before the economics project final push began, I kept the Art Dock open for any LAVA tourists who might pass in front of the dock after a visit to AAA Art. I closed the dock early to go to LACE's Samsizdat (Soviet underground art) Art opening. On Sunday I left the Art Dock to Lenny Seagal to keep open for the tours.

LACE's Samizdat Exhibition came to LA after a showing at Franklin Furnace in New York in 1982. Its tie to the Olympics was ironic, since, two months prior to the opening, Russia decided to boycott the LA Olympics because they were highly commercialized. The LA Olympics were the first ever to be privately financed. I guessed that the Soviets were not coming because America boycotted the Moscow Games in 1980 as a protest against the Russian invasion of Afghanistan. The Soviets were giving us tit for tat. The two events weren't tied in any way, but LACE's Samizdat presented a literal slap in the face to the repressive Soviets. The Samizdat show displayed the work of twenty-eight Russian artists who self-published books of art, poetry, and photographs starting in the 1960s. Since the work was illegal (copy machines were forbidden in the Soviet Union, and publishing was controlled by the state), ingenious methods were utilized to get the work into the hands of sympathizers. Some books were boxes full of typewriter paper, drawings on scrap paper, and photographs. One book used tobacco for the pages. One book was a collection on toilet paper. There was a six-foot man displayed

against a wall made of boxes covered with a soft material with bells inside. Writing covered the inside surfaces of the open boxes. I could understand little of what I saw, because I neither spoke Russian nor understood Cyrillic letters, but I could appreciate the ingenuity, creativity, and perseverance of these artists, whose battle was with the state and not the compression of the American market where few were chosen and many squeezed out.

"What do you think of Socialist Realism?" I asked the dog. She didn't react. "Exactly my sentiments, give me a little agitprop any day. What do you think of Douglas Huebler and his comic strip 'Crocodile Tears?' It's kind of agitprop in a capitalist setting." The dog lifted an ear, but didn't bark approval.

Douglas Huebler, head of the art program at the California Institute of the Arts, was quoted as saying, "The world is full of objects more or less interesting, and I do not wish to add any more." Huebler began a series of cartoon features called "Crocodile Tears" in the *LA Weekly* that explored ideas about the contemporary art world and avoided the creation of another object by exploiting mass media. "Crocodile Tears: Howard" told the story of Howard Kunzler, a fictitious artist, who painted in an expressionist style, which followed the angst and anguish of his fellow "K's," Kirchner and Kafka. Howard was unrecognized for years. His work was declared "nothing new." Then Neo-expressionism came along and sold like hotcakes, but Howard was again snubbed. He wasn't young and fresh. He was "a middle-aged crank" and his work wasn't marketable. The cartoon was right on the money because the money was in youth, and the art market required a constant supply of young talent to be promoted and then dropped as the latest "ism" came along. The market, contrary to Douglas' dictum, demanded objects. Huebler, a conceptual artist who felt the idea behind the art was more important than the object, couldn't avoid creating objects—commodities. His most famous piece, "Duration Piece #17 (Truro)," was displayed in

eight framed photographs and text panels in galleries. The residue of the conceptual art was for sale.

My invisible dog, sensing my unspoken thoughts, looked up at me expectantly. "You like objects don't you, dog. A nice bone perhaps, or a disgusting carcass you could drag home," I said to the animal. "I like objects too, and there are some good ones floating around right now."

"Trickle Down Tingler" by Gary Lloyd 1981

At Kirk De Gooyer Gallery, Jacqueline Dreager was showing. I popped in for a peek before the Samzidat show. Dreager fabricated small constructions combining found objects and then worked over them with rapid brushstrokes of paint and dental tools. At Michael Salerno's AAA Art, Gary Lloyd was showing his sculptures and surveillance

pieces, paintings that had radio transmitters or receivers behind them. I went to see Gary Lloyd's show before the LAVA tour on Saturday, and, as always, his sculpture, especially "Trickle Down Tingler," was beautiful and provocative. "Trickle Down Tingler," which was a money-covered brain connected to a money-covered spine, referenced Reagan's economics and an old horror movie by Vincent Price, in which a parasite (the Tingler) that grows in the spine of the terrified gets loose and causes mayhem. I also got to see the A Broad Spectrum show. Over 106 artists were showing their work, including Peter Zecher, Phyllis Green, Dustin Shuler, Frank Romero, Victor Henderson, Woods Davy, and Joe Fay, amongst many other notable artists. Hundreds and hundreds of artists in LA vied for recognition. It was still up for debate who would be remembered.

"What are the economics of art?" I asked the dog. She cocked her head at me and wagged her tail. "Exactly," I said, "Art is labor. Labor is cheese. Art is cheese and Duchamp was a cheese maker. The comedy of art is that artists must make art, and art always turns into an object. Some kind of object to be sold."

What was interesting was that the LAVA tour map showed only a narrow slice of the downtown LA art scene. It didn't tell the whole story. Al's Bar, the center of the community, was not shown. Nor was the Galleria by the Water, nor the new MOCA site. The Art Dock wasn't shown either. I decided to make a map of the district using the LAVA map. It looked like a dog. The tail was the new MOCA. The Temporary Contemporary could be a flea on the dog's back. Al's Bar was the heart of the neighborhood. The Galleria by the Water was the front paw, AAA Art the mouth, and the brain was the Art Dock. This made me laugh, but what made me laugh more was that Skid Row was the intestine and anus of the loft district. (See map at the beginning of the book.)

"Do you think the loft district is a dog, MOCA?" I asked. The dog, hearing her name, gave a quick silent bark. "Exactly," I responded. "Profit is air, and dog is god spelled backwards. The dog district is a godly district, and the air is full of profit."

My cogitations took me on I-10 to the edge of the four freeways. I was close to the Coliseum, and the freeway traffic was sparse. It wouldn't be like this when the games began. We were close to the major artwork designed for the Olympics, Robert Graham's "Olympic Gateway." I decided to pull off and have a look. The invisible dog and I piled out of my truck and walked the short distance to the sculpture. The Olympic Gateway stood at the open end of the Coliseum, where the Olympics athletes would march in. Dedicated on June 1, the gateway was immediately controversial. The statues were without heads, screamed some detractors. Others were incensed because the statues showed the male and female genitals. I was surprised the gateway was so small. The columns on which the rectangular lintel stood were not colossal, but humanly scaled. On top of the lintel were two gold conical shapes. On top of the cones were the figures. They weren't massive, perhaps a little more than life size. The figures looked athletic, muscular, and firm. Their hands were hanging to the sides, but appeared ready to act. The design was postmodern, very much like the economics exhibits I was designing. There was a dignity here that evoked the classical sculptures of Greek antiquity. The whole ensemble was serious but joyous. It was a fitting marker and was in harmony with the Beaux Arts design of the old 1932 Olympic Coliseum.

"What do you think, dog? Can you find a bone?" I asked MOCA. She put her head to the ground and pulled at her leash, dragging me close to the base of the sculpture. I imagined MOCA starting to squat and relieve herself. "No, dog," I yelled, "you can't do that; it's art." I pulled her away. Back in the vehicle, I told the dog I thought this object would stand the test of time.

The Art Dockuments

Coming onto Center Street in the early evening, I saw the Art Dock was still open. I stopped in front of the loading dock and looked at the latest installation by Leonard Seagal. I thought his "Comedia Del Arte" quite elegant in a spare and abstract way. The forms created geometry similar to the geometry of the portal. Three black prismatic metal panels were suspended behind three rectangular planes of glass, which were covered in pebbles. The small rocks were piled up in a triangular form that matched the panels behind. No more pebbles could be piled on the glass. The small mound had reached a saturation point and the small rocks had begun to slide off. I waited and watched to see if a stone would fall off the glass plane. The vibrations in the earth and building settled the small rocks and they slowly fell from their piled-up hill. I tried to hear the ping of the metal panels as they vibrated from the falling pebbles. Plonk! Plonk! Ping! Ping! Two of them fell as I watched, joining a small field of fallen rocks on floor below the installation. The small event caused a vibration in the metal treads that held the metal panels. Each metal panel reacted to the vibration in its supporting strings and briefly collided with its neighbor, creating a quick, barely audible sound. The Art Dock was a little orchestra of natural sounds. The plunks and tings followed in a slow procession that seemed un-composed yet had a rhythm. The piece was calm—almost meditative—and yet unstable.

I waited for a long time, listening to the sequence of sounds and watching the pebbles that had inched almost imperceptibly to the edge of the glass. Was this a sculpture or a conceptual piece? The minimal construction drew something unexpected out of its three parts—metal, glass, and stone—that was more idea than thing. It was its own universe with a metallic sky, glass ground, mineral cover, and its own music of the spheres. The universe was transitory. When all the stones fell to the ground, the unity would be broken. It required its own mechanic to restore the stones to their proper position for the

music to start all over again. The celestial mechanic was the artist of the stone stack who had set up this little diorama of permanence and impermanence with movement and sound, but to make it work he had to do it over and over again. Who would have the energy and persistence to do the task?

Robert Graham's 1984 "Olympic Gateway"

I parked my vehicle and went up close to the dock. I called out Lenny's name. I called again; there was no answer. I went inside to discover my loft was empty. The artist had left the loading door open with no one in attendance. I was outraged. I phoned the artist and began yelling at him. I told him he could take his piece out of the Art Dock now.

Lenny came running from his studio on the second floor of the Citizens Warehouse. He was apologetic. He said he would never leave the space unattended again. I tried to calm down, but I was full of rage that my precious Art Dock was abandoned. Lenny tried to reason with me and calm me down by talking about his piece.

"Do you like the piece?" he asked.

"Yes," I answered grudgingly.

"Do you like the way the piece works with the space?" he asked. I answered yes again.

"That's good," he said. "I designed the piece specifically for the scale of the loading dock. Do you like the ideas behind the piece?" he asked. Again, I truthfully answered yes.

"That's good," he said. "I think the piece is very reductivist and very abstract. Do you think the work nonetheless has a human quality?" he asked. I told him I did.

Leonard Seagal & the "Comedia Del' Arte"

"Good," he said. "Because the sound and the movement give it an inherent metaphorical content."

"Cut the bullshit. The dog can decide if you get thrown out. If she barks you can stay, if she doesn't you're out," I said sharply.

"What dog?" he asked confused.

"Can't you see her?" I snapped. "She's sitting right next to me."

"You're crazy," Lenny said.

"No crazier than you," I responded. "Leaving my studio unattended and the Art Dock open with no one around."

I looked down on my invisible dog, which looked up at me. "What do you say, MOCA, does this artist stay or go?" The dog barked.

"Did you hear it, Lenny? The dog barked, and you can stay, but if you ever do that again your work will end up in the street."

Lenny looked at me quizzically. "You really are crazy," he said walking away. Several steps away he turned and said, "I feel this compulsion to do art. I will do anything for my art."

"I guess that is the comedy of art including leaving my studio unattended," I responded skeptically.

Postscript 2012: Leonard Seagal became the founder and managing director of AquaPhotic. This company provides underwater crews and equipment, underwater lighting, and dive services to the film and entertainment industry in Hollywood. The Economics Exhibit at CMSI was not ready for opening day of the Olympics, but the comparison exhibit of Marx (Socialism) and Smith (Capitalism) was. All of the world's different currencies were in the Money Case, but the Water Machine showing how capital is spent was not finished, nor was the Reward Show set up to give visitors diplomas for visiting and playing the Economic Exhibit. The exhibit opened later, after the Olympics were half over. The Samizdat movement of self-published books ended in Russia with the fall of the Soviet Union in 1989, but outsider artists still exist. They are the ones who make art with scant hope of recognition by the art establishment. Ron Bitticks, a Long Range Patrol survivor and decorated Vietnam War veteran, teaches painting at the Milwaukee Institute of Art and Design (MIAD). Jill Sebastian is professor of art at the Milwaukee Institute of Art and Design. Her work is in the collection of the Milwaukee Art Museum, and she has made several public art pieces in Wisconsin. Julie Belnick is a practicing art therapist in Los Angeles and she continues to make contemporary art. The LA Olympics were very profitable and well organized. The predicted

traffic jams never happened because of good planning and dispersion of the venues. LAVA tours still happen, but it's a different organization. The new LAVA (Los Angeles Visionaries Association) tours include everything from downtown art and architecture to the towns of South Los Angeles, Los Angeles, Route 66, and literary and criminal LA. Douglas Huebler died in 1997 at the age of seventy-two. He was a distinguished teacher and important member of the conceptual art movement. Jacqueline Dreager remains a respected Los Angeles artist, who has done notable public works for the Los Angeles County Metropolitan Transit Authority. Robert Graham died in December 2008 at the age of seventy, twelve days after he was inducted into the California Hall of Fame. His funeral took place at the new Raphael Moneo-designed Cathedral of Our Lady of the Angels, for which Graham had created the great bronze entrance doors. The comedy of art continues, as hundreds of new artists appear every year. Most of them still make objects.

ART DOCKUMENT #25 "FOUNTAIN"
BY BRETT GOLDSTONE—LATE SUMMER TO FALL 1984

A rusted water heater stood in the Art Dock. Brett Goldstone was in the street cutting the Los Angeles skyline into an old automobile hood with a blowtorch. Goldstone intended to create three pieces onsite for his Art Dock show. Only one of them would be in the Art Dock. The hood with skyline he was going to mount above the basketball hoop at the end of Center Street next to the First Street Bridge. The second piece would be a figure welded from junk that he planned to install behind the Citizens Warehouse in area next to the railroad tracks, a place I referred to as "the artist's playground." The junk figure was partly complete and lay propped up against a rear tire of the flatbed truck that served as Brett's mobile studio and home.

The third piece, intended for the Art Dock, was a fountain whose central form would be the water heater; its creation had just begun. A long rod with a metal dish on top was welded to the water heater along with several disks. Metal bars, plates, and coiled wire lay on the floor of the Art Dock ready to be welded onto the fountain. Other pieces of metal and welding equipment cluttered the sidewalk between

The Art Dockuments

Brett's flatbed truck and the Art Dock. A small tent was erected at the end of the truck where the scrap metal had been removed. Brett lived in the tent.

I was on the pathway to prosperity both literally and figuratively. Designing an exhibit called the "Pathway to Prosperity" was my last design assignment for the economics exhibit. It was a board game like Monopoly but played on a computer where the guests had to choose their route from two alternative paths and then pass by seven obstacles to get to Prosperity Station. I was in charge of the design look. Peter and Byron devised the game. I threw myself eagerly into final effort knowing that, come August 1, I would be out of a job. I wrote in my daily dairy:

"Flecko is coming to an end, and I seem to have adjusted. A calmness has descended. I'm no longer afraid of my coming unemployment. I'm enjoying the last days of this oh-so-long gig. I didn't think I could do it. I've completed this project without flaming out over some small issue or disagreement."

Not that the project ended easily. On the day and all night before the Olympics opened on July 28th, my design team spent harrowing hours trying to put the whole exhibit into place. Nothing went right. I tried to put one piece of each country's money in a money case, and the money would not stay on the wood plinths made to support it. The plinths all fell over. Tape didn't work. Pins didn't work. Finally, using cut-off nails, I made the mounting work. The History Wall went up with several glitches, but the cases with the computer games didn't arrive until five in the morning. When Nate from the fabricator arrived, he only had four exhibits out of the twenty or more ready to install. We opened, but the exhibit was pitiful. A few games, a few graphic panels, and one case of money were distributed around a big, otherwise empty room. Not until the Olympics ended did the economics exhibit achieve real completion.

My role was over. August 1 came, and I was out of a job. I collected all my design sketches for the exhibit and took them with me. I felt they were part of my art. The final paycheck of $4,000 would tide me over through the fall. I registered for unemployment knowing that I would be denied for my earlier failure to report earnings when I was getting unemployment insurance, cleaned up my studio, had my last sessions at the Learning Development Center, where I arranged dots on a grid and had to repeat the arrangement—I thought this was where I got the ideas for the Pathway to Prosperity exhibit—and made plans to head for the Dorland Mountain Arts Colony for a much desired rest and regroup. I felt prosperous and healthy.

My fortieth birthday came, and I was happy, but I was always happy at this time of year. My wife, with the divorce papers in her hand, came and brought my daughter to celebrate my birthday. I didn't get depressed or angry. I took my daughter to the beach and Disneyland full of good cheer. My friends gave me a birthday party with balloons and a big happy birthday sign in the empty Art Dock upon our return from Disneyland. Art and capitalism could work for me, I mused, thinking about all I had learned about economics from designing the economics exhibit

Brett had been working for a week, but he hadn't started until August 14, two days after the Olympics Games ended. For the entire time of the Olympic Games, the Art Dock was closed. I, like most Angelenos, hunkered down and kept a low profile while the games were on (many people left town), keeping the traffic light. With the Olympic torch extinguished and the city returning to normal, the Art Dock would be taking over the outdoor space around the Citizens Warehouse, creating a curious art park behind the building: a long axis to the car hood along Center Street, a fountain niche in the Art Dock, and a workshop in the road. The drive-by experience was becoming a drive-in experience. I thought of the Automobile and Culture show at the Temporary Contemporary, which gave homage to the drive-in culture of Los Angeles. The Automobile

and Culture show was a big art event in downtown LA. It opened just before the Olympics began on July 28 and wouldn't end until January 1985. The water heater with its disks and projections recalled for me a Picabia piece in the show, a lithograph of a spark plug from 1915 entitled "Young American Woman in a State of Nudity." I wondered if Brett knew that work.

"No," Brett replied. "I know R. Mutt's 'Fountain.' You know, the urinal by Marcel Duchamp. I wonder how clean that thing was."

"I think it was clean, but you could never tell with Marcel," I responded. "But Duchamp's 'Fountain' wasn't in the Automobile and Culture show."

"What do you think about American automobile culture and art?" I asked.

Brett took a moment to answer. "I'm from New Zealand," he said. "I never went to art school. I came to art through a passion for visual stimuli. I like documenting my experiences. I like the idea that anything can be art depending on how you look at it. My stance as an artist is directly involved with the experience of living and interpreting that experience of living. Things that move inspire me. I am intrigued by machines."

"No theory then?" I asked. Brett was busy puttering with his welding equipment.

"My work is determined by my tools. My mind is my greatest tool. Now I have this welding stuff. I can make preconceived pieces with it."

"Like what you intend to do at the Art Dock?"

"I think the Art Dock is art. It's a gem of an idea," Brett said. "I'm bringing the Ventura Beach down to LA. I'm Prometheus bringing the water to LA." I didn't tell him that the metaphor was incorrect. Prometheus brought fire, not water. I thought Brett was being ironic.

Brett was living on his truck at the Ventura Beach—where he found the water heater abandoned by the side of the road—prior to coming to the Art Dock. He was probably taking a break from

his adventures as Art Attack, an unidentified street artist who attacked various walls in downtown Los Angeles with crude images and slogans. One of his art attacks was a rough mural across from Gorky, one of the hip artists' hangouts in downtown, emblazoned with the slogan "A Christmas Carol from Ronald Reagan." At MOCA, Art Attack installed a series of small paintings and sculptures on the outside of the Temporary Contemporary. Brett never intended his works to be malicious. He espoused no political agenda. The art attacks were a means to show his work. It was reported in a *Downtown News* article titled "Masked Man Strikes LA with Guerilla Art Attacks" that Brett felt like Zorro and quoted him as saying, "It's nice to have a little romance in your work. The only romance left to artists is the poverty they live in."

Brett Goldstone by Ed Glendinning

"I understand you're going to build a fountain out of the water heater, but tell me about the other two pieces," I requested.

Brett told me he couldn't really comment until he had finished the work, and he might be working on the pieces for the entirety of the show. His life

was art. He displayed it on Center Street. I told him I would check in on him in a couple of weeks. I was leaving for the Dorland Mountain Arts Colony the next day and would be gone for most of the month of August except for an occasional weekend trip. I offered my studio for him to live in, but he preferred to live in his truck.

Up on Dorland Mountain, I sat each evening on the edge of the art colony's little plateau overlooking the sunset, the inexorable expansion of the electrical fungus, and the automobile culture across the Temecula Valley. I mused about Brett Goldstone, his art, and the two big art shows in Los Angeles at the time of the Olympics: LACMA's "A Day in the Country" and MOCA's "Automobile and Culture." The show at LACMA (Los Angeles County Museum of Art) couldn't be farther in aesthetic and attitude from the Art Dock's latest exhibitor. The Olympic offering was a survey of Impressionism and the French Landscape. All were beautiful paintings. None had any disquieting or critical content. They were eulogies to the delightful light in life. The only paintings that touched on the machine were Monet's paintings of the Saint-Lazare Train Station, in which the smoke of the train billowed upward like an airy veil under the canopy of the train shed. The colors and brush strokes were almost liquid as they dissolved the hardness of the forms. The train was not a monster, but a dreamy apparition. The era of Impressionism still loved the iron horse. Impressionism was easy to like. It was art that was understandable and tangible even when the image was insubstantial, like the light on haystacks. Unlike Duchamp, Picabia, conceptual artists, or even pop artists, Impressionism didn't challenge the notion of what art was. Art was a beautiful object. It didn't move. It was a commodity with meaning.

Brett's work was content with meaning, but as commodity it wasn't beautiful. The monster at the Cotton Exchange show was a pile of garbage formed with chicken wire stuffing itself with bent

cans. Was this a criticism of American consumerism, or merely a humorous statement that moved? There was something about Goldstone's art that seemed edgy and almost childlike, executed with a mad enthusiasm. I was eager to see what Goldstone would develop for the Art Dock.

Monet's "Saint-Lazare Train Station, The Normandy Train," 1877

The Automobile and Culture show was very different. Cars were shown that were so beautiful, they could be considered art objects, like the 1902 Olds Curved Dashboard Runabout and the Packard Le Baron V-12 Phantom of 1934. Automobile-inspired art was exhibited that romanticized the motor car, like Picabia's sparkplug lithograph, Severini's futurist oil "The Autobus," Jacques-Henri Lartigue's photograph of a speeding automobile from 1912, Edward Hopper's "Gas," which was a uncritical image—almost elegiac—of an American filling station from the 1940s, and Oldenburg's "Soft Airflow" made of canvas and kapok with a playfulness that made the automobile a cuddly toy. This survey of the automobile's impact looked at all of culture, from city planning and architecture—designs of drive-ins and the ethos of Las Vegas—to posters like Marcello Dudovitch's "Fiat Balilla," which stylized speed and elegance. The exhibit was a comprehensive view of the automobile's effect on the visual world. The view wasn't completely laudatory. Whiffs of criticism of this culture

could be found from Picabia to Oldenburg, but works like Andy Warhol's "Five Deaths Twice," a double silk-screen of 1963 portraying a gruesome accident in which an overturned automobile sat above dead bodies, and Carlos Almaraz's "Beach Crash" of 1982 could be interpreted as protests against this dominating force in American culture. The images were powerful. Almaraz's painting was Impressionism gone wild. The work was beautiful yet scary. Goldstone's work was neither beautiful nor scary. His monsters and his art attacks were humorous and a little crazy. He called himself a criminal artist, but this was because of his illegal immigration status, not because of his challenge to the prevailing aesthetics. His work questioned the gallery system, but not what was in the gallery.

Carlos Almaraz, "Beach Crash," 1982, oil on canvas

On August 22, after a walk through the chaparral to the far spring on Dorland Mountain in the company of the poet Carol Rubenstein, I returned to LA to see what was happening with Brett Goldstone's installations. I had heard strange reports of a fight breaking out over the art. I was reluctant to go. Dorland Mountain was so peaceful and idyllic, with its grove of oaks, ponds, and trails that led off into the thick shrub to distant natural settings, that it was difficult to face going back into the rapid pace of LA's auto culture. My day in the country, with its beautiful light,

contrasted sharply with a culture that I was beginning to think was malevolent. Carol Rubenstein and I strolled along a path in a dense and shadowed oak grove onto a narrow trail that snaked along the edge of the mountain, cut through a dirt arch, and finally ended in a thicket surrounding a small spring. Birds and animals rustled the gnarly California oaks. The stream bubbled gently over little slabs of slate and ran swiftly down the mountainside. Carol and I talked of faraway places, food, and artists. Carol, in her sweet voice, said she could never keep cilantro and coriander straight in her mind. I told her it was easy, just remember: "Allesandro Cilantro and Alexander Coriander." She said that doesn't explain the difference between the two herbs, but it was a funny statement. All the way back on the freeways to LA, I repeated my little mantra. It kept a grin on my face, stopped depressing thoughts, and prepared me to re-enter the grime of downtown.

In the late afternoon, I drove onto Center Street and looked up at the car hood mounted above the basketball hoop. Craning my head out of my truck, I could see the jagged burns of the blow-torch-created skyline on the red and blue blotched hood. It was mounted with its ornament cap pointed down. Over the hood, where the skyline wasn't cut into the steel, were letters in bold black paint. They said "Fuck All Not Art." I drove up the street and parked. Brett was sitting on his trailer truck, looking at his fountain in the Art Dock. I asked him what was going on.

"Not too much," he said. "But the building owners are hassling me about welding in the street."

"That's not what I meant," I responded. "What's with the writing on the car hood over the basketball hoop?"

"Oh, that," Brett said. "I caught Gary Worrell defacing 'City on a Car Hood.' He and I got into a fistfight. I won. I carried Gary into your studio and attended to his bloody nose."

"Is everything all right between you two?"

"We've resolved our differences," Brett said.

"Are you going to leave the piece vandalized?"

"Yes," he said. "It's all a part of street art."

"Has anything happened to your junk figure behind the building?" I asked.

"'The Junk Man' disappeared two days after I finished him."

"Why did the junk man disappear?"

"Probably some artist or a homeless person added it to his collection. That often happens with my work." It goes with working in the street.

"Did you finish the fountain?" I asked.

"I'm still in the process of perfecting it," Brett admitted. I looked into the dock and saw the fountain sputtering.

Inside the Art Dock space, surrounded by black plastic sheeting that draped over the lip of the loading dock, stood the altered canister of the water heater. Attached to the heater were many appendages: disks that spun, wheels with spoons cans on their spokes' ends that caught water, levers, balances, gears, basins, a suspended metal bar, and three soldiers who stood on top of the heater that moved back and forth in a line. Water from a garden hose was pumped up into a basin positioned several feet above the heater. The water fell through holes in the basin into bent and curved pipes. The pipes directed water over the spoked wheels and levers. Some of the spoked wheels constantly spun from the force of the small stream of water, others with larger water catchers—cat-food cans—wouldn't spin until the cans were full. The cat-food-can spoked wheel turned several revolutions, and then stopped, waiting for a can to fill again. Water falling on the lever pushed it into a collision with another steel pipe that activated a sequence of operations. Another dribble fell onto a steel disk, but nothing happened. Not everything worked yet, as Brett stated. I couldn't determine what made the three soldiers move back and forth.

Brett informed me that the *LA Weekly* and *Artweek* were going to review his work in the Art Dock. This would be the first review ever for an instal-

Daily Diary Page by Carl Davis

Not Approved Tag by LA Building Department

lation in the gallery. Brett had given his assurance to the reviewers that he would keep the Art Dock open on regular hours. I returned to the Dorland Mountain Arts Colony, happy with this development.

When I returned to Los Angeles and the Art Dock in September, the temperature was in the hundreds. A heat wave was hitting the city. The fountain was fully working. The whole assemblage sputtered, whirled, rotated, slid, gyrated, and bumped in a daffy symphony of movement and sound. Ticks, clicks, clangs, bangs, and whirrs emanated from the construction in never-ending progression. Water flew in all directions, spraying light drops onto the viewers in the street. Water dribbled off the plastic sheets onto the sidewalk and into the street in little rivulets. In front of the Art Dock was the only cool place on Center Street. Little crowds formed to laugh at the contraption and be cooled by its spray. Brett's "Fountain" was a hit and was praised in the *LA Weekly* and *Artweek* along with his "City on a Car Hood." The critic Ray Zone declared it was "an archetypal icon for Los Angeles, it is a creation as powerful as the best work in the Automobile and Culture show."

On September 5, the building inspectors returned to investigate the Citizens Warehouse. Their attitude and the artists' responses had changed. Intimidation through possible eviction gave way to helpful consultation, and the artists' sullen hostility had turned into offers of iced tea and cookies to the hot and overworked inspectors. Their attitudes, which had been so negative in the past, had become bemused interaction. The artists no longer seemed a threat and their work unintelligible. The Art Dock was open because I had to keep regular hours. Chief Inspector Padilla of the A.I.R. task force, upon seeing the fountain dripping water into the street, let out a big laugh and affixed a building-code violation to wall of the building next to the Art Dock. He turned to me and said, "This is the worst plumbing job I've ever seen." Brett Goldstone's work never looked better. He had created a contraption that was fun and engaging. It wasn't beautiful, but it worked beautifully. Everyone who saw it loved it. I knew the Art Dock was having its finest hour and had made a worthy contribution to the Olympic Art Festival. In my art Olympiad, I gave "Fountain" a gold medal.

Postscript 2012: Brett Goldstone is a master welder and artist. In 2006 he had a 25-year survey of his work at Dangerous Curves, an experimental exhibition and live art/visual art performance space. He has crafted metal gates and fences for the LA River and various homes. He is no longer "the poorest person in LA," as he described himself in the *LA Weekly* article of September 1984. He owns several houses and spends his spare time sailing. The Economics Exhibit didn't last long and was destroyed when the California Museum of Science and Industry was remodeled and rebuilt. The exhibit was outdated by then. Its computers were surpassed, and the premise of the exhibit as a contrast of capitalism with communism was superseded by the fall of the Soviet Union in 1989. The Dorland Mountain Arts Colony burned to the ground in 2004. All its structures and the oak grove were incinerated in the devastating Cedar Fire of 2004. Since that time, Dorland has been rebuilding; two of the ten original cabins have been rebuilt, and Dorland is once again accepting applications for artist residency. Carol Rubenstein traveled the world, became an expert on the Sarawakian Dayak culture of Borneo, and settled in Ithaca, New York. She remains a poet who has received many grants. Ray Zone is an American film historian and artist. Called the "King of 3 Comics," he has pioneered the conversion of flat comic-book images into stereoscopic pictures. Chief Inspector Padilla retired.

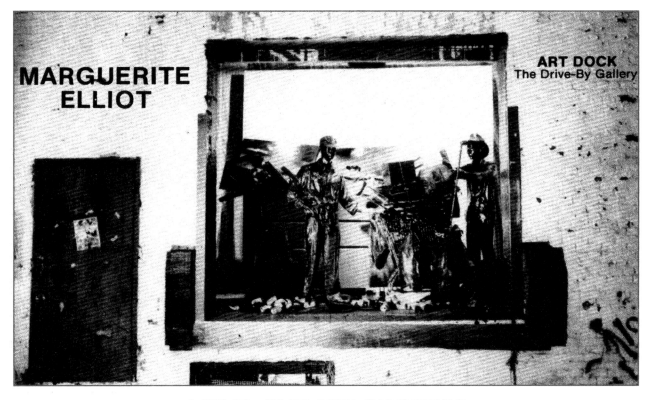

MARGUERITE ELLIOT

ART DOCK
The Drive-By Gallery

ACT III THE ART OLYMPICS

ART DOCKUMENT #26 "STREET HARVEST IN LOS ANGELES" BY MARGUERITE ELLIOTT—FALL 1984

"Still hot in paradise," I said as Marguerite Elliott and I removed Brett Goldstone's "Fountain" from the dock to make way for her installation. The fountain fell apart as we moved it. The parts had rusted to decomposition. Wheels fell off; a leg collapsed. We tried to treat the sculpture gently, leaning the rust-encrusted tank carefully against the wall inside the studio, but this wasn't art made to last. Another leg slowly bent under, and the fountain slid to the floor with a loud bang. Bang was the last note the fountain would make. Brett's humorous contraption gave way to the harsh commentary of "Street Harvest in Los Angeles." It was harvest time again, but unlike a year before, when Miles Forst celebrated the fruits of the harvest with a succoh, where the weary might take respite from their labors and recall the days of

abundance and ease represented by the primitive hut in paradise, Marguerite presented an image of the poor who patrolled the streets of Los Angeles, scouring for aluminum, cardboard, and other debris that could be sold to the recycling center for pennies to buy food, liquor, or drugs.

Marguerite's black figures were hot and sticky as we placed them on the loading dock in the sun-broiled afternoon. The hot art paradise of LA cooled by the fountain became hot art *in* paradise. The Olympics were gone; the city was returning to normal. Paradise was showing its negative side. The downtown artists were seeing that things hadn't really changed. Homeless people were everywhere again. The horse patrols that drove them from downtown had ended. Strings of the

The Art Dockuments

indigent once more lined up down Main Street in front of St. Vibiana's Cathedral waiting to enter the Union Rescue Mission. Bums once more stretched out on the green lawns of Pershing Square and City Hall. Cardboard box shelters returned along 4th Street in front of the Asian toy wholesalers. Stick and paper lean-tos found their way back to the left-over places around downtown, from the underside of the freeway overpasses to the alleys behind the warehouses. The drunk and narcotized passed out again all over the district east of the central core. Shopping-cart pushers were busy at the garbage bins, harvesting the waste of the Olympic Games.

In the Art Dock stood a silent tableau commemorating these lost people and their fall harvest. Two male figures painted black from head to foot were engaged in gathering cans, cardboard, and bags from a trash bin and loading the harvest into their shopping cart. The back figure in a cowboy hat was shown lifting a black plastic bag into the cart. The figure at the front in a baseball cap stood looking out, one hand on the handle of the cart, and the other lifted as if he were going to react. He epitomized the street poor who, whenever they were aware someone was staring at them, froze and assumed a far-away gaze. They pretended they didn't exist until the observer, in embarrassment, averted his or her eyes, and the poor returned to their anonymous activity. The figures were tar-black, slick, hard, and shiny like new asphalt shimmering in a blazing sun. The tar-like surfaces evoked the outcast status of the tarred and feathered. Everything was painted black except for the trash bin, which was left its original dull green, and the cans, which were painted white. There was so much trash overflowing the bins that white cans and black cardboard littered the floor of the Art Dock. The shopping cart was full to overflowing with a crutch sticking out, black plastic bags hanging off the side, cardboard piled high over the rim of the cart, and a black painted jug hanging off the cart's handle. This was strong visual imagery, but something was lacking to me.

The tableau installed, Marguerite departed for Japan. Since the assistant curator, Marti, was away visiting his relatives in Sweden, I was left to care for the installation alone which meant that the Art Dock would revert to its irregular hours: open in the evenings, weekends, and part-time during the weekdays. I got a part-time job with an architecture firm in downtown. I could walk to work, and on the way to and from the office in the Bradbury Building, I thought about the piece. One day I stopped at MOCA's Temporary Contemporary and went through the Automobile and Culture Show a second time. This marvelous and engaging exhibition that celebrated the car deflected me from my ponderings, except when I came across the photograph by Margaret Bourke-White called "At the Time of the Louisville Flood" from 1937. A startling picture, it showed a line of African Americans—a relief line—standing in front of a billboard that at the top said "WORLD'S HIGHEST STANDARD OF LIVING." Below the banner, the billboard showed a white family in a car: husband, wife, daughter, son, and family dog. They were all smiling except the dog, whose mouth was open and tongue hanging out. To the right, in script, was written, "There is no way like the American Way." The eye was drawn to the white shopping bag in the hands of a somber man in line beneath the billboard. This was the focal point—the punctum, as Susan Sontag would say—of the photograph. From this white bag, the eye followed upward to the grim African American and from him to the smiling white man. From this vantage point we could decode the whole image, which made a meaningful statement about our culture. We saw its inequities and the pain of those inequities. We saw the strength and the weakness of our culture captured in one telling impression. The automobile distanced us from reality, creating a contradiction that made the artwork all the more significant. It had what "Street Harvest" didn't have: a visual narrative that made the line of indigent

people come alive and confront us in our safety zone. In the Art Dock piece there was no contradiction. The tableau didn't go beyond itself. It was just two black figures gathering trash. There was no focal point.

Margaret Bourke-White, "At the Time of the Louisville Flood," 1937

Maybe I missed the point. The white cans scattered around the feet of the front figure were like the white trash bag in the photograph. There was a layered meaning in the white shopping bag. It was in great contrast to the rest of the black-and-white photograph. It jumped out at the viewer. The bag was a metaphor for a culture divided between black and white, rich and poor. It was the key to the photograph, and the whole photograph became an artistic statement about the ruin of the American dream during the Great Depression. Crumpled cans in this tableau didn't have the same power. I wondered why. *Too many of them, too scattered, too much on the periphery of the image*, I thought. If she hadn't gone to Japan, would Marguerite have worked on the installation like Dennis Goddard did on his until he found the right composition, placement of elements, and colors?

I considered the weakness of Marguerite's installation in the Art Dock and what had happened to my life since the end of the economics exhibit,

as I lay sick in bed. It was mid-October, halfway through the exhibit of "Street Harvest." I sketched in my daily diary a cartoon of lips with antennae. When I was happy, the lips, a play on Man Ray's image of floating lips, were curved up in a smile. These lips attached to a sickly body were turned down. I played a new mantra in my mind that my psychologist had me say, "I am a miserable failure." He had me say these words again and again in hope that I would see how ridiculous that view was. I couldn't see it. All I could see was how miserable I felt, how broke I was again, and how nothing I did worked out. The wolf was at my door again. The money I got from my last big paycheck from the economics exhibit was almost gone. I had a hundred dollars in checking and a thousand in savings. Rent was due soon, and I calculated that I could only barely make the payment. Deep depression had grabbed me again. I had made a pact with Dr. Wortz that I would not commit suicide until October. October was now here.

Why wouldn't I kill myself? I was a miserable failure as an architect. The artist housing projects I tried to start all went belly up. The latest was 117 Winston Street, which failed when my cohorts and I couldn't find $40,000 to hold the building while we negotiated with the Community Redevelopment Agency for funding. The jobs I got as an architect were part-time and low pay. I worked for a company who made trade show exhibits out of thick stock cardboard. I became employed as a draftsman on a temporary basis on a vehicle maintenance facility. Neither job was creative or interesting. I wasn't very successful at being an artist. I had no time to pursue art as I scrambled all over town to find work to pay my bills. I imagined myself a corpse. Retribution for my failures came in the form of disease. I could end this slow Black Death with one stab of a knife.

But like a good student, I replayed my mantra that I was a miserable failure over and over again. Gradually, I remembered good things. I recalled

The Art Dockuments

Michaelmas Day September 29th in San Diego. In my daily diary I wrote about my day with Carol:

Daily Diary Page by Carl Davis

"With her remember. We rose early before sunlight and walked in the dark and cold toward the beach, two or three blocks away past the clean, neat, affluent beach homes and apartments. The road curved and opened out on the ocean. We descended the embankment to the rocky beach. A great vast chunk of smooth rock was cleft with deep fissures where fascinating worlds of fish, crabs, and mussels lived in isolated but frequently flooded pools. We slid along this quiet world laughing, talking, and enjoying life, until we both did the big

splits with our dividing legs slipping on the wet stones, coming to a hard wet landing on the red-rock-ocean-edged planet. Later, in the little writers' cottage, amongst the wall of books, we made love."

The illness abated, and I rose still saying, "I am a miserable failure" but laughing at my self-seriousness. I should relax, I told myself; whatever happens is out of my hands. I laughed at my old friend, Mervyn, over our $1.45 Chinese lunches when he complained about architecture, and how poorly we were paid. The food was terrible, our professional careers were stalled, but what could you do? Nothing. I laughed at my art career, thinking I should promote myself more. I should be more political, but that wasn't my style.

Marguerite was a very politically involved artist. She was one of the original members of the Woman's Building in Los Angeles, an organization that promoted equity for women artists in the male-dominated art culture. In their building on North Spring at the far edge of Chinatown, women artists put on many provocative events. Marguerite made art protesting nuclear war, and now she illuminated the plight of the homeless. I admired this woman. Her work was strong. It was George Segal-like with a political edge. It was tough in imagery and tough in that she created these black figures out of resin, a nasty material to work with. Why did it give me pause?

I was thinking about this while walking to work in early November when I confronted a dark brown African-American man lying on the sidewalk. We were across the street from St. Vibiana's Cathedral. This was the third day in a row I had seen this man in this same spot. Usually he lay flat on his stomach on the concrete. Today he was twisted at the waist. His pants were half-open, exposing his buttocks. A streak of shit smeared the cleft of his cheeks. A green shirt, discolored with dust, dirt, and garbage, was pulled up toward his shoulders, exposing a caked hairy chest. A filthy hand partly covered his grimy upturned face while his other arm flopped to

his side. His feet were bare and blackened. He shook like a machine gone out of kilter.

I strode past and gagged. A stale and sour smell arose from him, as foul as anything I had ever breathed in. I passed by him and turned to look back. The gagging in my throat diminished. Should I help him? Was I not my brother's keeper? Could I overcome my revulsion? An old hag turned the corner. She walked up to the man, leaned down, and spoke to him. He screamed back at her. She stood up and doused the man with part of a bottle of cheap wine. I rushed away, wondering why I walked this path to work when it always took me by the destitute. A thought popped into my mind. This was what "Street Harvest in Los Angeles" needed to make it truly meaningful: smell. If the tableau had a squirter that gave anyone who approached the dock a whiff of what street culture really was. And the black figures were too nice. The black color and slick surface distanced the viewer from the reality of the homeless. Even in old clothes and battered shirts they weren't so formidable; it was the wretched odor that distanced us, very literally, from them. I laughed at this idea, but never broached it with Marguerite until the night of her closing, when a few of us gathered in front of the loading dock and sipped a few glasses of cheap wine. She scoffed at my idea. I guessed it would never work. Who would stand in front of a piece of art to be sprayed by the smell of real poverty? No museum would allow it. Nor could I endure it on the other side of my wall in the confines of my studio, where everything was arranged according to my interest, and I was shielded from the chaos of the street.

Sketch book page of loft by Carl Davis

The Art Dockuments

When I shut up the loading dock after the closing party, I again wondered why I didn't love this piece. I liked what it stood for, but it didn't grab me. Maybe it was the lack of a focal point. Maybe it was the composition, which seemed off-handed. The figure on the right in the background was largely lost. The left side of the tableau was bare. The man in the ball cap filled the middle. Maybe the tableau was too axial. What if the man in middle were moved to the left and the shopping cart were given center stage? Suddenly, I understood. The black figures, black shopping cart, and black trash pushed the viewer away on purpose. The tableau created a psychic distance that allowed us to see but not accept. Were the figures white, like in a George Segal sculpture, we would feel a certain empathy with the cast. Black, these figures were the untouchables. They pervaded our lives, and we did nothing about them but push them away. "Street Harvest" pointed the finger at me, who walked by the homeless man shaking in the street and did nothing. A canyon of darkness separated us. They stood on the other side of the chasm tending to their lives in a land far different from the land I inhabited even if we shared the same sidewalk. Their land was foreign to me, and frightening, best left un-experienced and kept at a distance. Marguerite's piece reflected that distance back to us.

I know I took chances inviting someone to show and saying, "Do whatever you want." I still had some qualms about the installation, but it was provoking. "Street Harvest in Los Angeles" didn't win a gold metal in my Art Olympiad, but I would give it a bronze. And it was all right that the Art Dock, low-powered radio to the world, was at a reduced volume. "Street Harvest" didn't need to scream at me. Its dark power lay in its understatement. "Street Harvest in Los Angeles" had guts.

Postscript 2012: Marguerite Elliott went on to have her work featured on the cover of the *Village Voice* and in the *Los Angeles Times* and *Time Magazine*. She has been a curator and is now producing Web videos for other artists to promote their work. She lives in Marin County, California. Photographer Margaret Bourke-White died in 1971 from Parkinson's. She was one of the first great female photojournalists. Her work broke barriers for women. Bourke-White photographed steel mills, dams, Soviet industries, and concentration camps. Henry Luce hired her to work for *Life Magazine*, and her photo of the Fort Peck Dam was the first cover of the magazine. Bourke-White was the first female war correspondent. Her work is known for its sharp focus, clear light, and emotive quality. The Cathedral of St. Vibiana, built in 1885, is one of the last remaining buildings from the early period of Los Angeles history. In the 1990s, the Archdiocese of Los Angeles gave the cathedral to the City in return for land on Bunker Hill that was developed into the new Cathedral of Our Lady of the Angels. Now called just "Vibiana," the former cathedral is the site of a performing arts complex as well as the Little Tokyo branch of the Los Angeles Public Library. Homeless people are less frequently seen in the area around Vibiana. Development and relocation of the Union Rescue Mission have pushed them further south and east along 5th and 6th Streets. However, in this area it's still common to see the destitute sprawled in the alleyways and on the sidewalks. Their numbers grew with the Great Recession. They smell just as bad as they did thirty years ago.

ART DOCKUMENT #27 "FIRST AMERICAN SCULPTURE" BY JAN TAYLOR—WINTER 1984

The Art Olympiad was drawing to a close. Artthinkfulness waned with the end of 1984. The great communicator, Ronald Reagan, was reelected. Was he Big Brother? Traffic resumed its congestion. Business returned to normal. The homeless organized. They established a tent city for the Yuletide season in front of City Hall. The downtown art community worried about housing. The city, which was hands-off during the Olympics, now enforced its regulations. Earthquake reinforcement of the old brick structures was coming. On Center Street, the community of artists was preparing for the renewal of leases. Those whose leases had already expired were given notice that the owners intended to substantially increase the rent. The owners wanted to bring the studios up to market rate. The Art Dock received notification from the city that the gallery was a business and

must therefore pay the business tax. Jan Taylor, the Art Dock's next artist, didn't want to hang "Christ Among the Vagrants" again. He wanted his new piece to stand alone in a newly legitimized gallery.

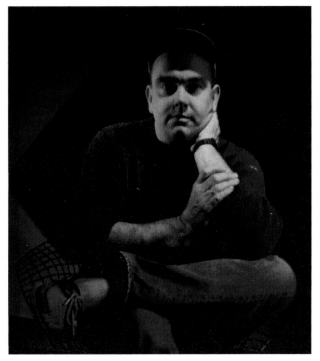

Jan Derek Taylor by Ed Glendinning

Jan Taylor was the first artist to exhibit a second work in the Art Dock. For three years, his first piece, "Christ Among the Vagrants," hung on the outside wall of the Citizens Warehouse during the Christmas season. Each year the work became a little more broken down. In 1983 it was nearly impossible to light (and keep lit) the Christmas decoration. Jan asked that the sculpture not be reinstalled in 1984 and that he be invited to create a new work for the gallery. His request seemed appropriate. Times had changed. "Christ Among the Vagrants" was a statement from the first years of the artist occupation of Citizens Warehouse. A bold and defiant statement, the cross symbolized art beyond commodity. It was a sign of the art life and a marker of the affinity of the artists struggling to live in downtown for the poor struggling to survive. In late 1984 the artists were more

concerned with their professional careers. They were organizing, like the homeless, to protect their interests. They became more businesslike. The indigent, who were looking to have something, and artists, who were trying to protect what they had, no longer had a kinship. Los Angeles's bohemia was assimilating.

There was no better symbol of this than Jan Taylor's new piece in the Art Dock, "First American Sculpture." The work was clearly an art object. Floor-mounted and upright, this beautiful work could be displayed in any regular gallery. A lozenge shape bowed out gracefully from the base, and then arced sharply to a point. The mottled and rippled grey surface was elegant and mysterious. It was easy to associate the sculpture with other items. It reminded me of cherished objects displayed in art and ethnographic museums. This thing could be the blade from a spear of a prehistoric giant, the shield of an Athenian warrior, or an ancient stone erected in ritual honor of a forgotten event. Then I realized what it really was. It was a surfboard covered with lead. The "First American Sculpture" was a joke.

A comic dimension added to the appreciation of the form. You could imagine a Stone Age cartoon character shooting the waves on an impossibly heavy board. The Flintstones could have set up their boards on the beach attesting to their prowess just like contemporary California youth. The surfboard became a stele commemorating not only a mystical past, but also the present bright culture preserved in lead, the X-ray-proof material. "First American Sculpture" was an inverse Brancusi.

Standing in front of the Art Dock, I was thinking about Brancusi when a stunning young woman swept past me as she moved toward the end of the building. I turned to look at her after she passed by me. She was wearing the thinnest of dresses on this December day. I watched her swing her hips in rhythmic motion as her supple back fluttered the gauze dress. She had to be a model headed for the photography studio of Ladi Von Jansky.

"That is form perfection," I muttered to myself.

"No, it isn't," a voice behind me uttered. I turned to see the critic next to me.

"Where did you come from?" I asked.

"I was strolling along the sidewalk, and I saw you distracted by that luscious female."

"That babe is as good as any Brancusi I've ever seen," I said. "Pure sensuality and delicious movement."

Bird In Space by Brancusi

"Brancusi would say you are distracted by what you see," she said. "'What's real isn't the external form, but the essence of things...it's impossible for anyone to express anything essentially real by imitating its exterior surface.' The 'Bird in Space' expresses the fundamental essence of the winged species."

"Whatever. That bird was something else."

"You look like you're dressed in new clothes. This isn't your usual rumpled appearance," said the critic, changing the subject.

"Oh yes, I did. I was depressed, so I went out and got some new clothes. You like them?"

"They're not like the person I know," replied the critic. "But they're all right. It's like taking a surfboard and covering it with metal. The surfboard is transformed, but it's still a surfboard."

"The material is lead. How did you know it was a surfboard?"

"My dear friend, anybody raised in California knows that shape."

"'First American Sculpture' has new clothes," I said.

"The sculpture would be closer to Brancusi if the artist had simply displayed a surfboard. The form is sensual and expresses the speed of roiling water. It would have been a Duchamp readymade," said the critic.

"But if he called it 'Surfboard,' there would be no joke, no perception of the object as a work of art. Perhaps he could call it 'In Advance of a Shark Bite,' like the title for Duchamp's show shovel 'In Advance of a Broken Arm,'" I replied.

"I like the name Jan gave it. 'First American Sculpture,' right?" the critic asked.

"Yes," I replied. "I think of it as an inverse Brancusi, kind of like Mark Lere's piece 'Untitled,' which invokes 'Bird in Space' but plays with its idea. Lere gives us a wedge that is grounded but bent. There's an intimation of movement but a contraction in the material and bluntness of the form."

"So what's Jan's sculpture, a ready unmade?" chortled the critic.

"Yes, I like that description," I said. "A lead-covered surfboard is a negation of the object—it would be impossible to surf on such a heavy board—yet it is an affirmation of it as an art object. Duchamp's readymades were a negation of the art object, yet they reaffirmed art. Jan's reversal of the joke makes you stop and think. He takes the utilitarian object, covers it with a material often used

The Art Dockuments

by sculptors, sets it upright like a stele, and calls it a sculpture. The aesthetics of the form are made more evident by the wrapping, which recalls the actions of Christo. The commonplace is altered to reveal the aesthetic in ordinary, and the ordinary in the aesthetic. I think it's brilliant and witty."

"I think the emperor should have no clothes," the critic said. "Consider this. That new shirt you're wearing doesn't go with the pants. You'd look better with no clothes."

"Not as good as the lady who just walked by."

"I can't argue with that, but we haven't seen her inner beauty." The critic turned and walked away. She stopped and spun around. "Two last thoughts. I think you're in the art gallery business now. You've learned to lay it on thick like a curator, and you're going to need classier clothes if you're going to play the part."

I had bought the new clothes at Sears. They weren't expensive, and they did cheer me up briefly. They certainly weren't the kind of fancy duds that a gallery owner would wear if he were serious about selling art, but then I wasn't sure if I was going to keep the Art Dock open. One day I was committed to the idea, the next I was ready to close up and move away. My life was changing at the end of 1984. I began to realize there were two of me. One was positive, energetic, and male. The first me wanted a normal life, love, and a stable existence. The second was negative, angry, and often low energy. It wanted death, self-abuse, and an exotic existence. I cycled through these states many times through December. The month I usually loathed, because of the Christmas holidays, came and went. Again I severely questioned my choice to be an artist.

I had no time to make art, nor could I identify which one of me wanted to be an artist. It may have been both for all I knew. The Art Dock was my only connection to the art world, and it was more of a pain in the ass than a giver of joy. I only had time to open it at night, on weekends, and on the occa-

sional day when I wasn't working desperately for the cash to maintain a studio I couldn't devote time to. All my efforts seemed contradictory and divided like my psyche.

"Untitled" by Mark Lere

I had nowhere to turn for answers. Doctor Wortz ended his group therapy sessions. They had been my lifelines as I tumbled in the waves of my alternating ego. My retraining at the Learning Development Center ended because my new job did not allow time to go. They had provided an insight and path toward being more whole. None of my

artist friends could unravel my dilemma. They were struggling with their own careers. Gary Lloyd and Karen Kristin went into the sky painting business for backdrops in movies and commercials. "Go back to architecture," my friend Mervyn recommended, even though it was distasteful. It was what I was trained to do.

I was offered a job with Frank Gehry, and I took it. I remained attached to my identity as an architect even though I disliked the work I was usually called upon to do. Drafting was boring. Checking drawings for errors was a necessary part of the professional practice, but wasn't creative. But Frank Gehry's office looked as if it could provide the kind of creative stimulation that I craved, and it did. I allowed myself to be consumed in designing weird details for a millionaire's house. I thought that maybe this was my art.

I wrote in my daily diary on January 1st, 1985:

"Has this life as an artist been worth the sadness? I'm left without the one I love. (I was referring to my daughter.) I made the choice to go this way. I wonder now about its validity. This year of 1985 will bring many changes. Perhaps I'll leave Center Street and begin again somewhere else without the baggage of possessions and definitions. No more the artist? I'll become divorced, and, now that I know this reality, will I find myself wishing for love and relationships, which I turned my back on five years ago? I want love in my life. All the rest is bullshit: the careers, the ambitions, and the ego-centered life. It makes me laugh. The fame and fortune I have sought so unsuccessfully seem so much a disorienting delusion unworthy of all the concentration I have put upon it acquisition. I'm becoming free and my freedom fills me with joy."

Thus the third act of the Art Dockuments ended. Maybe with my new job, I could afford the fancy clothes and the means to keep the Art Dock open. But how could I knit together my divided self, which, if I didn't, threatened everything, including my life?

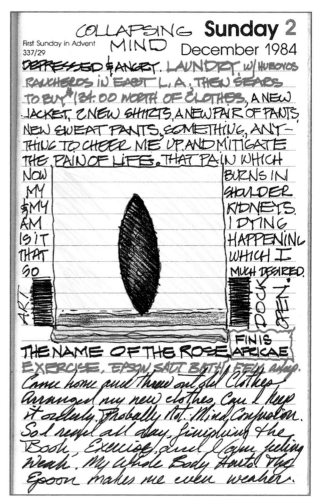

Daily Diary page by Carl Davis

Postscript 2012: Jan Taylor today is a real-estate broker and works at Pitzer College in Claremont, where he is involved with sustainable building projects. He continues to make art. His last show was in 2010. At the time of his show, Jan wrote the following:

Having based my identity, my world, my expectations, and my faith in my paintings, the whole system literally imploded around 1992. Up until then, I was certain my life's work was to be as a visual artist. All the arrogance that fueled this belief had become a self-supporting closed-off system whereby my identity and my career were one and the same.

In examining the work that I produced at that time,

The Art Dockuments

I came to an alarming conclusion: what I was creating was simply mediocre abstraction, based in abstract doggerel, and was only a continuum of morphing one mediocre idea into another. How sickening at thirty-five to give up this world, live in an ordinary house, wear brightly colored clothing, conform like all the other "Civilians"—in short, be normal.

I stopped making anything other than the occasional drawings and doodles. In 2004 I concocted an idea that would impose some self-discipline, I would make paintings by chance, by the flip of a coin, and I would do it for one year…For 365 days, I flipped the coin every day and obeyed the outcome. During this time I reclaimed pieces of painting and myself…I loved painting again.

Jan Taylor lives in Ontario, California. Ladi Von Jansky continues to photograph beautiful women. He lives in Beverly Hills. Constantin Brancusi, renowned Romanian sculptor, died in 1957. Mark Lere remains a well-recognized sculptor. He does many public art commissions and maintains a studio in the Los Angeles area.

ACT IV
THE BUSINESS OF ART

"Being good in business is the most fascinating kind of art. Making money is art and working is art and good business is the best art."
—Andy Warhol

"I love the gallery, the arena of representation. It's a commercial world, and morality is based generally around economics, and that's taking place in the art gallery."
—Jeff Koons

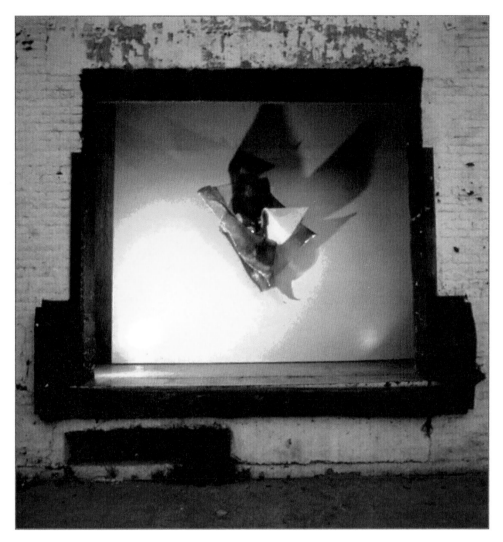

ART DOCKUMENT #28 "UNTITLED"
BY CARLA PAGLIARO—WINTER 1985

"You've got a corsage pinned to the Art Dock wall," snarled Sauren Crow, looking at the open loading dock. It was LAVA (Los Angeles Visual Arts) Day, and the dock was open for the few who found their way to Center Street. I passed out flyers for the show at all of the galleries the day before, the first day of LAVA, while Marti kept the Art Dock open. On Sunday, Sauren Crow, the next designated Art Dock exhibitor, appeared and confronted me in the street. He violently waved a flyer in his hand as he berated me for Carla's show.

"You've sold out and become commercial," he yelled at me.

"Why do you say that?" I asked calmly, knowing that yesterday, like a proud gallery owner, I had papered the LAVA show galleries with my hand-colored flyer. On Traction Avenue, by the Museum of Neon Art and the artist's swap meet, I had

passed out hundreds of my quickly rendered flyers while the crowds gathered to watch the antics of Michael Mollett and a group of his artist friends hawking all manner of junk, to the great amusement of onlookers.

"What this?" several art patrons asked when I put the flyer in their hands.

"It's the best art in downtown. Drive by and see," I responded happily.

Sauren drew me back from my reverie as he sneered. "Look at it. It's pretty, like a corsage. You have a flower on your wall. It's a violation of everything the Art Dock stands for."

"I didn't know I stood for anything other than letting each artist do whatever they wanted in the Art Dock," I replied.

"What about your manifesto, and your anti-art establishment stance? Have you given up your principles?" Sauren retorted.

"There's nothing here that goes against the manifesto. The manifesto doesn't prohibit a beautiful object."

"I don't know that I can put my work in such an unprincipled gallery."

"Come on, Sauren, is that bad? She's been shown at a number of other galleries. I think she has another show coming up in James Turcotte's gallery in June. Turcotte has even shown Marc Kreisel, to talk about a noncommercial artist. And she's showing other work at Victory Contemporary Art right now. That's more than you have going," I said.

Sauren looked at me, furrowing his brow and pursing his lips. I knew I had gotten to him.

"Those are garbage galleries. I have high principles. I don't show my work just anywhere."

"What you mean is that few places will have you," I retorted. Sauren was known to be a talented but difficult character, and several artists had warned me about getting involved with him.

"Not true! My work is very demanding. It requires curators who understand it. This work," Sauren

yelled, pointing a finger at Carla's piece, "requires nothing of the viewer."

"I don't know that that's true. It may be beautiful, but it's not made of beautiful materials."

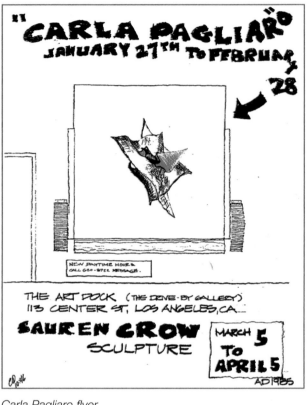

Carla Pagliaro flyer

Honeycombed metal and aircraft aluminum sheet made up the construction. The work had contradiction. Like Rauschenberg's junk and Oldenburg's plaster, the unusual materials were twisted, folded, creased, and crumpled to create an evocative form. The form was transparent, then shadowed, then solid, depending on how the light fell on its elements.

"You're right when you say it looks like a flower," I said. "The petal shapes and the pink stamen express an extreme delicacy, but none of this is fragile. It's tough and hard."

"Horseshit! Stop sounding like a pitchman!" Sauren, a short wiry man with wavy black hair and large rimmed glasses, stood on his tiptoes and

leaned aggressively into my face. "I don't like my name being on the same flyer with Pagliaro." Sauren ripped the flyer in half and tossed the top half with Carla's name on it on the ground and worked his foot over the fallen paper. "I'll keep the bottom half with my name on it," he said, and walked away from me.

"Does that mean you'll still show in the Art Dock?"

"I'll think about it," Sauren huffed, climbing into his battered Plymouth and roaring off.

I stood in the street in front of the open dock and watched Sauren speed away. *He'll show*, I thought. *Not that many people will put up with him.* I was glancing at Carla's piece when several cars motored past the loading dock. A BMW stopped and the window rolled down. I waved to them and pointed at the piece.

"Do you like it?" I asked.

"We do," said a woman, leaning out the window for a better look. "It's beautiful."

"'Untitled' is by the artist Carla Palgiaro. I call it 'Corsage.' The mixed-media assemblage looks like a flower pinned to the wall, doesn't it? It reminds me of the desert flowers that grow out of the barren rock walls of canyons to the south of Los Angeles. Exotic metallic orchid blossoms," I said in my best silken voice.

"Very nice indeed," replied the woman. The vehicle moved on.

This wasn't not a bad way to start 1985. "Untitled" was probably the first saleable work ever exhibited in the Art Dock. Maybe I could join LAVA and be the thirty-first gallery on their list. The number of galleries in downtown listed for LAVA day had gone from twenty in 1984 to thirty in 1985. The future was looking bright. I should get a price from Carla on the piece. Maybe I could make a little money off the Art Dock idea. If this was selling out, I was willing to do it. 1985 was the year to get down to business.

"How are you?" my beautiful poet lover asked over the telephone from the artist's retreat at Montalvo in Northern California. "So so," I replied.

"I'm in a fog looking for my fog cutters." She laughed and asked if she might visit me on her way to Asia. "Oh, yes," I said. "I may be in a fog, but I'm focused. I can't see much except what's right in front of me." She came by and was right in front of me. I was happy even when, too soon, she departed.

I was focused on my work for Frank Gehry and my health even though my mind was full of confusion about my life as an artist and full of concern about my recurring depressions. All week long I toiled in the lightless room in Venice, where the pundits said the sewer met the sea. Gehry's office was at the end of Brooks Avenue across the boardwalk from the pavilion where the homeless congregated. Each lunch hour I ate yogurt laced with bran yeast, wheat germ, and lecithin and went for a walk along the beach past the unwashed, wondering if I could handle working in this place. No windows. No phone at my desk. I sat in the middle of a big cold room amongst a jumble of desks. I was one of the fodders. The important architects in the firm had their desks on the outside edges of room. I tried hard to hold my mind together, telling myself to just enjoy my situation. Everyone was nice at first. I spoke only two words to Gehry. He smiled as he entered the john, and I was walking out.

"How's it going?" he asked.

"Fine, fine," I replied.

Greg, Frank's former partner now his principal design problem solver, was gruff. I thought he was overworked. He directed a group of architects on changes Frank had listed to the rich man's house in Malibu. We were to move a window, revise the steps to the weight room, change the pipe rails for stairs one and two, push out stair eighteen so it hovered over the entrance, and make the front element stucco over block. We met with the structural engineer, who said that moving the window like that meant he had to recalculate all the footings and we would have cracks. If we did what we proposed with stair eighteen, we had to have something there

to support the cantilever or we would have differential deflection. Tempers were rising. "I've heard that argument again and again," said Greg. "You can make it work." He gave stair eighteen, a curving stair that projected into space over the entry door, to me to draw.

I didn't quite know what to do. So I did anything I thought might work. Somebody like Jasper Johns once said, "So what is art? You do something to something then you do something else."

"What was my art? Don't make me laugh," I wrote. "My art is sitting at this desk and doing the art of Frank Gehry. And do it well I will. Head down and just keep drawing. Didn't I say once I would be happy if you put me in a room and let me draw?"

I played with a slippery fish. I played all day long. I fantasized about how you could make a fish column coming out of a pool. Frank Gehry was making fish lamps and fish buildings. I figured out what drawings you need to describe its form. What would the scales be made of and if it should be a light. Yes, the fish column in the Jacuzzi should be a light. Four fluorescent lamps, maybe more, would be grouped around the column covered by a series of transparent glass scales layered over one another like a fish, waterproof like a fish, and radiant like freshly surfaced fish. Out of the mouth of the fish, which would appear like it was emerging from a pond, water would gush. I showed my preliminary drawings to Greg. He dismissed me. "You don't understand how a Jacuzzi is supposed to work, and you are not to do that design," he growled. My good cheer was completely deflated. From that time on, Greg treated me with disdain, and depression swept over me.

Claes Oldenburg, one of my art heroes, was collaborating with Frank Gehry. I watched in envy as he and Frank sketched a project in the office conference room. My creative efforts retreated to my studio. There I drew, painted, and schemed about my new creative business of the Art Dock. I created special, individually-colored flyers for the Pagliaro

show in the drive-by gallery. I brought one to Frank's office, and as Claus Oldenburg walked past me, I placed a flyer in his hand. I told him about the Art Dock and how it was a legacy from his efforts to create the art store. He said nothing, but did hand the flyer to his partner Coosje van Bruggen. "That flyer will be worth something someday," I said to his back as he walked away.

Count Panza in 1985 at MOCA

I fantasized becoming like Count Giuseppe Panza di Biumo, who sold parts of his collection of modern American art to MOCA. The Countess Panza was reported in the "Downtown News" as saying that economic hard times had forced them to sell eighty pieces to the new museum. The poor Count might have to give up his vineyards and palazzo if he didn't deprive himself. Those divested works were now on display at the Temporary Contemporary. Perhaps I could sell Carla's piece to the museum, along with other art works I had collected over the life of the Art Dock, and no longer be one of the "voluntary poor." What would I say about my artists to promote a sale? Could I say something like what Count Panza said about Oldenburg, Lichenstein, Rosenquist, Rothko, Fautrier, Kline, Tàpies, and Rauschenberg, the artists in his collection? Count Panza, quoted in MOCA's Winter/Spring newsletter called "The Contemporary," when asked how he evaluated art, said:

"We have to build inside ourselves a model of the artist's world in order to check if his work was able to translate it. We need to check in which way the form is functional. This is a complex operation, which needs time and a lot of attention."

childhood home. It was a glass dump, but in it there were scraps of metal bent into fascinating shapes. Her work drew me to her. It wasn't a complex operation. I liked what I saw and invited Carla to show. I had not asked Carla if these mixed-media construc-

The Panza Collection at MOCA's Temporary Contemporary, 1985—photo courtesy of MOCA

Did I build a mental model of Carla Pagliaro's world, and did I believe her work translated it? I hadn't ever thought of such an idea, maybe because I didn't think in Italian? I'd been to her studio over on 7th Street. The studio was on the second floor, way in the back of a two-story unreinforced masonry building. In a space off her living area she had piles of honeycombed mesh and aluminum sheets. On the walls were a number of her finished pieces. None looked as flowerlike as the piece in the Art Dock. I knew Carla was Italian-American and went to art school on the East Coast, but I didn't know her world. The crumpled, folded, and painted aluminum pieces recalled the crushed material I often found in the dump that was across the street from my

tions represented her memories. Memory was one of the aspects of Rauschenberg's work that Panza commented upon. Panza claimed Rauschenberg's work had the "capacity to establish this relationship between our past and the object that is a witness to our past."

I thought about the Rauschenberg pieces I saw in the Panza collection. The window frame piece with the curtain partly bunched and falling in the opening was the most memorable for me. I had seen this image many times in old and abandoned houses that I played in as a kid. Rauschenberg toyed with this image. He made something more of it. The ladder, the wire, and the boards forced the work into our collective consciousness. I was

reminded of Carla's piece in the Art Dock. I recalled the corsages I pinned to young ladies' dresses going to proms when I was a teenager. The corsage had developed a collective meaning through time. These petals expressed beauty but also impermanence. Carla's work must've had some relationship to memory. I bet she was pinned by some beau in her teenage past. I thought she had translated her world into her art.

Franz Kline, "Buttress" 1956, photo courtesy of MOCA

But was it functional? Did the work work? I thought of Franz Kline's "Buttress" in the Panza show, where the bold black gesture across the canvas and the streaks coming into the center of the image from above and below were bolstered and stopped by three broad lines of black. The buttress held the energy of the lines like a clamp on an electric circuit. The painting worked. I found the corsage functional in that it captured an essence. Carla's constructions, in which the forms collapsed as if crushed by some enormous vise and released to expand outward as if they were coiled, were functional too. They had an expressive and beautiful aesthetic, but maybe they were too pretty—too nice to compete with Kline and Rauschenberg. Maybe

they didn't confront the viewer enough, as Sauren Crow intimated. Maybe they didn't shock us with the expression of the new. Not that I would ever say so, since, like Count Panza, I would only have the best thing to say about my artists. I would never say that a room full of Rauschenbergs gets tiresome, that too many Klines gets monotonous, and most Rothkos become repetitive. It was probably why the count kept most of this work in storage for eleven years in Munich.

I thought heard the dog bark in my studio. It was the time I usually walked the dog. I had to break off my contemplations. Count Art di Dock would walk his mythic hound in the metal vineyards behind the Citizens Warehouse, where once some Italian immigrant probably farmed grapes before the railroad came through. As I walked the tracks, I thought about the complex operation that, according to Panza, great art requires. Could Panza's ancestors have walked this riverbank?

Postscript 2012: Carla Pagliaro moved from downtown Los Angeles a few years after her Art Dock show. Her work was featured in the real-estate section of the *Los Angeles Times*. Sixteen years ago she moved to Livingston, Montana. She opened a successful furniture and mural-painting business. She continues to paint and show her work. In August of 2010 she showed her paintings at the Livingston Center for Arts and Culture. Michael Mollett continues his career as an artistic provocateur. In October 2010 he exhibited his large bundles of sticks, twigs, and other shafts. Count Panza was the first European collector of post-World War II American art. He brought international attention to Los Angeles "light and space" artists. The Count said in the *Los Angeles Times* in 1985 that "history will regard Los Angeles as a great center of the art of this (20th) century." He never favored any downtown artists with his patronage. Panza died in Milan, Italy, in April 2010, at the age of eighty-seven.

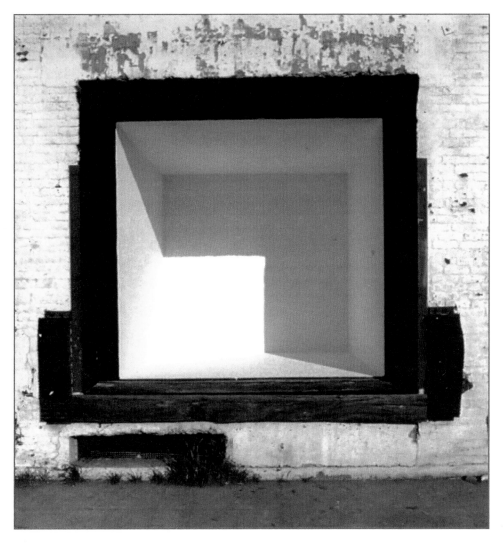

ART DOCKUMENT #29 "DISSOLVING VIEWS" BY SAUREN CROW—WINTER TO EARLY SPRING 1985

"I survived the Art Dock," Sauren screamed, but the Art Dock almost didn't survive Sauren Crow. He killed the idea for me by his actions, and he nearly killed himself. With purposeful intent, Sauren pushed the idea of the Art Dock to its opposite. The Art Dock became the white room. Everything it was before—a loading dock in a warehouse, an opening in a wall with little definition, an idea whose existence questioned the circumstances of art and the commodity of art—was subverted. What I thought not possible was done. He mimicked the gallery situation where the white room is the common denominator and the commodity of art is king. He created an art shrine. Sauren Crow converted the Art Dock into a white cube whose exterior plane was missing. There was nothing further that the Art Dock could be. The Art Dock idea had reached it limit, and the drive-by gallery would have to come

to an end soon. The only problem was the art didn't arrive for the opening in its white room.

On March 15th, the Ides of March, I stood in the street anxiously waiting for the art. The day was drawing to a close. The opening was only a few hours away. The cube was empty. My calls to Sauren were unanswered. Finally he picked up the phone.

"Where's the art?" I asked.

"No problem," he responded. He'd be on his way soon.

This opening, instead of the typical closing, was the biggest day in the Art Dock's history. A beautiful invitation had been sent out to all the major collectors, art critics, and museum curators in the city. Many had responded that they would come.

As I paced back and forth in front of the Art Dock, I thought about how this show began. It started with a big bang.

Sauren Crow was seen standing in Center Street months before his show began, contemplating the opening. In March, his observations became more intense. Carla Pagliaro's piece was removed, and the dock was empty. Sauren would open the steel door and stand outside and inside the space, measuring and thinking for hours at a time. Crow, part Indian—his father was a Sioux—and part provocateur, began to be a constant presence at the Art Dock. A week later he started to work, acquiring Gary Lloyd's assistance with his construction. Sauren intended to build three walls made of stretched muslin to form the top and two sides of a perfect cube nine feet wide by nine feet deep. The cube was to be positioned in the Art Dock's opening with an open side facing the street. The back wall of the cube was to be made by the Art Dock wall, the immensely cumbersome and heavy moveable wall fabricated by Bob Gibson over a year before. In this cube Sauren planned to place his sculpture "Dissolving Views."

On the fateful day of March 7, Gary and Sauren began by moving the Art Dock wall back some

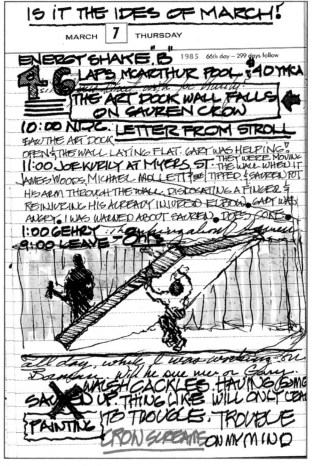

Diary page by Carl Davis

three or four feet to correctly establish the depth of the cube. In the process of inching back, the monstrous wall tipped forward and fell facedown on the loft floor with a crash and reverberation like the jolt of an earthquake. Sauren was nearly crushed. Sauren wasn't a large man. He was perhaps five feet, five inches tall and slight of build, but very strong for his height and stature. As the wall pivoted over him, he instinctively reached up with his arm to stop its descent. His arm broke through the surface drywall, and the wall's frame slammed into his shoulder. Simultaneously, Sauren pitched his body backward, and, as the wall's full weight bore down on his body, he hurled himself into the space of Center Street. Miraculously Sauren was not horribly crushed, just injured. The impact of the wall on his

arm severely sprained the wrist and elbow and tore the rotator cuff in his shoulder. He was in serious pain and dazed with shock.

Arriving in Gehry's Venice office for work after a morning of overcoming-dyslexia training at the Learning Development Center, a meeting with a structural engineer on my artist housing project, and lunch on the boardwalk hearing the bums sing in the toilet pavilion at the end of Brooks Avenue in front of the Gehry office, the Art Dock was the farthest thought from my mind. I was amusing myself thinking about doing the same and saying the opposite, which was my training on the trampoline at the LDC where I would turn left as I bounced to look at the bear picture on the wall and say "seal, "which was the picture on my right, bounce turn to my right and say "bear." This exercise was to help me with my inability to know right from left. I wondered if any of this effort was working.

I was encouraged by my meeting with the structural engineer and felt an artist housing project I was starting could become a reality and make my life a whole lot better. I could get out my unhappy circumstances at Frank Gehry's office, where my boss's obvious dislike of me was making my life miserable. He hated my ability to draw and castigated me for using colored pencils in my sketches of the elements of the Malibu house I was charged with working out in detail. The call from Gary pulled me back into the Art Dock project, which I had begun to conceive as real business venture. His call was not good news.

Gary was angry when he called. He told me about the wall falling on Sauren and how Sauren was blaming him for the accident. He reiterated that he had warned me about Sauren. Now trouble had happened. Gary thought Sauren would sue him and me. He was going to consult with a lawyer after he hung up with me. My boss overheard my conversation and cackled; "Having something like your drive-by gallery will only lead to trouble." He was right.

The next day Sauren screamed at me on the telephone while I was trying to forget and concentrate on my work designing a reflected ceiling plan. "It's your fault. Do you have liability insurance?"

"No!" I shouted back.

"Can you pay for my medical bills?"

"No," I stated strongly.

"Then I'm going to sue you for your loft and Gary Lloyd for his land in New Mexico."

I pleaded with Sauren to reconsider, but he kept bellowing into the phone until I hung up. I couldn't concentrate on my work and went for a walk along the beach. Once again I thought that this was probably the end of the Art Dock experiment. A few days later Sauren cooled off and stopped his threats, but his tantrum indicated to me that my concept of the Art Dock as a business venture was ridiculous. I had no liability insurance. I had no business acumen. I had no desire to put up with artist shenanigans anymore.

When I asked him later about the accident, Sauren replied angrily. "That wall weighed what, 800 pounds, maybe more? It was the world's biggest pancake." His emotion grew. "I knew I could die. Time slowed down. What an adrenaline rush. I lost track of reality. I actually threw the wall off and threw myself into the street. Gary said, 'Wow, that was amazing. Could I see it again?' Bastard! That threat, that danger, changes things. I will never have a fast ball again!" Sauren worked himself into a fever pitch, glowering at me. "I survived the Art Dock," he screamed.

After the accident, Sauren had been taken to the hospital where his arm was placed in a sling, and he was told to go home and rest. It had looked like the grand opening of the installation would have to be canceled. This was very sad; never had the Art Dock planned such a fancy affair. The invitations to the opening were fine pieces of printing. All previous Art Dock announcements were instant printings on cheap papers. This was an invitation on quality stock with relief letters. White on white, the words "Dissolving Views" could only be seen at

certain angles. The announcement had gone out to all the luminaries of the Los Angeles art world, and a grand party was planned for March 15ᵗʰ to celebrate the Art Dock's new status as a recognized and respected gallery.

I was doubly worried. What was I to do now? Send out a new announcement canceling the first and rescheduling the event for who knows how long? There was no way to forecast how long Crow would be incapacitated. There was the question of liability. My wall injured Crow, and like the good bohemian I intended to be, I had no insurance. Indeed the Art Dock was a business in name only. I had avoided all requirements for a real business, including describing the Art Dock as art in order to avoid the business tax and the subsequent questions of legality if the Art Dock was declared a commercial venture.

Sauren answered my worries by deciding that he was going to continue no matter what. He threatened a suit again against Gary and me if we stood in his way. Sauren responded to this situation with an iron determination to complete his art. Driven by the pain in his body and dulled by drugs to a crazed frenzy of activity, Sauren Crow was ready to die for his art. Two days after the wall fell, he was back on the job. Gary Lloyd, during Sauren's absence, had re-erected the wall and built a set in place of the muslin flats that constituted the cube. The room was ready for Sauren to paint it white. His arm in a sling and in obvious pain, he began to coat the walls and the floor of this perfect cube, all while threatening me, and sometimes Gary Lloyd, with legal action. Coat after coat he placed on the surfaces. Late into the night he would be in the cube, rolling white paint. In his white paper painter's suit and white paper shoe covers, he muttered and agonized over his art and his prospects. I myself became crazed from the stress. The more he painted, the more I worried, and the more I hated the artist.

Gary Lloyd left town, worrying what would happen if Sauren Crow didn't complete his piece or perma-

nently injured himself with his unending labor. Gary sought legal representation. At the lawyer's advice, Lloyd wrote a long letter explaining what happened on the day the wall fell. Each day moving toward the 15ᵗʰ of March, Sauren spent longer and longer hours in the cube painting and preparing the space for the sculpture, which was being fabricated by another artist, Jack Brogan, to Sauren's specification. He assured me daily that there was "no problem." He would be ready on the date of the opening and his piece in the Art Dock would be the "best ever."

For the last two days before his installation, Crow worked all day and all night with the aide of one new assistant, still painting, still sanding, and still patching the ever more startling white and increasingly perfect cube. I was driven from my studio to seek peace and sleep in a neighboring space. The one rule of the Art Dock, that I not be disturbed in my studio, was broken in a manner I felt I couldn't protest. Could I deny the man his monumental effort to complete the installation? Could I protest the upset of the peace of my studio when he was nearly killed by my wall? He had me cornered, and I grimly suffered on, wondering all the time if art was worth this stress.

The sight of Crow nauseated me. This little pale man in a white paper suit that rustled with every move, this little man with the long jet-black hair, high cheekbones, and thick-rimmed black glasses became—as my friend Gunga Ma called him—my petty tyrant. Calling on the philosophy of Carlos Castaneda, Gunga Ma called Crow a sorcerer and the third type of tyrant, the tormentor. A tormentor was that person who was caught in his own pain and suffering and would take it out on others. Misery loves company, so the tormentor takes us to his level of suffering. The tormentor came to take the spark of happiness and joy from my life. I could either succumb or be a warrior. I could, as Castaneda says, either make myself miserable, or make myself happy: "The amount of work was the same." I decided to be a warrior and stand up to

my petty tyrant. When he yelled at me in his pain, I yelled back at him. I told him to back off and give me space to breathe, and he did.

The hour of the opening came. The art hadn't arrived. Friday evening was balmy. Michael Salerno had jointly planned the opening of an exhibition of Paul McCarthy's drawings in his AAA Art gallery. The mailing lists created a big crowd, and for once we attracted many of the big names in the art scene—collectors and even some well-known artists. It was going to be a grand event. For AAA Art it was terrific, but for the Art Dock it was a comic disaster. The art never arrived. Perhaps for the first time in gallery history there was an opening in which there was no art. The Art Dock opened with an empty white cube.

Sometime later in the evening, after I had already expressed apologies to the invited guests, Sauren arrived with the parts to the sculpture and they were laid on the floor of the cube. A pile of unfinished metal was lumped in the center of the still-incomplete cube, because, according to Sauren, the space was still not white enough. It was a forlorn sight, and we who were the sponsors, assistants, and friends of the artist were a sad group. Michael Willowa, a visiting poet from New Mexico, described the assembly as "the apostles of silent and anxious grief who, when the angel rolled away the stone from the tomb of the Art Dock, found nothing there."

Thank goodness there was an opening down the street. AAA Art saved me from complete humiliation. The Art Dock crowd wandered over there and jammed Michael's space to overflowing. The Art Dock event became a wake, with some of the art lovers returning to my studio to imbibe the large amount of liquor Sauren and I had purchased for the big show. We all became quietly drunk.

Sauren, totally upbeat, stated, "No one looks at the art at an opening anyway. The Art Dock merely saved everyone the embarrassment of commentary by leaving the art out of the opening."

Sauren, inebriated, drugged up with painkillers, and expressing great satisfaction with the opening, continued, "The opening fits my position vis-à-vis the commercial art world. It's appropriate for the avant-garde status of the drive-by gallery. After all, the Art Dock should retain its outsider status."

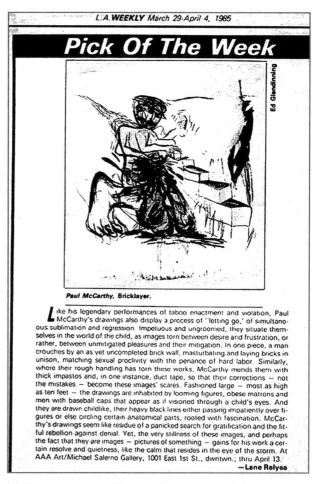

L.A. WEEKLY March 29-April 4, 1985

Pick Of The Week

Paul McCarthy, Bricklayer.

Like his legendary performances of taboo enactment and violation, Paul McCarthy's drawings also display a process of "letting go," of simultaneous sublimation and regression. Impetuous and ungroomed, they situate themselves in the world of the child, as images torn between desire and frustration, or rather, between unmitigated pleasures and their mitigation. In one piece, a man crouches by an as yet uncompleted brick wall, masturbating and laying bricks in unison, matching sexual proclivity with the penance of hard labor. Similarly, where their rough handling has torn these works, McCarthy mends them with thick impastos and, in one instance, duct tape, so that their corrections — not the mistakes — become these images' scares. Fashioned large — most as high as ten feet — the drawings are inhabited by looming figures, obese matrons and men with baseball caps that appear as if visioned through a child's eyes. And they are drawn childlike, their heavy black lines either passing impatiently over figures or else circling certain anatomical parts, rooted with fascination. McCarthy's drawings seem like residue of a panicked search for gratification and the fitful rebellion against denial. Yet, the very stillness of these images, and perhaps the fact that they *are* images — pictures of something — gains for his work a certain resolve and quietness, like the calm that resides in the eye of the storm. At AAA Art/Michael Salerno Gallery, 1001 East 1st St., dwntwn.; thru April 13.
— Lane Relyea

LA Weekly *review of Paul McCarthy Show at AAA Art*

"Go to hell, Sauren," I replied.

I was sick. He destroyed the credibility of my gallery as a serious and competitive art space. In one fell swoop, the Art Dock had been returned to joke status. I believed I would never again get another review, nor could I hope to attract the attention of the legitimate art world.

Paul McCarthy's show got the review and pick of the week in the *LA Weekly*, the reward I had thought

would be the Art Dock's. McCarthy's exhibit at AAA Art was the antithesis of Sauren's polished and precise art. His works were rough, free markings on huge torn sheets of paper, repaired as needed with duct tape. These drawings were adjuncts to the provocative and often scatological performances by Paul.

Diary Page by Carl Davis

The drawing reprinted in the *LA Weekly* showed a mason building a brick wall while simultaneously masturbating. The drawing was childlike, distortedly scaled; a foot was shown as an immense appendage to a body with small head and arms. A blur of black marks signified the ejaculation. The commentary by Lane Relyea reminded me of the Herculean labor of Sauren Crow. He mentioned the artist's penchant for hard labor as represented by the brick wall and

then went on to describe these drawings as "situating themselves in the world of the child as images torn between desire and frustration." The analysis continued. "The very stillness of the images…gains for his work a certain resolve and quietness, like the calm that resides in the eye of the storm." The description could be of the white cube, whose stillness was beautiful. It stood in mute testimony to the frustration and the desire of the artist, whom I had come to think of as a young child determined to get his way no matter the consequences to himself or others. In this single-mindedness was a silence and authority that forced all others to join him in the eye of the storm. We had dissolved into the calm.

The tale did not end with the failed opening. The following week Sauren returned to finish his cube, and the sculpture returned to the fabricator for more work. The threats of a suit ended as the pressure of the performance disappeared. More coats of white paint were applied. The cube with Sauren in it became the exhibit. Passers-by saw, day after day, the small black-haired figure in his white paper suit working diligently in the dazzling white space. The cube was a marvelous white box. In the indirect light of the morning the cube emanated a cool white presence that seemed to make a diaphanous mass of the light reflected and trapped inside. The viewer sensed something like an apparition inside the cube, filling the space with its essence.

In the afternoon, the cube became a study in light and shade. The sun's direct rays penetrated the cube, creating geometries of light that constantly changed and drifted over the surfaces. Inside the cube a small square of light appeared in the lower right back corner as the sun moved into the afternoon. This square grew in size as the afternoon progressed until it almost filled the entire cube before it quickly faded as the sun disappeared behind the one-story building across the street. The sun made the cube into a light machine describing perspectives of space and varying hues of light

during the process of illumination. The cube was a wonderful work in its own right, and, if one had not known this was merely a container, it would have easily satisfied. One could have said the Art Dock had been graced with a light-and-space installation, for which California was well known.

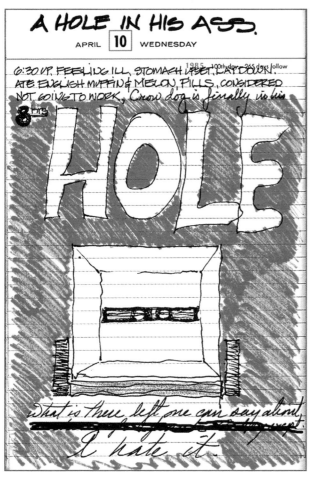

Daily diary page by Carl Davis

Sauren Crow, however, was not a light-and-space artist, and finally, on April 10th, well over a month since he started his installation and over three weeks since the disastrous opening, the sculpture for which the cube was the setting was finally installed. On the back wall of the cube and centered just a little below the midline, Sauren placed a long, narrow sculpture. Around the sculpture's outside was a thin frame of black anodized aluminum, which served to visually separate the plane of the piece from the plane of the wall. Inside the black frame and flanking the centerline of the sculpture were two long rectangles of copper. At the center of the sculpture, surrounded by black anodized aluminum, was a copper disk. On the copper disk, a solid stainless wheel-like element with a hole through the middle supported a quartz rod. To the right and left of the centerline and separated by the black anodized aluminum were two optically-turned discs of stainless steel. The discs were concave to the surface of the sculpture. The quartz rod supported by the wheel-like element stretched the length of the sculpture without deflecting downward. The straight line of quartz caught the light. Light traveled down the rod and refracted in the concave metal disks into a spectrum of color. The sculpture floated in space with a glowing white line down the middle and two flares of color partway down its length. These were the dissolving views. It was extremely beautiful. But I hated it. I wrote my evil thoughts on the April 10th daily diary page in bold letters at the top, "A hole in his ass," and below in script, "The crow dog is finally in his hole."

Sauren explained his piece. Sauren began with the assertion that looking at the piece would divide the eyes and create a response much like the Kundalini experience of Indian mysticism. He claimed that staring at the piece released biochemical oils that cause spiritual release, like "seeing beyond." He claimed that encountering the piece in the setting of the white cube would make the viewer "wall-eyed like a Buddhist" and could lead to an enlightenment experience. The metal wheel divided the eyes and the quartz rod grabbed light. The rod sucked the light inside the cube and transmitted it down the length, turning the quartz into a luminescent tube. The optical discs positioned behind the rod refracted the light of the tube into a series of prismatic effects, further emphasizing the division of the eyes. I watched this piece intently and felt no flash of

enlightenment. I did see the beauty and ingenious effects, but then again my mind had closed to the piece's ultimate effects due to the feelings of frustration left over from the history of its arrival. I could not come to this work with an open mind. My eyes were too much pulled inward in anticipation of another possible disaster. But I could not deny "Dissolving Views" its beauty no matter how high a price the artist and I paid for its creation. It was without a doubt the most seductive installation ever created in the Art Dock.

At night the piece was most exquisite. The black

"Dissolving Views" by Sauren Crow in the Art Dock at night

frame pulled the piece away from the wall. The careful lighting of the cube, something that Sauren devoted considerable time to after the final installation of the sculpture, made the edges of the cube dissolve. "Dissolving Views" appeared to hover in the air in a volume of bright light. The quartz rod made an even more dazzling line in the general brilliance. The refracting discs twinkled with flares of light, and the colors of copper, stainless steel, and black aluminum were clear and bold. The contrast of this visual purity with the context of the Art Dock heightened the experience. In this environment of urban decay—the paint-peeled warehouse with its chipped and eroding bricks, the power poles, asphalt, concrete, soot, and cars—to come upon this object floating in the perfect white cube was startling and disturbing. "Dissolving Views" was an apparition from another world. The viewer sensed himself looking through our reality into something from the fourth dimension. I was awestruck.

The Art Dock became a shrine to the idea of art. The shrine was a spiritual experience at this level, one born of an incredible intensity, dedication, and hardship. I questioned whether I wanted the Art Dock to be so good, but in retrospect I came to realize that "Dissolving Views" was the zenith of the Art Dock. It had reached everything that it could be. Anything thereafter would be art in the context of an idea that reached its fruition. No new statements of possibility seemed feasible, and I resolved to end the experiment at the appropriate time in the future when the energy of its existence had run its course.

On April 16, the art committee of the Community Redevelopment Agency (CRA) came to see the work. They liked it and subsequently purchased the work. "Dissolving Views" became the one and only piece of art ever purchased from the drive-by gallery. The piece began another story in the headquarters of the agency which took two years to reach its culmination. The agency would not take the white cube, so Sauren had to find an appropriate spot in their building. He eventually did, locating the piece on a marble wall near an elevator. He negotiated permission to cut out a part of the marble wall to install his piece flush with the surface, not without protests of disbelief by agency staff. In the ceiling he installed a very expensive light to illuminate the work, and later had to replace the quartz rod several times because of breakage. The difficulties of "Dissolving Views" were fortunately turned over to someone else, and I had a good laugh. Sauren never gave the Art Dock any commission from his sale.

Postscript 2012: Sauren Crow divorced his wife and moved to Taos, New Mexico. In 1993, he volunteered his services in the war in Bosnia, distributing food, clothing, medicine, and toys. In 2001 he married a fifteen-year-old girl in Nevada, where a Clark County District judged allowed the underage marriage with permission of the mother. Sauren was the young woman's guitar teacher. The outraged father sought legal action. In a court affidavit, Crow described himself as "an artist, poet, sculptor, dancer, and musician." The Supreme Court of Nevada overturned the marriage in 2002, but the girl was already sixteen, and the victory was hollow. However, the legal costs impoverished Sauren. He began taking sex-change hormones. He/she developed cancer. Trinity or Veronica, as Sauren began to call himself, became homeless and moved into in a van in Santa Cruz, California. Given only a short time to live in 2008, Trinity was too tough to die. She remains a sorceress of uncanny ability, and, in spite of her desperate circumstances, has a Facebook page under the name Amelia Akasha Serene Corvinus, with, according to her, 5,000 friends.

Sauren Crow, or should I say Veronica/Trinity, and I met after 25 years of being out of contact. She was in LA, having come down from Santa Cruz to deal with a long-outstanding traffic ticket. She and I had dinner, discussed the past, and laughed. She was smoking hand-rolled cigarettes. I said to her, "Those things will kill you."

She barked back at me, "What—am I going to get cancer?" It was a very healing experience for both of us. I dropped Trinity off at the photographer's studio where she was staying. I came to admire the pluck and sheer will-to-live of Trinity. She was thin, still had cancer, and lived on almost nothing, but had an iPhone and was in contact with many collectors who bought her work. She wrote poetry and made small sculptures. She walked across Los Angeles from the train station to the courthouse where she pleaded her traffic ticket and walked back to a studio in downtown where I picked her up, a distance of more than four miles. She was wearing mismatched heeled boots because she was almost blind in one eye and selected the boots in her van, which had neither light nor electricity. Trinity was not downhearted or defeated. She was full of life and talked about the grace, light, and space of life. I wished her well.

Lane Relyea, art critic and historian, taught at California Institute of the Arts before moving to teach at Department of Art Theory & Practice at the Weinberg College of Arts and Sciences, Northwestern University, where he is an associate professor. Jack Brogan, art and art fabricator, is a legend in Los Angeles. He worked with many Southern California artists, including Robert Irwin, creating amazing highly polished and gorgeous colored finishes. Carlos Castaneda, anthropologist, author, philosopher, and mystic, died in 1998. Paul McCarthy has become an internationally known artist whose work has been exhibited in the Whitney Museum of Art, the Tate Modern, the Stedelijk Museum, and other international galleries and art museums. He works mainly in performance, video, and sculpture.

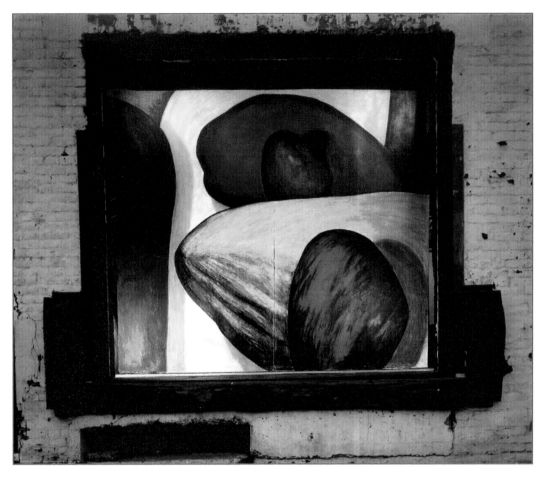

ACT IV THE BUSINESS OF ART

ART DOCKUMENT #30 "LARGE DRAWING"
BY JEFF LONG—SPRING 1985

Life returned to normal. If life in downtown Los Angeles could be considered normal. I continued to work in Frank Gehry's office—a long commute from downtown to the beach at Venice and less enjoyable than walking to work as I did on my previous job—to work on window details and wall sections of the rich man's house, relieved that "Dissolving Views" had dissolved. I got back to the regular routine of my life. I went shopping and did my laundry with all the other artists in Latino east LA because there were no grocery stores or laundromats east of Alameda in down-

town. I visited art galleries. I went to see the "Off the Street" exhibition in the old printing company at First and Central. I walked my invisible dog along the railroad tracks, pursued my interest in low-cost artist housing, and hung out with the other artists on Center Street. Trouble was in the air concerning our leases, which were up for renewal after five years. I attended a couple of tenant meetings to discuss what should be done when the rents escalated, but that was nothing compared to the stress of the previous few months. The future would hold something different, however.

The Art Dockuments

"Gehriated" I called it. In my daily diary I wrote, "Sundays finds me working on an amazing piece of world architecture for the world famous architect. Yes sir, I was so proud to be allowed—Don't be cynical! —to work my ass off without appreciation. Who says you should have appreciation? This is work. This is modern slavery. This is it, art for art's sake. Oh, yeah." And I hated it. I hated almost everything. Another down had come, and negativity had wrapped me in its coil.

At the Learning Development Center, I called my therapist a sadist. "Why don't you dress in leather and carry a whip," I suggested. She laughed, and I thought it was always the bitches that pissed me off. I was in a foul mood, and I fucked up the exercise of knowing right from left. "Why are you torturing me, bitch?" I yelled at Jackie.

She said, "You can't say that to me. Leave now."

I stormed out of the center, and drove to Frank Gehry's office in Venice. Across from me was another smiling female, sitting there so happily. I wanted to put a fist in her face. "Keep your happiness to yourself," I said sharply. She was startled, put her head down, and wouldn't speak to me for the rest of the day. I had insulted a good friend.

My mind was on fire. I went to my new girlfriend's bed. Her body was firm and supple, and I slid my hands over her breasts. Yet sex with her made me angry. I found the only way I could enjoy it was to be rough with her. I pushed her down. I hated making love. It was just work not pleasure. Finally it was over. Thank god it was over, and I could go home. My life with women was sick. But I didn't go home. I went to the gay baths. It was less work, less trouble, but more weird. Afterwards I felt very guilty. Why was this happening to me? I liked women. Suicide thoughts filled my mind.

In several days the anger passed and the suicide thoughts evaporated. I was okay, even happy. I could relate to women and not be cruel. I could laugh when Marti, my friend and assistant curator of the Art Dock, looked at Jeff Long's newly-installed, large drawing in the Art Dock and said, "I think he spends too much time in the bath houses." I did not respond, but thought how personal his observation was to me. There was definitely something wrong in my head. I could not go on this way alternately happy and heterosexual then deeply depressed and gay. I discussed this situation with my psychologist; but I kept my gay activities a secret from everyone else.

Jeff Long arrived from San Francisco on April 22; two days after Sauren Crow removed "Dissolving Views." The white cube had been destroyed, and only the Art Dock wall remained. Jeff and I positioned the Art Dock wall back in its place some four feet behind the rollup door, and Jeff began his drawing the next day. His plan was to do the work right where the art was to be displayed. For three days, Jeff worked intensely on the enormous drawing while artists walked by and interacted with him. He finished the drawing on April 26, packed up his supplies, and departed, to be seen again only at the closing party on May 31. This show was as easy and pleasant as the previous event had been hard and acrimonious. I appreciated this. I needed a breather from the intensities of Art Docking. This was not to say that Jeff's work was careless or without rigor, rather, it was efficient and clear while being bold and very appropriate. Once again the Art Dock provided a forum for an artist to experiment and do something he hadn't before.

The Art Dock show began a significant change in Jeff's work. Never had he done a drawing this large, nor had he worked with the paint sticks with which he drew the image. The character of his imagery changed from the refined rendering of natural forms like trees, rocks, and water and manmade artifacts such as oil drums, and boats—he was well-known and sold pieces with relative ease in the San Francisco art scene—to bold and rough forms that hovered at the edge of abstraction. He said the

work had been percolating for some time. The Art Dock provided the opportunity to bring it out in the open for the first time at the right scale.

Jeff Long is a gay artist. The new crisis of AIDS affecting his community so drastically, especially in San Francisco, caused Jeff to reach, as he said, "a spiritual and emotional crisis." He saw many of his friends contract the disease and decline into death. He worried about his own mortality and began to see the world in terms of a fragile and transitory existence. Jeff's work in the past had themes of disaster and waste. In one work, entitled "Drums along the Mohawk," the bottom of a river was portrayed littered with oil drums seen through a veil of water. The image was very beautiful; the elements of the composition were drawn and colored with precise lines and bright hues. This work treated serious subjects, such as pollution and ecological damage, very accessibly and sold easily. "Drums along the Mohawk" was purchased by the McDonald's Corporation and currently hangs in its headquarters: Hamburger University in Illinois. Jeff's new work, of which the Art Dock drawing was the first public example, took the disquieting undercurrent of his previous work and brought it forward with emotional intensity. Where the older work was cool and specific, the newer work was hot and universal.

In the Art Dock drawing the whole visual field— nine feet wide by nine feet high—was filled with large shapes that could either be rocks, fruits, or physical organs. These forms were at once familiar and abstract. They loomed out of the opening with visceral, sensual, and brooding impact. Without direct reference to anything in particular, the image was emotionally expressive. The shapes appeared to be imbued with mortality. I thought they could be sentinel rocks guarding a sacred burial ground, embodying both the life force and its opposite, destructive energy. Or these forms could also be taken as metaphor for the human body. The viewer was looking into the aperture of a gigantic micro-

scope, peering at interior organs, particles of blood, or the shapes of viruses. These generic shapes— bumpy ovoids of huge scale and audacious color—created a still life that was a contradiction of itself. The forms, while motionless, seemingly caught in a state of equilibrium, were filled with a feeling of sexuality and anxiousness. They were poised at the juncture of turbulence. They were packed with energy, yet about to become enervated. To look at this drawing was to be overwhelmed with a sense of loss and to confront the reality of impermanence.

"Given: 1. The Waterfall, 2. The Illuminating Gas…"
Marcel Duchamp, Philadelphia Museum of Art, 1946-66

The drawing and context reinforced one another. Jeff described his view of the Art Dock space as alternately an aquarium and a sanctum. Like the aquarium, where we look into the fish world not easily

seen or contained except in a transparent tank, the "Large Drawing" in the Art Dock allowed a view into an imaginary landscape of illusion and feeling. Beyond the image and behind the warehouse wall was a world unseen. Jeff wanted the viewer to think the entire building was full of these forms.

The action was analogous to Duchamp's "Given: 1. The Waterfall, 2. The Illuminating Gas..." at the Philadelphia Museum of Art, where the viewer looked through a doorway to another dimension. In the work in Philadelphia, we looked through a door by means of a peephole at a naked woman on a bed of twigs, holding aloft a light. The concept introduced an otherness to the aesthetic activity. It separated us from the object while simultaneously making us part of the picture. We symbolically looked into another dimension while becoming one with its reality. The Art Dock similarly divided the viewer from the scene inside. The wall around the portal became the fortress that imprisoned these fertile shapes and separated them from us.

The viewer in a car driving by or walking past the open loading dock of the industrial warehouse on a dingy inner-city street got a glimpse into another world. These gigantic fecund shapes were an unreality that underscored the reality of the environment. The context placed the viewer in the work. There was no separation between the art and the environment. The art was the environment. The drawing extended out into the street, included the sidewalk, the road, the vehicles, and the people. At once the art was removed and integrated. We were aware that there was no glass to create a barrier between us and the object. The object was on the street. There was no frame around the image other than the cut in the wall of the opening. The image flowed into the context. The piece was part of the context, and we were also part of that context. Like Duchamp's great and final work "Given...," the art looked at us looking at the work. The aesthetic distance was destroyed. We became one with the other-

ness manifested by the art in the loading dock. The dock, the building, the street, ourselves, everything became part of the art.

I looked down on my mythic dog as I deliberated in front of the open loading dock. The dog looked up quizzically at me.

"Yeah, you're right, MOCA, I sound like a long-winded curator. Let's close up and go for a walk," I said. The dog wagged its tail enthusiastically. "We can think about something else, like the 'Off the Street' show. You can always tell when a building is doomed: They allow artists to come and play in it."

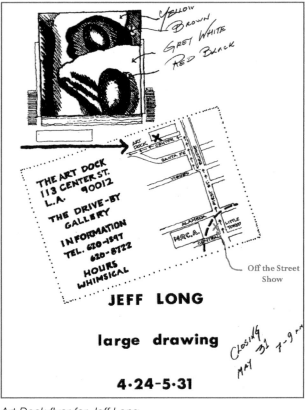

Art Dock flyer for Jeff Long

The City's old printing plant at the corner of First Street and Central Ave., just south of the new temporary Museum of Contemporary Art (MOCA), was soon to be demolished. The Community Redevelopment Agency, which earned great praise for the Cotton Exchange Show in the Cotton Exchange

Building demolished last year, gave its approval for another show in the old City of Los Angeles printing plant. This time, however, it was not a cattle call in which 200 artists got to do their thing. This time exhibition space was given to only forty-seven artists. Most of these artists were associated with the downtown scene or the Latino community. Just like the Cotton Exchange Show, the artists took over a vacant building, turning the first and second floors of this cavernous structure into a big art fair. Each artist claimed an area of the interior or exterior for him or herself.

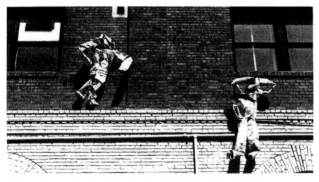

Adam Leventhal's piece in the "Off the Street" show —photograph courtesy of the Downtown News

Several of these artists had shown at the Art Dock. One artist, Gronk, who, like several others in this show was in the Cotton Exchange Show before, chose to paint his work on an interior wall of the building. This work showed the influences of the artist's environment and other artists on creative work. The mural was a reference to the Art Dock and the show in 1983 by Pamela Burgess. Monique Safford, also an Art Dock exhibitor in 1983, had a piece mounted to the outside of the building above the entrance. An image of a Greek statue was combined with a statement analogous to her Art Dock installation, but this time the work was a painting and was mounted like a sign. Marguerite Elliott exhibited the same piece she had in the Art Dock as well as another made up of a group of men and women gathered around an oil drum warming their hands. This work got the photograph associated with the review in the *Los Angeles Times*.

This show, which William Wilson of the Los Angeles Times archly termed "Apocalyptikitsch," reflected both the energy and the dark side, of living in downtown and being an artist in the commodity-crazed society of Los Angeles. The exhibit included Adam Leventhal's metal dollar bill figures pinned to the exterior, and John Valadez's enormous portrait of the great downtown Latino shopping street. Wilson pejoratively declared this work "a slice of Broadway's purgatorial street life," thus permanently allying himself with the clean white gentility of the Westside of Los Angeles. There was an installation of a crack den called "Alameda Street Bunker" by Michael McMillen; another horror-house installation with a figure shocked repeatedly with an electric charge by Fred Tomaselli; tar-paper paintings by Michael McCall; and the homeless tableaux of Marguerite Elliott, to mention a few of the forty-seven pieces in the show. The images of this show were generally raw and tough without the sunny attitude that was associated with Los Angeles art. Wilson slammed Elliott, calling her homeless mannequins too pretty, but Wilson did state that this show reflected the downtown art scene. Much of the art suggested the embattled and threatened existence that the artists experienced living in the hard, grey, concrete world inside the four freeways east of Broadway.

But not all of it was depressing. Jeffrey Vallance, the conceptual artist, created a performance piece called "The Office." Vallance was famous for his "Blinky, The Friendly Hen" piece, in which he documented the saga of a chicken he purchased at a local supermarket and ritually buried in a pet cemetery. In the "Off the Street" show, Vallance set up an office in one of the dingy old building's office spaces, complete with the national and state flags, a coffee machine, Sparkletts water dispenser, telephone,

The Art Dockuments

Jeffrey Vallance, "The Office" 1985 in "Off the Street" Show

and an ugly old desk. He printed up business cards and had appointments. You could go to him and discuss economics, business, politics, and art. I came in to see him one day to talk about art.

I asked my usual first question. "What is art?"

Jeffrey looked up at me with a gentle smile and said, "Art is cheese, food for thought."

The man must have read my and Duchamp's minds. I was about to press him further when his phone rang. He excused himself saying he had to take a call for Mayor Bradley. The telephone company unknowingly gave him a number that was formerly the mayor's. I wandered away disappointed. What else had I expected from an artist who lived in the San Fernando Valley and was notorious because of a chicken?

I returned to the loft from my evening excursion along the railroad tracks, accompanied by my invis-

ible dog, where I ruminated over the "Off the Street" show. I thought that art should be fun. Jeff Long's "Large Drawing" was proof of that. It was fun and spiritual at the same time. Long had reinvigorated me. I decided to keep the drive-by gallery open a little longer.

Postscript 2012: After returning to San Francisco, Jeff Long continued his career as an artist and curator. In 1986, Long suffered a major studio catastrophe. The wood warehouse building where he had his workspace exploded, caught fire, and collapsed with Jeff inside it. He lost all his work, including the Art Dock drawing, but he miraculously survived. Thirty artists and artisans died in the disaster. In 1998, Jeff moved to New York where he continued to paint until 2001 when he returned to San Francisco. His work has gone through a number of transitions—he calls them distillations. He now makes more hard-edged

Daily Diary page by Carl Davis

abstractions and Aububon-like bird paintings. His last solo shows were in 2010 at the JayJay Gallery in Sacramento and in 2009 at Toomey Tourell Fine Art in San Francisco.

William Wilson was art critic for the *Los Angeles Times* from 1965 to 1998. He was well known for his wit and was twice nominated for a Pulitzer Prize. In 2008, Jack Rutberg Fine Art Gallery hosted an evening with Wilson, who talked about a book he was writing since he had left the *Times, 100 Years of Los Angeles*.

Gronk, Fred Tomaselli, Michael McCall, Michael McMillen, and Jeffrey Vallance continue to make art. Gronk (Glugio Nicandro) is a recognized figure in the Chicano art movement in LA. Fred Tomaselli has had solo exhibitions of his work in the Brooklyn Museum, the Albright Knox Gallery of Art in Buffalo, NY, the Whitney Museum of American Art in New York, and several international venues. Michael McCall showed at the Hickory Museum of Art in Hickory, North Carolina, his hometown. Michael McMillen is represented by LA Louver gallery. Jeffrey Vallance teaches at the California Institute of the Arts and was a recipient of the John Simon Guggenheim Memorial Foundation Award.

The sculptor Adam Leventhal sold several of his crumpled-metal, silkscreened, dollar-bill figures to the Coca-Cola Company in Atlanta, Georgia, and the Federal Reserve in Washington, D.C. Leventhal became a master of the art of steel fabrication and blacksmithing. A sufferer of bipolar disorder, he committed suicide at age forty-two in 2000. His legacy lives on in an organization called Adam's Forge, which forges character and community growth through the art of blacksmithing.

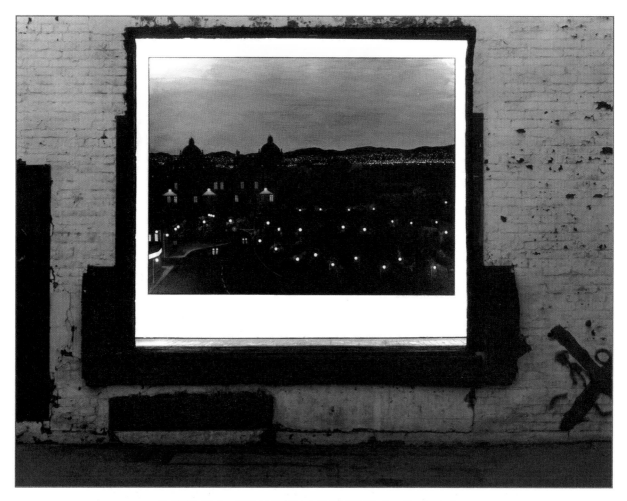

ART DOCKUMENT #31 "ALAMEDA SUNRISE" BY WALTER IMPERT—EARLY SUMMER 1985

The Art Dock had taken on a life of its own. The director became unnecessary. I came home on the evening of June 2nd to discover an ongoing opening of which I had no knowledge. On his own, Walter Impert had installed his painting, sent out notices of his opening, and never informed me of his plans nor sent me an invitation. I had to laugh, and then I screamed at Walter's insensitivity.

"The black brain turns blue," I wrote and sketched in my daily diary. I screamed into space for help, but no one responded. My friends didn't help. They were too caught up in problems and needs of their own. The therapist at the Learning Development Center had me playing with shapes, but my mind was cloudy, and I couldn't find a solution. I wrote, "Mind won't work; mind won't work" over and over again. My therapist had me try a new exercise based on an old one. I had to say the opposite and do the same. I was no better at this than the old exercise of saying the same and doing the opposite. She had me listen to sounds and try to hear the differ-

ence. I could hardly hear any differences. My anxiety became so great I yelled at the therapist again. She said I should go back to see my psychologist.

Doctor Wortz told me I was a very bright person with great flaws. I couldn't spell or hear properly, yet I wasn't deaf. I didn't know what was wrong, but something was definitely wrong. I had felt wrong-minded and out of place all my life. I was alternately angry, depressed, and gay then happy and heterosexual. Dr. Wortz gave me a prescription for an anti-depressant. I took the drug diligently. My depression blue turned a happy bright yellow like the full sun. I threw myself into my work at Gehry and the design work on a new artist housing project. I asked for a leave of absence from Gehry's office, but the Malibu beach house was at a critical juncture, and I couldn't leave right away. Once again I was working night and day on architectural projects, and I had little time for art.

I did visit one art exhibition at MOCA in which Allen Ruppersberg, the respected conceptual artist, exhibited his dirty sheets turned backwards. I thought the exhibit was crap—was it literally?—and wondered if I was interested in art at all anymore. Why should I make art if this kind of work was considered great and cutting edge? Perhaps it was better just to draw and paint for the pure pleasure of the act than to concern myself, as so many did, with being innovative and recognized.

In the proscenium of the Art Dock hung a painting, the first oil on canvas ever exhibited in the drive-by gallery. The metamorphosis was complete. The Art Dock had become a traditional gallery. Many galleries hung paintings in their front windows, and the Art Dock perfectly imitated them, except for the lack of intervening glass. The Art Dock became a window space backed by a neutral white wall. On the wall was positioned a smaller, self-contained image: a cityscape. I thought of all the small and familiar galleries, the kinds that place a painting in the window to entice the pedestrian into the salon to see their stock of similar images, reasonably priced and aesthetically coordinated to the décor of any modern room. The joke gallery had truly come full circle and became its opposite. The Art Dock was in fact an idea that could absorb the ideas it criticized. It had become a Melrose Avenue Art Gallery.

"Alameda Sunrise" really looked good. The frame of the opening holds the frame of the canvas. The sight was as tasteful as the best gallery window displays. Standing in the city, the viewer looked into the opening at an illuminated scene in the same city, not far from this location: the Post Office with Boyle Heights beyond it. The sun was beginning to rise in the east, but the buildings were still in darkness. Just the street lamps, the shadow shapes, a roadway, and the rising sky were seen. Walter wanted his painting of Los Angeles to be seen at night. I decided to interview Walter, beginning with this exhibition requirement.

Walter Impert by Ed Glendinning

"Your announcement says you only want the painting shown at night. Why do you ask that?" I asked Walter.

"This is a painting of downtown at night, and I thought the viewer should see it at night instead of in the daytime, which is when most people see paintings in the gallery. It also seemed fitting to see an outdoor scene in an outdoor setting. Besides, I decided it looked better at night when everything was dark. The painting became like a gem," Walter replied.

"Any kind of image jumps out of the nighttime environment when illuminated," I said.

"To me, cities at night, especially American cities, become a kind of wonderland of green, red, and yellow lights. In the daytime the city is ugly, but at night it's fantastic. It comes alive. It takes on the quality of a billboard."

"You have a preoccupation with nighttime scenes. Why's that?" I asked.

"I remember driving back from Hollywood one night after a seeing a movie. I thought what a fantasyland I was driving through. It looked like a Disney cartoon. You said to me once that my drawing has a Disney animation quality. I don't think you meant that negatively, and I didn't take it that way. I thought you were right, and I wanted to push that. Walt Disney was underrated as a fine artist."

"You put a painting in the Art Dock. Most people don't do that. Why did you?"

"First of all, I'm a painter, and it's the only art I'm interested in making. I think of my painting as similar to the mainstream of American Realist painters like Winslow Homer or Thomas Eakins. Not that I'm in their league. I have an appreciative relationship to the world that I see. I don't have a sarcastic or ironic connection to the world around me," responded Walter.

"The Art Dock's shape has always reminded me of a postcard and a Polaroid. Your image brought out the postcard quality," I said.

"I completely agree. My work looks good on postcards because it flirts dangerously with the idea of cliché. Sometimes my paintings work, and sometimes they don't. Sometimes my works are just nicely drawn or painted sunsets, and other times they tran-

scend the cliché. My work has a picturesque quality, but I don't mean that ironically," Water stated.

"Toying with the real and the non-real is something I sense in your work."

"I think what you're getting at is the unreal or dreamlike quality in my paintings. I like the look of the cartoon. They have a magical realism."

"What's your opinion of yourself as an artist?" I asked.

Daily Diary Page by Carl Davis

"I don't know how to answer that. My painting isn't intellectual. I have a strong desire to paint and a strong response to my natural environment. Hopefully it's strong painting in the tradition of American Realism. If you look at Edward Hopper you don't

The Art Dockuments

need a lot of theory to understand it. His work is a straightforward rendering of the visual environment and how he felt about it. Most of his paintings are mediocre, but he created a new way of looking at things. He created Edward Hopper environments. We can drive down the street and be looking into an old hotel and find them. Painters can do two things. They can create great paintings or they can create new ways of looking at things."

"You made me think of Edward Hopper's gas station painting, 'Gas,' at the MOCA Automobile and Culture show," I responded.

colors and the smooth richness in the half-light of darkness. Objects take on a singular aspect."

"What do you think of conceptual art?" I asked.

"I like artwork that doesn't need a lot of theory to understand it."

"Did you see the Allen Ruppersberg show that's at MOCA right now?" I asked.

"I don't think I have," responded Walter.

"I don't think you'd like it," I said. "I didn't, and I like conceptual art. There were twenty canvases on which the artist inscribed the complete text of Oscar Wilde's 'The Picture of Dorian Gray.' The

Edward Hopper, "Gas," 1940

"That's a great painting and a new look."

"Are you interested in light?" I asked.

"Not in the way the Impressionists were. Realists are interested in art because it reveals form, but Impressionists were interested in light itself. I'm interested in things that are glowing. I'm intrigued by

whole thing blurred into a gray field. I thought it was boring. Then there were the dirty sheets that were turned around. I won't comment other than to say I thought it was tasteless. Here, let me read you a few of Ruppersberg's 'Fifty Helpful Hints on the Art of the Everyday':

The ordinary event leads to the beauty and understanding of the world.

Art should be as familiar and enigmatic as human beings.

The artist is a mysterious entertainer.

Reality only needs a slight adjustment to make it art.

What do you think of that? Maybe this artist is so well received because his work is so single-minded, but you won't think that from reading his 'Helpful Hints.'"

"I guess I could agree with most of it. I'm a cerebral person, but I don't want my art to be that way. The best art works in a sensual way."

Allen Ruppersberg, "The Picture of Dorian Gray," 1974 (image courtesy of MOCA)

· ·

"Has art become philosophy, as some critics think?" I inquired. "Beauty is hardly mentioned anymore in conjunction with art."

"I think philosophy is the essential element. Francis Bacon, even though he paints horrific physiological images, his paintings work because they're beautiful, and the relationship of colors is beautiful and life-affirming. I think beauty is the basis of all good art, even though we don't understand why. You can find beauty in anything."

"I guess even in script on a canvas. Maybe I'll have to rethink my estimation of Ruppersberg. Tell me what you thought of the Art Dock as a conceptual idea."

"The Art Dock is a sophisticated idea. The Art Dock is your art," replied Walter.

"And living in downtown and the Citizens Warehouse, what do think about that?"

"You know, I found two dead bodies in the street. One of the bodies I discovered was a black woman under the First Street Bridge. I walked by her on my way to mail a letter. I couldn't tell if she was dead or sleeping. I passed her by and thought I should check it out on my way back to Center Street. On my way back the cops were there. They lifted her dress to see if she was sexually molested. I tried to ask how the woman died. The cops told me to mind my own business and get away."

"Something weird is always happening around the Citizens Warehouse and Center Street," I responded.

The time of Walter Impert's show was full of weirdness for me. I went and watched, for no particular reason, the installation of a time capsule in the new sculpture by Eugene Sturman, a sculpture that was positioned awkwardly at the corner of Figueroa and 8th Street in front of an undistinguished, but new, office building. Into the six-foot-diameter copper cone of "Homage to Cabrillo: Venetian Quadrant" various dignitaries placed objects: an autographed glove belonging to the famous Dodger pitcher Fernando Valenzuela, a cassette of the opening and closing of the Olympic Games (I wondered if anyone could use a cassette tape in 100 years), a phone-answering machine, a copy of the *LA Times*, and Mayor Tom Bradley's blueprint for Los Angeles in the year 2000. I laughed at this last inclusion since I figured the artists in downtown would be long gone by then. Unknown to the Mayor and other invited dignitaries, Sturman also included an article about AIDS, a pistol, a porn video, and videotapes of workers before the capsule was sealed and lowered into the ground. I chuckled over how art was used

· ·

by the powers that be and how the artist responded. The whole event seemed very strange to me.

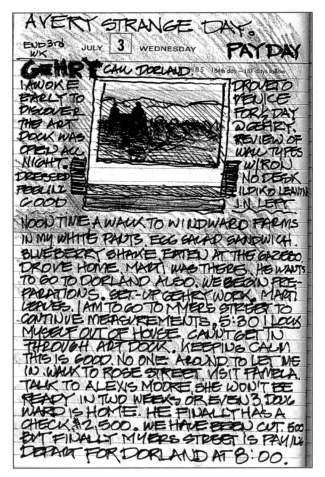

Daily Diary Page by Carl Davis

I was laid off by Frank Gehry's office after the Malibu beach house was completed, and I asked for a leave of absence to do my own project. With partners Marti Kyrk and Jose Foncesa in a firm we called Davis dot Kyrk Architects, we began a Community Redevelopment Agency-supported artist housing project. The dot was Jose. Payment for our services was slow in coming, and I was

almost bankrupt once again. The landlords of the Citizens Warehouse were demanding a thirty-five percent increase in the tenants' rent. Four of us in the center of the building, Gary, Karen, Gunga Ma, and I, formed a tenants' organization. We hired a Beverly Hills lawyer to be our representative. My stress level started to rise. It culminated when I discovered that on the night of July 2nd I left the Art Dock open all night while I was in bed asleep. I dodged a bullet again. No marauders invaded my studio or damaged the painting. Art, I believed, was a good home-protection plan, at least for those of us who lived in the rough underbelly of the city, as long as the art wasn't made out of money.

Postscript 2012: Walter Impert's painting "Alameda Sunrise" was shown at the Orlando Gallery in November 1985 and sold to a collector who, according to Walter, painted his living room and bought a couch to go with the art. The buyer lived in a house in the Hollywood Hills that had lots of glass. You could look out his window and see the lights of the valley and then see Impert's painting of the same city lights. Walter continues to paint and teaches art at Pasadena City College. Allen Ruppersberg carries on his successful career as a conceptual artist and was a part of the Pacific Standard Time Exhibition at MOCA in November 2011. Eugene Sturman's "Homage to Cabrillo: Venetian Quadrant" was in 1986 awarded a "Lemon" as one of the worst sculptures in downtown Los Angeles, an attribution that I found a bit unfair. Sturman remains a sculptor and now resides in New York City. In another seventy-five years the time capsule in "Homage to Cabrillo" will be opened. I wonder what people will make of a phone-answering machine, and if newspapers will survive until then.

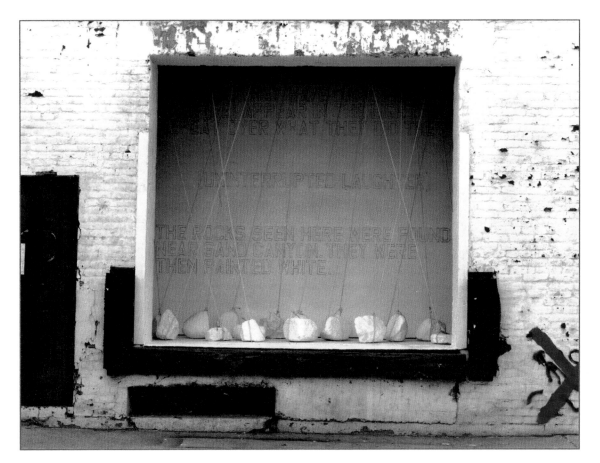

ART DOCKUMENT #32 "STILL LIFE/LIFE STILL" BY ALEXIS MOORE—SUMMER TO FALL 1985

I returned to the city in time to see Alexis Moore's still life in the daytime. Marti, assistant curator of the Art Dock and my partner in Davis dot Kyrk Architects, had the Art Dock open. I was away a lot: first in Columbus, Ohio, and then at the Dorland Mountain Arts Colony down south in Temecula. I had only seen the installation at night before I departed. I studied the piece, which seemed to be a subtle statement about light as well as a silent stage scene where the immovable actors were rocks tied down by ropes and their lines were written on the wall. It struck me as a surprisingly rich conceptual narrative. I read the text of "Still Life/Life Still."

THE USUAL PICTURE IS ONE
OF SELF CONTROL.
THEY HAVE DARK NIGHT
AND THEN REAPPEAR IN
THE LIGHT TO REPEAT OVER AGAIN
WHAT DID THEY.

(UNINTERRUPTED LAUGHTER)

THE ROCKS SEEN HERE WERE FOUND
NEAR SAND CANYON. THEY WERE
THEN PAINTED WHITE.

The Art Dockuments

A very mysterious tableau was presented. The upper statement disappeared into shadow and the hanging white ropes cast fine gray lines across the text. I watched the shadow lines move slowly across the white wall inscribed with the moderately gray, outlined text. The stationary white rocks seemed as if they could move if they weren't suspended at the end of the taut ropes. A gentle and meditative peace came over me as I contemplated this quiet, motionless play—a play of words, a play of images, a play of ideas. I couldn't translate the installation into anything intellectual, yet it stayed in the mind, softly resonating. I appreciated the calm this work presented. I was dreading my return to the city, which held so much instability and unease.

The building inspectors were at it again. They had appeared twice before I retreated from downtown. Padilla, Komar, Barrilli, and Sanchez had walked through our lofts. We offered them cookies as before, but this time they weren't taking. This time it was all business. I had many electrical problems. I needed an electrical box with a two foot, six inch passage and three feet clear all around. I needed another switch to my lights, another smoke detector, an eighteen-gauge wire to an approved grounded outlet in my kitchen, two more outlets in my kitchen with conduit or a Romex connection, two plugs on different circuits in my studio, and outlets at twenty-five feet on centers around the walls. I was overwhelmed. No problem, they said. I didn't need to do this immediately; earthquake reinforcement of the building came first. Earthquake reinforcement requirements would be announced soon, and then they would be back. It was very depressing.

The building owners were in trouble because of their inadequate earthquake reinforcement plans, and the city was threatening eviction if the owners didn't comply with better plans and a faster schedule. While dragging their feet on the earthquake requirements, the building owners—the group of artists and their backers—pressed a thirty-five percent rent increase now that the first five years of our leases were up. Six of us banded together to fight the owners. We formed the 1001 East First Street Tenants Organization. The owners refused to meet with us or provide any information about when the earthquake reinforcement would happen or how long it would take. They threatened us with eviction. We made charts of the owners' and our responsibilities. We hired a slick Beverly Hills law firm to represent us, but the members of the tenants' organization started to fight one another over strategy and roles.

Life is what remains after you've done your laundry. The pressure was on, and my life was rapidly changing. The summer arrived, and my mood turned sunny in spite of the smoggy yellow haze that smothered the city and the personal disaster that I was sure was just around the corner. The therapy at the Learning Development Center was over. I quit when the therapist said, "Two more years and you can graduate."

"Two years?" I asked incredulously. "You've got to be kidding."

"No, I'm not," she said.

"This is impossible, I have to stop," I replied.

No more would I walk on the balance beam, hop clap, or bounce on the trampoline. I had wasted two years. *Nothing ever works out*, I thought. I should've been depressed, but I wasn't. Free of this frustration, I raced to Beverly Hills for the second meeting at the office of our lawyer to prepare for our up-coming battle with the building owners. The rent strike was on.

With the money I withheld, I bought an Apple II computer. I was hooked. Here was a machine that allowed me to easily correct my dyslexic errors. With trepidation and some glee, I wrote letters to the owners from the tenants' organization, documents for my artist housing project, and a résumé. Having received some design money, the artist housing project drawings were completed after an energetic push during which we came up with the idea of

wrapping the brick warehouse on Myers Street with exterior steel reinforcing. It was an innovative idea. We designed art elements over the stairs to the roof similar to Frank Gehry's forms. We submitted this first set of drawings to the CRA. No further funding for the construction documents would be available until the redevelopment agency reviewed our drawings and identified a source of funding. This process would take months.

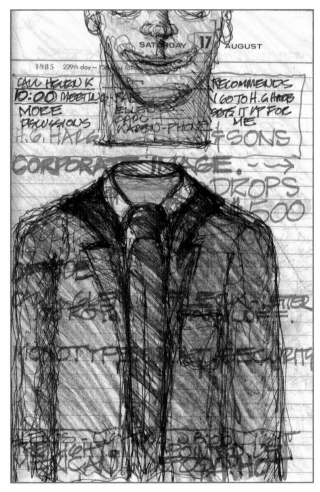

Daily Diary page by Carl Davis

I needed a job, but first I had to come up with some money to buy clothes I could wear to a mainstream architect office for interviews. After several arguments with our development partners using the funds remaining from the artist housing project, I went and bought some corporate-looking clothes. The first job I interviewed for was with a big downtown office, which turned me down. My second interview was with the famous graphic designer Saul Bass. He liked my post-modern economics exhibit drawings, remarking that they were the most appropriate use of the style he had seen. I was offered a job starting after Labor Day.

I was in need of a vacation and some quiet time to consider my life as an artist. Should I give it up completely? Could I give it up, since art was a paramount love? First, I took a trip back to see my family in Columbus, Ohio, taking my daughter for a visit to her grandparents. Afterwards I went to the Dorland Mountain Arts Colony.

Spending hours sitting in a grove of oaks at the center of the arts colony, I re-energized myself and studied the light through the trees. Mrs. Dorland, who founded the colony, used to sit with her cat every day in her cabin at the edge of the grove, reading and watching the ever-changing light filtering through the leaves and branches falling on the brown leaf carpet where an occasional rattlesnake would slither across silently. On my first visit to the colony, I sat on the porch with her and listened to her talk about the past. She was over 90 years old. Older than the trees, she said, because a fire back in the late 1890s charred them, and they had slowly grown back. Mrs. Dorland had watched those trees grow and the light change since the 1930s when she and her husband came to own this land, which was once a special Indian place where the tribe came every year to collect acorns or to bury their dead chiefs on the chaparral-covered mountain behind the oak grove. This time at Dorland I sat alone on her porch since Mrs. Dorland, finally too old to stay independent, was moved to a nursing home. I sat there in her chair under the roof of her kitchen house, a rough-hewn log structure whose small windows had old glass in them that rippled on its surface. Mrs. Dorland had a second house fifty

yards away from the kitchen house, at another corner of the grove, where she slept. Twice a day she walked with her cane across the grove from house to house.

and up the canyons that led to trails used by illegal immigrants to get to Lake Elsinore and Los Angeles. Every trail led through and back to the oak grove. I called it the cathedral of light. I photographed it dawn

The Oak Grove at the Dorland Mountain Arts Colony at dawn and at noon

The Oak Grove at the Dorland Mountain Arts Colony in late afternoon and evening

There was no electricity here. At night every cabin was lit with kerosene lanterns. Mrs. Dorland saw the colony as an artists' respite from the modern world. An electrical fungus was fast spreading across the Temecula Valley toward the colony. Here artists could get in touch with nature and the rhythm of the world defined by sunrise and sunset. They might touch their true selves. Artists could work or not work as the spirit moved them. I came to study the grove and walked across it as many times as I could from kitchen house to old woman's sleeping house, from my cabin to the Far Spring to the Dorland pond,

to dusk, and from many different positions as the shadow patterns shifted when the sun moved overhead. I sat on the kitchen house porch, observed the light dim when clouds hid the sun, and marveled as a chorus of light swelled when a cloud departed and direct sunlight bore through oak limbs. Watching the symphony of light was a calming and transcendental experience. I brought the calm back to Los Angeles, but I was prepared for the worst.

I stood in front of "Still Life/Life Still," and it augmented the calm I brought from Dorland and mitigated my dread of return. The installation had

elements like the Dorland Oak Grove: soft light, shifting shadows, and dark night. The rocks and ropes were abstract trees rooted by weight on the ground and stretching up to disappear in the darkness of space's canopy. I was happy and uninterruptedly laughed. The conceptual still life in front of me created life still—a life calm and contemplative that let in meaning and beauty. I thought the Art Dock worked. In so many ways I enjoyed the experience of creating and running it.

competition to the gallery. The sealed-up building was opened and the action on the interior revealed to the street. The dimensions of the loading dock portal were special. It was almost square but not quite. The thickness of the wall was enough to establish a sense of separation, and the rubber bumpers to each side stabilized the opening like lions flanking a special entry. The wood bumper below the opening underlined and emphasized the open area above. Even the long, narrow, low

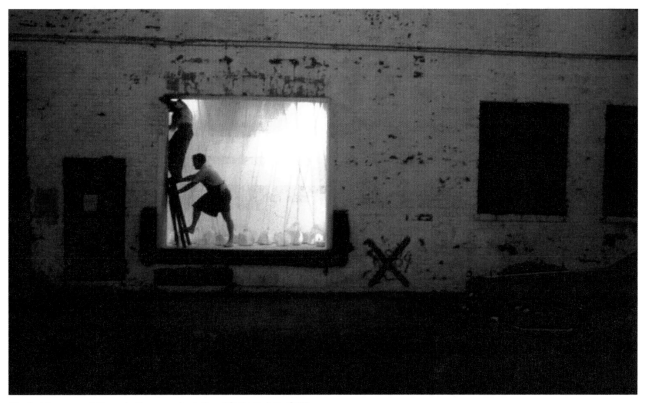

Alexis Moore and Pamela Burgess installing "Still Life/Life Still"

I loved seeing the artists create their pieces in the Art Dock. What is best about art is the process of making it. That process was very much exposed at the Art Dock. I liked how the installations could be seen by passing cars—the few that did roll by—and by the artists in the Citizens Warehouse who interacted with and questioned the Art Dock artists as they worked. I loved the ambience of the dusty old industrial street, where there was little visual

window into the basement below the loading dock added visual interest. It was a dash of difference to the balanced composition above.

Each artist commented on the work of those who went before. Each Art Dock installation was evaluated critically by the artists of downtown. The lost, the homeless, the policemen, the building inspectors, the actors, the film crews, and the occasional critic also took the time to stop in front of the

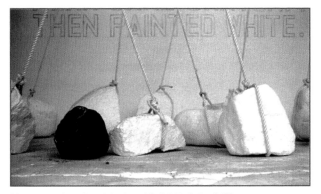

Unpainted rock added to "Still Life/Life Still"

opening and look. I could hear them comment while I was in my studio. I got an earful of opinion when I was on the street. Some even interacted with the work. The street defined which works were strong and which were weak. I liked the definitions that each artist brought to the loading dock: TV, radio, window, picture, Polaroid, billboard, white room, and stage. Alexis Moore chose a staged metaphor.

Alexis Moore said she set up the black and white scene in a silent play. Her installation, she said, was site-specific, relating to interior (private) and exterior (public) spaces. She saw the street audience as players in her installation. The people going to work and coming home were like the mundane statement at the top of her installation. They repeated over and over again what they did before. The "uninterrupted laughter" statement interrupted the repetition and the workers going to and fro. The rocks added a sense of mystery to the installation.

Alexis said, "I rewrote the bottom part. I decided to have fun with this piece. The rock statement yanked you back so you had to deal with an idea of fragmentation." I didn't fully understand her idea, but the whole piece worked visually.

"It's about freedom and containment, the outside and the inside, but it doesn't have a beginning or an end," she said. "A fragment is enclosed, yet also free like the light that changes on the piece. Light comes. It goes. It comes again. The action is repeated infinitely. Night is an interruption like the uninterrupted

laughter identified in the piece. Things happen. The rocks come. The action is circular but spontaneous."

I asked, "What's your view of yourself as an artist?"

"I'm putting out ideas that are in my head. I'm not making some object you can put over your couch. I had some people over to my studio to buy something. I found it very disruptive. For artists who make salable objects, there's no way out."

"If you're not making a commodity, what are you doing?" I asked.

"I'm compelled to be an artist. I write and read about ideas. Then I do something about them," she replied.

"Do you see yourself as a conceptual artist?"

"I am in the sense that I work with ideas. If you wanted to put it into that category, my work would best fit there, but I don't like placing work into

Diary Page by Carl Davis

those categories anymore. I hesitate to categorize anything. A lot of conceptual work is a dead end. It can't turn on itself and come back. People need to take something with them."

"People could've taken your rocks," I said.

"But they're tied down," Alexis replied with a smile. "People will have to interact with the installation in other ways."

A few days after my return to Los Angeles, I came outside from my studio to look at the Art Dock installation. Amidst the white rocks someone carefully had placed an unpainted rock. I howled with laughter. I called Alexis to let her know of the development. She said she loved that someone put a rock into her piece. She wanted audience participation, and she got it. In a typical gallery a strange rock could not be placed into the work. I knew then that Alexis and I had successfully created a social sculpture.

Postscript 2012: Alexis Moore remains active as an artist. In 1995 she began to work with inner-city youth, providing visual and performing arts workshops. She founded the Lincoln Heights Arts Collective, a not-for-profit program, in 2000. Funding ran out by 2008, so the program folded after providing arts education for hundreds of school kids. Alexis continues to teach art at Pasadena and Long Beach City Colleges. In May 2004 the Dorland Grove was partially destroyed in the wildfire that leveled the whole colony, but, just like the colony, it's coming back. The electrical fungus has spread all across the Temecula Valley. It's like LA now. The only refuge is the Dorland Mountain Arts Colony.

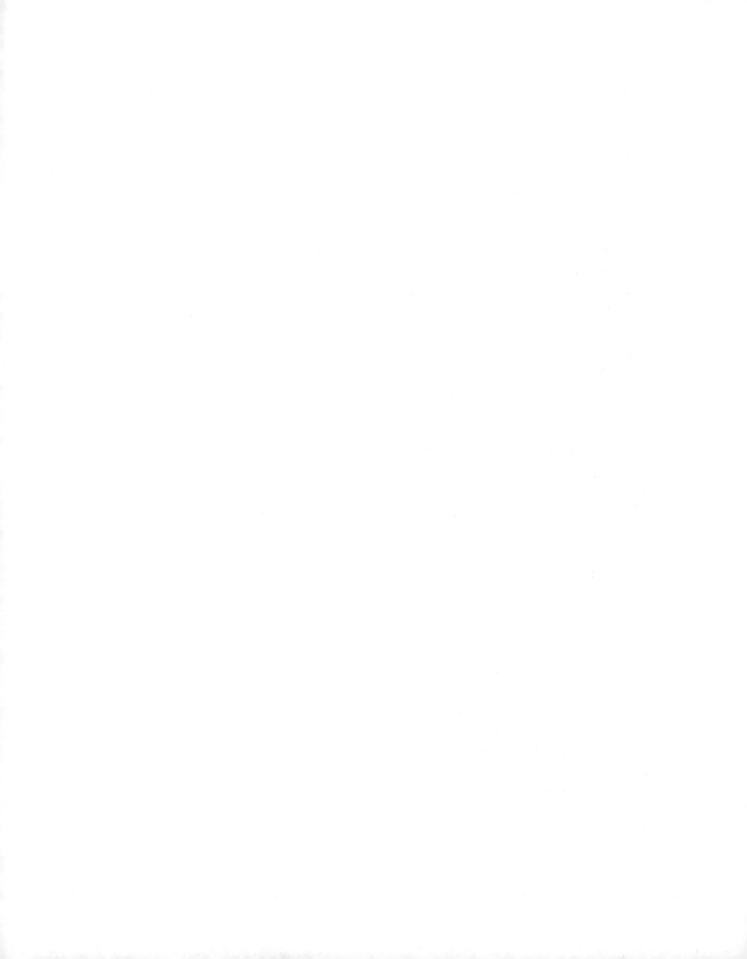

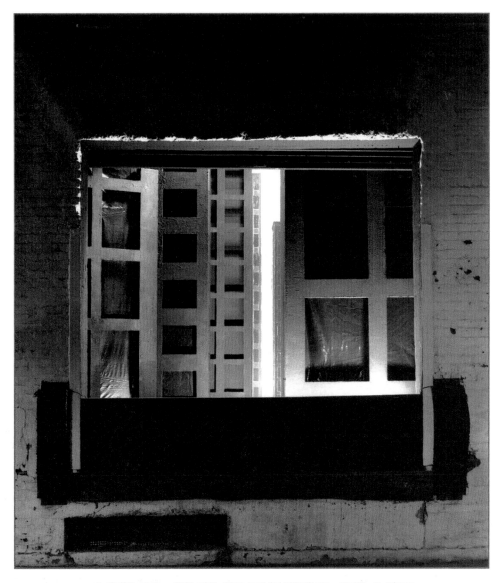

ART DOCKUMENT #33 "CITY LIGHTS"
BY MICHAEL HUGHES—FALL 1985

All was black and white and shades of gray. A black-windowed city loomed inside the Art Dock. The outside was the inside looking to the outside on the inside. The street became the room and the loading dock the window to the city beyond. The sill was high and black, too high to peer over and see from where the light emanated. Could the light come from the street or a lonely marquee floors below? Gray buildings crowded the view; the windows were rippled sheets of darkness. In the gap between the massed buildings a white vertical seam glowed. It should be night, but was it? This city was mysterious and ominous. The colorless view fit my mental state.

The Art Dockuments

The high mood of August passed and descended into the hell of September. I was in another down. By mid September, I was totally depressed and thinking about jumping off the First Street Bridge into the concrete river or strangling myself. My desire was to die soon. Immediately. Crying into the void, I gripped the black mind.

I was tired and bored. My work at Saul Bass's office was minimal. They were waiting for approval to proceed with the gas station design project, so I busied myself skimming product brochures, reading articles about big business' alliance with Adolf Hitler, and thinking evil thoughts. I went into the office bathroom, locking the door, and lay down on the floor between the toilet and sink counter wishing I could fade away, but I couldn't. Someone knocked on the toilet door. "You've been in there a long time, give someone else a chance."

I left the office and made my way up Vermont Avenue to Griffith Park's Dante's View, which provided a magnificent overlook to the Los Angeles Basin stretching out from the park hills to the ocean beyond. On the way up, I passed a vagrant African-American man holding a crumpled and discarded bag of chicken McNuggets. Through gapped teeth he told me he was joining the navy. I found this oddly encouraging. My once-desired future was now past. I could, like this wounded person, find a new beginning. I decided then that I would stop making my strange Daily Diary books after the Art Dock ended.

Several weeks passed, and my mood improved. Marti and I went to Taos, New Mexico, for a hippie wedding. Gary Lloyd and Karen Kristin, who were pursuing new lives as sky painters and building a house, decided to tie the knot. Ellen (Gunga Ma), our friend from the Citizens Warehouse and de facto leader of our tenants' organization, presided over the ceremony. Standing on a bluff overlooking the Rio Grande River under the big New Mexico sky, Gary and Karen exchanged vows before Ellen, who read and waved feathers, sticks, and bones. I could

hardly hear their words, since the wind was blowing gale force. The celebrants lit a small fire in the brush. Why, I wasn't sure, but the rest of the wedding party had to work vigorously to put it out before the whole mesa caught fire. Everyone laughed, and at the dinner party at the best restaurant in town I was toastmaster. I drank copiously to everyone's health and cracked jokes about fire starters in New Mexico and what they ought to do to a certain warehouse in Los Angeles.

While I was in Taos with Ellen, I went to the Hindu Temple where we met Ram Dass and joined him in meditation. I learned how to maintain calm, balance, and ability to make necessary decisions while learning how to control my mood swings. I knew I had to pursue meditation to answer questions about how I should fit art into my future life. Gary, Karen, and Marti became concerned when we were in the meditation hall for a long time. They even asked a devotee how to get us out of there.

Back in my loft in LA, I rolled up the Art Dock door after rearranging my studio to get ready for the sprinkler work. I was ready for a last look at Michael Hughes' "City Lights" before it closed.

Standing in front of the loading dock on the dark and empty street I wondered if this life, this art, and this Art Dock had been worthwhile. Life in the Citizens Warehouse, always tough, was about to get tougher. Art—making it, seeing it, and appreciating it—wasn't much fun anymore. As usual, I didn't have much time to make art. I was trying to survive. In the past few months, the only art I that drew me in was colorless, like "City Lights." The Art Dock was an idea that had run its course, and it was almost time to end the performance. I could see nothing new to be gained from loading-dock art. Only two more shows were planned and no more invitations made. I was sad at this reality, but I felt it to be the right path. I was walking around in a black-and-white movie. The color had been sucked out of the world. I had, for the majority of this show, been gloomy.

Michael Hughes by Ed Glendinning

The 1001 East First Street Tenants Organization won a great victory over the landlords. This was sweet, especially after one of owners threatened me with putting a wall for earthquake reinforcement down the middle of my studio, thus dividing it into two. In a tense meeting where the owners screamed about all the tenants' violations of their leases including the creation of the Art Dock, Gunga Ma (Ellen Fitzpatrick), Karen Kristin, and our Beverly Hills lawyer Shelley Shafron negotiated an agreement with the owners and the owners' lawyer. The rent strike ended. We got eighty percent of what we demanded. Rents wouldn't be increased thirty-five percent but only six percent. The cost of earthquake reinforcement of the building wouldn't be borne by the tenants. The cost to tenants of adding fire sprinklers to the building would be determined later. I should've been happy, but I wasn't. The agreement

meant that earthquake-reinforcement work would begin on the building soon. Earthquake reinforcement of a building is a messy and very disruptive job. Once earthquake reinforcement was done, the building department would enforce compliance on the long list of electrical deficiencies in my loft. And the sprinklers were a financial unknown.

Weeks later, the tenants met to discuss our participation in the cost to provide fire sprinklers for the building. Some fire sprinklers were already in place, but not enough to satisfy the fire code. It was a raucous meeting where no two tenants agreed on a common stance. Rae Burkland refused to pay anything. Gary Lloyd and Karen Kristin proposed to pay a third. I said I would pay half. Zorba offered to pay a quarter of the cost. Arguments arose about the share and cost of moving sprinkler heads already in place but too close to corridor walls. The

meeting broke up with no agreement. The tenants' organization was beginning to fall apart. Facing the black-and-white realities made each of us unhappy; the fantastic game of life in Citizens Warehouse was about to get very real. It wasn't a pretty picture.

to make a living at it. My interests were too varied. Making Carl Davis pieces for the rest of my life didn't interest me. The thought was sobering and not easily swallowed. Michael Hughes' "City Lights" appeared to me as a special message. It was the

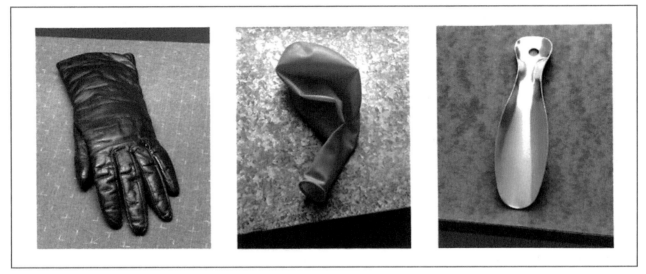

Jo Anne Callis, "Glove, Balloon, Shoehorn," 1983

My life as an artist seemed to be waning. Five years ago, I left behind my old life in the profession of architecture to become an artist and a member of the downtown art community. Reluctantly I found myself drifting back toward architecture. The artist housing project I pursued still wasn't funded and probably wouldn't be. I took a full-time job, not a bad one as it turned out once the work got underway. I worked closely with Saul Bass, the famous graphic designer, on re-imaging gas stations. I recalled a wonderful afternoon on my first day there when Saul discoursed on the color blue and which corporation was associated with each color blue. IBM and Exxon each had their own blues. We were working on finding a blue for SOHIO and designing them a new station. I was actually having a good time, but since I was working full time, there was little time to make or enjoy art. Slowly I was realizing that I couldn't make it as an artist. I would always think of myself as an artist, but I would never be able

visual equivalent of the black-and-white page of a government notice. Looking at this piece I was looking at my fate. I might not like it, but it was real.

At the time of Michael Hughes' installation, I managed to go to the MOCA show of nine Los Angeles artists and an evening of discussion with artists about their work.

William Wilson, who didn't like anything that the new contemporary museum exhibited, panned the MOCA exhibition. In his August 18th review in the *LA Times*, he compared the art atmosphere of MOCA to "department stores, mindlessly promoting the latest cultural fashion" and said the show was "virtually unreviewable except as individual entities." Nine artists were exhibited, including neo-expressionist painters Steve Galloway, Susanne Caporeal, Jill Giegerich, Gronk, and Willie Herron; one minimalist painter, Mary Course; one photographer, Jo Anne Callis; the video artist Bill Viola; and one performance artist, the late Guy de Cointet. Wilson

excoriated Jo Anne Callis, saying her work was "chic as a Melrose boutique, but vaguely agonized to demonstrate seriousness." I was drawn to Callis' photographs because of my black-and-white mood. Her images of solitary items assembled together in threes intrigued me. These were small objects made large, each isolated, yet set next to each other for comparison. The lack of color was not stark, but almost sensual. One could feel the softness of the glove, the flaccid surface of the deflated balloon, and the hard crispness of the shoehorn. Each object was an everyday item we hardly think about, but these portraits combined gave each one a new presence. Callis made them chic, but I didn't find them agonized. She had managed to make the everyday thing special. Images desaturated of color have a quality of separateness. They are removed from the everyday color-filled world, allowing a nuance of light and shade. In my bleak mood the gradation was full of meaning.

Ruth Weisberg, "Dreamers II"

I didn't get a chance to study the other artists in this show since the hour grew late, and MOCA closed.

At Barnsdall Park there was a talk called "the Spiritual in Contemporary Art." Because Rachel Rosenthal, my former teacher of performance art at Otis Art Institute, was presenting, I felt the urge to go. Ruth Weisberg, Kent Twitchell, and Jim Morphesis joined her. The artists showed slides of their work, and tried to talk about how they related to the transcendent. Twitchell made a weak case for the spiritual in his work as he showed slides of his monumental public portraits and his Olympic murals. Jim Morphesis said he grew up around Greek Orthodox images of the crucifixion, but he wasn't painting them because they were spiritually weird. Ruth Weisberg spoke about how she was nourished by the history of art and the Jewish people. She stated that she believed art created meaning and could be transformative for the viewer. Transformative to what she didn't say, but her drawings were beautiful. I was especially drawn to her monochromatic images. I conjectured that this work appealed to my dejected and alienated perception of the artistic life.

Rachel Rosenthal

Rachel Rosenthal arrived in military fatigues with her head shaved and the rat "Tattie Wattles." Rachel walked onto the stage with the rat, a rat she

had gotten from Kim Jones, positioned on top of her head, and sat down at the table with the other artists. Throughout the presentations of the other artists, she had to restrain the big white rat from escaping. When it was her turn to display her slides, she cuddled the rat against her chest, said how she owed her artistic life to the women's movement, and began to talk about her performances "Grand Canyon," "Charm," "Soldier of Fortune," "My Brazil," and several others. Images of Rachel flashed across the screen while she talked about how her work was redemption and exorcism of the past. The performances were very autobiographical. Rachel talked her depression and about her mother while the audience viewed pictures of the artist stuffing her face with French pastries and plunging her head into a chocolate cake. There were laughs from the audience. She showed images of herself in an army uniform plunging a doll's head into a water bucket while pretty girls around her were trying on hats. Rachel spoke of her difficult relationship to her sister Olga. We saw images of Rachel dressed in a very long gown, then stripping off long black gloves so men could try to penetrate her wrists with fishhooks. She explained how this work was an exploration of sadomasochism and how it was a distorted mode of spirituality, where "the soul pierces through the membrane of pain to dissolve into the cosmos." She denied she was a shaman even though she had participated in a show called "the Artist as Shaman."

"Performance artists are not shamans," she said. "But they do ritual." She showed slides of audience members wandering one by one through a black labyrinth where they confronted three women. Each represented an aspect of the goddess: the virgin, the mother, and the crone. Rachel, the consummate actor, gave a vivid talk. I left the symposium encouraged about the possibilities of art but still felt I was walking in a dark labyrinth. I wondered if all art was ultimately autobiographical, and if the Art Dock was the autobiography of me as

an artist. Did I continue the Art Dock to get beyond the need to function as an artist? Perhaps the Art Dock was my exorcism.

Michael Hughes' "Combat Assault" painting

While I was standing in front of the loading dock contemplating the installation and all the black-and-white art I had seen in the past several months, the critic appeared out of nowhere and surprised me.

"What happened to the painting Michael first put in the Art Dock?" she asked.

I jumped a little at hearing her unexpected voice. Recovering, I said, "He took it out, saying he thought it didn't work. It didn't use the Art Dock space effectively."

"Too bad," replied the critic. She was dolled up wearing a light green coat and bright red heels. I thought she must have just returned from an opening. "I thought it was a strong painting and worked with the frame of the Art Dock," she said. "The lack of color was effective and the composition with the dark shape in the foreground and the black lines of the helicopter blades drew the viewer

into the picture. The image had an ominous feel. I'm sorry he took it out."

"Michael felt he needed to do something more three-dimensional and more theatrical that responded to a loading dock in a building," I responded. "This piece was based on a series of photographs he did of alleys. He wanted you to feel separateness and loneliness through the piece." I explained to the critic how Michael saw the street as the inside of a room from which you look over a balcony rail at the city beyond. The critic shook her head.

"I'm troubled by this piece," she said. "The roughness and crudeness of the construction puts me off. The black material in the windows of the buildings doesn't seem effective. I can see that it's stretched plastic. The piece is much more effective at night, as we're viewing it now, but during the daylight hours it isn't a convincing tableau. I think the man is a much better painter. He should have stuck with his original piece."

"Michael said he always wanted to paint like a Dutch master, but then he got involved with photography. He wasn't happy with that, so he went back to painting."

"He could make a living as a painter in my opinion, but he works in construction for his income he told me. He grew up in a blue-collar neighborhood where everybody worked in the building trade."

"Isn't that the reality most artists face?"

"Painting is the highest art. It's the most sublime art, higher than architecture. Painting has the greatest tradition, but it's a difficult taskmaster. Maybe the artist is making an unconscious statement by removing his painting and replacing it with this gloomy architecture. Maybe it portends the artist's sense of doom."

I was shocked by the critic's statement. Was what she implied meant for me or for the artist? I felt I had to defend Michael and myself.

"Architecture is as noble a profession as art," I said. "This work doesn't denigrate architecture or

building. It's about alienation and the dark side of city living."

The critic hooted. "My dear man, you're deluded. Where are the alienation and the dark side of city living in this piece? It's a crude cityscape, unworthy of the Art Dock and unworthy of the talents of our friend Michael Hughes. Get him to put the painting back in."

"It's too late," I said. "The show's over."

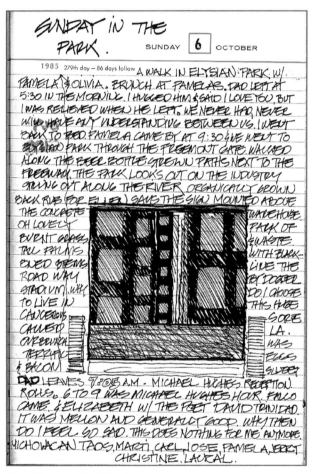

Diary Page by Carl Davis

"Yes indeed, the show is over," the critic replied. "For your information I'm moving out of the Citizens Warehouse. I've had enough antics. I can no longer take the epic battles and amorous reconciliations of Don and Tina Preston. Nor do I wish to be around once they start drilling into the brick for the iron anchors of earthquake reinforcement."

"Where are you going?" I asked.

"I think a trip to Europe is in order," said the critic, turning and starting to stroll up the street toward her entry at the south end of the warehouse. Secretly I wished I could be going away with her; I was already leaving mentally.

"Where will you go when you come back?" I asked.

"Venice or somewhere else along the beach," the critic replied, stopping at the entry to 112 and looking wistfully at the silver door with the red numbers. "Sad, so sad. Downtown isn't happening like we thought. Better to visit these hard streets than to live amidst them. Los Angeles is sun, waves, palms, and light, not garbage and darkness."

"Downtown isn't all that way," I responded, knowing that I spent more and more time away from downtown. I felt as if I was becoming a visitor in my own loft.

Postscript 2012: Michael Hughes went on to a very successful career in the construction industry while continuing to paint, showing at several local galleries over the years. He became a project manager on numerous significant building projects in Los Angeles. A recent construction accident left him with major injuries, and he had to retire. He lives in Las Vegas and continues to paint. Jo Ann Callis remains a respected Los Angeles artist. Ruth Weisberg was the dean of the Roski School of Fine Arts at USC from 1995 to 2010. Her work is in numerous museums, including the Getty Center, LACMA, and the Norton Simon Museum.

Rachel Rosenthal became an icon of performance art and instant theater. She toured the world with the Rachel Rosenthal Company. She founded Espace DBD, where she taught others about performance art and theater. Rachel has been a visiting artist many places, including the Art Institute of Chicago, UCLA, UC Irvine, and the California Institute of the Arts. Robert Rauschenberg honored her in a suite of prints titled "Tribute 21." She lives in Los Angeles with her dogs. She no longer has the rat. Don Preston, one of the original members of the Mothers of Invention, is a rock 'n' roll musician and composer who scored more than twenty feature films and fourteen plays. He has performed with the Los Angeles Philharmonic orchestra, London Philharmonic orchestra, John Lennon, Yoko Ono, Yusef Lateef, Nat King Cole, Herbie Mann, and Charles Lloyd. The critic disappeared and never came back to Los Angeles.

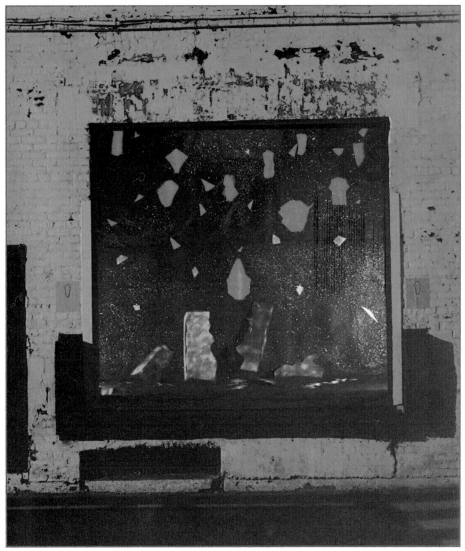

Neal Taylor & Drew Lesso, "Still Among the Living," "10/30-11/5/1985

ART DOCKUMENT #34 "FIVE INSTALLATIONS" BY NEAL TAYLOR WITH DREW LESSO, COMPOSER— FALL TO WINTER 1985

was still among the living, but listening every evening to the heartbeat, and the nails being pulled out and driven into a coffin was making me crazy. The sound was insistent, playing over and over: the pounding of the hammer, the crunch of tool adjustment, the ting of metal to metal, the screeching of a claw, and the thump thump thumping of the heart. The cadence jostled every fiber of my being. Music of death and resurrection hung in my mind. When "Still Among the Living"

displayed every night for a week, the only way I could deal with the strange rhythm was by meditating in my darkened loft. Within the perimeter of the four wood columns of my space, behind the Art Dock wall, and twelve feet away from the tape player, I sat upon my new black meditation cushion. I listened, trying to be P.I.E. (precise, impermanent, and equanimous) as my meditation teacher instructed me. I heard acutely the slow beat of a heart about to die or emerge into life. The dull thumps slowly repeated, then began the racket of smashing and retraction of steel pins. Was I being let out or nailed in? I tried to be unruffled and maintain equilibrium. What I wanted to do was run screaming from the loft, but I didn't. I sat and listened until I could stand it no more. I turned off the tape and closed the loading dock roll-up door. It was past midnight. My love of art subjected me to such weirdness.

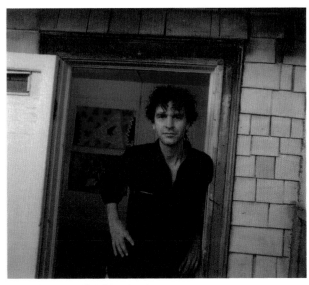

Neal Taylor by Ed Glendinning

"PIE are squared," I wrote at the top of a daily diary page. I became a dedicated Buddhist meditator at the suggestion of Dr. Wortz. I had meditated before, but I now I would give the practice my complete attention.

At our weekly session, he said, "Your despairs are so large because your hopes are so large.

They are the ends of the same stick. Can't you just be here now without reference to the past and projection of the future?" I answered no, and he recommended I start Vipassana Meditation with Shinzen Young at the Community Meditation Center. I said I'd give it a try.

October 21, I made my first visit to the Center. I sat for an hour and listened to a description of the three traditions of meditation, one of which was Vipassana, the oldest form of meditation and one that purports to be a direct piercing of the pain of existence. I felt very up and energized by this visit and decided to take a beginners class at the Center. In the second class lead by Shinzen, I was told to focus on the sensations in my body remembering three essential things: precision, impermanence, and equanimity. P.I.E.

P.I.E. became my mantra. As I scanned my body, looking at each sensation in my head, arms, torso, and legs, I repeated P.I.E. I carried those words and tried to act on them everywhere I went. When I confronted frustration, boredom, or anger I thought P.I.E. When I went out with a woman, I thought P.I.E. I reacted with P.I.E after my lady friend and I found a young deer hit on a road in the hills above Malibu. The deer was still struggling when we stepped out of our car. I touched the wild animal on the soft fur of its head, and it died with spasms of movement and a glaze coming into its eyes under a bright shining sun. I carried the carcass to the side of the road saying P.I.E.

"Everything is transitory," I said to Elizabeth. We were quiet, lost in our own thoughts until we came out at the beach and watched the surf change moment to moment as it curled up onto the beach with a frothy thud. "I think I can be here now because tomorrow my life could be gone, and my projections of desire, fear, and failure won't matter," I said to Elizabeth. P.I.E. face was smiling.

The artist, Neal Taylor, said the piece, the first of five installations, dealt with inevitable change, the

Score by Drew Lesso
"Still Among the Living," 1985

"*It sounds like those bloody idiots upstairs are playing their Stockhausen records again.*"

"Those idiots up stairs must be playing Stockhausen"
Punch Cartoon, 1974

beginning of life, death, and the afterlife expressed as explosive charge suspended in a moment of time and infinite space. The black light installation, only to be shown at night, celebrated Halloween. Red shapes like shards appeared to fall against a blue-and-black space dotted with stars. A few shards lay on the Art Dock floor like globules of congealed phosphorescent blood. In this bewitched environment, I heard Drew Lesso's score, which was based upon the proportions and ratios of a coffin, the twenty-seven beats per minute of the human heart, and eighteen nails removed every three minutes. Lesso was a composer of harmonics. He said his music conveyed ratios and proportions in sound.

Drew was a student of the famous 20th century German composer Karlheinz Stockhausen. The composer, little known in the United States, had a significant influence on such rock bands as the

Grateful Dead and the Jefferson Airplane. Stock-hausen inspired John Lennon in his song "Revolution 9," and jazz trumpeter Miles Davis acknowledged Stockhausen's impact on his work. Called "the Father of Techno" by some because of his interest in electronic music and electronic sound synthesis, Stockhausen said, "New technical means is one thing and musical innovation is another." Like John Cage, Karlheinz Stockhausen was in the vanguard of musical change. Influenced by Edgard Varèse, Anton Webern, and painters like Piet Mondrian and Paul Klee; his interest was in aleatoric music, which was chance music, where elements of composition were left to the accidental. He used transformers, generators, modulators, magnetophones, and other electronic devices to elicit sound possibilities. To understand the effect of Stockhausen's complex music on the music world, I referred to a quip

about him by Sir Thomas Beecham, the famous conductor of the London Philharmonic Orchestra, who, when asked if he had heard any Stockhausen recently, replied, "No, but I've trodden on some."

Luckily, I enjoyed the symphony of the nails and the telltale heart for only seven days before the installation changed. Halloween was over, and a new concept would arrive in the Art Dock. I could hardly wait.

Neal Taylor & Drew Lesso "Drawing from the Source" 11/6—11/13/1985

To some, he was the single most extraordinary and original composer of the 20th century. Drew Lesso's compositions had antecedents in Stockhausen.

Neal Taylor stated that his concept for the next installation, a large triptych, represented a threatening image that, when contemplated, could become a

SOUNDSCAPE SCORE

SPECIAL THANKS TO MIKE MOLLETT & STELLA KIROV
FOR PERFORMING THE PARTS OF MAN & WOMAN.

Drew Lesso, score for "Drawing from the Source," 1985

source of strength. Neal created an altarpiece in the Art Dock, where his strange alien form—was it figure or was it symbol?—became an object of veneration like Christ the King in the center of the Ghent Altarpiece. The two flanking panels were shaped canvases whose randomly hatch-marked surfaces had no imagery. There was no Virgin Mary or John the Baptist flanking the Son of God as in Jan Van Eyck's masterpiece. The red thing stood alone. The shaping of the trapezoids, leaning inward and pushing upward, made them buttresses to the long rectangular center canvas with its solitary image. The red double-forked mandala floated in an atmosphere of black and white scratches. It alone was the force; an old story told in a new form. I saw the triptych as a field of energy in which a primordial protozoan appeared. This installation was a visual follow-up to the first installation in that the red form could be taken as the source of life creating arousal from death. The red globules from "Still Among the Living" coalesced and became an animate form. I internalized the image and felt a field of energy all around me. Compared with the torpor of the week before, I was filled with excess energy, as if I were drawing directly from the source. Was this art voodoo?

Diary Page by Carl Davis

I doodled the image on sheets of paper and sketched it in my daily diary. The double-pronged force was with me while I raced around the city doing this and that. I was totally consumed by a red-hot vigor. I moved all my possessions, work, and work surfaces into a corner of my loft out of the way for the plumbers to work on my fire sprinklers. The plumbers came early. I convinced them to do my space first. Then I ran off to Saul Bass's office to design gas stations, then back to work on the artist housing project with Marti, then to get a haircut, and finally to the doctor's to get the results of my AIDS test. I was negative. Hallelujah, I could live on. My attempt by going to gay bathhouses to kill myself with this disease when depressed failed. I went to the tenants meeting. Then I started a new painting

on wire of a red fish, wrote, and meditated. I was full of good power. I was going without sleep, charged up by the red amoeba. Each following day was filled with the same furious pace. Each night at the end of my wide wild journeys, I meditated, trying to slow down. I didn't slow down. I got back up to paint, to write, to work on architecture. The Art Dock was open. It stayed open all night for three nights in a row. I was smiling my P.I.E. smile and listening to the new score by Drew Lesso while the double-pronged creature burned in my mind and filled my body with its force.

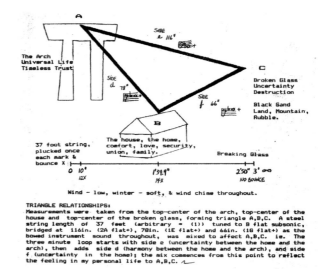

Neal Taylor & Drew Lesso, "A View from the Top," 11/13 -11/19/1985

The score started with tapping. A steady tone began, and then a male voice said *Oh?* A female voice responded *E?* The male voice said *Ooh*; female, *Ee*. There was the sound of pattycake, hands gently slapping the flesh. The tone slowly rose. More

Drew Lesso, score for "A View from the Top"

Ooh's and *Ee's* were heard. She said *Hum* and *Ahh*; he, more *Oh's* and *Ooh's*. The tone rose higher. The voice inflections changed, expressing surprise, then pleasure. *Oh! Ooh! Ahh! Ahh! Ahh. Ahah. Hummm.* There was a squeak, then the sound of kissing, more *Oh's*, more *Ahh's*, pattycake, more *Humm's*, and kissing, some *Oooohs*, some *Aaahhs*. The tone became steady at a higher pitch, and the tapping ended the tape before it began again and was repeated over and over and over. Sex! I was listening to sex, a gentle and loving sex of surprise and delight. The fundamental force released the ooze from which life began. I collapsed from my cushion, joyful and giggling. It was a good week to be born into the oomph of life. Yet the Art Dock omens would change; disaster lay ahead.

Coal bits lay on the sidewalk and piled up against the edge of the building below the Art Dock. I was strung out from lack of sleep, and the shiny black debris bothered me. The broken glass windshield in the third installation, "A View from the Top," was jammed into a pile of small anthracite particles. What was on the street was the excess that had been brushed aside. Neal didn't identify this black material, which crunched under foot as part of the show, but I did. I received an angry telephone call

Neal Taylor & Drew Lesso, "Summit Window," 11/21-11/26/1985

from the artist manager of the Citizens Warehouse about this new hazard in the street. No, I wasn't going to clean it up. I told them the black fragments were part of the show. I wasn't happy, but I wouldn't give in. I stood by my promise to each artist to never interfere unless they disturbed me in my loft.

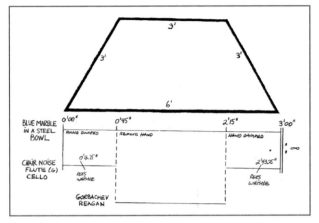

Drew Lesso, score for "Summit Window"

Standing on the sidewalk grinding coal into the concrete, I observed "A View from the Top" and its three elements. Broken glass in the mound of black coal, the house, and the gateway were the next genesis from the red-hot protozoic form. The arch and the house were painted in the same black and white hatching that was the background in "Drawing from the Source," but there was no color in the third installation. It was all black and white. They were forms generated from the same field of timeless energy. The gateway or arch, as Neal Taylor described the form, recalled not so much a passing through from place to place, but the mathematical pi, which was a fundamental truth. Neal stated the form symbolized trust. Mathematical truths were trustworthy at some level of existence. "The house," Neal said, "stands for comfort, love, security, union, and the family. Usually home was a trustworthy idea unless you live in an unreinforced, illegal, brick masonry, loft building. The broken glass signifies uncertainty and destruction." The black fragments,

black sand Lesso called "the stuff," was rubble, the residue of shattered lands and mountains. This view from the top spoke of the true and transitory nature of all things.

I felt that as I staggered through the week of this installation, gradually slowing down, sleeping and oversleeping. I missed an important appointment, and meditated to the sound of Drew's new score. The tone was a steady buzz saw in a forest of wind chimes. A flutter occurred as if air blew through someone's cheeks. There was a *wooh* like an airplane passing close by. Meditating to this score again and again—it only played for three minutes and some seconds—I could hear subtle differences in the sound. The tinkles were slightly different. The tone changed pitch and the mix altered. I was aware of the vibrations in my ears. A follower of Vipassana meditation was supposed to be attuned to changes of sensation in the body. I was precise. I sensed the sound waves on the hairs in my ears and the vibration on the skin within the ears. The impermanence of all things was evident as I listened to the minute changes in this score and thought about the arch, the home, and the broken glass. I was full of equanimity as I sat, but unbalanced when I rose and walked about. I thought disaster lurked ahead. Yet I was ready for more changes that the Art Dock oracle would prophesy.

I caught on. Each installation related to the next. Number one was death and the return to life. Number two demonstrated the power of life and the energy of individual life. Number three was the transitory nature of individual life, its issues, its destruction, and its relation to the timeless. The new installation, number four, looked at the larger life of the species, its concerns and actions that provided a window to the beyond. It commemorated the American-Soviet summit taking place between Gorbachev and Ronald Reagan. The shutter of the Art Dock opened each time and a new snapshot was revealed. This week, the fourth week, three

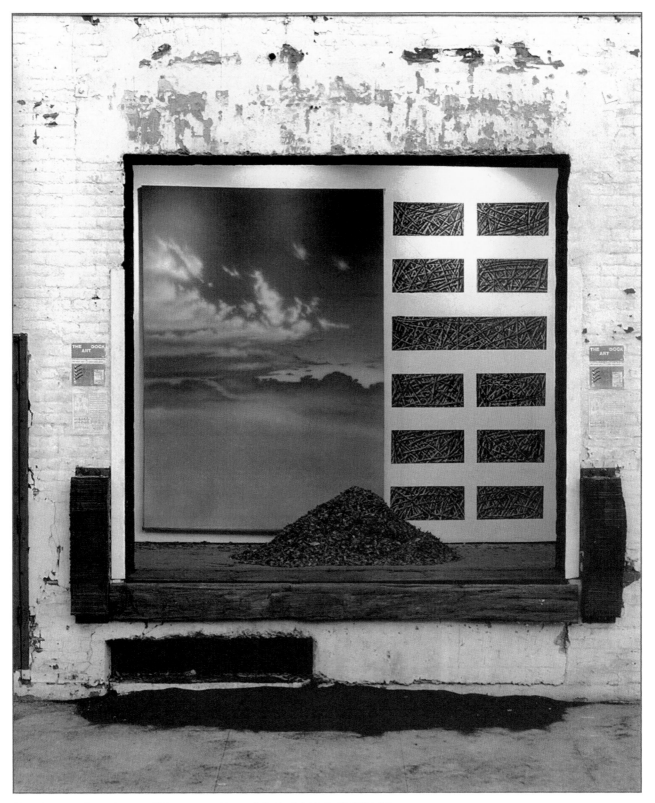

Neal Taylor & Drew Lesso, "Means to a Natural Order," 11/26–12/4/1985

more elements made a three-dimensional picture. The picture became four-dimensional by the inclusion of sound. The oracle of the Art Dock sent its messages to the world and me. This was art about the meaning of life and what art could do to decode that meaning. Decoding began with listening carefully to Drew Lesso's compositions.

Drew Lesso, score for "Means to a Natural Order"

Thruph, thruph, thruph, and the sound of marble balls spinning in a steel bowl began the tape. *Thruph, thruph* again, then some whistles sounded, not too loud, not too shrill, followed by the noise of chairs being moved around while the spinning sound continued. The spinning of the marble balls could be heard in the background, changing in sound with the velocity of the spin, rising and lowering in volume throughout the tape. A low voice said, "We hope this is not the last word of the American side." The statement was repeated, followed, and overlaid by the distinctive voice of President Ronald Reagan saying, "We have passed a lot in

the past few days." The first voice was the voice of Soviet Prime Minister Gorbachev's interpreter. He said, "We hope this is not the last word." Reagan replied, "We are headed in the right direction." Interplay of two voices overlaying one another continued with the rhythmic sound of spinning balls and a commentators saying, "The most important parts of the arms race," which was followed by, "We can hope this is not the last word of the American side," said twice, more moving of chairs occurs, more low whistles, the music of something that sounded like a lute, more thumps, and finally the tape ended in bagpipes and a tone playing part of the American national anthem very slowly.

Neal and Drew created a subtle interplay between sound and vision. The three oddly stacked chairs related to the gathering of the summit partners. The sounds of moving chairs as each side sat down at the conference table would never be given importance at a meeting, but the sound was a common noise heard at the beginning and end of any important gathering. The earth and its concerns were symbolized by a globe sitting on top of a stool that was placed in a low mound of black coal. We heard Reagan and Gorbachev remark on our fate as they discussed the arms race and Soviet-American relationships, dynamics that could determine mankind's existence on the globe. If they failed, we would end up rubble. The excess rubble remained in the street like debris cast into space from an exploded globe. The planet earth, the discussions of adversaries, and the consequences of failure were all captured in one combined gesture. The spinning marble in the steel bowl recalled the continuousness of our concerns. On the other hand, we knew at some point the spinning ceases, the world ends, and the big concerns and the small concerns of each individual were transitory. If we looked at our situation from the right viewpoint, we could see and hear how this condition was a window into what was beyond time and space.

During the week of the fourth installation, I took this pronouncement with me to the Dorland Mountain Arts Colony where I rested and recuperated from the previous weeks. The oracle of the Art Dock and the sacred oak grove, where I watched the light vary through the trees, spoke to me about the timeless beauty of change. I meditated in the oak grove listening to the carpet of leaves whisper as a deer approached. The deer smelled my presence and bolted into the chaparral, reminding me of the transitory nature of all flesh. The memory of the rust brown leaves under the canopy of trees came back to me when I viewed the last installation upon my return to the Citizens Warehouse.

Knowledge of the condition of mankind does not tell us how to live. "Means to a Natural Order" attempted to answer that question. Installation five was the conclusion. Like the previous installations, number five had three elements: sky, leaves, and an I Ching. The three elements recalled the three elements of the Trinity, a key doctrine of the Christian faith in which the Father, the Son, and the Holy Ghost are unified in one being. Triangles and triangular relationships are also important to followers of the Buddha and were part of mystical traditions of Judaism. The implied triangle Lesso used in his scores and Taylor utilized in the Art Dock imbued installation number five with a quasi-mystical feel. Element one, the sky, which was a sky painting borrowed from Karen Kristin, implied the universe and heaven. The sky had a double meaning. It was at once infinite and ordinary. The clouds in the sky passed over us and drifted away while mankind toiled beneath. The second element, the pile of leaves, addressed the beauty in decay and the physical work of raking up leaves to burn. The multiple symbols also applied to the coal, which was a product of millennia of compression of leaves and other organic material. Coal, which Taylor used to signify rubble and thus destruction, was also a usable material, important to mankind as a source of fuel and heat for effec-

tive living. The coal dust left in the street symbolized rubble and its use sustaining life.

Element three, the I Ching, the ancient Chinese system for divining the future, provided an answer to the question "How do I find a means to a natural order?" The answer in the hexagram was repose. Like all answers of the I Ching, this combination of lines—painted canvases bearing the same black and white hatch marks like parts of the previous installations—was simple but not so easily interpreted. Repose meant to be at rest, but it also meant to be peaceful and have freedom from uneasiness, worries, and trouble. The question was, in a sense, answered with another question: "How do you be in repose?" To answer this question, the three elements had to be thought of together.

I did this as I meditated in my new spot way back near the rear wall of my studio: back by my bed, my red fish painting in process, next to the wall of square tables used as a screen for my storage. I sat facing across the loft and listened to Drew Lesso's score. Being quiet and at repose was not easy. Hollywood was in Center Street, and they had rented Gung Ma's studio behind me. Actors, directors, camera operators, gaffers, electricians, and go-fers were walking up and down the corridor on the other side of my studio wall. They were dragging cables, cameras, chairs, and light stands. Out in the street in front of the Art Dock, they had a boom truck for filming outdoor scenes. Cars were constantly moved about, and orders shouted. The boom truck was parked in front of the Art Dock, blocking any view of the installation. Alfred Hitchcock Presents had come to the Citizens Warehouse. They were making a loud racket. In response I turned up the volume of Drew's score to hear and to annoy my persecutors while I meditated.

In the din of voices all around me, I listened keenly to Drew's tape. This music was not easy to describe. The score began with hammering,

recalling the first tape, and static. There was a sound like water running, chirps, dots and dashes that sounded like Morse Code, the rising volume of a score like the beginning of a dramatic TV show, *dut, dut, dut-dee-too, dut-dee-too, dut-dee-too,* taps, more taps, and a *wheeh wheeh* sound. The water flowing and the hammering in the background persisted, the *duts*, chirps, and *wheehs* repeated several times, bells, the dramatic rising volume played again, taps, *whooh, whooh,* taps, and the end of the score that sounded like waves on the beach. The music was mysterious, yet oddly soothing. As I listened, I was increasingly tuned to the variations of change in simple sounds. The noise of Hollywood faded away. I was in the sky and with the leaves. I understood the leaves and felt the form of the hexagram. The question "How to be in repose?" was answered. Be awake, be aware, see the world for what it is—its reality and its passing nature—and be equanimous. Repose was P.I.E. (precise, impermanent, and equanimous). I'd said it before, but I hadn't internalized the concept. Sitting in my loft meditating to Drew's score, I felt it. I was at peace and without worry, but not for long. Above the tape, I heard a male voice in the street outside the open Art Dock. He said loudly, "What if I threw a match into that pile of leaves?"

I rose calmly from my cushion. MOCA, my invisible dog, rose from her cushion and followed me. I walked to the curtain beside the Art Dock wall, pulled it open, stepped into the Art Dock, and stood beside the pile of leaves. "Could you repeat what you just said?" I asked the man, who stood below me with several of his fellow movie workers.

He looked to them and turned to me, smirking. "I said, 'What if I threw a match into that pile of leaves?'"

"That would be a bad idea," I said calmly. "Have you no appreciation for art? Besides, arson is illegal."

"Listen, buddy, your art or whatever you call this pile of leaves is interfering with our film shoot. Close it up!"

"I don't think I will," I said. I could see the anger rising in the man's face above his black beard and on his balding head. In his hand he had a flashlight. He turned it on and waved it in my face and on the Art Dock installation.

"The light coming from this loading dock is interfering with darkness I need for shooting my film," he barked at me.

"What you need is not my concern," I answered.

"What will it take for you to close up?" he demanded. The man had on a safari jacket with pockets brimming with items. He pulled a billfold from one of the pockets. "Ten bucks?"

"I don't think so," I said.

"Twenty bucks?" I shook my head no.

"Forty bucks. Say fifty bucks." I shook my head no. The man turned to the others around him. They shrugged their shoulders. He looked back at me. "Okay, a hundred bucks."

"Okay," I said. "I'll close up for 100 dollars." He peeled five twenties from the billfold and handed them to me. "Have a nice night, gentlemen," I said, walking across the Art Dock opening to the chain dangling from the gear above. I grabbed it and, hand over hand, rolled down the metal door.

I turned to MOCA the dog, who watched my negotiation silently, and said, "This is the first money I have ever made from the Art Dock, and I get it to close it up. I think the gods are sending me a message." In my mind, MOCA barked.

Postscript 2012: Neal Taylor actively continues to make sculpture, photography, cutouts on paper, rugs, and graphic art. His recent activity returned him to his roots in Mail Art, popular in the 1980s. He is making First Day Covers and Art Stamps. He lives in the Mount Washington neighborhood of Los Angeles, an area populated with many artists. Drew Lesso remains an active composer. He lives in downtown Los Angeles. Asked to write a statement about himself as an artist, Drew wrote:

"I choose to create a sensible expression of

Sketchbook plan of Loft with "Means to a Natural Order" in the Art Dock Dec. 3, 1985

music. This choice takes the long and winding road. Just as a drink of fine Scotch warms our hearts, hands are coveted above all else for musical articulation. I compose mainly at the piano. My work also encompasses writing programs for signal processing and graphics using the computer program Mathematica 8. To help further my evolu-tion and involvement in the arts community, I have developed a lecture series that expresses my usage of Harmonics—the science of ratio and proportion."

Composer Karlheinz Stockhousen died in 2007. The hundred dollars I made on December 3, 1985 was the only money I ever received from the Art Dock.

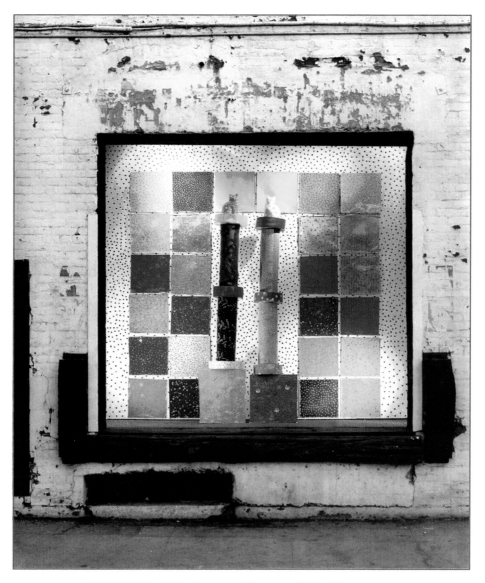

ACT IV THE BUSINESS OF ART

ART DOCKUMENT #35 "CAT COLUMNS IN SHAKEY TOWN" BY ANDREA AYERS—WINTER 1985-86

The 'Cat Columns in Shakey Town' looks pretty kitschy to me, MOCA," I said with a laugh. Quickly, I realized I was standing in the street looking at the Art Dock installation alone on the last evening of the last show in the Art Dock. I still felt the presence of the animal. I wanted to talk to her and give her my final views on the art in the

drive-by gallery as I had done for the previous three years. MOCA and I had walked the railroad tracks and stood in front of the open loading dock while she wagged her tail as I pontificated. The dog listened to my thoughts silently, only barking approval after I asked her, "What do you think dog?" One bark I took to mean approval; repeated barks, disap-

AD#35 **265**

proval. Silence meant she didn't care. What would she have thought of this installation? I thought the dog would have barked once.

"Cat Columns in Shakey Town" wasn't great art. It was tacky, but Andrea Ayers had warned me before she installed. She had told me, "I'm not an artist. I'm a potter; I'm a maker of kitsch."

I smiled and said, "Don't discount yourself. There are pots that are great pieces of art, like Greek amphoras."

She wouldn't listen. Again and again she said she wasn't an artist until it became tiresome, and I stopped paying attention. I wondered why I had invited her to show in the Art Dock. I had seen her work in her studio in South Pasadena and liked the square ceramic boxes that she made. I had even commissioned her to make several that I could use as bases for my painted sculptures. Maybe I was perverse. For the end of Art Dock, I installed a joke in the joke that was the drive-by gallery.

I jested with Andrea. I said to her, "The Art Dock is nothing; no one ever sees it, it's never open, and it's a joke."

Andrea became very serious. "No, it isn't. The Art Dock is wonderful," she said.

I scoffed. "You needn't worry, my dear, the Art Dock won't make you famous."

Andrea didn't know quite what to do with the opportunity I gave her. At first she tried to back out. I wouldn't let her. She was going to put up a wall of her plates. She called them plates although they were square, and if you ate off their lead-infused surfaces you would die. I suggested she could do better, so the two of us came up with the installation in the Art Dock using her plates, her square bases, her small column sections, and her spotted ceramic cats. All together the combination was humorous and joyful, almost childlike. It wasn't intellectual or serious, but it was appropriate for the holiday season. It had presence.

"You know, dog," I said silently, pretending the dog was still with me. "The frame of the opening—

Daily Diary Page by Carl Davis

the very presence of the loading dock—makes a lot of art look better. Do you recall the article by the critic Michael Fried titled 'Art and Objecthood?' It was highly influential in art circles in the '70s. You probably don't. Bones, not criticism, interest you. Talking about Minimalist work that he called 'literalist,' Fried argued that perceptually framed art was theatrical and unsuited for an art gallery. Modern art is supposed to be directly absorbed into the consciousness of the viewer. The art experience diminishes when the viewer is conscious of a mental or physical framework; the experience should be complete unto itself and visceral. Fried would have dismissed the Art Dock as an obstacle to the honest experience of the art. I think this is an argument that favors the benign atmosphere of the white room. I

think Fried is wrong. Art, all art, including modern art, can be enhanced by the circumstances of its placement. This is true from the first marks on a cave wall to the street murals of Los Angeles. Even the white room is theatrical abstraction. The clear bright spaces of the museum, whether they are white or some wonderful hue, are places removed from every day life. Museums are special experiences. To remove art from its context—whether it's a place, history, or culture—is to make the art experience less complete, not more. I reject the idea of looking on an art object without references. Duchamp's doorway, where you look through the peephole to see the art, is a good example for my point of view. This would be a good time for you to bark several times before I get carried away if you were here, dog."

Shining a light into my mind carried me away from art, the Art Dock, and the Citizens Warehouse. I now meditated every day and spent a lot of time at the Community Meditation Center, which was an old two-story house on the edge of Koreatown in a drug-infested, Central-American-dominated neighborhood. On December 9th, the day Buddha achieved enlightenment, I attended an all-day retreat at the center, sitting on a cushion in what was formerly a living room, next to the fireplace, surrounded by twenty other meditators dispersed around the perimeter of the pale yellow room. Forgoing the desire to get up and run away after a fiery heat arose in my knees and hips, a peace gradually enveloped me. I realized that being recognized as an artist didn't matter to me anymore and that my need to have an Art Dock was no more. I knew I would always love art and probably always make art, but it was no longer the center of my life. I had other issues more important to confront and the way to confront them was precision, impermanence, and equanimity. Mediation was my path forward.

I met with the meditation teacher, Shinzen. He had private interviews with the retreat participants in a small room nearby the meditation hall. Soft light through a high window illuminated his face. He was dressed in a black gown indicating his Zen training and sat on a cushion in front of the cushion I sat on. He asked me why I had decided to become a meditator. I told him how my psychologist had recommended that meditation could help me with my depression and my desire to get off dope. Shinzen laughed and told me that he used to be a pothead until he meditated by scanning his lungs, and the urge to smoke went away. He said if I practiced meditation diligently it could end my depressions. I told him I was committed to finding a solution to my cyclical "Attacks of the Black Brain," as I called them. He suggested I might try living in the Community Meditation Center. I said I would think about it.

I planned to divide my studio into the architectural office of Davis dot Kyrk Architects and a much smaller studio by building a dividing wall down the center of the old studio. The Art Dock would revert to being a front porch. I renewed my lease for another five years and departed for the Dorland Mountain Arts Colony for the Christmas Holidays, where I worked on reroofing a kitchen house and Mrs. Dorland's cottage with the help and commentary of my friend, the African American writer Leroy Musgraves, who functioned as a caretaker at the Colony.

He pruned the trees and gave me grief at every opportunity. If I didn't watch carefully, I would fall off the roof, then what would he do? If I wasn't careful I could damage the trees that hung perilously close to the top of the roofs. He had me move my ladder positioned on the side of Mrs. Dorland's cottage when it was in the way of his pruning. I moved it then hit my head on an overhanging limb.

"You see, that's why I didn't put the ladder there," I said.

Leroy gave one of his long "Ahs" and changed the subject to tell me what was wrong with South Africa.

"The world is too much with you," I said, looking at my hands spotted with roofing tar.

The Art Dockuments

"I can't help it, man," he said, holding up his arms and looking at his pink palms on the other side of his dark brown hands. "Next year I won't listen to the radio."

"I'll bet," I said.

"Yah know," he replied, putting on his best southern black accent. "The twos of us is like a Jazz duet."

a network of shifting shadows. I listened to the rustle of the wind and sounds of the leaves as they moved under the small feet of nighttime visitors: mice, rabbits, skunks, and deer. I was awake and aware. I was happy. Returning to LA before New Year's, I was at peace. I readied myself for closing the Art Dock.

Daily Diary pages by Carl Davis

The duet continued each evening when we met for dinner together and talked about life. Afterwards the music of words and thoughts played on while I meditated in the Oak Grove as the moonlight cast a silver glow under the canopy of trees. I watched the light pattern change over the carpet of fallen leaves as it moved slowly through

On this last night, I thought of all the art I had seen in past month. The Newport Harbor Art Museum had an Abstract Expressionist sculpture show, and James Turrell's work was on display at MOCA. I mused about the art I found at the Dorland Mountain Arts Colony. I particularly liked George Sugarman's polychromed wood pieces at the

Newport Harbor Art Museum. They had presence. I mulled over in my mind Sugarman's statement that "all art is metaphor" and that "to escape from metaphor, artists have often chosen other means: the sheer physical stimulation or the insistence on a system of formal relationships that has meaning in and of itself." He then questioned whether an artist had to choose among metaphor, stimulation, and formal relationships. In his own work, like the work I sketched, it appeared he tried to combine all three. The metaphor lay in the history of sculpture, perhaps a reference to Russian Constructivist work. The curving gesture of the rendered wood slabs encapsulated stimulation as if a force had twisted the wood. The formal relationship lay in the feel of how each wood piece seems part of a complete system, as if each plane could fall and stack neatly. Did the Art Dock piece have any of these qualities? The metaphor was easy to see. The cat columns harked back to classical columns with sculptural figures on top, like the column in Trafalgar Square in London, where Lord Nelson presided over the flocking tourists. Stimulation was seen in the casual way the columns were erected with tubes and disks of different colors, sizes, and inclinations piled up upon one another. Finding formal relationships was a little tougher. The background of plates created an archway behind the columns, which created a relationship of scale and color.

Did I believe "Cat Columns in Shakey Town" was art? Perhaps the answer lay in reflecting on James Turrell's marvelous work at MOCA. He installed a Ganzfeld (a visual field) of a color that was every color and none at all. You couldn't take photographs of this work. A photograph would show nothing but a colored surface on a wall. This artwork was about light itself and the qualities of metaphor, stimulation, and formal relationship that we bring to it. Light was a metaphor for almost everything in life and death. People described near-death experiences using a vocabulary of light, yet there was no vocabulary that

could explain light. It was ultimately inexplicable. We could say it was bright, dull, or even, but that didn't capture light itself. It only described its circumstances. Color didn't explain it either because pure light was all colors. The metaphor was deep and mystical. Light created presence. When light was captured in one of Turrell's Ganzfelds, it had presence.

Turrell stimulated light by the scale, construction, and technical manipulation of the large rectangles and special voids he created in his installations. Walking into the semi-darkened room, you found a hovering field of light, silvery and chromatic. As you stared into this field of light, it appeared to include all colors in subtle variety, and it seemed to pulse. It felt unreal, yet there was a definite surface in front of you. It was a surface without form and without substance. In actuality, it was a hole in a wall that the light screens, but there was no materiality to this screen. It just was. The formal relationship was established by the context. You entered a special room darkened to the appropriate level for the Ganzfeld to become visible. The rectangle of color was seen from a distance, hovering in a wall like a window into another world where no form could be determined other than the form of the rectangle. As you approached the form, form dissolved into light. There were no clues (like dimension, for instance) to the edges of the rectangle. Only the color that was no color in particular could be seen. Light was the actor in the theater. The stage was the rectangle, the concert hall, and the museum. In this aspect I saw the Art Dock installation as an extension of this idea. It didn't hold a candle to Turrell's Ganzfeld, but the stage of the loading dock enhanced the comical cat columns as art. Where Turrell was providing a symphony of light in the opera house of the museum, the Art Dock provided a popular tune in the music hall of the loading dock. "What do you think about defining the Art Dock as a lowly music hall?" I asked the absent dog. I imagined the dog barking several times. "You don't like that, MOCA?"

Perhaps there was another way to think this installation and the Art Dock.

I returned to Los Angeles from the Dorland Mountain Arts Colony. While cleaning one of the adobe structures there, I found a lithograph by Jose Clemente Orozco, the renowned Mexican muralist. Tree rats had chewed the edges of this signed lithograph. I borrowed it to preserve, draw, and frame it.

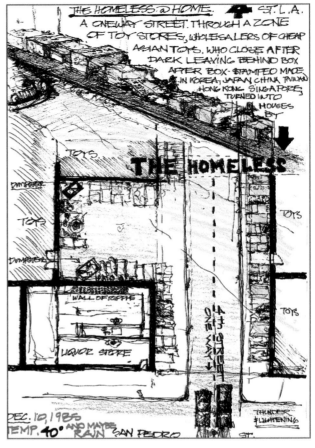

Sketch Book drawing by Carl Davis

Orozco lithograph found at the Dorland Mountain Arts Colony and drawn by Carl Davis

I considered the issue of framing. Without the frame the lithograph would still be art, but framing it made it special. A frame separated the art from the observer and isolated the world around it. The frame made the work precious. The modern art inclination to leave paintings unframed required that the isolation take place by other means. Usually this was the white room devoid of anything to interfere with the presence of the art itself, but this wasn't done with works on paper. They were usually too fragile to be unmatted and unframed. Modern art outside the museum setting, for example in a house, always seemed diminished by the clutter of domesticity, yet framed pieces retained their isolation and thus their specialness. The Art Dock was a frame more than anything else. A frame and a framework—a framework because of its location in an old warehouse in a decaying industrial part of the urban context—that required art to be in it to become extraordinary. The art influenced and was influenced by the frame. Without the art, the loading dock was nothing surprising; with the art, the frame—its dimensions, its situation off the street level, and its location—became remarkable. The Art

Dock becomes art. "What do you think about that, dog?" I silently asked the dog's ghost. "You're going to be silent, ehh?" I was getting too far into my head. "Let's close up for the last time, dog." Before I could move away, a homeless person approached me.

It was Peter, the homeless painter I had met when Miles Forst had his piece in the Art Dock. He was wheeling his shopping cart full of his belongings with a small black dog on top. From the sides of the shopping cart dangled plastic bags full of discarded bottles. Peter wore the same blue sea captain's cap he had when I last saw him. His faded blonde hair flared out beneath the cap. He was wearing a scruffy-looking naval pea jacket with the lapels up around his neck.

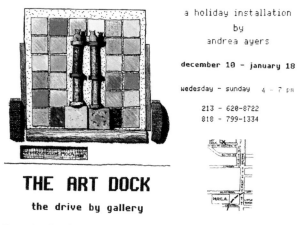

a holiday installation
by
andrea ayers

december 10 – january 18

wedesday – sunday 4 – 7 pm

213 – 620-8722
818 – 799-1334

THE ART DOCK
the drive by gallery

Final Art Dock flyer

"How are you, Peter?" I asked.

"Not bad," he replied. "I'm living over on 4th Street now."

"Are you living in one of those cardboard boxes on the street?" I asked. I was in the area on December 10th and sketched many of the boxes used as lodging by the destitute in front of the toy warehouses and around the corner from a liquor store that sold cheap Ripple wine.

"Yes," he said. "I have a sturdy box. It's a good place, better than the missions. They have too many rules. I can't have my dog there. The cops come

every once in a while and chase us away. They destroy our homes, but we come back. There are always a lot of boxes."

"What brings you this way, Peter?"

"I always come down this street. There are lots of bottles in the dumpsters, and I like to see what you have in the dock."

"Do you like this? I call it 'Cat Columns in Shakey Town,'" I said. Before Peter could reply his dog rose up on his front legs and barked. "I think your dog likes the piece."

"Scooter likes the cats, I bet," Peter said.

"What do you think?" I asked.

Peter looked over his red-rimmed glasses and peered very intently at the installation. "It's very cheerful," he said turning to look at me. "You've brightened my day. Would you consider me to paint a painting on your wall?"

"Too late, Peter, I'm closing the Art Dock for the last time tonight. Thank you for asking."

"I'll miss the Art Dock," he said and turned away, pushing his shopping cart toward the corner and the dumpster.

I looked one last time and sighed. "I'll miss the Art Dock too, dog," I said to the empty street. I climbed the three steps into 112 Center Street, opened my loft door, and walked across my office to the open loading door. I stepped through the curtain, passed in front of the cat columns, grabbed hold of the long loop of the lowering chain, and, hand over hand, began to close the loading door. The chain jumped its sprockets on the winding gear and crashed to the floor, nearly hitting me in the head. Rapidly, the heavy steel door slid down in its guide way, slammed to the wood floor, and closed the Art Dock with a shuddering bang. The show was over.

Postscript 2012: Andrea Ayers could not be located. George Sugarman died in 1999. He was a prolific sculptor and distinguished teacher. He was known for his colorful geometric and biomorphic work, which was influenced by Surrealism,

The Art Dockuments

Cubism, Baroque sculpture, and Abstract Expressionism. He taught for many years at Hunter College in New York City and at Yale University. His foundation in Novato, California, donates his artworks to institutions, museums, and universities throughout the U.S. James Turrell continues to be an active and engaging artist. His "Roden Crater," being constructed in a 380,000-year-old dormant volcano in the Painted Desert of northern Arizona, will gather light—daylight and particularly moonlight—in a space sculpted in a way that you will feel its physical presence. In a sense, Turrell is creating a passive light machine in which every changing, captured shadow and light become tangible. Turrell has compared the experience to tasting fine wine. A Ganzfeld Effect, which in German means "complete field," is an experience of visual perception caused by staring at an undifferentiated and uniform field of color. The effect can alter the brain and cause hallucinations because of the lack of sensory stimulation.

Jose Clemente Orozco died in 1949. He, along with Diego Rivera and David Siqueiros, established the Mexican mural renaissance. His most famous work in the United States is his mural at Dartmouth College in New Hampshire. The Dartmouth mural, still visible, is titled "The Epic of American Civilization." Painted between 1932 and 1934, it shows the artist's interest in human suffering and his fascination with machines, war, and death. The Dorland Orozco lithograph perished in the fire of 2004, which destroyed the art colony. The Community Meditation Center no longer exists, but Shinzen Young became a leading meditation teacher. He lectures and leads retreats throughout the United States and lives in Vermont. Leroy Musgraves left Dorland and Southern California. He resides in Oakland and works with an organic food market. He continues to write. Peter, the homeless artist, was never seen again near the Citizens Warehouse. The Art Dock closed in January 1986.

EPILOGUE

"We must welcome the future, remembering that soon it will be the past; and we must respect the past, remembering that it was once all that was humanly possible."
—George Santayana

"Art is always and everywhere the secret confession, and at the same time the immortal movement of its time."
—Karl Marx

"Contemporary art challenges us. it broadens our horizons. It asks us to think beyond the limits of conventional wisdom."
—Eli Broad

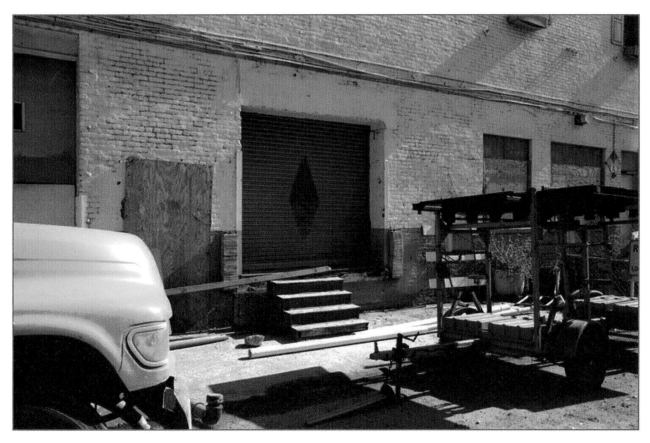

ART DOCKUMENT #36
DUCHAMP'S PARTY CONTINUES 2012

uchamp's party continues," I said to myself as I drove east toward downtown from the west side of Los Angeles. It was late 2011, and thirty years had passed since I had opened the Art Dock; much had changed, as it always does in LA. Here, rapid change is normal. I went back to downtown to look around, but I wouldn't stay. I no longer lived in downtown, and I hadn't lived there for twenty years. I lived only seven miles away in Pasadena in an old house on the edge of the Arroyo Seco. My place overlooked Brookside Park where, in the distance beyond the shallow gorge, I could see the San Gabriel Mountains. In winter, the mountains were dusted with snow. Pasadena is not

far from downtown, but it is a world apart. I hadn't had a studio in a long time. Twelve years ago, I gave up a small studio behind the architecture office that I had in downtown. I missed the really big space I had in the Citizens Warehouse. I missed the Art Dock and the freedom I had, but I didn't miss the hassles that went with the studio. I wrote and drew in a little space underneath the house with large windows looking into the arroyo. I lived a more peaceful life.

I went to the Westside to see Phyllis Green's marvelous twenty-five-year retrospective at the Otis College of Art & Design. Phyllis' quirky sculptures and video tapes included one piece called "Duchamp Party" that I particularly liked. It was an oversized

L12 "Duchamp's Party" by Phyllis Green 2001

bottle rack à la Marcel Duchamp. Positioned on the bottle pins were stylized forms reminiscent of gnomes covered with hair. They seemed to me to be like artists gathered in the bottle-rack temple of the master of modern art. They were relishing the artist's life and paying homage to the joy that art created. Phyllis moved to the west side of the city and really established her career after she left downtown. I thought about Duchamp's evolving art party as I drove east. I thought about the art muse and how she always moved on. The scene for the artist's life always changed, and it changed in downtown Los Angeles.

I thought about 1986, the year I departed downtown for life in the Community Mediation Center and later for a studio switch with the artist Lloyd Hamrol. That year brought many changes to the community of artist in the Citizens Warehouse and in the larger area east of Broadway and east and south of Little Tokyo. The artist-owners of the warehouse sold the property to a real estate investor, who was much more businesslike in his treatment of the tenants but also committed to bringing the building up to code. There would be no more evading and toying with the city's demands for code compliance. Other artist-occupied structures met a similar fate. In a March 1986 *LA Weekly* story about earthquake reinforcement of the American Hotel, they called it Hotel Hell, where the residents were faced with gaping holes in the floors and walls and damage to their personal belongings. One resident fell through a hole in the floor of his room, but his accident was discounted when it was reported the guy "takes too many drugs."

Final earthquake reinforcement of the old brick warehouses took place all over downtown. The Citizens Warehouse's new owner pushed ahead with the work while tenants continued to occupy their spaces. Once again the noise was intolerable, not to mention the dust and debris from drilling and installing the bolts that anchored the brick bearing walls to the wood joists and beams. As planned, I

slipped away to live in the Community Meditation Center while the work was done. The artist's party got a little grimmer and certainly more costly.

After I returned to my loft, I was left to deal alone with the new owner and all the other code violations of my space. I had to pay for the electrical upgrades without help, which nearly bankrupted me. Investing in a space I didn't own made me wonder about my sanity. My low-cost artist housing project on Myers Street finally failed after the City Redevelopment Agency required that the work on the project be done at prevailing union wages, according to the Davis-Bacon Act. If the project proceeded, it would no longer be affordable artist housing. The rated of leasing would have to be over seventy-five cents per square foot, which would put the studios we designed well over $1,500 a month. No artists I knew could afford spaces costing that much.

Gunga Ma decided to sublet her space and departed for India to be with her guru. Gary and Karen, my neighbors across the entry corridor and co-directors of the Art Dock, decided to profit from their lease by subletting their spaces and moved to the Brewery Art Colony on the far edge of downtown, into what would be and still is the largest collection of artist lofts in the city. The energy of living in downtown was waning for my wave of artists, the second generation following the "Young Turks." The thirty galleries that populated the artist in residence area were beginning to fade. Thirty galleries became twenty as dealers followed the money to the Westside. Over the years that number would continue to diminish and rearrange. In 2012 in what some said was a resurgence of the art community, there were listed fifty galleries in downtown LA centered around Main and Spring Streets, but many of these weren't real galleries. They were false galleries appearing only during the Downtown Art Walk. Downtown was now the domain of young professionals.

Thus, weary and worn, I traded studios for an unspecified time to Lloyd Hamrol, an artist known for

his public art projects. Lloyd moved into my space, where he intended to fabricate a large wood piece consisting of platforms and benches for an ocean cliff in Isla Vista, California. The loading dock available to my studio was a big advantage to him and the large space gave him plenty of room to mill his timbers. I moved into his studio in Venice where once again I had access to the beach and the boardwalk,

let me back into my studio. I had to find a new place to go. I ended up in Pasadena, renting a room from Virginia Tanzmann who later became my wife. Six months later, after Lloyd had finished his piece, I moved back into the loft for the last three years of my lease. Virginia joined me in the studio after we were married, and we walked to work at our architectural office, which was three blocks away.

"Sea Look Out Park" by Lloyd Hamrol, Isla Vista, 1987

and close proximity to a new architectural office where I worked. The arrangement suited us both until I came home one afternoon to discover a large pile of dirt in the middle of the studio. On top of the pile of dirt was the toilet. The owner had decided to redo the plumbing in his storefront studio building. The place was uninhabitable, and the owner of the building was unwilling to give me an estimate of how long I would be forced out of the studio. Lloyd was in the middle of his project and could not move to

The last years of my lease in the Citizens Warehouse were unmarred by battles with the owner or by invasions of building inspectors. There was no longer a question whether or not we lived there, the earthquake reinforcement was complete, and all the code violations were resolved. Zorba, my nemesis neighbor whose makeshift plumbing used to leak all over my kitchen, was gone. Two ladies who sold Asian antiques lived across the hallway—they had hundreds of Buddhas big and small—and the artist

Sketchbook drawing of studio in December 1989 by Carl Davis

The Art Dockuments

Martin Gantman lived in Gunga Ma's old space. I divided up my space into Virginia's (Ginger's) area and mine. We slept on top of a storage area in a little loft inside the big loft. A ladder provided access to this aerie. We had two dogs, Nikki and Sadie, and they would hang out in the half-open loading dock watching the street and guarding our space. They barked furiously when a homeless person walked or wheeled a shopping cart past the loading door. I didn't go out and look in the street after the warning woofs, or carry on dialogue with the homeless or with artists anymore. I told people the Art Dock had gone to the dogs.

When my lease was up, the proposed rent was seventy-five cents per square foot. This would have made my studio cost over $2,000 a month. I didn't hesitate. I moved out, but not without regrets. I didn't ever think I would have this much space to play around in, nor the opportunity to make a community sculpture arena like the Art Dock again.

I drove east on the Santa Monica Freeway toward downtown thinking about the past and the present. 1986 was a seminal year for the arts in Los Angeles. Two new museums opened in November and December: the redesigned campus of the Los Angeles County Museum of Art (LACMA) and the Museum of Contemporary Art (MOCA). LACMA's new *Robert O. Anderson* Building for Modern and *Contemporary Art* (now known as the Art of the Americas Building) was designed by Hardy Holzman Pfeiffer. It hasn't maintained any critical acclaim over the years. One pundit called it "functionalist in drag." By 2011, the County's hodge-podge campus of art museums at LACMA—ranging from '60s Modernist to Bruce Goff's idiosyncratic Japanese Pavilion to the vaguely postmodern Anderson Building—had been reorganized around new pavilions with a new entrance orientation designed by Renzo Piano. MOCA, designed by Arata Isozaki, has fared better. The postmodern museum—a style of architecture now out of favor—was, as Isozaki described

it, a "small village inside a valley created by skyscrapers." With exquisitely proportioned rooms and a main gallery 58 feet high covered by a pyramidal skylight, MOCA was a tour-de-force of the white-room religion. Sam Hall Kaplan, then design critic of the *LA Times*, stated in November 1986 that "art appreciation has taken on the form of a religion in this acquisitive secular age, and museums have become a measure of municipal worth as cathedrals were in centuries past." MOCA was the first art cathedral on Bunker Hill in downtown Los Angeles. It wouldn't be the last.

I cruised into the loop of the four freeways surrounding downtown and exited the 101 Freeway north following the signs leading to MOCA and the exuberant Disney Hall, a galleon in full sail by Frank Gehry, my once-long-ago employer. Disney Hall overshadowed the quieter forms of MOCA. The religion of art would soon have a new cathedral on the hill that had become the center of cultural life in Los Angeles. I looked into the empty hole across the street from MOCA where the new Broad Museum would sit on a parking garage plinth. The empty hole would be filled with parked cars, emblematic of LA's other great religious obsession, the automobile. On top of the cars would sit a jewel box filled with the precious art collected by Eli Broad, the man who created Kaufman and Broad, the homebuilders we have to thank for spreading suburbia throughout Southern California, the United States, and the whole globe. Their basementless houses were a big part of the electrical fungus of a bland American Dream that spread across the Temecula Valley choking the land around the Dorland Mountain Arts Colony. Our art cathedrals collected a select few of the artists that the market determined to be valuable—the Broad Museum will be full of Rauschenbergs, Ruschas, Rothkos, and Koonses—but the structure and the foundation underlying the new cathedral honors the benefactor. I wondered how much these cultural monuments could foster a productive creative atmosphere.

Looking further for that atmosphere, I headed for the "Arts District," as the city of Los Angeles designated the old artist neighborhood I knew in the 1980s.

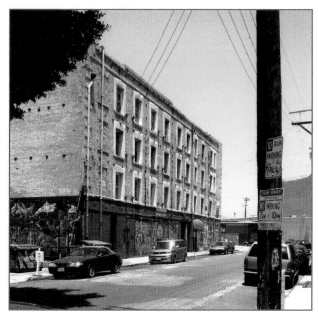

The closed Al's Bar and the American Hotel, Arts District, downtown LA, 2011

Around Traction Avenue and Hewitt Street, the former center of the neighborhood, a lot had changed and some remnants remained. Al's Bar was closed, but the American Hotel above the bar still operated as a low-cost entryway into the neighborhood. The American Gallery was gone, as were most of the galleries in the neighborhood. They were replaced by restaurants and coffee shops. Many of the old artist-in-residence buildings remained in the area to the east of the American Hotel. The Southern California Institute of Architecture (SCI-ARC) converted a block long railroad storage building on Santa Fe Avenue into a school, bringing many students into the neighborhood. Artists, students, and young professionals populated the eateries. Apartment buildings and architect-designed loft conversions sprung up all around the district and were reported in the press.

The term "loft" now signified an apartment in an old warehouse structure like the Barker Brothers building, where small spaces of fewer than 1,100

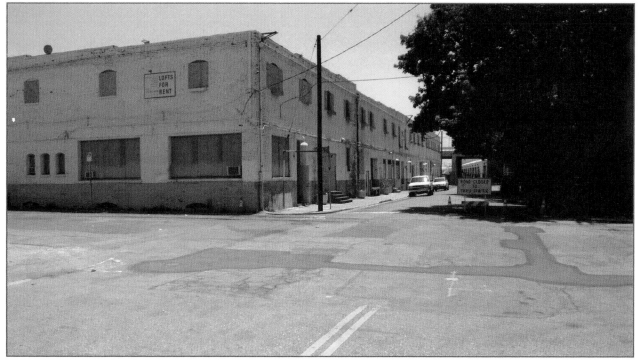

Citizens Warehouse, downtown Los Angeles, 2008

square feet were carved up into one- and two-bedroom units with defined living and kitchen areas. Some of these spaces were very handsome, but they were not affordable for low-income artists, compared to the 2,600 square feet I had for $350 a month on Center Street in the 1980s. Some of these new units were converted to small condominiums with an asking price of over half a million dollars. In the down market of 2011, these prices were shrinking and some conversions had reverted to rental units. Rental prices were at minimum a dollar per square foot, which led to loft size reductions. Units as small as 500 square feet were on the rental market. The big spaces without definition of rooms disappeared. Artists were still to be found in the neighborhood, and they were fighting the trend to price them out. Artists appealed to the city to institute a program that would keep them in the Arts District.

I steered the short distance down 2nd Street and turned on Santa Fe north toward the Citizens Warehouse to see if it was still there. In 2008, the city bought the warehouse and vacated it for the building of the Gold Line Transit system from Union Station into East LA. At the south end of the building, about fifty feet of the structure was demolished to allow the transit line to cross over the LA River next to the First Street Bridge. The rest of the building, including the Art Dock, remained, but perhaps not for long. I asked the construction team that used what was once Jan Taylor's studio as a field office if the building were in immediate danger. They told me that construction on the Gold Line abutments would probably continue for four months; after that there was no guarantee of salvation.

I stood in front of the old Art Dock and thought of all the possibilities for the Citizens Warehouse. Suddenly I remembered the one little show I never wrote about in the Art Dockuments. At the end of 1983, when I returned to my loft after my first exile at the beach in Venice and before Bob Gibson

installed "Between the Heartbeats" to start Act III, my daughter Sevra and I constructed a child's house in the Art Dock made of painted paper tubes, tape, yarn, and dangling colored metal shapes found along the railroad tracks. "Snowflake House" jingled when she ran around the house and caused the metal shapes to strike one another. She loved dancing around the little structure, and people in the street listened and partook in her joy. There is nothing serious about the little piece. It demanded no interpretation. It was just fun. "Snowflake House" reminded me of what is so wonderful about art. There is the pure delight in creation. There is the happiness and meaning it provides for others. "Art is a gift," as the psychologist Ed Wortz once said. Art is a gift to those who make it. Art is a gift to those who possess it. Art transforms the way we look at the world.

Sevra Davis' "Snowflake House"—winter 1983-1984

The weather was cold in December and January 1983-84 when "Snowflake House" was in the Art Dock. Even in Southern California the winters can be chilly, especially if you have a nine-foot-square opening in your home to the outside and no heat. I feel a great affinity with the homeless who live in their cardboard boxes in the open. I froze when I opened

the Art Dock, but I did it anyway because I knew whatever the Art Dock showed brought smiles to faces of artists, homeless, policeman, building inspectors, and any other occasional passerby. I felt great joy in the creation of the Art Dock. Whenever I passed a loading dock I could not help visualizing its potential to display art and be art. Rrose Selavy, Marcel Duchamp's alter ego, might smile ironically, perhaps because, no matter what happened in the world, when art was made and shown, the art party continued.

"Loading docks along Central Ave in downtown Los Angeles" by Juliane Backmann, 2010